STEEL-ENGRAVED BOOK ILLUSTRATION IN ENGLAND

Steel-engraved book illustration in England

BASIL HUNNISETT

David R. Godine, Publisher, Boston

First U.S. edition published in 1980 by
David R. Godine, Publisher, Inc.
306 Dartmouth Street
Boston, Massachusetts 02116

ISBN 0-87923-322-2
LC 79-92108

Printed in Great Britain by
The Scolar Press, Ilkley

TO AMY MADELINE

CONTENTS

LIST OF PLATES

Illustrations are reproduced actual size unless otherwise stated.

PREFACE

This study was conceived just over twenty years ago, when the predominance of books from this period in the reserve stocks of libraries with which I was connected aroused my interest in them. A realization that steel engravings were the Cinderellas of book illustration was followed by the discovery that no serious attempt had been made to investigate them. This essay is the result. A systematic analysis of hundreds of books and thousands of prints ensued, lasting at intervals for about fifteen years, one of the most important by-products being a detailed survey, by no means complete, of the published plates of over four hundred engravers, with an associated index of artists. This already contains much information gleaned from many sources which considerably supplements existing reference books, and helps to fill the lacunae referred to in a review of Ottley's supplement to Bryan's *Dictionary of painters, engravers* . . . (1866) : 'We have searched it but in vain . . . among English engravers [for] R. Graves, A.R.A., R. Wallis, [T.] O. Barlow, G. R. Ward, H. Lemon, Lightfoot, Greatbach, the brothers John and Charles Cousen, J. B. Allen, Vernon, C. Rolls, E. Goodall and others . . . It is only right to remark that he acknowledges in his preface his inability to procure information from many artists to whom he has applied . . .'. The survey, however, does not form part of this present work, since to give even a checklist would add considerably to its bulk, but it has been drawn upon in the preparation of Chapters 6 and 7.

Because of the paucity of published work on the subject I have not included a Bibliography. Full references to sources will be found in the Notes (pages 217–39).

John Pye, in his *Patronage of British Art* (1845), says: 'It would be a nice matter to trace the progressive introduction of steel' (page 372), and Percy Muir, in *Victorian Illustrated Books* (1971), comments on the lack of information on books illustrated with line engravings, thus causing them to be unduly neglected. The aim of my work has been to provide a basis from which the reader is enabled to develop his own views and taste, so it has been constructed upon practical bibliographical considerations. It avoids, whenever possible, any artistic judgements, which I do not feel particularly competent to express. Those which do exist are not very helpful, since personal taste is so much involved, and an endeavour has been made to demonstrate the wealth and variety of engravings produced, and the conditions

under which they appeared, indicating, by reference to named examples, the standards applied by me. Any value judgments have been formed by the engraving's impact as an engraving, not as the translation of another's work.

Hove, August 1978 B.H.

ACKNOWLEDGEMENTS

Without the help and encouragement of a number of people, this study could never have been undertaken; the access freely given to all kinds of information sources is gratefully acknowledged. A particular acknowledgement is due to Mr H. M. Nixon, Librarian of Westminster Abbey, who was my supervisor for the thesis submitted for the degree of Doctor of Philosophy in the University of London, and upon which this book is based. The brunt of my demands has fallen upon Elaine Baird and the indefatigable staff of Brighton Reference Library, where the Bloomfield Collection is so rich in material of this period that much of my work has been done there. Roger Churchill, Miss Green and the staff of Hove Reference Library, and Esme Evans, Robert Elleray and the staff of Worthing Reference Library have likewise contributed much to the work. James Mosley of the St Bride Printing Library has given unselfishly of his time and expertise, and my thanks are due to him and to members of his staff.

Debts of gratitude are acknowledged to E. M. Kelly, Archive Section, Bank of England; Andrea Rose, Deputy Keeper, Art Department, Birmingham Art Gallery; the Local Studies Librarian, Birmingham Reference Library; Adam and Charles Black; Lucy R. Bradbury, Researcher, of Bradford; David James, Archivist, Bradford Metropolitan Council; Reprographic and photographic staff and John Plummer of Brighton Polytechnic; staff of the British Library (Reference Division); T. P. Moore, British Museum Print Department; Mr Holmes, Camden Reference Library; J. Luby, Duns Area Librarian; Mrs N. E. S. Armstrong, Head of Reference and Information Services, Edinburgh Reference Library; staff of the Mitchell Library, Glasgow; staff of Leeds Public Library; Hornby Librarian, Liverpool; Ian McKee, Vice-Chairman, Methuen Educational; Virginia Murray, Archivist, John Murray, Publishers; Librarian of the National Book League; Alison E. Harvey-Wood, Assistant Keeper, Department of Printed Books, and Miss E. D. Yeo, Assistant Keeper, Department of Manuscripts, National Library of Scotland; Elspeth A. Evans, Research Consultant, National Portrait Gallery; J. A. Edwards, Archivist, Longman Archive, Reading University Library; Frances D. Pomeroy and Philip N. McQueen of Thomas Ross and Son; Constance-Anne Parker, Librarian, Royal Academy; D. G. C. Allan,

Curator-Librarian, Royal Society of Arts; Ian Grant, Assistant Keeper, Scottish Record Office; Sheffield City Libraries; the Revd R. Tydeman, Rector of St Sepulchre, London; staff of the Library and Margaret Timmers, Research Assistant, Department of Prints and Drawings, Victoria and Albert Museum; and the staff of Westminster Reference Library.

To my daughter Elizabeth, Colin Bradley and Marie Roe for valuable suggestions and help, and to my wife, without whose encouragement the rest would have been in vain, my grateful thanks.

CHAPTER ONE ·
Introducing the steel engraving

Engraving was traditionally regarded as a branch of the goldsmith's art in the fifteenth century, but the etching of armour and swords gives steel engraving at least as old, if not as respectable, a lineage. The ability to engrave on steel was present, but its use for reproducing prints was not seriously considered because the metal was difficult to work and the number of copies which could be printed from a copper plate was more than sufficient for fifteenth- and sixteenth-century needs.

The earliest attempts to use iron or steel employed etching with acid, which was natural enough in view of the hardness of the metal; one of the first plates in this medium was by Daniel Hopfer (*c*. 1470–1536), who worked at Augsburg. It is entitled 'Figures in Military Costume', the plate measures roughly 15 by 8 inches, and is about one thirty-second of an inch thick with the design etched into it.[1] Hopfer was an armourer and was credited locally with the invention of etching[2] but, although much of his work is very spirited, he lacked the artistic ability of his successors. It was possibly due to his influence that Albrecht Dürer undertook six etchings on iron dated between 1515 and 1518, the best known being 'The Turkish Cannon' (1518). All these have rough characteristics due to the uneven texture of the iron. Hans Burgkmair's etching of 'Venus and Mercury' is executed on quite a thick plate of iron, and Lambert Hopfer (Daniel's brother) is known to have etched three steel plates with ornamental panels, which are of uneven thickness at the top.[3] *A Booke of Secrets* provided instructions for scriveners and painters on etching in iron and steel with 'strong water', giving recipes for this purpose. The pamphlet was written in Dutch, translated into English by W.P. and printed by Adam Islip for Edward White in 1596.[4] When, in about 1528, a suitable etching fluid was found for copper, this metal came to be used almost exclusively by engravers and etchers for several centuries.

Engraving on steel was first attempted, according to tradition, by Cornelis van Dalen the younger, who flourished in the mid-seventeenth century in Amsterdam,[5] but it seemed to be an isolated attempt because, in the eighteenth century, writers on prints, such as William Gilpin, make no reference to it. Gilpin merely mentions copper, pewter or wood.[6]

The coming of steel engraving in the nineteenth century was a fresh beginning, arising out of the needs of the age, and firmly based upon the state of the book trade

at that time. The late eighteenth century had created a new reading public, fed with the tracts of Hannah More and other cheap literature, so that books were put into the reach of all, especially the working classes. With the vital interest in French affairs, newspapers and periodicals were much in demand, but although there were signs in the 1790s that the age-old craft of printing was about to make some changes, none actually arrived until the opening years of the nineteenth century. The first steps involved the replacement of wooden presses by those of iron and the revival of stereotyping in a practical form, both due to the efforts of Lord Stanhope. The gradual increase in the size of type area which could be printed at one pull of the press speeded up production a little to meet the demand, but in the first two decades great strides were made with the aid of the Koenig and Bauer cylinder press (1814), the use of an inking roller system and large rolls of paper to feed these machines. The printing of texts was able to keep pace with the demand, although book printers were slow to introduce the newest machines, tending to stay with the improved versions of the traditional presses, such as the Albion and Columbian, so popular from the 1820s onwards. During this time, the bookseller lost two of his eighteenth-century functions. The first he lost because publishers, firms such as Murray and Longman, assumed responsibility for producing the books and for finding the necessary capital to pay authors, artists, printers, etc. The second function he lost was bookbinding. Whereas previously the bookseller had had a binder working on his premises binding sheets to a patron's instructions, the development of uniform cloth casings in the 1820s transferred this to the publisher as one of his responsibilities, thus opening the way to the mechanization of the craft. The first step in this direction was taken when William Burn introduced the rolling press in 1827, an adaptation of the mangle principle to the process of compressing the folded sheets of paper before sewing commenced. Books could be produced twenty times more quickly, bulk reduced by a sixth and books made cheaper as a consequence.

Quite apart from these technical advances which reduced book prices, the expansion of the economy in the 1820s and 1830s increased spending power to the point that the public was willing to pay for works which were to their taste. The boom years of 1824–5 were brought abruptly to an end by the Great Panic of 1826, when bank failures were at their height, but the gradual revival of fortunes brought the middle classes further affluence until the economic crisis of 1841. People were motivated by an unfavourable comparison of conditions in Britain with those in France after the Napoleonic Wars. Furthermore, the period coincided with a great interest in art, and the desire to own pictures and *objets d'art* as a sign of culture and breeding manifested itself among those who had money to spare. Pictures were often too large and too expensive, so prints were the most popular way of securing copies. The market boomed, aided by the introduction of steel mezzotints in 1820, thus enabling many more copies to be printed from a single plate than heretofore.

There followed a great demand for the illustrated book, which, though it might be expensive, seemed less so when published by the eighteenth-century device of parts and, therefore, paid for by instalments. This era of change was thus described by one who lived through it: 'I suppose that more new-fangled notions came into vogue during those few years, say from 1825 to 1840 than had disturbed the old order of things for a hundred years before.'[7]

Book illustration attained three main levels during the early nineteenth century. The expensive, limited editions of aquatinted, hand-coloured books, came from publishers such as Ackermann (until his death in 1834), and were usually volumes of large format. At the lower level were the very cheap books, illustrated by woodcuts or wood engravings of varying quality, printed with the text and integrated into it. This class had a very long ancestry and was to achieve greater importance in the second half of the nineteenth century through the influence of Thomas Bewick and others.

In between was the second level, where steel engraving held sway practically unchallenged for several decades – it consisted of reasonably priced books with monochrome engravings, reaching out to a middle-class market largely untapped before. It encouraged the kind of book where the illustrations created the text, which merely became an extended caption to the pictures. Line engraving had always been regarded as the highest form of the art and the one most likely to convey the impression of quality. The ability to acquire low-cost high-quality line engravings was considered to be one of the biggest bargains associated with the movement to make art cheap. The number of volumes devoted to art and its illustration increased at such a rate that they far exceeded previous publications in this field. It was the creation of a new type of book, able to meet contemporary production requirements as well as capture the public's imagination, which made steel engraving's rise meteoric. Unfortunately, it contained within itself the seeds of its own destruction. The very proliferation of engravings made them commonplace and, since all impressions were near perfect, the rarity value of a line engraving and its 'states' vanished overnight; advertisers stressed that every print was a proof impression, a factor which upset the print market considerably and, to some extent, prejudiced many of the eminent engravers against it. The print publishers struggled on for some years insisting on higher prices for their proofs but, in the end, steel was blamed for most of the ills which beset the trade.

The boom of steel-engraved book illustrations took place in the twenty years between 1825 and 1845, during which time most, if not all, of the important volumes had been published. Steel continued to be used, however, to the very end of the century, by which time all the old line engravers had disappeared.

A factor which added to steel engraving's difficulties was its inability, compared with lithography and wood engraving, to adapt to full colour. The production of the necessary number of plates, problems of register and slowness of printing would

have rendered it even more expensive in the preparatory stages than it was already. The engraver John Henry Le Keux did take out a patent on 23 June 1841 for using two or more metal plates engraved with portions of a subject, thus enabling other colours to be used, but also permitting the more rapid completion of a plate by enabling more than one engraver to work on it simultaneously.[8] Very little more is heard of it; certainly, no widespread use was made of the invention. A few books were issued with steel engravings coloured by hand, some advertised at one price plain and a higher one coloured. Charles Tilt and David Bogue were among the leading exponents of this trade. Tilt coloured a few sets of plates to be sold at three pounds as against the ordinary price of 31s. 6d. for the *Waverley Gallery* (1840–1), consisting of 'portraits' of Scott's heroines, and *Le Byron des Dames*, a similar publication covering the poet's principal female characters. Bogue's *Heroines of Shakespeare* (1848) was advertised at 42s. plain and 73s. 6d. coloured for forty-five plates (see plate 1), and the seventh edition of Sir James E. Smith's *Introduction to the Study of Botany*, published by Longman, contained thirty-six steel plates for 16s. cloth, and £2. 12s. 6d. with them coloured. In 1837, Thomas Moule's *English Counties* was published in two volumes by George Virtue at three pounds; with coloured maps, it cost £4. 10s. 0d. These examples are comparatively rare, however, and, since the plain steel engraving seems to invite colouring, most of those seen in scrapbooks have been perpetrated by amateurs. In the twentieth century, books have been broken up in their thousands to provide a profitable trade in framed hand-coloured engravings. Some of the plates have doubtless been rescued from volumes damaged beyond repair or parts which have never been bound. It must be confessed that the loss of some texts would not cause great concern, but every endeavour should now be made to preserve such copies as remain intact. The examples of engravings *printed* in a colour other than black are even more rare. Those which most readily come to mind are contained in John Ruskin's *Modern Painters*, where one or two are printed in violet, mainly as an experiment. The 150 engravings illustrating *The Complete Works of William Hogarth* printed in sepia underline the medium's need to use the maximum contrast of black and white in order to produce the best results.[9] An edition of *The Poetical Works of William Cowper* (1855), published by T. Nelson, contains six steel engravings printed in mauve, although the frontispiece and engraved title-page are printed in black. The engraver spent considerable time in translating colours of the original into tones of black and white, the essence of his art, so that any attempt to replace those colours can only have a harmful effect upon the appearance of the engraving.[10]

A pure line engraving in steel has probably never existed, nor is likely to. The main reason for this is the hardness of the metal, and the difficulty of cutting it

PLATE 1 'Olivia', a line and stipple steel engraving by W. H. Mote after W. P. Frith, from *The Heroines of Shakespeare*, 1848.

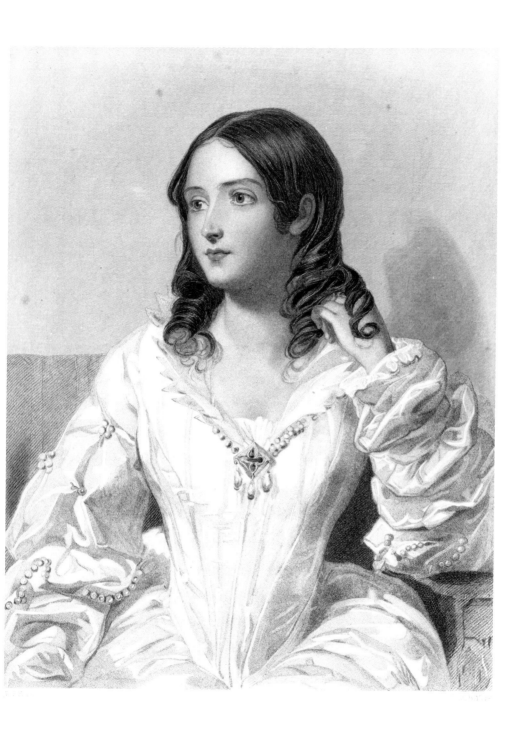

manually, so that engravers have depended upon the use of acid to remove the drudgery and hard work, as had their predecessors for hundreds of years before them. Engravers would only use steel when absolutely necessary; throughout the nineteenth century copper was still used for short runs. Every steel plate, therefore, starts life as an etching, the majority of plates retaining the marks of such work in the finished state, usually in the foreground of a picture, where the lines are deeper and print the blackest. In the very fine vignettes, most, if not all the evidences of etching have been removed, so that all the line edges are firm and accurately engraved to produce a crisp, sharp impression.

The problem of identifying a steel engraving is not so easy to resolve, however. To determine its peculiar characteristics, account must be taken of the advantages presented by the metal itself, compared with that of copper, the traditional material of engraved plates. Its hardness allows the cutting of very fine lines, with the expectation that they will resist the wear which, in copper, would result in their complete removal after a comparatively short run of copies. These fine lines could also be laid more closely together without fear of the intervening metal breaking down and ruining the effect. This hardness and suitability for fine work results in much smaller plates, since it is very difficult to maintain an engraver's interest if the work is physically hard and if a long time is needed to finish the plate. Some engravers, it is true, worked for several years to produce a large plate, but the artistic effect has usually been severely impaired and the finished work far from satisfactory. The texture of the steel itself is much finer than copper or iron. Apart from the clean edge this imparts to the engraved line, the overall effect is brilliant and it is this quality which, above all others, distinguishes a steel engraving. When a plate exhibits the coarser treatment needed by copper and yet only uses the hard wearing qualities of steel to secure a much larger number of copies, it is virtually impossible to detect which metal has been used. The silvery, almost luminous, effect of a good steel engraving is its hallmark, but very often this property is held against it, destroying, it is said, much of the warmth of the earlier copper. The cool appearance of good work can deteriorate into an unwelcome hardness, but much depends not only on the engraver but also on the printer. An insensitive printer can render every line mechanical, whereas, with a little care, he can give a gradation of tone over the whole picture which restores some of the interest, if not of the warmth.

Engravers were quick to use the qualities of a steel plate to the full, but soon fell into the trap of engraving much which would not be readily visible to the naked eye. Most engravings display a number of obscure details of great interest when enlarged, and it was this factor which tended to reduce the work of all engravers, good and bad, to a common denominator. Individual engravers' characteristics were not so readily visible as in former days, with a consequent inability to distinguish engravers and schools. The 'View of Northumberland' (see plate 2) has had the bridge area enlarged (see plate 3), bringing to the fore many details of the

house and island between the bridges, the reflection of this scene in the water, and the occupants of the boats in the foreground. Much of this is lost when the complete picture is seen for the first time; the eye fails to take it in at a cursory glance. J. T. Smith referred to the 'Liliputian [sic] labours' of 'these pigmy burinists' which, in due course, would make them totally blind, implying that they would be better employed engraving large plates than wasting their time on illustrations to scrapbooks. He may well have expressed a biased view, since at the time (1829), he was Keeper of the Prints at the British Museum.[11]

It is not surprising, therefore, that there were many outspoken contemporary critics of the medium, especially in artistic circles. Many, both artists and engravers, expressed their dislike by standing completely aloof from the use of steel: Abraham Raimbach, George Doo and John Pye, for example, rarely, if ever used it. Late-nineteenth-century critics could be scathing. Ralph Thomas, writing in 1899, gave vent to his feelings in the following terms: 'I have always had a profound contempt for "steel engravings" from the almost uniformly bad work I have seen... A statement on the title page of a book that the engravings are "executed on steel" has always been sufficient to deter me from looking further...'[12]

Two years earlier, Hans Singer and William Strang had been as astringently critical, both belonging to the 'modern' school, where the interpretative work of an engraver was regarded as an interference with the artist's freedom to express himself directly to his public. In 1897 they wrote: 'There is [another], perhaps even more odious, form of engraving prevalent during the first half of our century – this time especially in England. I mean steel engraving . . . All freedom and light-ness of hand which burin engravers have acquired slowly from century to century, were lost at a blow, and the character of the work is one of stiff and inartistic exact-ness...'[13]

Although other writers such as Philip Hamerton and J. L. Roget[14] were kinder, very little in the way of praise was given until the middle of this century, and even then it came as an awkward compliment: 'An etched, lithographed or steel-engraved illustration may be beautiful, but only a wood-engraving can have exactly the same qualities of black and white crispness as type itself...' This was written by Ruari McLean in 1960.[15] Wood engraving here occupies the favoured place once held by its rivals. As an intaglio process, steel engraving found it very difficult to integrate with relief-printed text, as witness the books which have tried, by two runs through the press and at great production costs, to achieve this. The oft-quoted examples of Samuel Rogers's *Italy* (1830) and *Poems* (1834) show this lack only too well; the vignettes engraved after Thomas Stothard, J. M. W. Turner, Samuel Prout and others have their own charm, but the delicate approach here is at variance with the heavy and clumsy type-face which accompanies them (see also plate 26). The reader tends to see either the engravings or the text. Furthermore, it is impossible to view an opening exhibiting one or two engravings

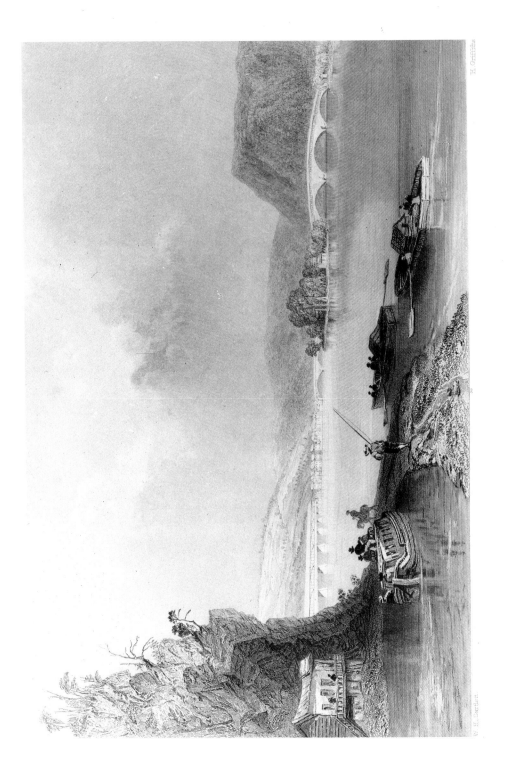

VIEW OF NORTHUMBERLAND.

(On the Susquehanna)

W. H. Bartlett

H. Griffiths

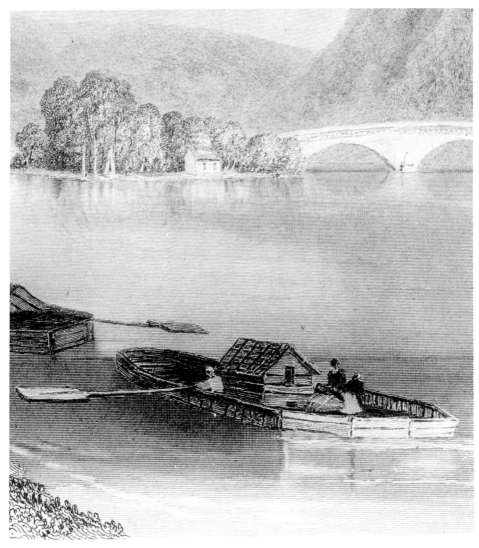

PLATE 3 'View of Northumberland', enlarged detail (see plate 2).

as an artistic entity. As books, they are far from satisfactory, and the printing of intaglio work on separate sheets which can harmonize with a page of text opposite produces much better results.[16] The French recognized this very well in the eighteenth century, when they engraved both illustrations and text in order to achieve harmony on the page. To their credit, most publishers took this view, and the vast majority of books with steel engravings are aesthetically satisfying.

PLATE 2 'View of Northumberland', a steel engraving by H. Griffiths after W. H. Bartlett, from *American Scenery*, 1840, by N. P. Willis, vol. 2, p. 63. (By courtesy East Sussex County Library, Brighton Reference Library.)

CHAPTER TWO · Siderography and after

'Siderography', according to the *Oxford English Dictionary*, derives from the Greek *sideros*, meaning iron, and *graphia*, style of writing. Literally it can be translated as writing on iron, and here the term appears to be ideally suited to the description of steel engraving. In connection with nineteenth-century printing practice, however, the word acquired a more specialized meaning.

Elizabeth Harris, discussing the use of the term, indicates that it is a shortened version of 'the siderographic art', and a form of 'siderographia'. Neither of these terms seems to have been used before 1818, when the meaning was limited to 'the process of transferring engravings from steel to steel with the hardening and softening operations, or the "perpetuating" of steel engravings.'[1] At first, the process was concerned with the reproduction of exact replica plates for multiple printings of bank-notes, being extended later to include postage stamps, etc. It is this definition of siderography which has been used throughout this work, and which distinguishes it from the term 'steel engraving'.

Siderography was invented in the late eighteenth century by an American, Jacob Perkins. He was a man of many parts, involved in all sorts of ventures connected with his varied interests, ranging from the manufacture of nails, through improvements to the steam engine, to methods of ice-making. Born on 9 July 1766 at Newburyport, Massachusetts, Perkins was left at the age of fifteen to carry on the goldsmith's business built up by his late master, Edward Davis. His ability to cut dies led, in 1786, to the only successful attempt to produce a set for the state coinage; with the reputation thus acquired, he turned his attention to the urgent problem of counterfeit paper money.

He invented, in 1792, the 'check plate', made up of sixty-four separate dies, which provided a complete pattern when clamped together and which could produce many varieties of design when rearranged. The complete die was then put into a screw press with a plate or block made of copper, soft iron or soft steel, and the design transferred by pressure. This could then be repeated at will to give as many exactly similar plates as desired. The number of prints thus obtained would be far in excess of that produced by a single plate engraved in the usual way and, by using several presses, more impressions could be taken in a given time. When a plate was worn out, another would replace it, taken from the master die, and in this way, a

higher standard of impressions overall could be obtained by ceasing to use a plate as soon as deterioration was apparent.

This method needed a great deal of pressure, and a good impression was difficult to obtain, even on a small plate. To overcome this, Perkins introduced the roller die, where only a very small part of the surface was in contact with the plate at any one time, thus enabling greater and more even pressure to be exerted at that point. The diameter of the roller had, of mechanical necessity, to be small, and sometimes several rollers have to be used to complete a larger design. Maximum roller sizes were about three inches long and from half to three inches in diameter. The original die was prepared in very hard steel as before, the soft steel roller run over it to produce the design in relief the right way round, and this was case-hardened; from it were mass-produced the printing plates in intaglio and with reversed designs.

This step was only possible after Perkins had realized the potentialities of the annealing and case-hardening properties associated with iron and steel, which he appears to have done about 1804. The extension of this process to the actual printing plate was the next logical step, but it was here that the uncertainties attendant upon case-hardening became a problem. A common method of achieving this was by packing the steel in its soft state into an iron box with bone ash or leather charcoal, heating it to a cherry red, or for a specified period according to the thickness of the metal and, after removing the plate, plunging it into cold water. This procedure was repeated twice more to produce the desired temper. A thin plate subjected to such treatment would, more often than not, buckle and warp, with the consequent loss of all the work upon it. This was not too serious if another plate could be produced quickly from the master roller, but it could be prevented from happening too frequently by increasing the thickness of the plate. In this form it really became a block of steel, and could range in thickness from half an inch (requiring three hours heating for the first hardening process) to one and a half inches (requiring five hours heating). Ramshaw the printer, in his testimony to the Society of Arts Committee on Forgery said that he was employed to prove a steel plate for J. C. Dyer in imitation of an American bank-note. It weighed fifty-six pounds and was over an inch thick.

The block used for printing thus received a perfect design by transfer, needing no correction or amendment before hardening. Any mistakes in the original die would only result in a very small piece of the whole being re-engraved, so that this system could work perfectly where absolute uniformity and extremely long runs of prints were required. These are two crucial factors, and when they are absent, the process becomes a costly and clumsy one. Moreover, these blocks needed specially adapted presses to print them; because of their thickness and weight, they had to be fixed to the bed, and could not be removed for heating and inking, as could the thinner ones. A heater had to be incorporated into the press, and the blocks were

always inked and wiped in the same direction, resulting in uneven wear, especially in the finely engraved parts. Perkins was at first solely concerned to use his invention for bank-note printing, and the use of steel for producing book illustrations was not exploited until the arrival of Gideon Fairman. He was an experienced engraver, working in Newburyport for William Hooker engraving maps and charts from 1803 to 1810, in which year, the two men had a business disagreement and parted company. Perkins and Fairman had already met, and jointly published in 1808 a number of schoolbooks, which in 1810 were followed by a series of copy books for teaching writing under the title of *Perkins' and Fairmans' Running Hand*, printed locally. Each book comprised eight pages, 3 by $7\frac{1}{2}$ inches in size, and were the first books known to have been printed from steel plates in America. Only one copy is known to have survived and that is now in the Taylor Collection of the American Antiquarian Society in Worcester, Massachusetts.

Fairman then joined Murray, Draper and Co., an established book-plate firm, but in 1813 this aspect of their work was overshadowed when they bought out a bank-note printing concern, a much more lucrative line of business. The partnership continued until July 1818, when it broke up by common consent, and during this time, the use of steel for book plates seems to have been relegated to a minor place. Nothing further is heard of this matter until the firm needed to exploit it in England.

The plate-maker Stephen Hoole is thought to have produced hard steel plates for engraving about 1793 in England (and did so again about 1820), but as J. T. Smith found, the material was too difficult to work, 'broke the tool almost every minute and took two months to finish' an engraving, which on copper would have taken only two days. He engraved a representation of the ceiling of the Star Chamber in 1802 on an old saw, but was so discouraged that he did not repeat the experiment. The engraving was issued on copper in January 1805. Richard Williamson etched on unprepared steel in 1807, but did not follow it up until some years later.[2] The arrival in England of Joseph Chesswood Dyer in 1810 as Perkins's agent strengthened this interest in steel among a few engravers here. The Bank of England was interested as a result of a British patent taken out on Perkins's behalf for 'improvements in copper-plate printing' in 1810, and Dyer was asked to supply steel plates and a printing press upon which the Bank engravers could experiment. Dyer supervised their work personally, all of which was unsuccessful. One of the engravers was Abraham Raimbach, who worked on a plate in 1811,[3] and whose subsequent views on steel engraving may well have been coloured by this attempt. In his memoirs, he had few good words to say for the process, and seems never to have used it again. By 1813, the Bank engravers reported that steel took four times as long as copper to engrave and that half the plates were ruined in the hardening process.[4]

In 1812, James Watt, the great inventor, mentioned the possibility of using steel

for mezzotint engraving to Charles Turner, newly appointed Engraver in Ordinary to the King. Watt had some experience of working with the metal through his partnership with Matthew Boulton, whose fortune had largely been made upon the manufacture of buttons from steel plate. When Boulton established his factory at Soho, Birmingham, in 1764, a whole department was engaged upon the button process. In 1786, Watt conducted personal experiments into the quality of iron used there; this was sufficient to give him some first-hand knowledge of its properties, and doubtless led to his conversation with Turner. The engraver adopted the suggestion, but his experimental plate must have been a hard one, so that even his attempts to 'rock' it precluded further work, resulting in his rejection of the metal. His subsequent attempts to use brass were likewise unsuccessful. It was not until Wilson Lowry gave him a steel plate in February 1821 that Turner produced a mezzotint portrait satisfactory enough to obtain Sir Thomas Lawrence's approval. He attributed this success to the work of Jacob Perkins in producing blocks of steel soft enough to work upon with mezzotint tools; these blocks became better known here after the American's arrival in England in June 1819. Turner also engraved a mezzotint on decarbonized or soft steel of 'Miss Bowles' after Sir Joshua Reynolds, published 29 May 1824, and presented to members of the Society of Arts with volume 42 of their *Transactions* by the Chairman of the Committee of Polite Arts, R. H. Solly.

More success attended the efforts made by the Bank of Ireland in Dublin. By 1816, John Oldham had been appointed engineer and chief engraver to the Bank, and in that year was reported to have invented a new process, involving the use of steel plates, by which bank-notes could be produced more cheaply. A later report indicated that, even if Oldham can be credited with a separate invention, his method was very similar to Perkins's transfer process, which was, in any case, adopted by the Bank in 1821. Oldham's second contribution related to the printing of engravings, involving the use of an eight-horsepower engine to drive a plate press, but for various reasons, its employment was confined almost exclusively to the printing of bank-notes.[6]

Among the many communications received by the Bank of England during this period was one from J. T. Barber Beaumont, who had written to them in 1817 about his suggestions, one of which was the substitution of steel plates for those of copper. He asserts that 'it is well known that engraving may be done upon softened steel' which, when hardened, may produce hundreds of thousands, even a million copies. The printer T. C. Hansard indicated in his evidence, given 18 April 1818 to the Society of Arts Committee on Forgery, that steel engravers were rare, so that it may be assumed that some were experimenting with the new medium, although without marked success outside bank-note engraving.

This, then, was the situation when Jacob Perkins was persuaded to come to England. The Society of Arts Committee on Forgery, when it first sat on 15 April

1818, heard evidence from Charles Heath the engraver, who presented specimens of American bank-notes printed by Perkins. The two men had been in touch over this matter and Perkins had also written to Dyer, who in turn, had insisted that the time was ripe to develop siderography in this country. With the attraction of the Bank of England's prize of £20,000 to be given for the note which it was impossible to counterfeit, the American's mind was quickly made up, and preparations were made for workmen, machinery and equipment to be transported to England for the attempt. They sailed on 31 May 1819 and landed in Liverpool about 29 June. By the end of July, they were established in London, and the President of the Royal Commission on Forgery, Sir Joseph Banks, was apprised of Perkins's intentions. By February 1820, however, it became clear that, as a result of many delays, the Bank was not going to adopt his system. Perkins had insisted that no other work be taken on while they were waiting for definite news, but as funds dwindled, despite injections of cash by George and Charles Heath (who joined the firm on 20 December 1819), some desperate remedies were needed. He found some relief in exploiting a few of his other inventions, such as his fire engine, to tide him over.

In the summer of 1820, the firm of Perkins, Fairman and Heath moved to 69 Fleet Street, and here sought other engraving work in book illustration, the reproduction of pictures, portraits and book plates. They also sold a number of prepared steel plates, mainly to the mezzotinters, and by September 1820 it was estimated that Perkins had disposed of nearly one thousand plates.[7] William Say was one of these purchasers, and in January 1820 he engraved in mezzotint a portrait of Caroline, Queen of England, after Arthur William Devis, from which hardened plate 1,200 impressions were taken.[8] This was almost ten times the number of copies normally obtained from copper, and was a very satisfactory result, but out of his total of 335 plates, Say never seems to have tried steel again and it was left to others to exploit the medium. Two years later, Thomas Goff Lupton was awarded the Gold Isis Medal by the Society of Arts for his engraving in mezzotint on soft steel of Munden, the comedian, after George Clint. The medal was presented on 30 May 1822. For some reason, only a few copies were printed from this plate, but another was made with the express intention of discovering how many impressions could be taken. In his letter to the Society of 1 November 1822, Lupton indicated that 1,500 prints had not worn the plate out, and his only comment on the method was to note that he needed to lay as many as ninety ways across the plate when grounding it, instead of between twenty-four and forty on copper.[9]

Lupton used steel almost exclusively for his succeeding plates. The result was that the art of mezzotint was given a new lease of life, reaching a much wider public through the fine-art reproductions made available from the printsellers. There was no significant effect on the use of mezzotint for book illustration, since the number of copies obtainable from a plate was still far below that required for an edition of a book, especially those calling for reprints. Some of the earliest steel mezzotints to

appear as book illustrations were engraved by George Maile and were portraits of Izaak Walton and Charles Cotton, first issued in James Smith's edition of the *Compleat Angler* (1822). Three years later, in 1825, John Martin mezzotinted two of his own designs for the 1826 edition of *The Amulet*, namely, the 'Angel Prophesying the Destruction of Babylon' and the 'Prophet in the Wilderness'.[10] As a mezzotint is worked entirely from the surface of the plate, the thickness of the metal is unimportant. This explains why Perkins's blocks were first used for this process and not for intaglio plates, where corrections must be made by 'knocking-up' from the back (see below, page 50). The public was introduced to steel mezzotints in January 1823 when examples of Lupton's and Turner's work were on show at the second annual exhibition held by W. B. Cooke at his house in Soho Square, London.[11]

Perkins's success in the book-illustration field may not have been as spectacular as they had first hoped, and very few examples of their work have been positively identified from this early period. The siderographic process was used for William Pinnock's *Guides* and *Catechisms*,[12] a series that was to be reprinted extensively throughout the nineteenth century. In 1820, Perkins's plates were used for the views in Pinnock's *Catechism of British Geography* and the illustrations to Thomas Campbell's *The Pleasures of Hope*, engraved by Charles Heath.[13] The earliest edition of the former work to be seen by the author is the fifth, dated 1827. This contains only an engraved frontispiece of William Camden and a title-page, the latter dated 1823. They are both executed on hardened steel plates, and the title-page carries a vignette of three female figures, with ornate lettering above. Both are finely engraved and the borders of the Camden portrait are distinctly reminiscent of bank-note engravings.[14] The Campbell was published in a new edition in 1821, but it, and three successive editions up to 1826, all had the same engraved title-page, dated 1820. There were three other illustrations, all from designs by Richard Westall, bearing the legends 'Engraved on steel by C. Heath' and, at the foot of the pages, 'Perkins, Fairman and Heath'. A copy in the British Library (Reference Division) has bound with it the eighth edition of *Gertrude of Wyoming* (1821). This contains an engraved title-page and two illustrations dated 1819, engraved by C. Heath, but obviously on copper. They are in the same style as the aforementioned plates and Heath appears to have been experimenting with the new metal, using it merely to increase the number of copies.[15]

The American press also took an interest in this branch of the firm's activities. In the *Boston Literary Gazette* of December 1820, there appeared the following: 'they are also preparing various engravings for popular books, as maps and views for Goldsmith's geography, frontispiece for Mavor's spelling book and a solar system for Blair's preceptor, all of which will have proof impressions of their engravings, although tens of thousands are sold annually.' A closer look at the publishing history of the first book presents a slightly less optimistic picture. *Geography;*

Illustrated on a Popular Plan ; for the Use of Schools and Young Persons was a very popular book, written by Sir Richard Phillips, the well-known publisher, under one of his many pseudonyms, the Revd J. Goldsmith. The seventh edition had been published in 1815, followed by the eighth in 1818, and a 'new' edition came out in 1824 under the Longman imprint, to which firm Phillips's business had been transferred after his bankruptcy sometime in the early 1820s. On 17 February 1821, Craig (probably William Marshall Craig) was paid ten pounds for drawings by Longman, probably used to produce a new set of illustrations, twenty-four of which had been engraved on steel by September 1824 for the sum of £10. 7s. 6d. The engraver or engravers are not named, neither are the prints signed, but the engravings themselves exhibit several styles, distinguished by the treatment of the sky, the extent of etching, and the use of lines well spaced out in the manner of copper engraving. The cost of drawing and engraving is considerably lower than the remuneration given to Henry Moses, who engraved '48 subjects on 12 copper in outline' for the eighth edition, and received £126 for them on 8 December 1815, and when he engraved two further plates of Athens on 28 October 1817, he was given six guineas cash for them. The evidence for Perkins's involvement is much stronger with regard to the maps in the 1824 volume. There are nine of these, one of which, 'England and Wales', is a worn plate from the earlier set engraved in 1813 by Cooper. Six of the remainder received the attentions of the engraver Sidney Hall. He was paid six guineas for repairing the map of Europe on 1 January 1820,[16] and was responsible for preparing new plates for the other five, all of which were probably, but three certainly, done on Perkins's plates. These three are dated 1821, measure roughly $7\frac{1}{2}$ by $6\frac{1}{2}$ inches or slightly larger, and those for the British Isles, South America and Africa carry the legend:

PERKINS, FAIRMAN & HEATH
London. *Patent hardened steel plate*.

The contrast in the engraving, compared with the earlier plates, is marked. The coastline shading has changed to take advantage of the fineness obtainable on steel by the insertion of shorter, thinner lines between the longer ones to give a gradual shading, rather than an abrupt one. Moreover, prominent physical features such as mountains are indicated by delicate shading, and the lettering, from being a good copperplate script, becomes a shaded, outline capital letter, in a manner followed by most subsequent nineteenth-century map-makers. Sidney Hall's name does not appear as an engraver with Perkins, and since the map size is almost twice that regarded as suitable for siderographic reproduction, it seems unlikely that Perkins did more than supply the plates. It is just possible that both the maps and the illustrations were done in the Perkins establishment, but there is no evidence to this effect either from the book itself or the publisher's extant records.

We know that 30,000 copies of the frontispiece to Mavor's spelling book were printed by Perkins and Co. for £61.6s.2d. in August 1821, and Goldsmith's *Grammar of Geography* appears to have had steel plates produced for seven maps, a globe and a clock in October 1821, with a further payment of £3.8s.9d. 'for use of plates'. In November 1822, two pounds was paid, probably to Hall for 'corrections and additions to steel plates'.[17]

'Blair's preceptor' was the *Universal Preceptor*, by the Revd David Blair, another of Sir Richard Phillips's pseudonyms, the twelfth edition of which was published in 1820.[18] The frontispiece to this edition was a diagram of the solar system, drawn and engraved by Wilson Lowry, measuring about $6\frac{1}{4}$ by $5\frac{1}{2}$ inches, and folded to fit the small volume. Printed from a hardened steel plate supplied by Perkins, Bacon and Heath, it was a very finely engraved piece of work, and was still being used in 1823, when another edition was produced. The only other line engraving was a map of the earth, printed from a copper plate dated 1812.

In 1821, Perkins and Heath could 'not yet say how long a well hardened plate will last, having never printed more than 500,000 impressions from the same plate. It should, however, be observed that this plate consisted principally of writing or work quite as strong and . . . that the impressions are yet good.'[19]

Perkins's failure to attain prominence in the field of book illustration was due to the fact that his methods did not conform to contemporary practice and to the difficulties encountered in printing the thick and heavy plates. S. T. Davenport, writing in 1865, observed: 'The process introduced by Mr. Perkins was inapplicable to large surfaces, both on account of cost, and the difficulty and risk of injury in applying it.'[20] Thus it fell to an English engraver, Charles Warren, to reconcile the use of steel with existing practice.

CHAPTER THREE · Warren's steel plates

It was in May 1818 that Charles Warren engraved the first successful design on steel plate in England. The picture was a head of Minerva; the steel plate was made from an old saw blade.

Charles Warren (see plate 4), born 4 June 1762,[1] was of obscure origins, and very little is known of his early life. Of his family, only a brother is recorded, and living in London, it was almost certainly to one of the local factories that Charles was sent to engrave copper plates for the calico printers. This would have provided only a very meagre training and a restricted practice, since the process demanded the repetitive engraving of a basic design, with very little chance of creative work. He also chased metal for gunsmiths. This craft was for centuries a classic introduction to the art of engraving, and it provided Charles with his first opportunity to engrave in steel.

By the time he was twenty-eight, Warren had contributed portraits of Fox, Pitt and Baron Thurlow, all after W. H. Brown, to *The Senator*, published by C. Cooke in 1790, which was followed by twelve others in the 1791 and 1792 editions of the work. Then came further work for the booksellers from 1792, producing frontispieces and illustrations to many of the literary editions then being issued in small format. Examples of his work include an edition of Addison's poems (1796), *Don Quixote* (1797), *Gulliver's Travels* (1798), Lansdowne's *Poetical Works* (1799) (see plate 5), and *Humphry Clinker* (1800). An artist's proof before letters of his engraving after a design by Richard Corbould, probably for an edition of Pope (see plate 5), shows Warren's signature.

His marriage, at the age of eighteen in 1780, had increased his responsibilities and the arrival of a family placed a further strain upon his resources, which, at the best of times, he seemed unable to organize effectively. Doubtless this factor contributed to his change towards more lucrative employment.

His book plates were certainly as good as any produced by his contemporaries, and his engravings of Troilus and Cressida after Kirk and Antony and Cleopatra after Tresham (published 4 June 1803) for Boydell's Shakespeare Gallery, were two of his early triumphs. When the eminent mezzotint engraver Valentine Green, who was an Associate Engraver of the Royal Academy, proposed Warren for election to the Society of Arts on 31 October 1804,[2] another sphere of activity was

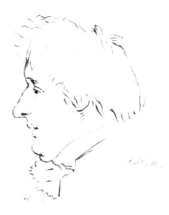

PLATE 4 Charles Warren (1762–1823), who was responsible for the development of steel plates suitable for engraving, from a drawing by William Mulready published in John Pye's *Patronage of British Art*, 1845, p. 329. (By courtesy East Sussex County Library, Brighton Reference Library.)

opened to him in which he made his greatest mark, being fully involved with their activities until his death nineteen years later. He was elected a member of the Committee of Polite Arts on 22 March 1805 and served as one of its two Chairmen from 1805 to 1807 and again in 1822–3.

His reputation among his fellow engravers is illustrated by three appointments which he held in differing fields. The short-lived Society of Engravers, established in 1802, appointed Warren as one of its governors, a distinction he shared with twenty-three other men of the calibre of John Agar, Cosmo Armstrong, William Bond, Charles Knight, Thomas Milton and James Parker. He was President from 1812 to 1815 of the Society's successor, the Artists' Annuity Fund, a position he shared with some of the eminent artists and patrons of the day. Then he was appointed, together with James Heath, A.E.R.A., as one of the patrons in engraving and honorary members of the Birmingham Academy of Arts, founded in 1809.[3] In view of the excellence attained by engravers like William Radclyffe already working in that city, this was a signal honour for Warren. His reputation was always that of a generous, if improvident man, whose help when sought was readily given. When, in later years, he turned his attention to the improvement of engraving methods, he did not keep his findings to himself but almost eagerly shared them with anybody who was interested.

The turn of the century saw a rise in Warren's fortunes and he was able to command a much better price for his work. In 1802, the plates after Robert Smirke for the *Arabian Nights' Entertainments* brought him thirty-five guineas each; much later, a plate of Brian and Roderick Dhu for Scott's *Lady of the Lake*, illustrated by Richard Cook about 1816, brought in fifty guineas, for which Warren said he

PLATE 5 Two examples of early book plates by Charles Warren. Right: copper engraving after Thomas Kirk, for Lansdowne's *Poetical Works*, 1799, published by C. Cooke. Left: proof before letters of copper engraving after a design by Richard Corbould, for an unidentified work, possibly an edition of Alexander Pope. (By courtesy the Victoria & Albert Museum.)

worked '13 weeks of regular and incessant exertion'.[4] His most important work derives from this period in the company of Heath, Bromley, Raimbach and other engravers of note.

This, then, was the man who decided one day to overcome the many difficulties attendant upon steel engraving and make it a viable proposition. *The Report of the Committee of the Society of Arts Relative to the Mode of Preventing the Forgery of Banknotes* was published in 1819, and it clearly shows Warren to be very much aware of steel and its possibilities for engraving. Evidence was given of its use in America for bank-notes, of which he doubtless had first-hand information from J. C. Dyer, a neighbour of his in the Gray's Inn area. It is also quite possible that he knew of Abraham Raimbach's abortive attempt to engrave a steel plate for the Bank of

England in 1811. Warren's own experience of engraving for the banks went back to the early part of the century, when he engraved vignettes for the Plymouth Dock Bank as a deterrent to forgery and, by all accounts, the results were very satisfactory.

Siderography, however, would have been a foreign method to him as a book engraver. Its principles had been introduced into calico printing in 1808 by Joseph Lockett senior, but probably Warren was unaware of this, since he had long left the field, and his main concern was to solve the problems of steel engraving in terms of existing techniques.

After Beaumont's first communication, dated 4 March 1818, the Committee on Forgery started taking evidence six weeks later, the majority of which had been heard by 15 May. A group of people, headed by the Chairman of the Committee of Polite Arts, Richard Horsman Solly, went into the whole problem in very great detail but did not present their findings until 22 December. Warren was a member of this group, and produced the central vignette of the main test piece (see plate 6) reproducing on copper the head of Minerva he had engraved on a steel saw blade a month earlier (see plate 7). The remainder of the plate was done by five other engravers, each employing their own particular skills. During his evidence given on 15 April 1818, Warren showed that he had already conducted some work on steel engraving: 'From his own experiments he is convinced that softened steel may be cut very nearly as easily as copper.' He was dealing with steel *plates*, as opposed to the mention in John Pye's evidence of steel *blocks*. The mainspring of his interest, therefore, was the prevention of forgery in bank-notes. At the outset, he was convinced of the superiority of plates over blocks of steel for two reasons. Flaws and mistakes could easily be rectified by knocking up and plates could be printed on ordinary, unadapted copper-plate presses, where they could be removed for heating and turned about when wiping off the excess ink, thus reducing friction on the most delicate parts of the engraving.

This explains the use of an old saw blade on that day in May 1818, when Warren engraved the head of Minerva as an experiment. The blade was decarbonized, that is softened, using a process which he had obtained from the Birmingham makers of steel articles such as buttons, ornamental candle snuffers, etc. These manufacturers had considerable experience in the working of steel and, since most of the trades were represented in the Society of Arts, Warren wisely sought advice from his colleagues. His main informant was Thomas Gill, Chairman of the Committee of Mechanics.

The process used by Warren to soften pieces of saw blade involved the use of a cast-iron box into which were placed layers alternately of steel plate and a compound of iron filings and crushed oyster shells, the box being filled so that the compound formed both the top and bottom layers. The box was then heated in a furnace to a temperature just below which it would melt and kept there for several

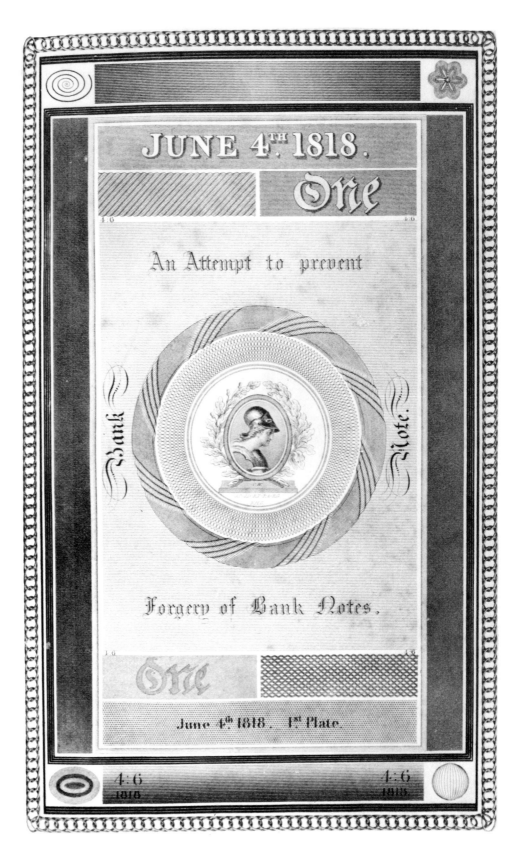

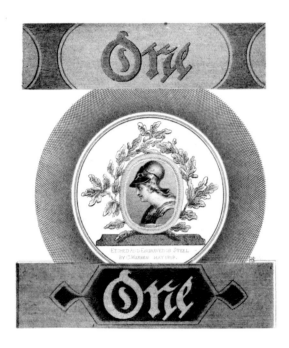

PLATE 7 The first engraving on steel in England, including Charles Warren's head of Minerva, May 1818. Original size $3\frac{1}{2}$ by $2\frac{7}{8}$ inches. (By courtesy the Trustees of the British Museum.)

hours, after which the plates were allowed to cool gradually, when they were found to be softer, decarbonized steel. The plates were usually warped after this first 'cementation', and in order to flatten them and separate the compound from the plates, Warren used a hammer. Only a certain degree of softness was achieved by one firing, so two or more 'cementations' were usually needed to produce the desired texture. The hammer marks were less affected by subsequent firings, resulting in a plate of unequal hardness, but this could happen at other spots as well, so the whole process needed to be revised if good, consistent results were to be obtained. Warren seemed satisfied with the proportion of usable plates he achieved

PLATE 6 Copper-engraved test piece to illustrate the *Report of the Committee . . . Relative to the Mode of Preventing the Forgery of Banknotes*, 1819, for the Society of Arts. It incorporates, as the central vignette, Charles Warren's head of Minerva. (By courtesy the Librarian, Royal Society of Arts, Mr D. G. C. Allan.)

at the beginning but, as time went on, he found the comparatively high incidence of spoilt plates which occurred when the steel was hardened again after engraving a far more exasperating and costly factor in view of the work expended on engraving them. In these circumstances, he questioned the need for this second hardening and devoted most of his further experiments towards discovering how many good copies could be obtained from a decarbonized plate before wear became apparent. This was a point upon which a number of people produced evidence, and certified copies abound where the taking of a specified large number of copies – for instance, 200,000 – has made little impression on the plate. For the purposes of book illustration, nothing like this number was needed at one time, but the two advantages of many more 'proof' impressions and the possibility of printing from the plates time and again over a long period were considerable ones for the book trade. Experiments were conducted on Warren's soft plates by the engravers Charles Marr, William Holl the elder and W. T. Fry. The last-named had tried Perkins's blocks but found that the burr thrown up by the burin parted more easily from Warren's plates. Among the earliest of these experimental engravings to be published were a stipple portrait of the Revd William Naylor in the *Methodist Magazine*, dated February 1822, followed by a portrait of W. B. Collyer after J. Rentin, dated 1 January 1823 in the *Evangelical Magazine*, both engraved by William Thomas Fry. The editors of this latter volume claimed a circulation of 20,000 copies,[5] so that the printing of 25,000 copies of each plate was a good test, at the end of which they were barely worn and needed no repair. Most of the extra 5,000 copies were run off for separate sale to print collectors. William Holl also did several plates for the *Methodist Magazine* – such as that of the Revd R. Waddy, March 1823 (see plate 8) – each of which produced 24,000 copies, but he first used steel on a Perkins block in April 1821 for a portrait of the Revd John Roadhouse. This was more than adequate proof for the sceptics, inasmuch as quantity and quality went hand in hand, a high recommendation in a sphere where mechanization was gaining a rapid hold on printing in order to cope with the increased demands of the reading public.

If the process was to overcome the high initial costs of plate-making, however, suppliers had to provide plates of guaranteed quality, free from flaws and uneven hardness. The mezzotint engravers were the first to complain, since it affected the mechanical roughening of the surface and the subsequent scraping away of the burrs. The whole appearance of the plate could be spoiled by unevenness of texture. Warren's lack of concern for this point was not shared by Richard Hughes, his plate-maker, who had been instructed in the engraver's process of decarbonization. He suspected that insufficient heat was applied in the cementation process and, in 1822, replaced the iron box with one of refractory clay, able to withstand

PLATE **8** Engraving on steel by William Holl of the Revd R. Waddy, from the *Methodist Magazine*, March 1823.

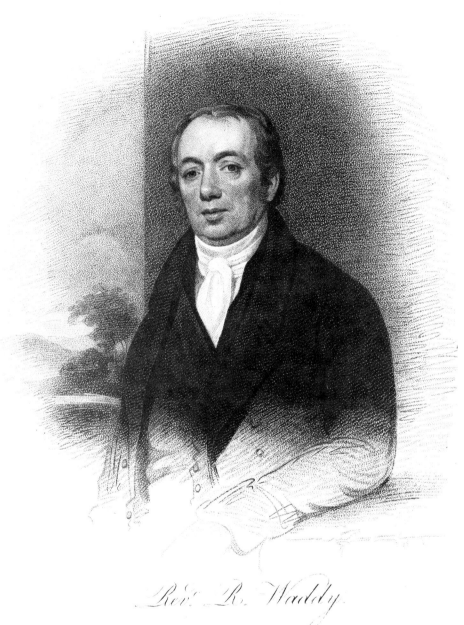

Rev.^d R. Waddy.

much higher temperatures. By this means, he obtained plates so soft that they could be bent over the knee. When separating the plates from the cement, Hughes used a mallet with very little force behind it, so that marks on the steel would be less susceptible to uneven hardening. Thus plates of varying degrees of hardness could be obtained to suit the engraver and the subjects to be engraved, bearing in mind that the harder the metal the more difficult it was to engrave but the softer the metal the greater necessity there was to harden it afterwards, with all the attendant hazards. It was a matter for the engraver's judgement, therefore, to establish his own optimum working requirements, and buy accordingly. W. T. Fry began using annealed steel plates between one-eighth and one-quarter of an inch thick about 1819, followed by some made by Stephen Hoole. He later worked on about fifty plates made by a Mr Hook. In 1820, Fry accepted Warren's offer of plates. He also introduced the latter to a Mr Duffy, from whom Warren received instructions for decarbonizing steel, resulting in even better plates. Later on, Fry recommended Richard Hughes to consult Warren. William Holl obtained two plates from Fenn of Newgate Street, but found those by Hughes much more satisfactory.

As a compliment to the Society of Arts, and to elicit information and encourage further experiments, Charles Warren eventually decided to present his findings to it; on 5 March 1823, his communication was referred to the Committee of Polite Arts. The Society itself had for some time encouraged work on steel engraving. In the session 1819–20, the following premiums were offered for the first time to artists:

Engraving on steel

For the best specimen of engraving on a steel plate not less than 5 inches by 3 inches in area, and not exceeding $\frac{1}{4}$th of an inch in thickness; the plate to be afterwards hardened without injuring the engraving; – *the Gold Medal.*

The Plate, with two impressions from it, both in its soft and hardened state, to be produced to the Society. The impressions, but not the plate, to remain the property of the Society.

During the four years they were offered, no record exists of an award for a line engraving, probably because nobody could be sure of a successful hardening each time.[6] When the specification was revised for the year 1823–4 (possibly due to Warren's observations and findings), three classes were made for finished engravings on steel or copper (note the order) of historical compositions, landscapes and portraits, with a fourth class for a mezzotint portrait (metal unspecified). An age limit of thirty was also imposed on candidates. The following year, the fourth class was amended 'For the best finished engraving on steel in mezzotinto: – *The Gold Isis Medal.*' In 1827, however, James Eke was awarded the Silver Isis Medal for an engraving on steel of a cotton machine.

Meeting at its Adelphi headquarters, the Committee of Polite Arts sat down on

the evening of 18 March 1823 to investigate the communication made by one of their most popular colleagues, Charles Warren, who exhibited specimens engraved on soft steel produced by himself for the purpose. The first of these specimens was an illustration from an edition of Mackenzie's works, published by Cadell, of which 5,000 impressions had been taken. The second was for an edition of Beattie and Collins (probably poems), published by Rivingtons, of which 4,000 impressions had been taken.[7] In each case, the landscape and figures were composed of very fine lines, elaborately and delicately engraved, and the Committee was invited to detect any deterioration or wear in the plate between the first and one of the last impressions. This they were unable to do and were suitably impressed. Further evidence was provided by the *Evangelical Magazine* portraits on Warren's plates, yielding 25,000 good impressions, and two independent witnesses provided corroboration of their own. Charles W. Marr first used steel plates in 1821 prepared by Mr Hook but, having worked on several of Warren's, had found them much more suitable. One plate, engraved with light, delicate work, had 8,000 copies printed from it, after which he proceeded to take proofs for himself (i.e. engraver's proofs), to demonstrate that even after a fair amount of wear the plates were capable of producing prints of proof quality. The second example was even more dramatic, where the printer, Mr La Hie (almost certainly James Lahee), certified that the artist's proofs of a portrait were taken off after 20,000 prints had been made. It may be said in passing that commercial use was frequently made of this facility in later years. A work produced in parts suddenly had the opportunity to sell 500 impressions to the Americans, and these were run off before the first proofs were printed for home customers.[8] Nobody appears to have been any the wiser. In addition to explaining the development of his work over the past four years, Warren went on to reveal his method of etching steel plates, which was to be the most controversial of all his findings (see page 48). The Committee recommended the award of the Large Gold Medal on three conditions. Warren had to leave impressions of the plates with the Society (these, unhappily, have disappeared). He had to produce for public use a complete description of these processes within one month and, finally, he had to relinquish all pretensions to a patent. In the account printed in the Society's *Transactions* much was made of Warren's unselfishness in communicating his findings and supplying his plates quite freely to anybody who was interested during the previous four years; clearly, any question of patent rights would have been difficult to establish. Nor was it in Warren's nature to worry unduly about monetary rewards for his work, so that the Committee's insistence on this point is difficult to understand, although it was probably part of their general policy to add such riders. Perkins had found that patents only gave him protection in law and were not necessarily financially rewarding.

Warren's tardiness in preparing his communication for the Society was rather

unfortunate because at his death, on 21 April 1823, at East-hill, Wandsworth,[9] it was still unwritten and, as a result, it had to be supplied from other sources. Warren was in his sixty-first year when he died suddenly, probably of a heart attack, while he was in the middle of a conversation. It is to be regretted that he did not live to receive his Gold Medal, but when it was presented to his brother by the Duke of Sussex on 28 May His Royal Highness is reported to have said: 'In the midst of your affliction, however, it must afford you great consolation to know how highly your brother's character was esteemed by the Society.'[10] Perhaps Warren had a premonition of his fate when he spoke three months previously, on 22 January, at a testimonial dinner to William Mulready. The members of the Artists' Annuity Fund had gathered at the Freemason's Tavern to present an inscribed cup and Warren had ended his presentation speech by saying: 'We hope that, when many of us cease to feel any interest in what passes on earth... you will recollect... that it was the spontaneous gift of seventy-three brother artists.'[11] He was buried in the vaults of St Sepulchre's Church, Newgate Street.

Later in the year, Warren's collection of prints was sold off in settlement of his estate. The highest recorded price was £4. 11s. 0d. for an India proof copy of 'The broken china jar', after Sir David Wilkie. Warren had been paid fifty guineas for engraving the plate late in 1821; the reproduction (see plate 9) is of an etched state of the plate. The picture was an illustration to *The Social Day*, a poem by Peter Coxe,[12] a fellow member of the Society of Arts and, according to some contemporaries, somewhat of a bore and an eccentric. The incident illustrated is the unfortunate result of a practical joke which misfired. Ghostly manifestations were produced by manipulated curtains, fire irons, etc., but the imperturbable victim turned the tables by attaching the curtain cord to the china jar with the sad result. The published plate is dated 1 January 1822, although the book was delayed a further year and bears the date 1823 on its title-page. Wilkie had painted it in 1817 and, in common with the artists of the other thirty-one illustrations, had presented it to the author, by whom it had been commissioned; the oil picture, only 7 by 6 inches, is now in the Victoria and Albert Museum, having arrived there as part of the Sheepshanks gift.[13]

This engraving was long held to be the earliest steel-engraved book illustration. According to a correspondent, C.D.L., in *Notes and Queries*,[14] a bookseller's catalogue was responsible for this ascription, but C.D.L. was not convinced. Subsequent correspondence shed no further light on the matter, except to reveal that William Bates of Birmingham possessed an artist's proof from Charles Heath's collection, and an etched state was in the collection of J. F. Phillips.[15] The main

PLATE 9 'The Broken China Jar', etched state of an engraving, 1821, by Charles Warren after Sir David Wilkie. An inscription in pencil at the foot reads, 'To Mr. Macdonald with C. Warren's compliments'. (By courtesy Liverpool City Libraries.)

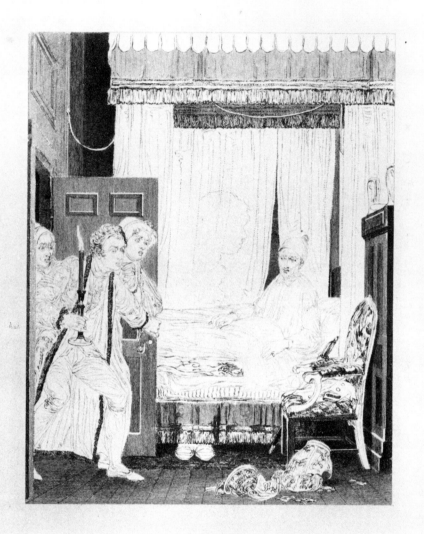

D. Wilkie, R.A. Pinx.
C. Warren Aquafortis

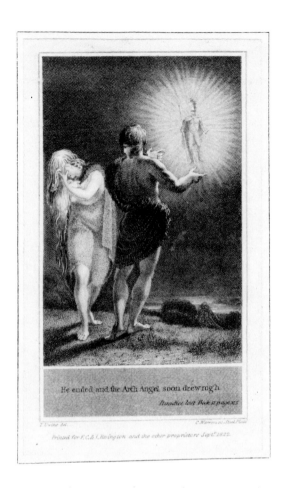

PLATE 10 Steel engraving by Charles Warren after a drawing by Thomas Uwins, for an edition of Milton's *Paradise Lost* published by F. C. and J. Rivington in September 1822. This is one of the earliest known book illustrations on steel plate. (From the Bosanquet Collection. By courtesy the Victoria & Albert Museum.)

uncertainty about this plate, therefore, is still unresolved – was it engraved on steel? The plate itself is unlikely to have survived and only a very few of the other illustrations are done by engravers who are known to have subsequently worked in steel; nor do any of the other prints exhibit characteristics of steel engraving. A larger plate of the same subject, certainly on steel, approximating to the size of the original, was engraved by William Greatbach for *The Wilkie Gallery*, published in 1849 by George Virtue.

The first illustration which can be positively identified as an engraving on steel plate came later in 1822. This was Warren's engraving after Thomas Uwins of Adam and Eve with the Archangel Michael after the Fall, to illustrate an edition of John Milton's *Paradise Lost*, published by F. C. and J. Rivington and other proprietors. After the engraver's name appear the words 'Steel plate' and below, after

the imprint, there is the date September 1822 (see plate 10). Warren had done a similar subject seven years earlier, in May 1815, after a picture by Edward Bird, R.A., historical painter to the Princess Charlotte. The 1822 version exhibits none of the later characteristics of steel engraving, indicating that Warren contributed comparatively little towards the artistic development of the medium, being concerned mainly with its practical aspects.

The account of Warren's work referred to earlier and published in the Society of Arts *Transactions*, was put together from details communicated by his personal friends, especially by Joseph Phelps, who was his pupil throughout the period of experiment and discovery,[16] later becoming an engraver on his own account. Warren had two other pupils also over this period, one being Thomas Fairland and the other Henry Chawner Shenton, who became his son-in-law some time before 1824. The last member of Warren's family to warrant a mention is his brother, Alfred William Warren,[17] to whom Charles's Gold Medal was presented 'in trust for his orphan daughter', the future Mrs Shenton. Warren's wife and seven of his eight children had predeceased him, leaving only this daughter to survive him. Certainly no son was living to succeed him, as some authorities aver. Alfred was also an engraver, engaged in the second and third decades of the century in producing technical plates for the *Transactions* of the Society of Arts. Finally, the third of Warren's pupils has a place in this early history. Samuel Davenport, although born in Bedford, moved in infancy to London, where he was apprenticed to Warren from about 1797 to 1804, proceeding then to follow in the same vein of book illustration and to become known as a portrait engraver. He was one of the earliest to engrave on steel after its introduction, much of his work being done for the annuals.

Soon after Warren's death, his mezzotint portrait after the bust by William Behnes was engraved by Samuel William Reynolds and published on 10 June 1824 by Colnaghi and Co. (see plate 11).

PLATE 11 (overleaf) Charles Warren, mezzotint (original size 13¼ by 9½ inches) by S. W. Reynolds of the bust by W. Behnes. Published 10 June 1824. (By courtesy the Trustees of the British Museum.)

31

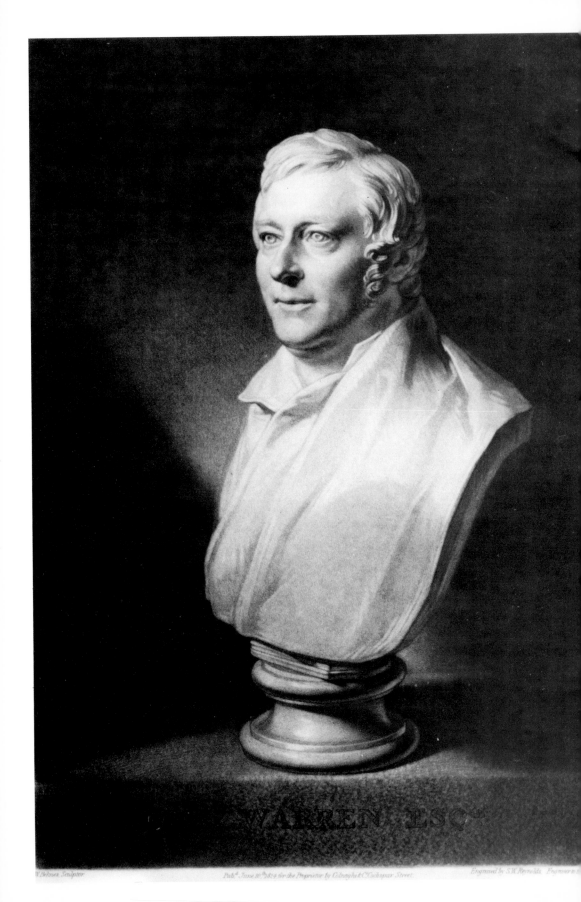

WARREN ESQ.

W Behnes Sculptor Pub.d June 16th 1824 for the Proprietor by Colnaghi & C.o Cockspur Street. Engraved by S.W.Reynolds. Engraver to

CHAPTER FOUR · The art of steel engraving

It was due to Warren's efforts that the art of engraving on steel was carried on in the same traditional way as copper, but although its eventual demise was chiefly caused by external factors, it was twice threatened by technical advances from within, each at twenty-year intervals. The first was the invention of electrotyping about 1838, and the second was an extension of the process in 1858, where an iron coating could be deposited on a plate of softer metal, usually copper (see Chapter 11). Both inventions came too late to be very influential, and the effect on book illustration was marginal.

There are a number of nineteenth-century accounts of the mechanics of engraving, few of which deal expressly with steel and its peculiar problems. Most assume that what is written about copper applies equally to steel, and no differentiation is made between the two. One account which does confine itself to steel is also one of the most amusing: it appeared in Charles Dickens's periodical *All the Year Round* for 27 October 1866. Beneath the comic overtones lies an accurate account of the engraver's view of his work, highlighting his pressures and frustrations. Pickpeck the engraver is called upon to produce in a great hurry a steel-engraved portrait of the eminent author Bunglebutt from the photograph by Jolterhead of Lower Pighurst to illustrate 'his truly stunning work, *Our empty coal-cellars, and what's to fill them?*', now in its twenty-second, and much augmented edition. Even the names possess the famous Dickensian touches, and conjure up most vividly the people concerned; the technical description is just as effective. Since there can be no substitute for this account, it is reproduced as an Appendix.

For all practical purposes, other nineteenth-century accounts derive from Partington, printed about 1825.[1] The author devotes much space to Perkins's siderographic process but failed to digest its importance, merely repeats the statistics relating to the number of bank-notes which could be produced and the consequent financial savings. No mention is made of Warren's work, but the description may have been written before it was either known or fully appreciated. Charles Frederick Partington is described on the title-page as the author of an historical and descriptive account of the steam engine, and as one of the lecturers at the London, Russell and Mechanics' Institutions. This makes him the rather unlikely author of an expert account of engraving; works on clock- and watchmaking,

the work of coach-makers and wheelwrights, shipbuilders and builders were also issued under his name. The anonymous author certainly practised the art himself, but so far his identity has remained a secret.

The second important account, by Theodore Henry Adolphus Fielding, was first published in 1841, and contains information on what were then the most up-to-date matters, including lithography and electrography.[2] Fielding quotes Partington extensively, almost verbatim in parts, describing his source as 'a celebrated work on engraving', but he commences with a highly critical view of steel engraving and its evils, having very little to say in its favour. There is, however, a grudging admiration for its success when, as he considers, wood engraving is so eminently more suited to book illustration. Fielding's opinions were calculated to carry some weight in art circles, of which he was a respected member; hence the frequency with which his book is quoted. His father, a Yorkshire portrait painter, had four artist sons, the most famous of whom was Anthony Vandyke Copley Fielding, water-colour painter of no mean ability. This medium also interested Theodore. When he was appointed as teacher of drawing and perspective at the Military College, Addiscombe, near Croydon, his duties gave him a certain amount of leisure in which to write. The book on engraving, one of several works, was used extensively a year or two later by W. L. Maberley, who published *The Print Collector* in 1844.[3] The accounts by Partington, Fielding and Maberley were the only ones contemporary with the heyday of steel engraving.

The next significant writing was by Philip Gilbert Hamerton in *The Graphic Arts*, published in 1882.[4] He examined the art in the light of contemporary practice; examples were taken from the work of Lumb Stocks, C. H. Jeens, Francis Holl and Edward Paxman Brandard, all of which were gently criticized. This is an independent account and owes little to earlier work, containing far less technical detail. The same author produced *Drawing and Engraving* in 1892,[5] based upon the articles in the ninth edition of the *Encyclopaedia Britannica* of 1878, in which he very briefly accounts for the rise and fall of steel engraving.[6] The mention of steel engraving in Singer and Strang's *Etching, Engraving* was disfigured by their almost vitriolic dislike of it.[7] The only account to be based upon a specific engraver's work appears in a biography of William Miller, the eminent Scottish engraver,[8] and is most valuable in consequence. None of these accounts is complete, and they tend to concentrate on the production of effects rather than the techniques by which pictures were engraved. Hamerton pays more attention to the latter aspect when contrasting, as he puts it, engraving with nature.

Any engraving is but a copy of an original, even if the exemplar originates with the engraver, i.e. he has both drawn and engraved the work. These originals are many and various, coming in all shapes and sizes, in all kinds of media and colours, yet having to be reduced in the end to a black-and-white engraving. This interpretation is the most artistic and skilful part of an engraver's work; it is also the

most likely cause of friction between the artist and engraver. The artist came eventually to resent this interpolation of another's work between him and the public; the second half of the century saw the rise of the painter-etcher movement, in which the plate was worked by the artist himself, thus rendering each print an original work of art. More often than not, however, very happy co-operation existed between the two artists, bearing particularly good results when they were contemporaries. The partnerships between Turner and some of his engravers, such as Edward Goodall, Robert Wallis and William Radclyffe, are often quoted as examples.

Living artists who co-operated thus were usually the most popular with the engravers. Originals made with the engraver's requirements in mind flowed from the pencils of Thomas Allom, William Henry Bartlett, Thomas Creswick and others who designed with the book illustration in mind, but next to these came the sketches by amateurs, often made on the spot in some faraway country and worked up later by another artist at home. Serving officers such as Col. Robert Batty, Capt. Robert Elliott, R.N., G. F. White and many others were of this category. That such men as Turner and David Cox were not above working up such drawings for the engravers was a tribute to the designs which provided the first inspiration. The best engravings were done where the engraver was able to control the size of the original, asking that the drawing approximate to the size of the finished engraving. Since the majority of books with steel engravings were produced in quarto format, the average size of the engraved area was about 7 by 5 inches and ideally drawings should have been close to those measurements. Turner's watercolour for a 'Village Fair', done in about 1832, was commissioned for Rogers's *Poems*, where it appeared on page 84, engraved by Edward Goodall. Drawn in pencil and coloured with blue, red and green predominating, it measured $4\frac{1}{2}$ by $4\frac{3}{4}$ inches, just a little larger than the finished engraving of $3\frac{1}{4}$ by $3\frac{1}{4}$ inches.[9]

The situation was very different when the engraver was faced with an oil painting, the dimensions of which were measured in feet rather than inches. Much depended, too, on the location and ownership of the originals. At first, the 'proprietor' of the publication, whether he was the financial backer, editor or publisher, tended to buy for himself the pictures he wished to have engraved. By this means, he built up a valuable collection of originals, but which only too often had to be sold to meet business debts. Alaric Watts adopted this plan when he started the *Literary Souvenir* annual; his collection was his pride and joy. The drawing-room and library housed his literary and artistic treasures, built up over a period of fifteen years, where they were crammed so close together that little of the wallpaper showed between the frames of the oil paintings.[10] John Murray, the publisher, had in his collection a portrait of Byron (see plate 12) painted by Thomas Phillips, R.A., and which still hangs in the boardroom of the firm's London premises at 50 Albemarle Street. The painting, 17 by 14 inches in size, shows Byron in Albanian

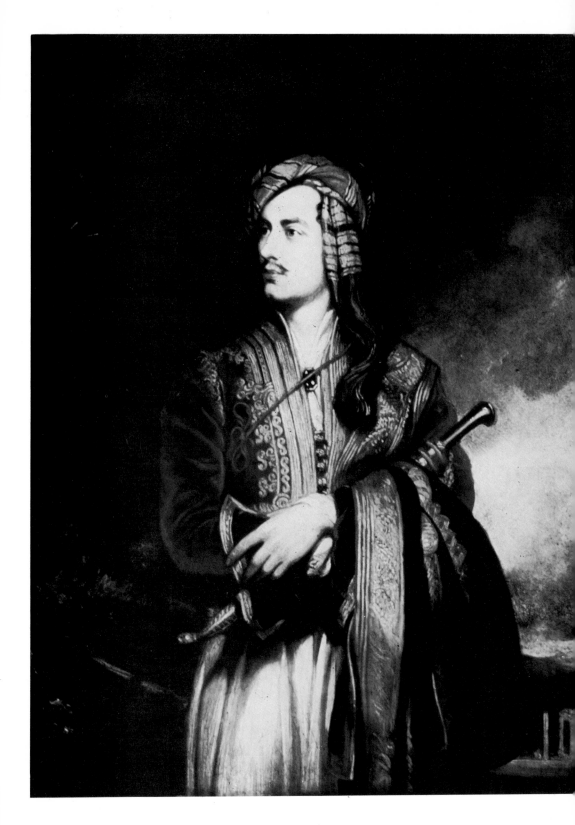

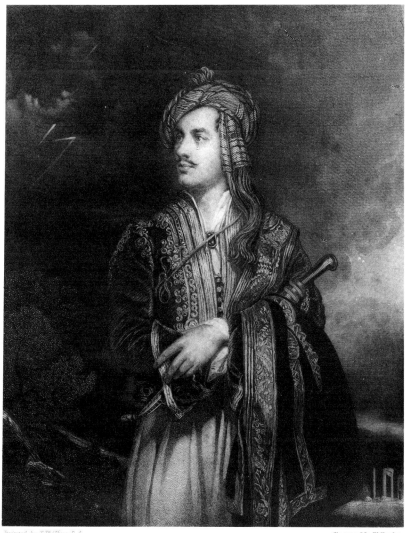

LORD BYRON,

In his Albanian Dress

PLATE **13** Lord Byron, steel engraving by William Finden after the oil portrait by Thomas Phillips, R.A. (see plate 12), used as the frontispiece to *Childe Harold's Pilgrimage*, 1841. (By courtesy East Sussex County Library, Brighton Reference Library.)

PLATE **12** Lord Byron, oil portrait by Thomas Phillips, R.A. Original size 17 by 14 inches. (By courtesy John Murray.)

dress; it was engraved as the frontispiece to the 1841 edition of *Childe Harold's Pilgrimage* (see plate 13). It is clear from the following letter from William and Edward Finden that Murray was anxious to have it out of his sight for as short a time as possible: the Findens had to send for the picture when they were ready to start work on it, and not before.

March 25th 1840.

Being now prepared to commence the engraving of the Portrait of 'Byron' we shall be greatly obliged if you will permit the Bearer to bring us the picture, that we may be enabled to devote the time necessary to produce a Plate that will (we trust) do credit to the work of 'Childe Harold'.

We are dear Sir,
Your truly obliged
W. & E. Finden.

At the top of the letter in another hand is written 'Picture sent Mar. 25'. George Virtue and his family, publishers, also acquired a collection of pictures from which they reproduced engravings for their own publications, especially the *Art Journal*, where 'reproduced from the original in the possession of the publishers' often appeared at the bottom of the plate. The Finden brothers also had a collection, plates from which exist today at Thomas Ross and Son with the legend 'from the collection of E. and W. Finden' engraved upon them.

Collecting was, however, outside the financial scope of many publishers, and the most frequently used source of originals was the privately owned collection. John Sheepshanks and Robert Vernon were very co-operative in this respect; pictures from the latter's collection were engraved and published as 'The Vernon Gallery' in the *Art Journal* from 1849 to 1854, and later in parts to be bound in book form. From 1855 to 1860, pictures were reproduced from the royal pictures with the Queen's permission. Requests were normally made for the loan of specific pictures and owners would usually agree to this 'for a reasonable period'. This clause, however, gave rise to a great deal of trouble, being interpreted as circumstances and the persons involved felt inclined. A particularly dilatory engraver could cause very bad feeling between the owner and the publisher, with the result that, in many cases, contracts were drawn up to specify the length of time an engraving should take.

William Powell Frith, the painter, recounts two examples connected with Dickens where the engraving time was in question.[11] In November 1842, Dickens had commissioned Frith to paint 'portraits' of two of his characters. The first was Dolly Varden, engraved by Charles Eden Wagstaff in 1843, and the other was Kate Nickleby, which in due course (about 1845) an engraver asked Frith as artist and Dickens as owner for permission to reproduce. Dickens, proud of his new possession, agreed 'for a reasonable time' to be without the picture, but after

waiting patiently for two or three years, sent Frith the following missive:

Advertisement

To K__e N_____y (the young lady in black).

K___N_____, if you will return to your disconsolate friends in Devonshire Terrace, your absence in Ireland will be forgotten and forgiven, and you will be received with open arms. Think of your dear sister Dolly, how altered her appearance and character are without you! She is not the same girl. Think, too, of the author of your being, and what he must feel when he sees your place empty every day! October 10th 1848.

The identity of the Irish engraver is not revealed! Eleven years later, John Forster, Dickens's friend and biographer, was finally persuaded to allow his portrait of Dickens painted by Frith to be engraved. In a letter dated 3 May 1859, Forster writes: 'The only condition I should hope I may be able to make, would be to impose a certain ascertained and definite limit of time for the engraver to return me the picture in.' He had possibly heard from Dickens of Kate Nickleby's fate. Three days later, another letter takes the position a step further.

I earnestly hope that it will be limited decisively to the twelve months, and as I think I have some knowledge of Mr. Barlow[12] as an obliging and gentlemanly man, as well as a most skilful engraver, I shall propose some early meeting between him and you [Frith] and myself, with a view to an arrangement of periods most suitable and satisfactory to us all . . .

Turner's communication to John Pye (see plate 14) is more to the point, and refers to 'Ehrenbreitstein' which he painted in 1828 expressly for Pye to engrave. This was done almost immediately; the plate appeared in the *Literary Souvenir* for 1829, followed by another version by Robert Wallis, published in *The Keepsake* for 1832. Apart from a showing at the Royal Academy in 1835, the picture remained in Pye's hands for ten years, so that a larger engraving could be undertaken, and the engraver accounted for the delay by saying that he could not live solely by engraving Turner's fine work – it 'meant starvation . . . owing to the enormous labour required and the time occupied . . . every stroke of the graver having to be deeply considered'.[13] Pye chose the subject from Byron's *Childe Harold's Pilgrimage*, and Turner asked only twelve proofs as the price of his copyright.

As a last resort, a case could be taken to court. Henry Graves of Pall Mall sued Charles Lewis for a breach of contract in 1855, the latter having failed to produce a plate of a Landseer picture within the artist's stipulated time of two years. During this time the picture had been sold, and the new owner was most anxious to take possession of his purchase, which in due course he did. Lewis was unable to finish his engraving, therefore, and Graves was awarded damages, to be reduced if, after a further four months, the engraver completed his work. The loan of the picture was extended, and all ended satisfactorily, with the judge, Lord Campbell, hoping that he could put his name down for a copy of the now completed and universally admired plate![14]

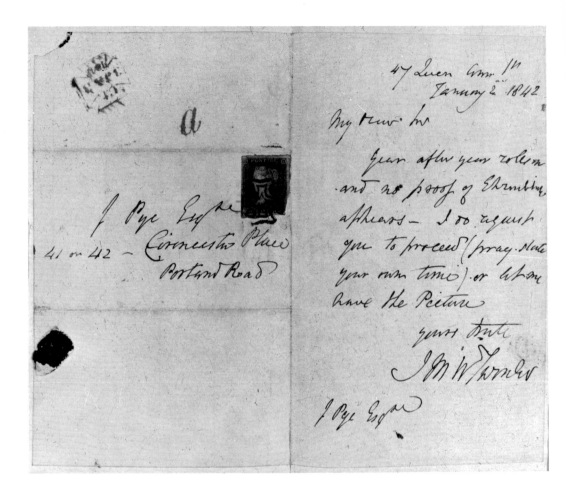

PLATE 14 Letter from J. M. W. Turner to John Pye, 2 January 1842. (By courtesy Birmingham Art Gallery.)

There were occasions, as Watts and others discovered, when borrowing a picture was out of the question. As time went on, new pictures became more difficult to buy or borrow. Watts's diary for 1827[15] shows how Sir Willoughby Gordon declined to lend 'Slender and Ann Page' after C. R. Leslie for engraving in the *Literary Souvenir*, despite the artist's presence (and one assumes, approval) when the request was made. Leslie later tried to make amends by suggesting that he paint something especially for Watts; there is no doubt that a direct commission was the best means of securing a satisfactory work. From Henry Howard, Watts commissioned a small picture of Oberon squeezing flower juice into Titania's eyes, and Abraham Cooper was asked to produce a picture for him in a year. He met another disappointment early in 1826, when H. W. Pickersgill gave permission for his 'Oriental Loveletter' to be engraved, but before this could be done, he had sold it.

There was always the chance, too, that a duplicate could be borrowed if one owner refused; this seems to have been done when a Mr Seward lent his copy of 'Juliet' after Henry Thomson.[16] William Hilton took Watts by surprise, however, when he wrote asking how much the editor was prepared to give him for the liberty of copying his 'Love Taught by the Graces'. Originally, Watts was flattered when Hilton, having refused Ackermann, Balmanno, Hall and Heath permission to use it in their annuals, suggested engraving this particular picture, even though its owner was now Mr Phillips, M.P. With the latter's permission given, Watts thought all was well. Hilton's letter roused his indignation and he wrote back saying that never before had he had to pay for borrowing a picture, even from the artist or another owner. However, he was willing to give Hilton something, though complaining that he still had to pay for an engraver's reduction, which would cost between ten and twelve guineas. At the other end of the scale, some of the rival annuals paid rather lavishly, ranging from twenty to one hundred and fifty guineas just for the loan of a picture.[17]

Quite apart from these personal failures to borrow, there were clearly times when a picture had to be visited and a suitable drawing made on the spot. Pictures in the national or royal collections and pictures too large or fragile to move were in this category, so instead of the picture going to the engraver's workshop, copies were made on the spot. This involved more work in comparing the engraving in its varying states with the original; the end result depended greatly upon the skill of the intermediate artist, who was not always the engraver. The latter could not spend time away from his workshop for many pressing reasons: he had to supervise pupils, attend to clients and cope with administrative tasks, to say nothing of the engraving he must do himself. There was an army of people employed to do drawings of this kind, much of whose work is now unknown or unrecognized, intended as it was only for the eyes of the engraver, and with whom its usefulness ended. Some eminent artists were not averse to making such 'engraver's outlines'. Thomas Uwins, R.A., was known to have done some for Charles Warren, including an indian ink copy of 'The Grecian Harvest Home' after Barry, which hung in the Great Room at the Society of Arts.[18] Joseph Clayton Bentley (see Chapter 6) made a number of the copies for S. C. Hall's *Gems of European Art* (1846), published by George Virtue in two volumes; he also engraved five of the illustrations.

Most of these drawings were executed in watercolour, a medium as much used by amateurs as by professionals, and the state of the art during the steel-engraving period gave both media increased impetus.[19] The demand for these drawings was enormous. Although some were coloured in imitation of the original, the engraver favoured monochrome copies because most of the translation into tone had been done for him. The copies were pleasing enough pictures and were treated as works of art in their own right, thus disguising their original purpose, so one of the few means of confirming a relationship is by close comparison of drawing with engrav-

ing. This can be done, for example (see plates 15 and 16), with a drawing of St Mary's Church, County Hall and Gaol, Warwick, by David Cox for an engraving by William Radclyffe, and the engraving itself, published in *Graphic Illustrations of Warwickshire*.[20] The comparison indicates some of the modifications necessitated by translation, as in the formal tree structure above the wall at the left, the shaft of light across the base of the tower, the architectural detail on church and County Hall, and the prominence given to the houses between these buildings in the background.

The engraver was thus provided with an original, from which he produced a finished printing plate. A busy studio could contain thousands of pounds worth of art objects from which copies were being made. The greatest care was taken in these workshops, particularly against the ravages of fire, and it is remarkable that, although disastrous fires were known in the premises of printers and publishers, none are recorded in those of engravers. Such problems, coupled with lack of space, would have encouraged the conscientious engraver to return originals quickly.

Basic engraving techniques have changed little since their invention. The following account, however, is concerned essentially with the practice of nineteenth-century steel engravers. The first step towards making the plate was the preparation of the 'reducing'. In these days of photographic reduction, ease and accuracy are combined in a virtually automatic process. Until this facility was available, much later in the nineteenth century, the method for reducing was the simple, but laborious, device of squaring off the original and copy to match. Threads of cotton were tied across the oil painting, which stood upon an easel beside the engraver's table, dividing it up into numbered squares. From it, the salient features and most important details were copied into similar smaller squares, drawn on a sheet of paper. The size of these squares (about one to three inches each) depended on the competence of the engraver; to ensure accuracy, beginners would use small squares, and gradually enlarge them as their competence grew. The resulting pencil sketch was the 'reducing', and was a key feature in the reversal of the picture and its transfer to a prepared plate. If there was no risk of damage to the original, the reducing could be obtained by using tracing paper, rendering the copy even more faithful than by other methods. The copy would then replace the original on the engraver's bench.

In the meantime, the metal plate had been suitably prepared to receive this reducing. Not many engravers could afford the time to prepare their own plates as Charles Warren did, and it was not long before the steel trade was producing satisfactory plates for the purpose. In November 1822, Thomas Lupton wrote, 'As to the making of steel plates, I conceive this art to be quite in its infancy; however, several intelligent men are engaged on it, and I presume we shall not long meet with any difficulty'.[21] In October 1824, Charles Turner observed:

Steel plates are now so well prepared, and are become so common, that they are easily obtained by all who desire them; the best are those manufactured by Mr. [Ebenezer] Rhodes and Mr. Hoole of Sheffield, who have paid every attention to rendering them fit for the purpose of the artist: they may also be had of Mr. Harris, Shoe-Lane, London.[22]

These accounts clearly indicate that great strides had been made between 1822 and 1824, and it is not difficult to see the influence of Charles Warren and Richard Hughes in all this. At the 1851 Exhibition there were three main exhibitors manufacturing steel plates for engravers. As in Turner's account, two came from Sheffield and one from Shoe Lane, Fleet Street, specializing in plates for mezzotinting 'with the finest surface, and of even temper throughout'. Spear and Jackson of Sheffield had their 'polished cast-steel plate', and John Sellers of the same city exhibited a large plate 36 by $26\frac{1}{2}$ inches (with an India paper impression), engraved by Charles Mottram, where the machine-ruled sky was 'perhaps the most severe test to which a steel plate can be subjected'.[23] The cost of such plates was about five times that of copper. Comparative figures from 1844 give the minimum price for a copper plate as 6d., and 2s. 6d. for a similar one of steel.[24]

The plates were supplied ready polished, so the engraver's first task was to lay a suitable ground. For a true line engraving, it was necessary to scratch the surface of the plate in order to transfer the design. To achieve this, the plate was gently heated either in an oven, on a hot plate or over candles and a piece of white wax melted over it to form a thin, even surface. The only purpose served by this coating was to enable graphite from the pencil lines of the reducing to be transferred to it under pressure from a rolling press or by the use of weights. This tracing was then used as the basis for the first cuts by the graver to produce incised lines.

Since steel is such a hard metal, graver work was usually kept to a minimum; even those lines which appear engraved in the finished plate were etched in the first place. This being so, instead of white wax, an etching ground was laid. The ground was a resin-based compound, the precise ingredients of which varied from maker to maker, or even from engraver to engraver if they made their own, but the basic recipe was akin to that used by the engraver C. W. Sharpe: one part each of black pitch, white wax, asphaltum and gum mastic plus a quarter part of Burgundy pitch.[25] A ball of this mixture, wrapped in silk, was then lightly passed over the heated plate, leaving treacle-like streaks, and the surface was dabbed smooth with

PLATE 15 (overleaf) 'St Mary's Church, County Hall and Gaol, Warwick', water-colour drawing by David Cox. Original size 9 by $6\frac{1}{16}$ inches. (By courtesy Birmingham Art Gallery.)

PLATE 16 (overleaf) 'St Mary's Church, County Hall and Gaol, Warwick', steel engraving by William Radclyffe after David Cox's water-colour drawing (see plate 15), published in *Graphic Illustrations of Warwickshire*, 1829, p. 70. Original size $9\frac{1}{16}$ by $6\frac{3}{8}$ inches. (By courtesy Birmingham Art Gallery.)

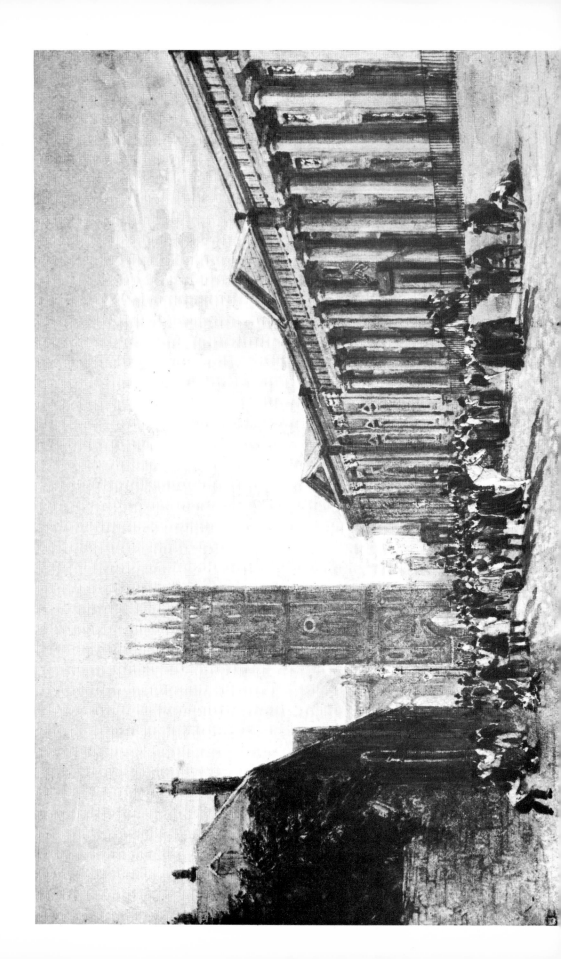

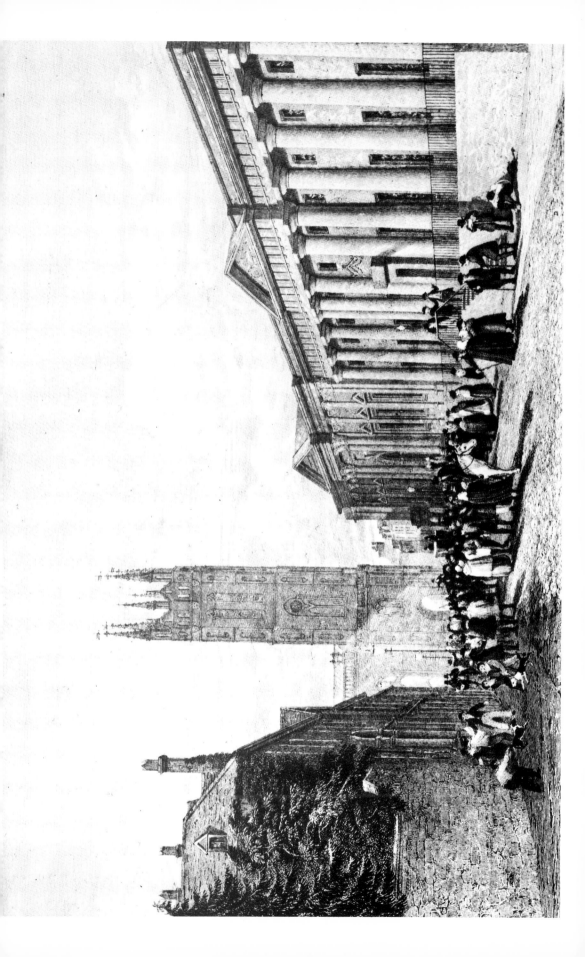

a silk- or leather-covered pad of cotton wool. A thicker ground than usual was laid for steel and, since the metal expands more readily, the plate had to be cooler than a copper one, or else the mixture would contract as the temperature dropped, presenting a cracked surface unsuitable for etching. This defect would also appear if the plate was too highly polished.[26] To facilitate the engraver's work, the greatest possible contrast was needed between the bright lines of steel and the background of the acid-resistant coating. To achieve this, the plate was smoked by a taper or lighted candle while it was held above the engraver's head, the soot combining with the ground to produce a hard lacquer. This was a most delicate operation because if the flame burned the surface, the whole operation was ruined and would have to be repeated. The dampened reducing was then transferred to the plate as before, and a reversed design was ready to be traced by the etching needle. An etching needle was a pointed steel bar, set in a wooden handle; since only the resist needed to be pierced, the instrument could be used very freely, like a pen or pencil. Following the lines of the pencilled design, the resist was cut to bare the metal beneath. Most of the lines were treated thus, so that when first bitten by the acid each line was of roughly equal depth. The outline of the design formed the basis upon which further tone was laid by deepening and widening the lines. Some engravers preferred to work the right way round, especially where lettering appeared in the design, and used a mirror for this purpose, but it was not universal practice.

To protect the resist from accidental damage, some engravers raised a frame of cartridge paper, supported by wax, some three quarters of an inch high above the surface; across it was laid a parallel ruler with brass edges, upon which he could rest his hands and arm when working.[27] It would be unnecessary for small plates, where all parts could be reached by resting the hands on the bench or table. Large areas of landscapes, such as sky and water, were often engraved with parallel lines; to complete them quickly and uniformly, a ruling machine was used. This was the invention of Wilson Lowry about 1790,[28] and first used by him in plate 9, volume 3 of *Antiquities of Athens* by James Stuart and Nicholas Revett, dated 3 April 1792.[29] A slide permitted a steel 'pen' to move accurately from side to side; the distance between the lines was precisely measured by means of a screw. A steel pen soon became blunt, so in 1798 Lowry substituted a diamond point, which lasted very much longer and made smoother cuts through the resist. With the common use of steel plates, the ruling machine was much in demand and at the height of its popularity. From 1820, the Society of Arts viewed a number of improvements to the machine, for some of which it gave awards. Some, such as that proposed by

PLATE **17** Percy Heath's improved ruling machine for engravers, from the *Transactions of the Society of Arts*, 1837, vol. 51, p. 25. (By courtesy East Sussex County Library, Brighton Reference Library.)

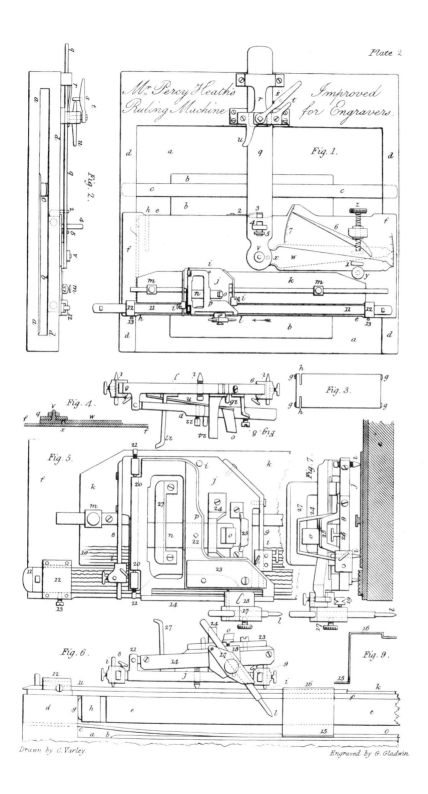

Plate 2

Mr. Percy Heath's Improved
Ruling Machine for Engravers.

Fig. 1.

Fig. 2.

Fig. 3.

Fig. 4.

Fig. 5.

Fig. 6.

Fig. 7.

Fig. 9.

Drawn by C. Varley.

Engraved by G. Gladwin.

Percy Heath (see plate 17), were of considerable complexity. Among the more successful amendments were those made by Taylor, Storker and Porter.[30] Other machines could rule parallel curved lines; in fact, using the new improvements, and with a certain amount of practice, almost any shape could be drawn with equidistant lines. In the opinion of one writer, this was 'one of the most signal improvements which had been made in the art of etching since its first discovery'.[31] But in other quarters it was blamed for the mechanical appearance of much work and, in unskilled hands, many of the criticisms could certainly be justified.

Once the plate had been prepared as outlined, biting could begin. An inch-high wall of wax, built around the area to be etched, had in one corner a moulded spout to facilitate the removal of acid. The acid was poured in and, according to its strength and the experience of the etcher, was allowed to remain from two to fifteen minutes, biting into the unprotected steel. After the first rapid action with bubbles rising to the surface, the steel becomes dull, but in a short time the concentration of metal particles in the acid prevents biting downwards. This encourages the acid to eat sideways and results in undercutting, thus weakening the edges of lines, which are liable to crumble under printing pressure.

The early steel engravers were handicapped by the lack of a suitable 'menstruum' or etching fluid, a search for which occupied a number of engravers before 1830. Nitric acid was used to etch copper and it was a natural choice for early experiments on steel, but alone, even in a more dilute form, it lacked efficiency, resulting in rough edges to the lines. Jacob Perkins and Charles Heath originally employed nitric acid which had been used to etch copper plates, the process turning it into an acidulous nitrate of copper in solution. The lines were far too shallow, however, and produced lifeless proofs, so Wilson Lowry was paid fifty pounds for the secret of his fluid, the composition of which was not revealed, but, it is thought, provided better results.[32] Charles Warren found this the most difficult of his problems, but after a series of experiments, he suggested a recipe of half an ounce of crystallized nitrate of copper in one and a half pints of distilled water, to which a few drops of nitric acid were added. This is a more precise version of that used by Perkins and Heath. Although it appeared to satisfy Warren, it was not acceptable to many of his fellow artists.[33] On 6 April 1824, Edmund Turrell sent the Society of Arts a fourteen-foolscap-page account of his process,[34] for which he was awarded the Large Gold Medal. His proposed solution contained four parts of acetic acid and one part of alcohol, thoroughly mixed, to which one part of nitric acid was added. Its usefulness was curtailed by a reaction with the mixture used to stop out lines fully bitten, made up of Brunswick black and alcohol. A substitute mixture of asphaltum and turpentine, which left the menstruum unaffected, was an improvement. W. Cooke junior and William Humphrys were each awarded the Gold Isis Medal in 1825 and 1826 for their work on etching fluids concerned with

the differing requirements of hard and soft steel. Humphrys also produced the first recipe omitting nitric acid,[35] but most etchers used it in some form because of its quick action.

Once the engraver had estimated that the shallowest lines were sufficiently etched, the acid (which should have been only one-sixth of an inch deep so that the work's progress could be observed) was poured off through the spout and the whole immediately washed in clean water until all traces of the etching fluid were removed. The plate was dried in front of a pair of bellows and the etched lines inspected. Brunswick black was painted over the parts sufficiently bitten (i.e. stopping-out), and the performance was repeated until the very darkest parts were etched, a total biting time of up to forty minutes. The engraver now had to inspect the plate even more closely under a magnifying glass, so the etching ground was cleaned off and a proof printed. The etched state of Warren's 'The Broken China Jar' reproduced as plate 9 on page 29, is such a proof, where the word 'Aquafortis' indicates that the engraver had etched the plate himself thus far. The white parts were to be engraved with the burin; the outline head in the centre was to be deepened into shadow and only its rough location was etched in here. It also clearly indicates how much of a plate was given a first etching. Fielding writes: 'In landscapes, the trees, rocks, earth, herbage, and indeed every part, except white objects, should be etched as much as possible; nothing should be left for the graver, but perfecting, softening, and strengthening.'[36] Partington observes: 'Even of those engravings which are considered as wholly executed by the tool [graver], the dark shadows, and such objects as trees, are usually done by etching'.[37]

Under some circumstances, a rebiting was attempted to strengthen parts insufficiently deep, but being a delicate operation it was not done unless absolutely necessary. The plate was cleaned with turpentine, then coated with a paste of whiting and turpentine, which filled the etched lines. The etching ground was relaid as before, after which, the dried whiting was cleared from the lines with stale bread crumbs. The etching process was then repeated. Re-biting was invented and first employed by Anthony Walker in the late eighteenth century, and was widely used by subsequent engravers. The strain of 'biting-in days' is recalled by Edward Goodall's son, affecting the whole household as the delicate operation progressed.[38] Some engravers, once they had etched the plate, handed it over to a trade engraver, but the results, predictably, were mostly mediocre.

The plate was now ready for the attention of the burin. The burin or graver is a strong bar of steel, curved upwards towards the point and sharpened at one end, the other being capped by a semicircular wooden handle. The burin used for stipple work is curved downwards towards the point. For steel engraving, its temper had to be extremely good, but despite this, engravers experienced great difficulty with points blunt and broken. Even the best gravers produced by J. Sellers of Sheffield and others required constant sharpening on a stone to keep

them in peak condition. Fortunately they only cost about 3*d.* each, so frequent replacement was not too expensive. The burin was pushed into the steel plate at the beginning of a line, and due to its lozenge section, it cut a wider line the deeper it went, finally emerging to a point as it surfaced at the far end of the line. A sliver of steel was removed or pushed aside, and the edge of the line was smoothed by the scraper and burnisher. The latter is a highly polished bar of steel, oval in section and pointed at one end, used also for rubbing down parts of lines to be printed more lightly.[39] A drypoint, rather stouter than an etching needle, was used to cut the finest lines, and a burin with a turned-back point which cut when pulled was sometimes used, but there is no indication of its popularity.[40]

Small plates rested on a leather-covered sandbag or cushion, and rotated against the burin, held steady in one hand, to produce a good curved line, but more elaborate provision was necessary for larger ones. A 'moveable table', said to have been invented by the Abbé Longhi, was raised at an angle by a rear support, and was drilled at various points to take an iron rod. This rod supported a second table, to which the steel plate was secured by twelve screws, both then being turned. Additional support was given by friction rollers.[41]

Both Partington and Fielding give detailed instructions for the delineation of various surfaces, e.g. linen, wool, silk, satin, velvet and plush, metals, armour, glass, smooth water, mountains, drapery, hair and so on.

Dark clouds greatly exercise the skill of the engraver, and generally require two strokes. Sometimes one set of the strokes are curved, and the other straight; sometimes both are curved; but in all cases, the intervals are more lozenged than for other objects. A serene sky is represented by strokes parallel to the horizon, or by strokes following the same direction, but gently waved. According to the general rule for the sky, the strokes must be gradually stronger as they recede from the horizon.[42]

As most steel engravings have etched areas, so some plates have the design treated in more than one manner. Some combine line and stipple, some stipple and mezzotint, and, more rarely, all three, but the method varies with the subject of the plate, e.g. portraits and sculptures are frequently done in stipple and line. A fashion for outline engraving, already a favourite with such engravers as Henry Moses, gained some ground, especially in subjects such as heraldry and architecture, where the effect of a drawing is obtained without the use of tone. It was a quicker method and was used by H. Adlard, for example, in Richard Brown's *Sacred Architecture* (1845), published by Fisher.

Small mistakes could be removed by the burnisher and scraper, but larger ones necessitated 'knocking-up', where a pair of calipers located the mistake on the front of the plate, and marked the position with a small scratch on the back. A steel punch was positioned over it, placed on an anvil, and several sharp blows pushed up the metal to an even surface on the front, which could then be re-engraved.

Proofs were taken as the plate progressed; by this means the engraver assessed the development of his work, and at the same time the various states of the plate were recorded. The later proofs were criticized by trusted colleagues, and one was sent to the artist, if living, for 'touching'. Turner was very conscientious about this, and it is said that he was willing to go to great lengths to meet the engraver's translation problems.[43] He would change details of an existing picture because a small spot of colour, effectively drawing attention to the focal point, would appear insignificant when changed into monochrome and would need to be enlarged or strengthened in some way to compensate.[44] He made small drawings in the margin of a proof, and notes, lengthy instructions or suggestions were written down. The touching was frequently made a condition of acceptance by a publisher, but difficulties sometimes arose, as Sir Edwin Landseer and the Count d'Orsay discovered. The Count d'Orsay had depicted the Queen on horseback and this painting was then to be engraved. He was also liable to be arrested for debt if he moved out of his house on a weekday and so he explained his dilemma to Landseer: 'My dear Edwin, what am I to do? The publisher will not pay me for the copyright till I have touched the proofs; and this miserable engraver [Henry Lemon] refuses to receive me on a Sunday!' Landseer then suggested a disguise and offered to go with him to the engraver's house on a weekday, where the engraving was satisfactorily dealt with.[45] An engraver's relief when he had completed his work on the plate must have been great, but not all of them showed the exuberance of William Woollett, who fired a cannon from the roof of his house in Fitzroy Square on such an occasion![46]

The final stage was to add the lettering and this was done by a writing engraver. The two branches of the profession were quite distinct, so the plate was sent to a separate establishment for completion. The artist's and engraver's names were first added immediately below the picture, the former at the left, followed by the abbreviation *del.* (drawn) or *pinx.* (painted), and the latter to the right, followed by *sc.* (engraved). Proofs then taken were described as 'before letters'. The writing engraver was dependent upon information supplied to him, accounting for misspellings and the addition of wrong names to the plate. An example of the latter appears in *The Keepsake* for 1833, where the plate on the half-title page is signed C. Heath, but the list of plates on page iv ascribes it to S. Mitan. It is probable that Mitan was working as one of Heath's engravers at the time of the latter's great publishing activity, but Heath was unwilling for any name but his own to appear on the plate. Much work, especially by apprentices, is hidden under the master's name in this way; that on the plate does not always truly indicate who was responsible for it. In some cases, the master may only have added finishing touches to his pupil's work and yet he took the credit for the whole plate.

A third 'credit' was sometimes engraved in the centre below the picture, indicating the artist who provided the 'sketch on the spot'. Below this was engraved the

title of the plate, usually in outline or open letters, although the older 'copper-plate' script was also used. Beneath this appears the publisher and date of publication of the plate (most frequently the same as that of the book) known as the 'publishing line'. To the right or left of these 'letters' was occasionally given the printer's name in very small characters, e.g. 'Printed by E. Brain' or, simply, 'McQ' (see Chapter 10).

At this point, no further 'states' were produced. Most of the proofs were taken on India paper, a process described in Chapter 10, and attention was sometimes drawn to this by engraving 'Proof' on the plate. This word was normally the last to be removed before the ordinary copies were run off.

The lettering underwent more changes than the picture during the life of the plate, sometimes being erased and replaced several times as the need arose. For example, Henry Fisher republished his books very quickly; as soon as one series of parts was complete he started another, changing the dates on the plates to match. Where the copyright of a book changed hands, the new publisher's name replaced that of the old. This occurred with John Carne's *Syria, the Holy Land, Asia Minor, &c*, first published by Fisher in three volumes between 1836 and 1838. Thirty years later, the plates were re-used in an edition produced by the London Printing and Publishing Co. Ltd. Some plates had acquired French sub-titles at a time when they were used in another book, John Kitto's *Gallery of Scripture Engravings*, published by Fisher in three volumes between 1846 and 1849.

After all this time, work and money had been expended on a plate, there was one last problem facing the steel engraver which had not affected the copper engraver – rust. A blemish will soon appear on an unprotected steel surface if left exposed for only a short time. Breathing upon it may even cause rust. Lupton admitted to meeting 'one or two serious accidents in this way'.[47] Charles Turner also emphasized the point and gave a recipe to avoid it, namely, 'warming the plate, and rubbing sheep's suet (from the animal) over it, and keeping it near a fire, or in a dry room; without this precaution, much mischief will arise'.[48] A solution of ether and rubber was also used, the gas from the mixture being used to work the first practical refrigerator, made by Jacob Perkins in 1835.[49] Sometime in the 1870s, the printing house of J. H. and F. C. McQueen discovered mildew in their steel plate room, despite the fact that each plate had been given a good coating of beeswax, and wrapped separately in paper. The house virtually closed for business over several weeks, and all the staff were employed in removing the old wax and replacing it with new. Very little damage had been done, fortunately, but the cause of the outbreak was never discovered.[50] Plates belonging to McQueen are still held by Thomas Ross and Son. Those not used for some time have rusted rather badly on the back; in a very few instances, the face of the plate has also been affected.[51] Japanese lacquer is now used to coat plates instead of beeswax, but an opaque medium obscures the engraving and makes identification difficult.

CHAPTER FIVE ·
The corporate life of the engravers

Over four hundred engravers are known to have been working on steel for book illustration from 1822 in Britain and more may yet come to light. Very few are known to have worked exclusively in the metal, as many engravers only used it when the length of run warranted it. Only the popular books encouraged its use; William Miller, for example, used copper for two plates illustrating Alexander Monro's *The Morbid Anatomy of the Gullet*, one of which was engraved in 1825. In the same year, he used steel to engrave a plate for *Constable's Miscellany* (1826).[1]

The number of engravers indicates the extent to which line engraving was used in book illustration alone. The figure takes no account of those who worked on steel in mezzotint or those who engraved almost exclusively for the printsellers, such as Charles and Frederick Lewis, Thomas Landseer, etc. Line engraving, although regarded as the highest form of the art, had been in a decline for many years before 1820. This was due to the slowness of the method, which restricted output, and even though engravers were able to keep up with the demands of collectors, the dictates of fashion at the end of the eighteenth century created a huge demand for prints to hang on the walls, following, no doubt, the rage in France, where engravings were to be found in all the fashionable houses. To speed things up, broken lines and dots were introduced, bringing into being the stipple method, in which dots of varying sizes are etched into the plate, thus eliminating much of the finishing work done by the burin. The process evolved during the late eighteenth century, being used by many engravers great and small, but associated chiefly with the Florentine engraver Francesco Bartolozzi, who worked in England from 1764 to 1802. The painting fashion of the day aided and abetted stippling, the ethereal style of artists such as Angelica Kaufman providing the inspiration for many prints taken from contemporary works. Stipple and line blend well together, and examples show trees etched, costumes finished in line, with hands and faces stippled. Some of the earliest steel engravings were done in this way; the portrait of the Revd R. Waddy from the *Methodist Magazine*, March 1823 (see plate 8, page 25) carries the inscription 'Engraved on Steel by W. Holl', but is, in reality, a stipple etching. This kind of production could be mechanized to some extent, since lines of dots can be made by running a small toothed wheel (a roulette) over the ground, and its effects can be seen on the outer edges of these vignette portraits.

The method had a far-reaching effect on the structure of the profession, however. This arose in connection with John Boydell's great production of the Shakespeare Gallery prints, which, line-engraved by the best engravers would, it was estimated, have taken over a century to complete. The scheme was launched in 1786 and wound up just before Boydell's death in 1804. During this time, he employed most of the important contemporary engravers, who included Peter J. Simon and Robert Thew, both of whom were well known for engraving 'in the dot manner'. They found that stippling reduced the engraving time of a plate, but was repetitive and could be done by 'mere mechanics'. Before long, the workshops were filled with assistants engaged upon the more tedious work, leaving the masters to add only the finishing touches. Fortunately, these assistants were not hard to find. The shift in men's fashion away from shoe buckles (of which examples in steel were invented by Matthew Boulton) brought with it a decline of the manufacturing industry in Birmingham and as a consequence the artisans who made and engraved these ornaments found themselves unemployed. However, those who could punch holes in silver and brass could equally well make holes on copper, and the men were soon encouraged to leave the Midlands for London to become the mechanics needed for stippling.[2] Their artistic abilities were not of a high order so few of them made a mark in their new field, but it firmly established the idea of an *atelier* system. Engravers such as Charles Warren and William Miller operated it with a small number of articled pupils, but Charles Heath and the Findens maintained a workshop staffed by men who worked for them continuously over a period of years. This inevitably resulted in a further breakdown of responsibilities, and it was possible to set up a kind of production line as used by Ackermann for his coloured prints. The most common specialization was etching. The finish of an etching was not critical, since it could be tidied up with the burin if necessary, and engravers who so wished could always use the trade etchers. Edward John Roberts was one who preferred to etch. He lived and worked under Charles Heath's roof for many years, assisting in the production of the various annuals. He spent most of his time etching for other engravers: 'the elaborateness and fidelity of his etching rendered the subsequent operations of the engraver a comparatively easy task'; from 1832, he put his own name to a number of engravings and supervised a number of publications, but reverted to etching plates for the *Art Journal* before he died on 22 March 1865, aged sixty-eight, 'scarcely known out of the profession to which he belonged'.[3]

An alternative speciality was an artistic one, where engravers could contribute their best skills to part of a plate only. From trial proofs we know that four engravers worked upon a print issued in *The Keepsake* for 1830, page 322. This work, 'The Prophet of St Paul's' after A. E. Chalon, measured only $4\frac{1}{8}$ by $3\frac{1}{4}$ inches and depicted an old bearded palmist, seated at a table covered by an ornate cloth, examining a young lady's hand. She is attired in a light dress, and a negro servant

stands beside her; close to the palmist is a globe. Notes indicate that 'Part by J. H. Watt, Rhodes graved up white drapery, D. Smith did remainder, and C. Heath, flesh'.[4] Heath's name alone appears on the published plate. Richard Rhodes was Heath's principal assistant in the latter part of his career, and James Henry Watt was apprenticed to Heath about 1815, working a great deal for him subsequently. This co-operation has been criticized on artistic grounds, but even the artists did precisely the same thing in their paintings. An engraving by J. C. Armytage published in the *Art Journal* for 1866 was taken from a picture entitled 'The Cavalier'. J. Herring painted the horse and dogs, Baxter the figures, and Bright the castle and scenery. Thomas Creswick asked the animal painter Richard Ansdell to do the sheep in 'Southdowns', painted in 1850, and examples could be multiplied. Only a month before Heath's death in November 1848, a severe attack on his and similar systems was published, commenting especially on the anonymity of engravers employed in the studios.[5]

The majority of engravers preferred to freelance, and after their apprenticeship years, set up on their own. A few were self-taught, thus being able to earn at a much earlier stage in their career. Engraving was a trade or profession which could be carried on in any kind of premises. Many workshops were set up at home with the minimum of equipment, most of which (apart from the ruling machine) was of a very simple character. Overheads were kept to a minimum, and these factors doubtless encouraged more people to try their hand than had true aptitude for the work. William Marshall Craig estimated that of the great number of people who tried engraving, no more than one in a hundred achieved a standard better than 'a mere mechanic'.[6] The rapid expansion of the market had a great deal to do with this; since cheap prints were now being sold to the middle and lower classes in large numbers, the demand for engravers increased. Abraham Raimbach observed that when looking for work after his apprenticeship in the 1790s 'the booksellers were at this time the only patrons (such as they were) of engraving, by the decoration, with little vignettes, of small volumes of poetry, plays, etc.'[7] In contrast to this, John Burnet, when asked by Joseph Brotherton in evidence before the 1836 Committee if enough students were coming forward to learn engraving, replied 'Too many. As the art advances, and so many prints are sold, everyone wishes to send his son to learn engraving.' He found the quality of these students rather poor and deficient in drawing and taste,[8] the one fault capable of remedy by teaching, but the other, being inherent in the person, capable only of development.

The art of engraving had increased its reputation during the first thirty-five years of the century, especially abroad. Whereas in the past, English students finished their education on the Continent, notably France, the position had reversed by 1836. The compilers of the report were able to remark that 'British engraving has attained a high degree of excellence ... the works of British engravers are diffused and admired throughout the Continent'.[9] John Pye, who had worked

in France for some time and was able to observe foreign reactions at first hand, accounted for this in two ways. Firstly, the English engraver could freely translate a picture into an engraving rather than make, as previously, a 'cold, rigid' copy. This was especially so in regard to landscapes where, by a 'new combination' of nature and art, they were able to excel. The second was as important. 'It appears to me that the art of engraving has attained considerable importance in this country, not only in the opinion of the English, but in the opinion of all the civilized nations in Europe, by its application principally to the embellishment of books.' Privately he expresses reservations, however: 'Engravers derive considerable advantage from being employed to embellish books, and but little from that employment which would elevate their art, and by which they would wish to be distinguished.'[10] The importance of book illustration was recognized, but its quality denied. The net result was that students now came to study in England from the academies of France, Holland, Russia and Prussia. At the same time, English engravers were sought after on the Continent, readily obtaining work there,[11] a point of some importance as the changes in book fashions reduced opportunities here.

Despite this, engraving was permeated with a feeling of frustration. If he went abroad, the English engraver was made to feel a person of consequence; the foremost amongst them were given high honours, including honorary membership of the fine-art academies. John Pye and John H. Robinson were Honorary Members of the Imperial Academy of Arts, St Petersburg, and Abraham Raimbach, besides having the same distinction, was given a similar rank in the Academies of Geneva and Amsterdam, being also a Corresponding Member of the Institut de France. By contrast, Raimbach's standing in England was poor, and his hope of full recognition by the Royal Academy non-existent. This state of affairs was of long standing, however. From the establishment of the Royal Academy in 1768, engravers were regarded as inferior artists, compared with painters, sculptors and architects, and only die engravers were excepted. The reasoning usually advanced was that engravers were mere transcribers of other men's work, not original artists. Be that as it may, those engravers who did reach full honours were elected on other grounds (for example, they were also painters). For eighty-seven years, a running battle was waged time and again over the same ground. In some ways, the engravers were their own worst enemies in that the profession was mixed and divided, its very divisions preventing the application of standards similar to those set up for painters and sculptors working in well-defined limits. Occasionally the suggestion was made that the highest branches of the art, such as historical line engraving, should carry high honours, but even this fell on deaf ears. Undoubtedly the Academy, too, had a point of view and, in the end, the upper hand. Appeals to the Prince Regent and King were of no avail; only time and the determined stand of one engraver broke the spell. From the beginning, the Royal Academy allowed the election of six Associate Engravers, but since the majority of the profession said

that it would sooner be without something which was only half an honour, and which had to be sought, those who permitted their names to go forward were looked upon almost as blacklegs. John Landseer, the engraver, and father of Sir Edwin Landseer, opened the nineteenth-century attacks by his letter to the Academy in August 1807, in which he appealed to their reason. A year or so later he followed this with an unsuccessful plea to the Prince Regent himself.[12] In July 1826, the following letter summing up their feelings was signed by nine eminent engravers.

July 10 1826.

We, the undersigned, being of the opinion that the Royal Academy, as now constituted, tends to degrade the art of engraving, and that those members of the profession who become Associates, by so doing degrade themselves, do hereby give to each other a voluntary pledge never to become candidates for election to that body of artists, until it shall have rendered to the art of engraving that degree of importance which is attached to it by the other countries of Europe.

(Signed) John Le Keux
 Hen. Le Keux
 John Burnet
 George Cooke
 Edwd. Goodall
 John Hen. Robinson
 W. Finden
 John Pye
 George T. Doo[13]

This protest notwithstanding, there were always those who were prepared to put their names forward for election to Associateship, thus undermining the work of the leaders. Occasionally, though, there was some difficulty in filling all six places. The election of a fresh candidate raised the controversy again, so it was sure of a regular airing. When the Government's Select Committee was announced to investigate the arts and their connection with manufacturers, the engravers presented a petition in 1836 'viewing with satisfaction the enquiry now proceeding', signed by six of the signatories to the earlier letter, together with Charles Fox, John H. Watt and Abraham Raimbach (George Cooke had died in 1834, and both John and Henry Le Keux had withdrawn).[14] This group viewed the Report very favourably; in February 1837, a petition, signed by forty-eight engravers, was presented to the King. Even this would not move the Academy, so when a periodical, the *Art Union*, provided a public forum in 1839, one of the earliest letters, signed by 'M.R.', took up the engraver's cause.[15] He pointed out that the Royal Scottish Academy had recently admitted engravers to full membership, leaving the Royal Academy the odd man out in all Europe. An 'RA' replied in the following terms:

The engravers complain, with some show of justice, that they are incompetent for pro-

motion; but upon this topic there is a strong difference of opinion among engravers themselves; and certainly they are so very numerous that to select a few from them might be invidious, and to prevent their doing that which they are now about to do – forming a Chartered Institute of their own . . .[16]

This Institute appears to have been the last in a line of such attempts made since the beginning of the nineteenth century. The first was in 1802, when the Society of Engravers was instituted under the patronage of the Prince of Wales.[17] It was formed primarily to care for the aged, infirm, widows and orphans of engravers, made up of three classes of members. The first comprised twenty-four Governors, who promised to subscribe the proceeds of a copperplate or plates. Next came annual subscribers, contributing a fixed sum each year, and finally, honorary members.[18] Francesco Bartolozzi became its president, but despite its distinguished patronage and membership (which included John Samuel Agar, Cosmo Armstrong, Jean Delatre, Valentine Green and Charles Warren), it does not seem to have survived the decade. When Thomas Tagg, the etcher, fell ill in 1809, it was private philanthropy which supported him until the efforts of Edward Scriven, Warren, Heath and their friends resulted in the establishment in 1810 of a single organization with two distinct and separate branches. The Artists' Annuity Fund for sickness and superannuation, open to members aged twenty-one to forty-five years, selected by ballot, was one, and the second was the Artists' Benevolent Fund for widows and orphans, supported by patronage.[19] Had the Society of Engravers continued in existence and the Royal Academy scheme not failed, Tagg's plight would not have caused such widespread concern, neither would it have induced its supporters to join a general society of artists.

The year 1810 also saw the first attempt to establish a society for promoting the professional cause of engravers, as opposed to that ministering to their welfare. A group of engravers came together, produced a set of proposals and submitted them to their colleagues for comment. John Landseer published his views in three letters, designating the new body as the 'Society for encouraging the art of engraving', and criticizing the proposed methods of fund-raising.[20] They endeavoured to enlist the help of Sir John Leicester,[21] a well-known patron of the arts, who in turn persuaded the Duke of Gloucester to give his support to a 'calcographic [sic] society'. The immediate objects were to improve the engraver's public image and to defend professional rights. The latter had been attacked in 1801 when the engraver Jean Delatre, who worked for Bartolozzi, brought an action against John Singleton Copley to obtain payment of £580. This was the residue of an £800 fee for a copy of Bartolozzi's engraving 'Death of Chatham', and was withheld by the artist because he considered the likeness unsatisfactory. The right of an artist to criticize his engraver was the most common cause of strife between them, and Delatre must have been very satisfied when judgement was given for him. William Sharp, the eminent engraver, when approached for support, declined to have anything to do

with this society. He was quite adamant that differences between the various groups of exponents would not allow them to work amicably together. In a letter dated 29 May 1810 to Charles Warren,[22] he expressed his conviction that the stipple engravers, the largest group, should form their own society and that similarly, the mezzotinters should have theirs. He saw no hope of gaining essential patronage if this was not done. Sharp had no good reason to like the stipple engravers after Bartolozzi's treatment of one of his 'Holy Family' plates,[23] but, having himself started life as a writing engraver, he had no particular prejudice towards any group, even though most of his own work was in line. He doubtless had in mind the 'mere mechanics' who had strengthened the stipplers' ranks to the detriment of engravers in line and mezzotint. Significantly, his views were very relevant at the end of the nineteenth century, when separate societies existed for the painter-etchers and the mezzotinters. In the end, Sharp's initial misgivings were justified because, although the project grew – and several thousand pounds were subscribed for its support – 'personal selfishness and jealous feelings among the engravers completely marred this prosperous beginning, and the business fell to the ground: the subscriptions were, of course, returned to their owners.'[24]

Yet from the ashes of this society another arose. A group of engravers, possibly the same as before, originated another kind of gathering in the Gray's Inn Coffee House, to the meetings of which, proofs of their plates were brought to be criticized and commented upon. Book illustrations were also exhibited; on 2 April 1839, for example, a graceful drawing of a young girl in an arbour was shown, then being engraved by Henry Rolls for Ackermann's *Forget me not*.[25] They were gradually joined by other artists and amateurs, so that larger premises had to be found at the Freemason's Tavern, where for years the Artists' and Amateurs' Conversazione met. The engravers lost the monopoly of this forum and for this reason they founded a more permanent group, known as the Chalcographic Society. It met at members' houses, and besides exchanging technical information, viewing states of work in progress, examining Continental prints, etc., also enjoyed a supper of bread, cheese, salad and beer, a repast kept deliberately simple in the early days. Later it became more sumptuous. It was said that the meetings assisted the members 'in their laborious and refined studies upon copper or steel'. John H. Robinson, Samuel Cousins, Edward Goodall, Frederick Bacon, William Finden,[26] William Holl and Thomas Oldham Barlow were all members. But, as individuals died, so the Society dwindled in numbers, eventually closing down sometime in the 1880s.[27]

The social life of the engravers did not appear to extend much beyond these fraternal gatherings, although between 1846 and 1848 they took the lead in two general entertainments to raise money for the Artists' General Benevolent Fund. A series of three plays was presented at the St James's Theatre on 27 January 1846, in which Frank Holl (see plate 18) and George Cruikshank took parts, the outstanding performance being by Francis W. Topham (see plate 19) as Tyke in Thomas

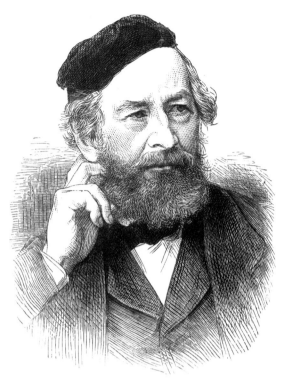

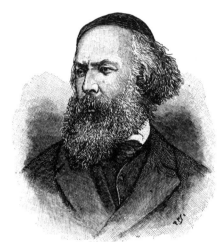

FRANCIS HOLL, A.R.A.

MR. F. W. TOPHAM, R.W.S.

PLATE **18** Francis Holl, A.R.A. (1815–84), wood engraving from the *Illustrated London News*, 1883, vol. 82, p. 469. (By courtesy East Sussex County Library, Brighton Reference Library.)

PLATE **19** Francis William Topham (1808–77), wood engraving after a photograph, from the *Illustrated London News*, 1892, vol. 100, p. 591. (By courtesy East Sussex County Library, Brighton Reference Library.)

Morton's *School of Reform*. In April 1848, the same company performed George Colman the younger's amusing *Heir-at-law*, with Frank Holl as Doctor Panglos and Francis Topham as Zekiel Homespun,[28] but although the first performance produced nearly £80, the second was disappointing, and discouraged further productions.

The number of engravers working during the period ensured adequate representation in societies of the kind so far described. When William Brockedon, the painter and book illustrator, began the Graphic Society on 20 March 1833 after several abortive attempts over the previous ten years or so, of the hundred artists who were members, twenty were engravers. This limited membership was an attempt to avoid some of the problems then facing the various open conversaziones. These had attracted printsellers and publishers and, as a result, the

meetings tended to become markets for their wares. Rule 10 of the Graphic Society expressly forbade this,[29] and its high standards were maintained until it was wound up sometime in the 1880s.

The suggestion of an Engravers' Institute in 1839 was the last of these attempts to organize engravers in a professional manner. The first steps were taken in March and the idea of a Royal Charter for the Institute of British Engravings [sic] promulgated,[30] but events had moved so slowly that a report in March 1840 merely stated that although a meeting had been held the project was not far enough advanced to warrant publishing the proceedings. The report also assumed that, since the promulgators were leading members of the profession, the younger men would join as a matter of course, so obvious were the benefits.[31] Perhaps the benefits were not so obvious after all, because nothing more is heard of the venture. It can only be surmised that it foundered, like its predecessors, on the rocks of division, apathy and jealousy.[32] The Royal Academy still remained the only institution of note to which full membership was denied engravers, and the climate of opinion only changed when it was almost too late.

During the fourth decade of the century, effective royal patronage of the highest order did something for art which Select Committees had failed to do. Prince Albert was a real force supporting the Society of Arts in their attempts to prove to the world that Britain's manufacturing industries had achieved a high standard. At the Great Exhibition of 1851, comparison with overseas competitors was encouraged, thus beginning a long series of International Exhibitions which adorned the second half of the century. Although the accent was on industrial and manufacturing design, the fine arts were not forgotten. Engraving obtained the best of both worlds, being both an art and a craft, and a number of exhibiting manufacturers and printers made a feature of new processes and the latest developments. In this atmosphere of euphoria, several events took place which wrought a remarkable change in the Academy's attitude. By the early 1850s, a number of engravers, including George Doo, J. H. Robinson and William Finden, had been successful in enlisting the support of the Queen and Prince Albert for the engraver's case.[33] The death of the elderly Associate Engraver John Landseer, on 29 February 1852, produced the usual comments on the Royal Academy's attitude,[34] but at a Council meeting in May, the engravers found a champion in the painter Charles Robert Leslie. He was, at this time, a most respected member of the Academy, having been closely connected with its affairs from 1813, when he was admitted as a student to their Schools. His election to Associateship in 1821 and as Academician in 1826 was rapid promotion, but his last appointment in 1848 as professor of painting placed him in a very influential position, even though he had retired through ill health in 1851. His writings exhibit him as a pleasant and kindly character, one calculated to earn universal liking and respect. His pictures, too, had often been engraved for the annuals, his Shakespeare illustrations for editions of the works,

and Finden's *Royal Gallery of British Art*, so that he was no stranger to the engraving profession. It was he, therefore, who brought a proposal that engravers should be admitted as Academicians, which, surprisingly enough, was accepted by that august body in 1853.[35]

Earlier in that year, Lumb Stocks had been elected Associate to replace John Landseer,[36] so it was not until two years later that the opportunity to elect an engraver as Academician occurred. On 10 February 1855, Samuel Cousins broke the spell, resolved the vexed question and was admitted to 'full honours' as an engraver. Even in this moment of triumph, dissension raised its ugly head. Complaints were made that he was a mezzotint engraver ('his practice is not in the highest branch of the profession'), line engravers would be depressed and 'if but *one* additional member was to be elected, it ought not to have been Mr. Cousins'; either the number of Academicians ought to have been raised from forty to fifty, or one of a dozen named artists should have been preferred for election.[37] It was probably a grateful Samuel Cousins who, four years before his death, gave the Academy £15,000 in trust, the interest on which was to provide annuities of a maximum £80 each for needy artists.[38] This victory brought very little solace to the engravers, since some of the greatest – such as Edward Goodall, John Pye and George Doo – had already felt themselves too humiliated by the Academy ever to forgive. Although one or two later engravers achieved full honours, only Lumb Stocks had more than a passing connection with steel-engraved book illustration. Stocks was elected as an Academician on 22 December 1871, almost exactly two months after the death of his predecessor, John Henry Robinson, who had been similarly elected in 1867. Finally, with Stocks's death on 28 April 1892, the Academy was left without an Academician engraver. He had been admitted to the higher echelons, however, because in 1874 he joined Samuel Cousins on the Council, and in 1880 and 1889 was a member of the Hanging Committee to advise on engravings.[39] In 1881 he was the sole Academician engraver in a total membership of thirty-eight; out of thirty-five Associates, only two were engravers.[40] The 1855 resolution incorporated a rule that no more than two engravers could be Academicians at a time, with a total of four engravers altogether, instead of the six Associates previously permitted. In an outspoken article published in 1896, one of the younger copper-plate engravers, Robert S. Clouston, castigated both the Academy and the painters, attributing the acceptance of photographic methods (in particular, photogravure) in high places as also bearing part of the responsibility for the engravers' plight.[41] Seven years later, Sir Walter Gilbey wrote to *The Times* on the subject, and in 1904 it was reported that 'the Academy is said to be considering the advisability of electing an Associate Engraver'.[42]

For the steel engravers it was too little too late, with the best of the nineteenth-century exponents choosing to remain aloof from the in-fighting of the Academy's art world.

CHAPTER SIX · Some steel engravers

To give a comprehensive account of individual achievement for nearly four hundred engravers is a task quite beyond the scope of the present study, but it is possible to build up a representative picture by examining about a dozen of the more prolific exponents. Half of those selected had close relatives who were also engravers. While it is recognized that there were differences between the work of individuals within a family, these groups (for example, the Brandard, Cousen, Finden, Radclyffe, Wallis and Willmore families) have been treated together. The remainder are names eminent in their own right, not associated with relatives or a distinguishable group. They include J. B. Allen, J. C. Armytage, J. C. Bentley, E. Goodall, W. Miller and L. Stocks.

The engraver's occupation is a solitary one, and in order to gain an informed view of his life, the reader cannot do better than refer to the account, published in 1877, attributed to Charles William Radclyffe.[1] Charles was the youngest son of William Radclyffe, the eminent engraver, and the brother of Edward, also an engraver, so although he himself was a painter, chiefly in watercolours, he had a first-hand knowledge of the conditions under which his father and brother worked.

Few men have more lacked the sympathy and appreciation of the public than engravers; few men have been less known, few have lived more solitary or more laborious lives. Bending double all through a bright, sunny day, in an attic or close work-room, over a large steel plate, with a powerful magnifying-glass in constant use; carefully picking and cutting out bits of metal from the plate . . . working for twelve or fourteen hours daily, taking exercise rarely, in early morning or late at night; 'proving' a plate, only to find that days of labour have been mistaken, and have to be effaced, and done over again; criticised and corrected by painters, who often or always look upon engravers – to whom they owe so much – as inferior to themselves; badly paid by publishers, who reap the lion's share of the value of their work; and treated with indifference by the public – such is too commonly the life of an engraver . . .

John Burnet recalls that he worked from seven in the morning until eight in the evening during his apprenticeship.[2]

Despite this gloomy picture, many men seem to have been dedicated to it, and to have lived into ripe old age; a number of them were still working in their seventies

and eighties. Nor were their workrooms always so depressing; some appear to have been quite light and airy, set in pleasant surroundings. Ideally, the engraver's light should come from the north, so that direct sunlight will not reflect from the plate. To avoid glare, even in the northerly position, a screen of tissue paper was usually set up between window and workbench in order to diffuse the light evenly – (see plate 20).[3]

The normal method of entry into the engraving profession was by apprenticeship. A few men were self-taught and reached a fair competence, but this was decidedly unusual. After the establishment of the Government Schools of Design, some engravers were trained in them. Birmingham was training sixteen engravers out of a total of 170 students in 1846, and Sheffield in 1847 had fourteen training to be engravers on copper and wood out of a total of 180.[4] The term of apprenticeship was, in most cases, the traditional seven years (John Burnet and James T. Willmore, for example), but it could range from four (William Miller) to nine (James Ward). There are examples of engravers attaching themselves to a master for anything from one to three years in order to improve their art, but usually they were already trained or had some suitable experience instead. The age at which apprenticeship began also varied, and ranged from thirteen (James Stewart) to sixteen (James T. Willmore), although fourteen seemed to be more usual (John Horsburgh and George Cooke). Most engravers were normally out of indentures by the time they were between twenty and twenty-three years of age. A bad master who taught his pupils little found that signed indentures were not always sufficient to hold them. Where less formal terms were laid down, a capable pupil was able to negotiate his release when he felt competent to stand on his own feet. Masters usually charged an apprenticeship fee of about £100, depending upon the eminence of the engraver, and how many pupils wished to be placed with them at one time. When William Miller took a pupil, Andrew Kilgour, in 1828, the fee was 100 guineas, but when William Chapman went in 1835, it had gone up to 150 guineas. Miller himself had only four years' apprenticeship to William Archibald, after which, at the age of nineteen, he set up on his own. In 1819, when he was twenty-three, he felt able, with his father's help, to find the unusually high premium of £250 enabling him to study in London under George Cooke for eighteen months.[5]

Remuneration for engravers was determined by a number of factors, not always related to the quality of the work produced. An established engraver could normally command a better price for his plates, but since most of the work would be done by his pupils, his part in it was nominal. Some engravers working alone did, it

PLATE **20** The workroom, Hope Park, of the engraver William Miller. The photograph by D.D. (i.e. Daniel Doncaster, Miller's son-in-law) faces 'A catalogue of engravings' in the privately printed *Memorials of Hope Park*, 1886, by William F. Miller. (By courtesy Edinburgh City Libraries.)

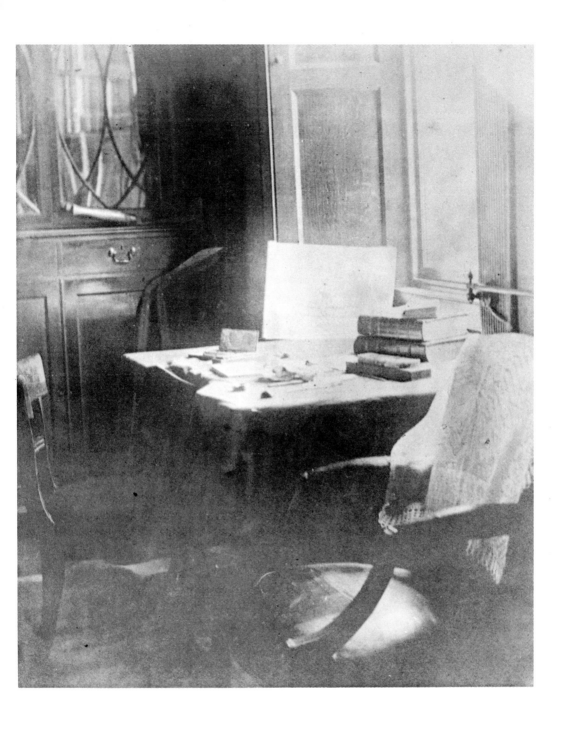

is true, execute whole plates themselves, but they were not in the front rank of the profession, nor could they produce a sufficient volume of work to make other than just a bare living. Payment for a plate depended mainly upon the amount of work put into it, represented by time spent. William Miller engraved a portrait $2\frac{1}{4}$ by 2 inches of C. W. Koch for volume 33 of *Constable's Miscellany*, and charged £1. 5s. 0d. for it. The following year, 1829, an engraving $2\frac{1}{2}$ by 2 inches, 'The Battle of Naseby', for volume 47 of the same periodical, commanded £7. 7s. 0d. These were both steel plates; because of the increased time necessary to engrave the harder metal, they were charged more than their copper counterparts. Miller engraved a copper plate for *The Winter's Wreath* in 1827, size 4 by 3 inches, from which 3,142 prints were taken; his charge was twelve guineas. A steel plate of similar size, engraved with a comparable subject in 1830, from which over 7,000 prints were taken, was charged at £31. 10s. 0d. With one exception, the highest figure he received for a single steel book illustration was £63 for 'Marly' after Turner, for the 1832 *Keepsake*. That exception was the £315 he received for 'The Battle of Trafalgar' after Stanfield, published in Finden's *Royal Gallery of British Art* and engraved in 1839.[6]

An engraver sometimes fell behind with his commitments owing to ill health or other circumstances, and enlisted the help of his colleagues. In the summer of 1818, Charles Heath was unwell for six weeks and, being engaged upon plates for John Murray's edition of Byron's poems, he wrote to the publisher on 24 July 1818: 'Perhaps as you are in haste for them you will give me leave to put some of the plates in other hands, such as Mr. Finden, Engleheart, Robinson, &c. to bear their names and to have the same price with myself, which to save you trouble I will pay – and you can settle with me as if I did them all . . .'. The plates were finished in due course, and delivered to Murray on 23 December, but the publisher appears to have upset Heath by arguing over the price. Another letter from Heath, 27 December begins 'With feelings much hurt by certain expressions you have thought it proper to address to me in your last letter', and goes on to assert that 'the price of the plates was to be 20 and 25 guineas *each* according to the quantity of work'. The last letter in the series, dated 2 January 1819, sums it all up:

Dear Sir,
I give you my Honour the estimate I gave you was 20 and 25 guineas each plate according as they were easy or difficult and I beg to assure you there is no sum of money would induce me to break an *engagement*. The difference here is too trifling to be of material importance to either. The last time I had the pleasure of seeing you in Albemarle St. the *price* was particularly mentioned. You then gave me a commission for two new plates, and this being my Idea of our agreement, I have promised Messr· Finden, Engleheart, &c. 25 Gns. each for their engravings, and I assure you that it was only as a *Personal* favour they would undertake them at that low price.

You must recollect the last set cost 30 gns. each except one which was 40 gns. and that you very liberally gave me 30 gns besides for my trouble in conducting this work, and that very lately you sent me three large drawings of Westall to be engraved the Byron size and my charge was 40 gns each, had I done them. The Plates in question are worth as much – they are as well as I can do them. The reason I proposed to take them on myself was from an unwillingness if you were displeased *to force* upon you a speculation I certainly was the promoter of.

I am receiving the same sum for plates little more than half the size, and by this arrangement I am really losing a large sum, and I have at least 100 plates from Westall I cannot touch till yours are done. With respect to the Bill, I asked it as a favor, assuming you would without hesitation oblige me as you did in Sir John Malcolm's Work and others – the date I left to yourself but said the shorter the better, as money is now scarce and it would be easier to cash. This I leave to yourself – only observing it will oblige, dear Sir, Yours respectfully, Chas: Heath.

These terms applied to copper plates, and although Murray's replies have not survived, he seems to have thought the charges rather high. About ten years later, Edward Finden was laying down his terms to the same publisher in the following letter, dated 22 December 1830.

In reply to yours of yesterday relative to the expence of the Plates for the Life of Hampden, I have to state that the Portrait of Hampden will be Thirty five Guineas, that of Pym, I should presume will be the same, as it is to be from an original, the Plate of the House of Commons eighteen guineas. Lord Nugent talked of having the residence of Hampden, but not having seen it, and not knowing the size it will be required, I can give no opinion. Of course it is a matter of no moment who I am to look to for payment, but from the conversation I had with you upon the subject, I concluded that if you published it, I was to include it in your account, have the goodness to say how I am to act. I am, Dr. Sir; Yours truly, Edw. F. Finden.[7]

These were steel plates; even allowing for that fact, the increase in price was not excessive, taking into account a general rise in prices over the period. William Finden, in a letter of 18 October 1830, replying to a request for his charges, wrote: 'for engraving the portraits of Ld. Byron ... it is 300 gs. which I hope will meet your approbation.'[8] This is a much larger sum, and it is difficult to establish precisely what was involved. If there were about ten to engrave, an average of 30 guineas each was reasonable; otherwise they may have been one or two larger ones, and probably not book plates.

The recent discovery of six letters and two notebooks belonging to Samuel Rawle, who worked chiefly for the Findens, gives some insight into an engraver's engagements and the kind of work for which he was paid.[9] One page from the later notebook (the year is 1830) summarizes this:

March 20th Recd. of Mr. Parker for an engraving on steel of

 Quebec, Pinnock's Geography — 3 . 13 . 6

Apr. 27th Rec. of Mr. Parker for a steel plate of Bombay

 Pinnock's Geo. — 3 . 3 . 0

Finden {

 March 20th Chinese Junk – 18 . 18 . 0

 upon finishing Geo. etching — 5 . 5 . 0

 finishing Brandon Hill Bristol — 4 . 4 . 0

 a steel plate of Calne (Britton) — 10 . 10 . 0

of Mr. Parker. 3 subjects of mountains — 10 . 10 . 0

July 4th

 of Mr. Finden for Cave of Ellora — 9 . 0 . 0

 17th

 of Finden for Bootha Temple — 6 . 0 . 0

 finishing two Brittons – 8 . 8 . 0

 & Greenwich — 4 . 0 . 0

Sept. 8 of Mr. Finden for two views of Suspension bridge

 over the *Menai* and *Conway Castle* (Steel) — 16 . 0 . 0

 22. Finishing 2 Brittons (Hythe & Newcastle — 8 . 0 . 0

Oct. 25 2 etchings (of Waverley) — 10 . 10 . 0

 the Hoy & Inverary — 3

Some years later, when Heath and others were spending large sums of money on the annuals, it was not uncommon for an engraver to receive 150 guineas for a single plate, probably due to the short time allowed for completion. A volume of *The Amulet* cost nearly 1,200 guineas for twelve plates, one of which, 'The Crucifixion' after Martin and engraved by Le Keux, brought the engraver 210 guineas. Of this sum, 180 guineas was for engraving and thirty guineas for making the reduction. Two other engravings cost 260 guineas, leaving about 700 guineas for the remaining nine plates. Notwithstanding the high expenditure on the plates alone, it was the only volume in the series of eleven to show a profit.[10] According to Burnet, discussing an edition of Scott's Waverley novels, one halfpenny per volume was charged for each embellishment, enabling the publisher Cadell to pay eighty guineas for each engraving, where over 40,000 copies would have had to have been sold to cover the cost of engraving the plate alone.[11] There appears to have been no standard scale of charges for line engravings of this type, although it is interesting to compare them with the much lower amounts paid for the etched illustrations to Victorian novels.[12] Line engraving, as the highest form of the art, would expect to attract more, if only for the labour involved. Otherwise, the same considerations, such as the engraver's standing and the size of the plate, applied equally.

 Most of the engravers worked very much as individuals, but the scale of their finished products gave no scope for personal characteristics to show. This was an

advantage to the publisher, since the plates for a single work could be done by a number of engravers with little or no effect upon the overall appearance of the book. Although it is too sweeping a statement to make that one steel engraving looks remarkably like another, it is not easy to find common features in the work of a single engraver and even more difficult to draw the work of engravers into schools. There is sufficient evidence, however, to name London, Birmingham and Edinburgh as centres of steel engraving, because it was carried on there by eminent men.

London was inevitably the mecca of the best exponents, who felt that residence in the metropolis gave them their best chance of reaching the top of their profession. Certainly, employment prospects were good there. Edinburgh was in much the same position, its printers and publishers providing a reasonable amount of work to support local talent. Birmingham, although it produced a number of eminent engravers by birth and adoption, was unable to hold many of them for long, and only William Radclyffe and Thomas Garner are recorded as spending their whole working lives in the city, the remainder leaving to seek their fortunes in London. It was no accident that the success of engraving in Birmingham and Edinburgh ran parallel to the existence of excellent drawing schools in both cities, something which London did not possess. John Burnet, when asked in 1836 about the educational standards of pupil engravers, replied that they were deficient in both drawing and taste. He suggested that the remedy for the former was to include drawing as part of the elementary education programme for all pupils.[13] He himself had been educated at the Trustee's Academy in Edinburgh and knew the value of such training.

THE BIRMINGHAM SCHOOL

At Birmingham, the drawing school of Joseph Barber was known as the Great Charles Street Academy, a small room which saw the early education of David Cox, Samuel Lines, John Pye (William Radclyffe's cousin) and William Radclyffe. On his death, Joseph was succeeded by his sons Joseph Vincent and Charles. In their time, the engravers James Baylis Allen, Samuel Fisher, Thomas Garner, Joseph Goodyear, Thomas Jeavons, and James Tibbetts Willmore were trained in the Academy, as were the artists Thomas Creswick, David Octavius Hill and Henry Room, all of whom were to provide drawings for some of their fellow students' future engravings. One of their contemporaries was William Wyon, R.A., who reached eminence in the field of coinage and medals as Chief Engraver to the Mint. Samuel Lines set up the Newhall Street Life Academy in 1809 to complement the work being done by the Barbers; many of the students attended both schools. These men formed a tight circle of acquaintances and it is not surprising to find them engaged together on various enterprises, the most important of which centred on William Radclyffe.

WILLIAM RADCLYFFE, born in Birmingham on 20 October 1783, was the acknowledged leader of the city's group of engravers. During his early life, he worked very hard, attending art classes under Joseph Barber and training as an apprentice to a local letter engraver, Mr Tolley, to whom William's cousin John Pye (see plate 21) was also indentured.

Since John could draw well, the two youngsters taught themselves lineengraving techniques, thus enabling them to do without a normal apprenticeship in this field. About 1800, when Pye was eighteen and Radclyffe nearly seventeen, they finished their indentures and both decided to try their luck in London. Unable to afford the coach fare, they walked all the way, accompanied by the sound of John's flute. Once there, they made the acquaintance of the Heath family, Pye becoming one of James's apprentices. William stayed in London long enough to make important connections, particularly with Charles Heath, for whom he was to work extensively in the years to come. In due course, he returned home, leaving Pye in London. Towards the end of this decade he married, and his eldest son, Edward, was born in 1809. It was in this year that the Academy of Arts was founded in Birmingham. William was probably a founder member, but his name first appears on the membership list in 1814; his interest in what eventually became the Royal Birmingham Society of Artists was lifelong. With Charles Barber he contributed some views of Birmingham, Leamington and Stratford to the first exhibition, which opened on 12 September 1814. In 1814 or 1815 William took on as one of his many resident pupils James Tibbetts Willmore, whose interest in outdoor sports was the cause of many complaints by his master about inattention to the study of engraving. Thomas Garner was another pupil, the only other steel engraver to spend his whole working life in Birmingham. He also devoted much of his time to the Society of Artists and to teaching locally.

William's work at this time included six plates after J. Roe for *A Historical and Descriptive Account of the Town and Castle of Warwick* (1815), printed by and for H. Sharpe, Warwick, and an engraving of the west front of Norwich cathedral after Frederick Mackenzie in John Britton's *History and Antiquities of the See and Cathedral Church of Norwich* (1816) published by Longman. His work for the printsellers included a line-engraved portrait after a painting by Samuel Lines of Mary Ashford (murdered in 1817 by Abraham Thornton) published by Beilby and Knott, Birmingham, and an engraved portrait of Bishop John Milner, D.D., catholic bishop and author, painted by Radclyffe's friend Joseph Vincent Barber, published by Revd E. Peach, Birmingham, 1819. This latter engraving attracted

PLATE **21** Two portraits of the engraver John Pye (1782–1874). Above: from a drawing by William Mulready, published in John Pye's *Patronage of British Art*, 1845, p. 362. Below: a wood engraving from the *Illustrated London News*, 1874, vol. 64, p. 185. (By courtesy East Sussex County Library, Brighton Reference Library.)

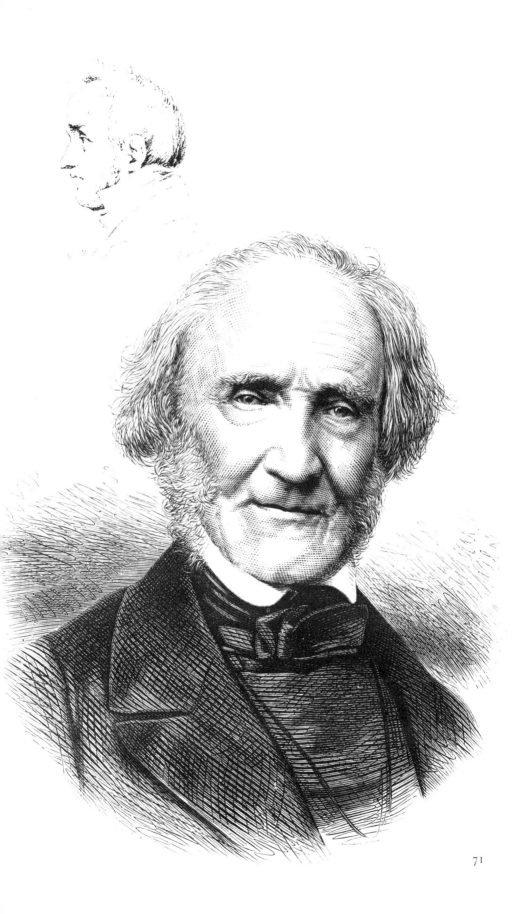

71

sufficient attention to establish the engraver's reputation.

When steel engraving arrived in the 1820s, Radclyffe was among the first to produce a work worthy of it. From 1823 to 1829 he personally engraved thirty-two plates for the *Graphic Illustrations of Warwickshire*, with text by Alexander Blair.[14] They included eight large vignettes, of which Charlecote Vicarage is outstanding, and a series of twelve smaller engraved vignettes, printed on the same pages as the text, unsigned by artist or engraver. The artists were Joseph Vincent Barber, David Cox senior, James Duffield Harding, Henry Hutchinson, Frederick Mackenzie, William Westall and Peter de Wint, all selected by Radclyffe himself. Most of their original drawings for the work are now in the City Art Gallery, Birmingham (see pages 44 and 45 for the Cox drawing and engraving from it of St Mary's Church, Warwick). Another factor contributing to its success was that some, if not all of the plates were printed by or under the supervision of William, aided by T. Radclyffe, another member of the family.[15] The text was printed by Thomas Knott junior, of Birmingham, and in every respect the production is equal to anything seen in the metropolis. William was also engraving eight plates for Thomas Hosner Shepherd's drawings in *London and its Environs* (1829), and *Metropolitan Improvements* (1829); in the next two decades, he contributed one or two plates to each of a number of publications. At the same time, he worked on two volumes for which he engraved a total of ninety-seven plates, i.e. Thomas Roscoe's *Wanderings and Excursions in North Wales* and . . . *in South Wales*, published in 1836.[16] Radclyffe tried to secure all the work on the drawings for David Cox senior, but the publishers, Wrightson and Webb, not sharing the engraver's admiration of his friend's work, threatened not to publish unless some better-known names were included. Even so, Cox retained over half the designs, sharing the remainder with George Cattermole, Thomas Creswick, Copley Fielding, J. D. Harding, Charles William Radclyffe (William's youngest son), Henry Warren, E. Watson and John Wrightson. Cox received £2. 10s. 0d. each for his drawings. For this he was indebted to Radclyffe's exertions in securing this amount from the publisher, to which travelling expenses were added, instead of the usual five or ten shillings which he normally received. Radclyffe also engraved the steel plates for the Oxford Almanacks from 1840 to his death in 1855. Peter de Wint's 'Village of Iffley, near Oxford' (1841) and 'Old Approach to Magdalen College' (1847), after Frederick Mackenzie, were the most successful of his engravings, possibly because he was familiar with the work of these artists.[17] He engraved William Muller's 'Prayer in the Desert' and William Collins's 'Crossing the Sands' for the *Art Journal* of 1847 and 1848,[18] both of which later appeared in Mrs A. M. Hall's *The Drawing-room Table Book* in 1849,[19] and were done from originals in the possession of two local men, Mr W. Sharpe of The Larches, near Birmingham, and Mr J. Gillot of Edgbaston. They were among his last works, executed in his mid-sixties; he died in his seventy-third year on 29 December 1855.

In 1814, his address was given as Edmund Street, close to the artists' quarter centred on Paradise Street in the heart of Birmingham, and almost certainly this was the site of his workshop and press. In later years he resided at George Road, Edgbaston, where George Cattermole, David Cox, Thomas Creswick and J. D. Harding were the most frequent visitors. He worked chiefly in landscape engraving, at which he excelled, but apart from this his importance lies in the excellent training given to a number of eminent engravers who succeeded him.

The eldest of his three sons, Edward, carried the name of Radclyffe to engraving circles in London. As befitted the son of an outstanding father and as one who had been taught by him, he was something of a prodigy. In 1824, at the age of fourteen, he won the Society of Arts' Silver Isis Medal for an etching of animals, and in 1826, when he was sixteen, the Society awarded him the Silver Palette for an engraving of cattle.[20] When out of his time about 1830, he set up on his own in London, where he spent the rest of his life. Like his father, he contributed on average one or two plates to a large number of books, one of the outstanding being Bishop Christopher Wordsworth's *Greece*[21] for which he supplied seven of the twenty-eight steel engravings. Many of his works were after Birmingham artists, but also included some by Thomas Allom and W. H. Bartlett. He was a leading engraver for Charles Heath's *Versailles*,[22] in which he did three plates after W. Callow, and one after Frederick Mackenzie. From 1848 he engraved seven plates for the *Art Journal*, one of which, 'Hay-time' after David Cox, was published posthumously in 1866, and from time to time, he engraved views on Admiralty charts, from which 'The Persian Gulf' was exhibited at the 1862 Paris International Exhibition. In the last four years of his life he turned to etching. The death of David Cox, a family friend, in 1859, sparked off two projects. The first was a series of eleven Cox designs, 300 etched sets of which were presented as Art Union of London prizes in 1862.[23] The second was a work similar to Turner's *Liber Studiorum* for Cox, but he had only etched three plates when he died in November 1863 at his home in Camden Town. The plates were published in 1875 by the Liverpool Art Club as souvenirs of their Cox exhibition.

The second son, William, amused himself with engraving, mainly in mezzotint, but his reputation was gained as a portrait painter in Birmingham and London, a likeness of his brother Edward being one of his most successful works. Efforts to locate this portrait have so far failed. He exhibited once or twice at the Royal Academy. He died of paralysis at the age of thirty-four on 11 April 1846.

Charles William went to London when he was eighteen and, in his early years, drew for reproduction by wood engravers and lithographers. His major book illustrations appeared in an edition of Gray's *Poems*, engraved by Edward. He returned to Birmingham to teach art about 1850, still retaining his house in London until 1884. Watercolour painting was his main interest and through his influence on the Birmingham Society of Artists, exhibitions popularized the art all

over the country. He organized the 1877 exhibition of Birmingham engravers and hung the 1875 Liverpool exhibition of David Cox.[24] There is mention of a J. Radclyffe, known only by a single print of the 'Bridges of St Cloud and Sevres', after Turner, which appeared opposite page 152 of *Turner's Annual Tour* (1835). It is possible that the letter engraver inserted the wrong initial, in which case it was probably done by William, who engraved two other pictures in the same volume.[25]

JAMES TIBBETTS WILLMORE (see plate 22) further enhanced the Birmingham school's reputation, becoming its most eminent pupil. He was born on 15 September 1800 at Bristnald's End, Handsworth, near Birmingham, where his father, James, was a silverware manufacturer. However, some time after the turn of the century his father became a farmer at Maney, near Sutton Coldfield. This change had a profound effect on the boy, encouraging a love of the countryside, especially of dogs and birds, which stayed with him for the rest of his life. At the age of fourteen, he was apprenticed to William Radclyffe for seven years, also learning drawing from J. V. Barber and Samuel Lines in the company of Thomas Creswick and Joseph Goodyear, another engraver. These three formed a great attachment for Barber, organizing the presentation of a cup on behalf of grateful pupils. On Barber's death in 1838, Willmore wrote to the *Art Union* recalling a trip to Richmond about 1836–7 with Barber and Goodyear, when 'They had many pleasing anticipations as to their future progress in Art! Alas! they were not destined to be realized. They both died in the prime of life, equally beloved and regretted.'[26] He came out of his indentures, having shown little enthusiasm for or ability in the art, and in 1822 he married. Faced with the necessity of supporting a wife, he moved to London in 1823, and worked for three years under Charles Heath, whom he left to set up on his own. His first important book commission came from William Brockedon. The artist gave Willmore eight plates from his book on the Alps,[27] the first being published in August 1827, another the following November, and three each in 1828 and 1829. The 1829 plates were a great improvement on the earlier ones and so pleased Brockedon that he continued to give him work for many years. In 1842, for example, he was the main engraver, with thirteen plates out of sixty-five, for Brockedon's *Italy*. His planning ability enabled him to work rapidly and thus he could average five or six plates for a single work. Most of them were after W. H. Bartlett, Thomas Creswick, Samuel Prout and Clarkson Stanfield, and nearly twenty plates were done for Jennings's *Landscape Annuals*, the best being 'Avignon' and 'Castle of Ivoire', both after J. D. Harding. Almost as many were done for the rival *Heath's Picturesque Annual*, including six Irish scenes for the 1837 volume.

PLATE 22 James Tibbetts Willmore (1800–63), from an oil painting on canvas, artist and date unknown but of the nineteenth century. Original size 28 by 23$\frac{7}{8}$ inches. (Presented in 1940 by Charles Willmore Emlyn. By courtesy Birmingham Art Gallery.)

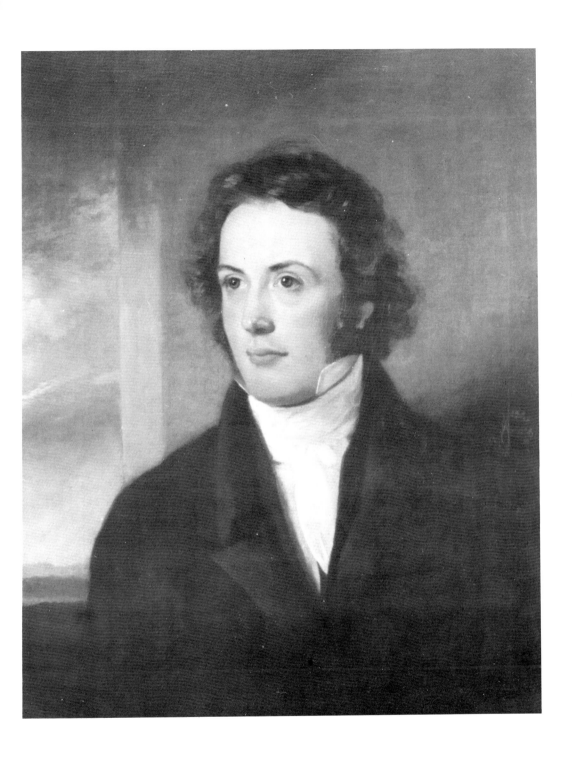

In the 1830s, when at least twenty books contained his plates, Brockedon, by recommending him to Charles Eastlake to engrave 'Byron's Dream', introduced him to larger works, a course which turned the young engraver away from book work and into contact with Turner. As a result, 'Alnwick Castle by Moonlight' was placed in Willmore's hands and, in due course, a proof was sent to Turner for touching. At the artist's request, the two men met and the interview, which passed well enough, ended with an exhortation 'to sacrifice everything to his Art' and an offer to engrave another picture. Willmore was too busy at the time, so, tired of waiting, Turner paid him a visit, only to find Mrs Willmore and the children at home. Unaware that the engraver was married, the painter was taken by surprise and promptly exclaimed, 'I hate married men – they never make any sacrifice to the Arts, but are always thinking of their duty to their wives and families or some rubbish of that sort.' Despite this, Turner proposed a joint speculation for a limited edition of 850 proofs and prints, of which Turner was to have 250 and Willmore 600, each to pay his own share of the printing. The copper plate was then to be cut in two, thus preventing further printings, but in the event, Turner took it from the printer intact. When taxed with this action, the painter merely replied, 'You need not trouble yourself – I'll spoil it.' Willmore's copies were bought by F. G. Moon, the printseller, who put them on the market early in 1841 – the print was the famous 'Mercury and Argus'.

On 10 February 1843, Willmore was elected to the Royal Academy as an Associate Engraver to replace John Bromley and in competition with Frederick Bacon, David Lucas, Thomas Goff Lupton and Charles Eden Wagstaff. This was an action not calculated to endear him to his fellows, but which was deserved by the quantity and quality of his work to date. His name was put forward for election to Academician in 1856, but he was defeated by G. T. Doo and J. H. Robinson.[28] Further plates after Turner and Landseer were very successful, so that by 1847, he had a European reputation.[29] By about 1857 his health began to fail and three years later he was unable to work. His only income was £40 a year from the Artists' Annuity Fund, so when he became paralysed, in 1862, he was in dire financial straits. His younger brother, Arthur, accordingly wrote to the Royal Academy, who received his petition favourably and placed James on their pension fund from January 1862.[30] Arthur also finished plates already begun by his brother, including 'The Volunteer Review, Edinburgh 1860' after S. Bough.[31] When James died, on 12 March 1863, he was buried in Highgate cemetery. It has been estimated that he engraved between 300 and 400 plates during his career, and engraved, with a total of 43, more plates after Turner than any of his contemporaries.[32].

James's work tended to overshadow that of his younger brother, Arthur Willmore, who did not develop his work to any extent until after his brother's death. His earliest book illustrations date from the 1840s, when he engraved after Brockedon and Allom, but in the following decades he did his best work, most of

which were vignette engravings, after W. H. Bartlett in *Nile Boat* and *Jerusalem Revisited*, and in Beattie's *The Castles and Abbeys of England*. By this time, the heyday of steel engraving was over, and Arthur was one of the dwindling band who continued to work into the 1860s and 1870s. In this period, he engraved after Birket Foster, the best works being four engravings in Henry Mayhew's *The Upper Rhine* (1860), published by Routledge. From 1852, he did twenty plates for the *Art Journal*, the most effective being those executed between 1875 and 1885, notably 'The Evening Hour' after B. W. Leader; these plates were in keeping with contemporary practice, i.e. heavily etched. From 1872, he engraved several presentation plates for the Art Union of London. Although he was proposed for election to the Royal Academy in 1874, he was unsuccessful, and the attempt was not renewed before his death, towards the end of 1888.[33]

ROBERT and EDWARD BRANDARD complete the Birmingham trio of families. Robert was born in that city in 1803, and after attending art classes under Barber and Lines, he went to London in 1824, staying in Islington. Here he learnt engraving under Edward Goodall for a year, and then set up on his own. Like Willmore, eight engravings for Brockedon's *Illustrations of the Passes of the Alps* between 1827 and 1829 were his first important commission, and were followed by many landscape plates after Clarkson Stanfield and others. Some of his best work dates between 1839 and 1842, when he engraved twelve plates for Nathaniel P. Willis's *American Scenery* (1840) and nine for William Beattie's *The Ports, Harbours, Watering Places, and Coast Scenery of Great Britain* (1842), all after Bartlett. Between 1851 and 1866 fifteen plates, many of them after Turner, a regular visitor to Brandard's house, were published in the *Art Journal*, one of the most striking being 'The Snow Storm', where this difficult subject produced a very interesting plate, shown at the Paris International Exhibition of 1862.[34] One of his last plates was 'Whalers', also after Turner, and a reviewer observed that 'it is a gem on which his [Brandard's] reputation may well rest'.[35] One of its unusual features was the small amount of etching involved and the greater use of the burin at a time when etching by itself was very much in vogue. Robert also painted in oils and watercolours, exhibiting a number of times at the Royal Academy and British Institution. One of his best-known works was 'The Forge' which has much of the charm of a Dutch interior, and which eventually graced the Earl of Ellesmere's collection. In 1844, when living at Eynsford in Kent, he published, with J. Hogarth, a series of seventeen etchings depicting scenes from the Weald and Kentish coast, entitled *Scraps of Nature*, and other etchings by him were reproduced in the *Art Journal* for 1875.[36] He died on 7 January 1862 at his residence in Camden Hill, Kensington, and his memoranda, drawings, etchings, etc. came into the possession of his brother-in-law, Mr Floyd (probably the engraver William Floyd) of Highgate, Birmingham. Victorian opinion placed his engraving 'Crossing the Brook' after Turner, done in

1838, at the pinnacle of his achievements. He had at least two pupils, his brother, Edward, and Joseph Clayton Bentley (see below, pages 100–101).

EDWARD PAXMAN BRANDARD was born in 1819, and in due course, followed Robert to London, becoming his apprentice early in the 1830s. The majority of his book illustrations were done after Bartlett, some of the best being the nine vignettes in *Forty Days in the Desert*. He engraved thirteen plates for the *Art Journal* between 1853 and 1887. When he died at the age of seventy-eight on 3 April 1898, the last of the steel engravers had passed away.[37]

JAMES BAYLIS ALLEN is the last important Birmingham engraver. He was born, 18 April 1803, the son of a Birmingham button manufacturer, for whom he worked in his youth. When he was fifteen, James was apprenticed to his elder brother, Josiah, working as a general engraver in Colmore Row. The work was uninspiring, consisting only of labels, patterns, etc., so in 1821 he went to Barber's drawing classes and the life academy of Samuel Lines, which enabled him to widen his engraving horizons. A year before his indentures ran out, he set off for London in 1824 and, after engraving Britannia satisfactorily as a test piece, obtained employment with the Bank of England for several years. Turning to book illustration, he worked first of all for the Findens, then for Charles Heath and finally for Robert Wallis. His work for the annuals was considerable, being most successful in Jennings's *Landscape Annual*, for one volume of which he engraved 'Bull Fight at Seville' at a fee of eighty guineas. The publisher was so pleased with the proof that he wrote a cheque for 100 guineas instead. His earliest landscape book plate was dated 1828, and appeared in S. W. H. Ireland's *England's Topographer* (1828–9), followed by two plates for *Metropolitan Improvements* by James Elmes in 1829. Among his best plates was the 'Theatre in the Palace of Versailles' after Frederick Mackenzie for *Heath's Versailles* (*c.* 1836). Another good example is 'Beirout' in the second volume of John Kitto's *Gallery of Scripture Engravings* (1846–9). In 1838, he engraved the landscape for Joseph Goodyear's 'Greek Fugitives' after Sir C. L. Eastlake, and he suggested the idea of the *Art Journal's Illustrated Catalogue* of the Great Exhibition, 1851, to the then editor, Samuel Carter Hall. After a long and painful illness, he died on 11 January 1876 at his Camden Town residence, and was buried in Highgate Cemetery, close to his friend Goodyear, who had died thirty-seven years earlier, in 1839.[38]

The remaining members of the Birmingham school, each of whom produced a number of book illustrations were William Floyd, W. Hill, C. W. Sharpe, Charles Westwood, Thomas Wright and John Wrightson.

THE EDINBURGH SCHOOL

Eight engravers comprise the book group here, all but one of whom attended the Trustee's Academy, the presence of which in Edinburgh was an important factor

in the state of art and engraving there. Many of the books published in the city were illustrated and engraved by local artists, much of the credit for this state of affairs resting with the teaching directed by Mr Graham and Sir William Allan, R.A., sometime President of the Royal Scottish Academy.

WILLIAM MILLER was the best-known of the Edinburgh engravers (see plate 23). He was born on 28 May 1796 at 2 Drummond Street, Edinburgh, into a Quaker family. After attending day school in that city, he went, at the age of nine, with two elder brothers, to a Friends' boarding school at Leeds, kept by Joseph Tatham. He remained there for two years, until 1807, when he returned to Scotland, dividing his time at home with a tutor and walking around Scotland. From the time he was five or six he was very fond of drawing and at fourteen he expressed a wish to become an engraver. His father did not share his enthusiasm, planning his entry into the family manufacturing business, and accordingly sent him to work in the warehouse. This was so uncongenial that William was eventually given his own way. In 1811, he was apprenticed to William Archibald, an Edinburgh engraver with Quaker connections. At the end of four years he set up on his own, one of his first independent commissions being plates to illustrate an encyclopaedia, possibly the 1817 edition of the *Encyclopaedia Britannica*. By this means he was able to earn enough money to further his studies. With some financial help from his father, he moved to London at the end of 1819 to work for George Cooke, the landscape engraver at Hackney. For the next eighteen months his work improved enormously in the company of three other fellow pupils; he returned to Edinburgh in the autumn of 1821. He first used steel in December 1825 for an engraved title-page to volume 2 of *Constable's Miscellany*, but his first book plate in this medium was done in August 1828 of 'On the Thames near Windsor' after W. Havall for the 1829 volume of *The Winter's Wreath*. Thereafter he employed steel continuously for books, and at least 200 such plates are known from his burin. Seventy-five appeared in Cadell's editions of Scott's *Works* between 1829 and 1847, eight for *The Land of Burns* (1840), after David O. Hill, done between 1835 and 1838, and a series of thirty-six Holy Land plates were engraved in four volumes from 1843 to 1854. In all, 112 works are known to contain Miller's steel-engraved plates, a detailed catalogue of which was published in *Memorials of Hope Park*. The title-page to volume 24 of the *Prose Works* by Scott (see plate 24) gives a good impression of

PLATE 23 (overleaf) The Edinburgh engraver William Miller (1796–1882). Frontispiece to the privately printed *Memorials of Hope Park*, 1886, by William F. Miller. (By courtesy the Trustees of the National Library of Scotland.)

PLATE 24 (overleaf) Title-page from Scott's *Prose Works*, 1836, with vignette steel-engraved by William Miller after J. M. W. Turner. (By courtesy the Trustees of the National Library of Scotland.)

My affectionate father
William Miller

THE
PROSE WORKS
OF
SIR WALTER SCOTT, BART.
VOL. 24.

Linlithgow

EDINBURGH PUBLISHED BY ROBERT CADELL & ROBT. CADELL EDINBURGH

Miller's vignette work. It is 'Linlithgow' after Turner, the plate of which was finished by the engraver in February 1836, and for which he was paid £26. 5s. 0d.

Miller had two assistants and six pupils at different times, none of whom, however, approached their master's eminence in engraving. The family returned to their old home in the 1820s and it was here that in 1831 William set up his workshop (see plate 20) from which emanated his most important work. Twice married, his first wife, by whom he had several children, died after only a few years of marriage; his second wife, Jane, survived him, together with one son and three married daughters. Very active in Quaker and social affairs, he still found time to visit friends all over the country and to enjoy his garden. He was Treasurer for the War Victims Relief Fund for casualties of the Franco-Prussian War when over seventy years of age, and he continued to work with undiminished skill until he was seventy-five. He retired after completing the illustrations to Thomas Hood's *Poems* in the summer of 1871. This was the second of such sets to the same work, both drawn by Birket Foster and published by Moxon, and which had occupied him for the three previous years.

He was elected an Honorary Member of the Royal Scottish Academy in 1862; thinking perhaps, in view of the new Academy rules, that he had been overlooked in England, he was exploring the possibility of election to the Royal Academy in 1866. In a letter to Edward Cooke, son of Miller's former master, William was endeavouring to enlist his help, indicating that some support might also be obtained from Clarkson Stanfield and George Doo.[39] Whatever the reason, nothing came of it. Hope Park was renamed 'Millerfield' in 1863, and was known as such until its demolition a year or so after William's death at Sheffield, on 20 January 1882, at the age of eighty-six.[40]

Miller had been assisted on several occasions by his friend Robert Charles Bell in the matter of some engraved portraits, at which the latter excelled in his early days. Bell was one of the Edinburgh group of engravers, which also included John Burnet (see plate 25). Although the latter learned his art in Scotland under Robert Scott, he practised in London for the rest of his life. Francis Croll finished his apprenticeship under Bell and engraved portraits for the Edinburgh publishers, but died of heart disease at the tragically early age of twenty-seven. John Horsburgh, another of Scott's pupils, worked mainly on book illustrations, combined with thirty-seven years as a lay pastor of the Scottish Baptist Church, his addresses to which were published in 1869. William Howison worked in comparative obscurity, owing a great deal to D. O. Hill's friendship. William Home Lizars, son of an engraver, specialized in bank-note engraving and copper-plate printing, but was more successful as a subject painter. The most attractive of his book engravings was of the ill-fated Richard Dadd's circular picture 'Puck and the Fairies', originally published in the *Art Journal* for 1864, and used again for an edition of Shakespeare published about 1872. The last of the eight was John Talfourd Smyth, another

PLATE 25 John Burnet (1784–1868), wood engraving from the *Art Journal*, 1850, vol. 12, p. 277. (By courtesy East Sussex County Library, Brighton Reference Library.)

promising engraver cut off at the early age of thirty-two, and whose best-known plate was 'John Knox Administering the Sacrament' after Sir David Wilkie.[41]

THE LONDON ENGRAVERS

London, as the largest book-publishing centre in the country naturally attracted the majority of workers, and for this reason, although commissions had to be competed for, there were more than enough to go round, certainly in the early days. With insufficient work to provide a good living in the provinces, able engravers moved to London, principally from Birmingham and Yorkshire. The migration from the former has already been noted, but there was a considerable contribution to engraving in London by J. C. Bentley, John and Charles Cousen and Lumb Stocks of Bradford and its vicinity, and Edward Goodall of Leeds. All five achieved some eminence in the profession, including, in the case of Stocks, the highest ranks in the Royal Academy.

The Finden brothers were among the best known of all steel engravers, pri-

marily due to their personal influence, and because they employed numerous assistants and pupils, having what amounted to quite an impressive studio. Their additional use of independent engravers such as Samuel Rawle has already been referred to (see above, pages 67–8).

WILLIAM FINDEN was the elder, and Edward Francis the younger of the brothers. Nothing is known of their origins or early life, but it was about the turn of the century when William was apprenticed to James Mitan, who was then a young line engraver of about twenty-five.[42] Edward followed about 1806, and for the next two years the brothers worked under the same master, William coming out of his time about 1808 and Edward in 1813. William modelled his early work on James Heath's style, thus influencing the small book plates he did for the Sharpe and Suttaby editions of literature.[43] He contributed, for example, three vignettes to John Milton's *Paradise Lost*, published by John Sharpe in two volumes in 1817; Edward did the engraved title-page to volume 2 and James Mitan did the title to Book 6. This latter, contrasted with William's good engraving for Book 8, shows how far the pupils had already outstripped their mentor. Other engravers represented in the volumes were George Corbould, Francis Engleheart, James and Charles Heath, John Pye and Abraham Raimbach. All the engravings are dated 24 August 1816 and, with one exception, were after Richard Westall, R.A. Between 1810 and 1817 William engraved fifteen plates for W. Y. Ottley's *Engravings of the Marquis of Stafford's Collection of Pictures* (1818) published by Longman in two volumes, from drawings made by William Marshall Craig. The largest is 'Rent Day Feast' after Teniers, for which William was awarded the Society of Arts Gold Medal in 1813. One of Edward's plates dated 1817 also appears in the volume. Plates were contributed to the four volume *Don Quixote* (1818) illustrated by Robert Smirke, published by Cadell and Davies, notably 'Camacho's Festival' and 'Don Quixote and Squire Mounted on Clavelino', both dated 12 August 1817. It was another plate after Smirke, 'The Carpet Dance', engraved by Finden for Coxe's *Social Day*, which was lost in 1815 when the manuscript had been purloined for a joke by a servant and subsequently never recovered.[44] His work also appeared in the new edition of Sir William Dugdale's *History of St. Paul's Cathedral* (1818), Dibdin's *Aedes Althorpianae* (1822), and four portraits for *Effigies Poeticae* (1824), published by Walker.

The brothers were well into their thirties, with William close to forty, when they embarked upon the great series of steel engravings for which they are so well known. Their success was mainly due to their joint efforts, which enabled them to share in the running of the business, allowed them to take a number of pupils and assistants and, less successfully, encouraged them to go into publishing on their own account. They depended, too, on their normally happy and close relationship with the publisher John Murray, who provided them with regular work over a period of nearly fifteen years. They worked in their studio at 18 and 19

Southampton Place, Euston Square, aided at various times by James B. Allen, John W. Archer, Frederick Bacon, Charles Rolls, and Lumb Stocks as assistants, and Samuel Hollyer, Thomas Phillibrowne, George Price (all three of whom emigrated to America), Samuel Rawle (probably the younger, born 1801) and Samuel Sangster as pupils, with Robert Staines, who was both pupil and assistant.

The first prestigious works with which William was associated were the two volumes by Samuel Rogers, *Italy* (1830) and *Poems* (1834), published by Thomas Cadell and Edward Moxon, in which he engraved the majority of Thomas Stothard's vignette designs, thirty-eight in all. In common with the other artists associated with these volumes, William's reputation was undoubtedly enhanced by the standard of his engraving in them. In the same way, Edward never did better than the great series of plates, fifty in all, for Brockedon's *Illustrations of the Passes of the Alps* (1827–9) published by the author. The link with John Murray was forged in 1823; between January and August, the publisher issued the thirty-five plates by Edward after drawings by Captain Robert Batty, which were then published in the latter's *Welsh Scenery* (1825) by Robert Jennings. Further illustrations to books of travel and voyages followed, such as Bishop Reginald Heber's journeys in India between 1824 and 1826, with ten engravings, and the arctic voyages of Sir John Ross, published in 1835, for which Edward engraved a quarter of the sixteen plates.[45]

Their outstanding work for Murray was the edition of Byron's *Childe Harold's Pilgrimage* (1841). In this their names appeared on about thirty vignettes each (see plate 26) printed on the text pages, each about 4 by 3 inches, after designs by both amateur and professional artists. The engravers had a financial interest in this work, which Murray had agreed to purchase from them in April 1841. In the letter dealing with this, they ask for twelve copies of the book to give to people who had helped them in preparing the illustrations.[46] A series of seventeen letters from the Findens to John Murray covering the period 1829–42 are extant, giving glimpses of their relationship. On 10 January 1829, Murray had the honour to receive the second proof (the first had gone to the King) of William Finden's only large portrait done for the printsellers, namely that of George IV, seated on a sofa, and published by Moon, Boys and Graves. Early in 1833 the Findens seem to have offended the artist Augustus Wall Callcott in some way, and were asking Murray to smooth it out. On 14 May 1835, two letters written on the same day refer to a furore and misunderstanding concerning Charles Tilt the publisher, while later that year, they are up in arms over Murray's threat to invoke a penalty clause if work was not completed on time. The last letter is an apology for losing Mr Ford's sketches. After turning the place upside down, however, they came to the conclusion that perhaps 'he omitted to send them'!

The financial rewards reaped by the brothers in their work encouraged them to try their own hand at publishing, with very mixed results. Their first joint venture

XLIV.

Enough of Battle's minions! let them play
Their game of lives, and barter breath for fame :
Fame that will scarce reanimate their clay,
Though thousands fall to deck some single name.
In sooth 'twere sad to thwart their noble aim
Who strike, bless'd hirelings! for their country's good,
And die, that living might have proved her shame ;
Perish'd, perchance, in some domestic feud,
Or in a narrower sphere wild Rapine's path pursued.

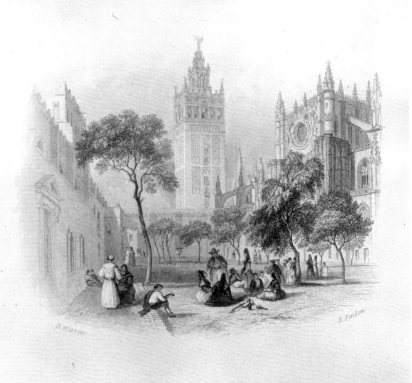

was *Finden's Landscape Illustrations to Mr. Murray's First Complete and Uniform Edition of the Life and Works of Lord Byron*.[47] These were published between 1832 and 1834 in parts without letterpress at first but, when it was seen that sale as an independent volume could be a viable proposition, William Brockedon was commissioned to write descriptions of the engravings, which were then bound up in volumes of eight parts each. The advertisement announcing these was issued in Part XI in 1833 (see plate 27). Three volumes with a total of 124 engravings resulted, and although Murray is given as the main publisher, with Tilt as the other chief outlet, it is said that the Findens took the sole risk, making a considerable profit.

Encouraged by this, further publications were undertaken. *Finden's Female Portraits of the Court of Queen Victoria* in two-monthly parts came in 1839, *Finden's Tableaux of the Affections* and *Finden's Portraits of Female Aristocracy* followed, all three published directly by the engravers. The work involved was so great that the effort could not be sustained, so regular publishers were brought in for later publications at some stage, if not at the beginning. J. Hogarth published their annual *Tableaux* from 1837 to 1844, quoted as 'the most handsome table book ever published', *Finden's Landscape Illustrations to the Bible* (1834–7) was issued by Tilt with descriptions by the Revd Thomas Hartwell Horne, *Finden's Gallery of the Graces* (1838) by Bogue and *Finden's Illustrations of the Daughters of Erin* (1839) by Chapman and Hall. The brothers even took over the production and publication of the ailing *Oriental Annual* in 1840. First published in 1834, the early volumes had been issued by Edward Churton, but a new series in 1837 was put out by Charles Tilt. This volume was in sharp contrast with the earlier ones in that it was designed to entertain less and instruct more; it was the *Lives of the Moghul Emperors*, by the Revd Hobart Caunter! The 1840 volume bears the brothers' imprint, and they also engraved all eighteen plates to Thomas Bacon's *Tales, Legends and Historical Romances*.

The profits from these publications were ploughed back into future productions. At the beginning, the book publishers were inclined to be indulgent and even helpful, being well aware of the pitfalls ahead. The first hint of trouble came

PLATE 26 'Seville', vignette steel-engraved by Edward Finden after a drawing by H. Warren based on a sketch by Richard Ford. This was one of about sixty vignettes done by the Findens for Byron's *Childe Harold's Pilgrimage*, 1841, published by John Murray. Original size of vignette approx. 4 by 3 inches. (By courtesy East Sussex County Library, Brighton Reference Library.)

PLATE 27 (overleaf) Advertisement in Part XI of *Finden's Landscape Illustrations to Byron*, 1833, published by John Murray.

PLATE 28 (overleaf) 'Men of War at Spithead', steel engraving by Edward Finden after E. W. Cooke, from Beattie's *The Ports, Harbours ... of Great Britain*, 1842, p. 98. (By courtesy East Sussex County Library, Brighton Reference Library.)

ON THURSDAY, FEBRUARY 14TH, WILL BE PUBLISHED,

AN APPENDIX

TO THE FIRST EIGHT PARTS OF

FINDEN'S LANDSCAPE AND PORTRAIT

ILLUSTRATIONS

OF

LORD BYRON'S LIFE AND WORKS;

EMBELLISHED WITH

A new and beautiful *Frontispiece* by TURNER, and a *Vignette Title* by STANFIELD.

CONTAINING

AN ACCOUNT OF THE SUBJECTS OF THE ENGRAVINGS, WITH EXTRACTS AND ORIGINAL INFORMATION.

EDITED BY W. BROCKEDON, ESQ.

AUTHOR OF "THE PASSES OF THE ALPS," ETC.

THE First Volume of this Work, thus completed, will contain Thirty-five Views, and Seven Portraits — it will be sold in plain, and in splendid bindings, and form one of the most beautiful and interesting, as well as one of the cheapest Books ever published; equally adapted for a Library of Illustrative Works and the drawing-room table, and forming an elegant and acceptable present.

Subscribers to "*Finden's Illustrations of Byron*" as they have been published in Parts, may, by application to their respective Booksellers, have the Appendix separate, and have their copies bound in the same tasteful style and at the same moderate price. As, however, only a limited number of copies of the Appendix are printed for separate sale, an early application is requested.

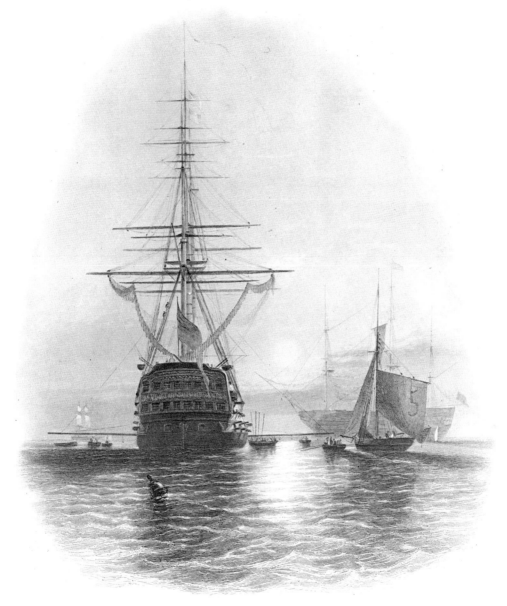

Painted by E. W. Cooke. Engraved by J. Fie...

MEN OF WAR AT SPITHEAD.

with the publication of their *Views of Ports and Harbours on the English Coast*. This work had been suggested to the brothers in 1836 by George Balmer, a self-taught artist emanating from the north-east of England, and they immediately set to, producing the plates in 1836 and 1837. Eight other artists drew twenty-eight pictures between them, and Balmer contributed twenty taken from the area around his home. Insufficient copies were sold to cover the cost of production, so the publisher, Charles Tilt, was only too pleased to hand the project over to George Virtue, who promptly planned an extension, edited by William Beattie. The new editor enlisted the help of his friend W. H. Bartlett, who in the first six months of 1839 managed to complete some seventy-seven drawings, in addition to other work, covering mainly the west and south coasts. Virtue had these engraved in 1840 and 1841, employing twenty-five new engravers to speed up the work, issuing the whole in two volumes in 1842.[48] 'Men of War at Spithead' (vol 1, page 98), one of the most striking plates in this work was engraved by Edward Finden after a painting by E. W. Cooke (see plate 28).

Even less success attended publication of their *magnum opus* in January 1838. This was the *Royal Gallery of British Art*, containing forty-two large plates, averaging $11\frac{3}{4}$ by $8\frac{1}{4}$ inches, of contemporary paintings with descriptive letterpress. The brothers engraved eight of the plates themselves, and twenty-four other engravers did the remainder. The first six plates were published for the proprietors by F. G. Moon, but the next eighteen were handled by the Findens from their offices between April 1839 and July 1841. Distribution problems compelled them to look for another publisher and, as a result, T. G. March commenced publication in April 1842 but only nine plates were issued under this imprint up to November 1843. In 1847, J. Hogarth was persuaded to publish the remaining nine; they were in a more flamboyant style, complete with fulsome dedications added to the usual publication line. The last six were brought out together in 1849. The hiatus between 1843 and 1847 is accounted for by the fact that Hogarth, having acquired full rights from the Findens commenced a re-issue of eleven parts, each containing three engravings, commencing 1 October 1844 at three-monthly intervals. At the same time, he was making arrangements for new plates and had written to William Miller, for example, asking him to quote a price for engraving a picture by Francis

PLATE **29** (continued overleaf) Letter of 29 April 1846 from William Miller to J. Hogarth, concerning the engraving of a plate for *Finden's Royal Gallery of British Art.* National Library of Scotland, MS 9994, f. 90^{r-v}. (By courtesy the Trustees of the National Library of Scotland.)

PLATE **30** (overleaf) Agreement of 1 May 1846 between J. Hogarth, publisher, and William Miller to engrave Francis Danby's 'Sunset at Sea after a Storm' for *Finden's Royal Gallery of British Art* National Library of Scotland, MS 9994, f. 91. (By courtesy the Trustees of the National Library of Scotland.)

4 Hope Park Edinburgh
4 month 29th 1842

Respected Friend

I have at length had an
opportunity of seeing the Picture by Danby
of "The Retreating Storm" which has just
arrived at Crichtons — It is the same
Picture which I recollect seeing many
years since in London, and is cer-
tainly in many respects a wonderfully
fine production, and well calculated
for Engraving — From what I can
judge of the amount of work contained
in a Plate measuring 15 Inches in length
by the corresponding breadth of the Picture
which I think would be about 9½ Inches

for Two Hundred & Fifty Guineas would be

I should be glad to have this long
pending negociation brought to a termina-
tion, as I have some present prospect
of another engagement which might
possibly interfere with it should I
be limited much in regard to time —

I may just add that it will
be my aim to make a Plate every
way worthy of the subject & work —

I am respectfully thy frd

William Miller

I. Hogarth &
London }

my charge

91

May 1st 1846

Copy

Dear Sir

I agree to pay you the sum
of 250 guineas for Engraving in your
best manner a plate from Mr Danby's
picture of the "sun set". The picture
to be delivered to you by Mr Crichton.

The size of the Engraving 15 inches
by the proportion this will bear
to the width of the picture

Yours very truly
J. Hogarth

Wm W. Miller Esqr

93

Danby. In his letter of 29 April 1846 (see plates 29 and 30), Miller quotes 250 guineas, and to this is appended a copy of Hogarth's acceptance, a rare example of this kind of agreement. The engraver received £262. 10s. 0d. in due course; the etching of the plate was done in the same year, but the engraving was not completed until 1849,[49] under the title 'A Sunset at Sea after a Storm'. Finally, Hogarth published all the plates in two volumes in 1851 as a complete work. Six years later it was re-issued in 1857 in Glasgow by Messrs Griffin.[50] The main opposition to this venture came from the print publishers, who were not well disposed to it because they felt it encroached on their preserves. This opposition, added to the understandable impatience of the public with a work spread over a period of eleven years, resulted in a financial disaster for the proprietors.

Edward undertook one final project, intended as the first in a series portraying the principal female characters in the poetical works of Thomas Moore, to be followed by those of Robert Burns, Thomas Campbell, etc. In addition to engraving twenty of the forty-nine plates, he superintended the remainder, which were issued between March 1845 and May 1846. This remarkably fine book was published by Chapman and Hall; although it was yet another financial failure, it was re-issued by John Tallis in 1853. In this latter edition, one of Edward's plates, 'O'Donohu's Mistress' after W. Maddox, had been re-engraved, the lady being given a different face, and there being no band in her hair.[51]

The brothers had devoted most of their lives to book illustration, and only William had produced any large plate. Besides his early portrait of George IV, for which he received what was said to be the largest sum ever paid for an engraved portrait, i.e. £2,000, he turned increasingly to the printsellers in the 1840s, probably in an effort to relieve their financial difficulties. 'The Naughty Boy' after Sir Edwin Landseer brought him 200 guineas in 1843, 'The Girl with the Fish' after the same artist came in 1844, and 'The Highlander's Return' after Sir David Wilkie produced a further 600 guineas in 1845. It was announced in 1848 that he was to do two prints for the Art Unions. The first, for the Royal Irish Art Union, was 'Irish Courtship' after Frederick Goodall, followed by 'The Crucifixion' after William Hilton for the Art Union of London. For the latter, which was to be his last plate, he was paid £1,470, including £210 for a copy, made by the engraver himself. A contemporary observed that 'he must work hard to produce these two plates before 1850 – for so we believe his contract runs.'[52]

William found time, however, to take part in various outside activities; for instance, from 1834 to 1836 he was President of the Artists' Annuity Fund, which he had joined as a founder member in 1810. On 20 March 1845 he was elected to the Council of the Institute of Fine Arts. Just a week before he died, he was named, with seven or eight of his colleagues, as a signatory to a petition to the Queen, outlining the claims of engravers to full honours in the Royal Academy. Returning one evening from a meeting of engravers (probably the Chalcographic Society), he

caught a cold and, weakened by the pressures of work over the past few years, he suffered a series of heart attacks, expiring on 20 September 1852 in his sixty-fifth year. He was buried in Highgate Cemetery.

The shock of his brother's death and the worries of the business brought on Edward's illness, described as 'a painful bodily affliction' which only ended with his death on 9 February 1857 at St John's Wood, also at the age of sixty-five.

Both Findens had enjoyed high reputations as gentlemen who were quiet, kind, warm-hearted and always ready to help others. William was a widower at his death, and although nothing is positively known of children, a Geo. C. Finden was an engraver, working for the *Art Journal* between 1848 and 1883, and an Adam Edward Finden died on 13 October 1846, aged twenty-two.[53] William was looked upon primarily as the engraver and Edward as the man of business, controlling and training the studio staff, finishing plates and directing the issue of publications. The Murray letters show, however, that both brothers tended to share the work almost indiscriminately.[54] They were primarily landscape engravers, but William was responsible for about twenty-six portraits, done mostly for books, and Edward is credited with at least forty.

ROBERT WALLIS, a prolific engraver associated with many of the period's best books, was born on 7 November 1794 in London, though his early years were spent outside the metropolis. In due course he was taught engraving by his father, Thomas, a figure engraver, who worked until his death in Charles Heath's studio. By about 1818, Robert had set up on his own in London, and soon achieved a good reputation with such plates on copper as 'Ramsgate' (1824) and 'Folkestone' (1825) after Turner, which appeared in the two volumes of *Picturesque Views on the Southern Coast of England* (1826). He worked on steel for the first time in 1825, engraving 'Cascades of Gavarnie' after J. Hardy for Ackermann's *Forget me not*. In this Robert was one of the first to employ the metal to produce delicate tones, developing a new style in distinct contrast to the rather coarse approach used hitherto on copper. In the 1830s he worked for all of the important annuals: *The Anniversary*; a long series in *The Keepsake* from 1829, mainly after Turner, averaging one plate a volume; the *Literary Souvenir*; the *Landscape Annual*, with plates after Samuel Prout; and *Heath's Picturesque Annual* with engravings after Clarkson Stanfield. From 1834 to 1840 his output was prodigious; it included close on 100 plates after designs by W. H. Bartlett, seventeen of which were done for Beattie's *Switzerland* in 1834 and 1836. The two engravings of Tell's Chapel in the first volume are among the best examples of his work. One of his most outstanding however is 'Lake of Nemi' after Turner, which was published in Finden's *Royal Gallery of British Art* in the 1840s, during which time his work for books was much less prolific. He retired from engraving at the age of sixty-five in 1859 and resided in Brighton for the next nineteen years in good health, which, however, gave way a year or two before his death on 23 November 1878, aged eighty-four. James Baylis

Allen worked for Robert at one time, but otherwise he seldom had any assistance.

His younger brother, Henry, was the proprietor of the French Gallery in Pall Mall, turning to picture dealing after two strokes had compelled him to give up engraving. He did a number of plates from about 1828 to 1857, few of which, however, are of a high calibre, since most were done for second-rate publications, such as the twenty-nine out of fifty-eight he engraved for *The Fashionable Guide and Directory to the Public Places of Resort*, published by Thomas Fry, about 1840.[55]

Among the earliest of the migratory engravers were the brothers John and Charles Cousen. Born in Bradford, Yorkshire, they worked all their lives in London, since no opportunity to follow their profession presented itself in their native city. Most of their important work was done after designs by W. H. Bartlett and for the publishers Virtue and Fisher.

JOHN COUSEN was the elder, born at Mira Shay, an estate near Tewit Hall and Bradford Moor, to the north-west of Bradford, on 19 February 1804. He was apprenticed to the animal engraver John Scott in London about 1818, but his master suffered a paralytic stroke in 1821 before John had finished his indentures. His time would have been up about 1825. By then his preference for landscape engraving was firmly established and he soon took his place as one of 'Turner's engravers', notably in the *Rivers of France*. His first important book plate was 'Val d'Ossola' (November 1828), engraved for Brockedon's *Illustrations of the Passes of the Alps*, but he was most active in the 1830s when he worked on some engravings for Caunter's *Lives of the Moghul Emperors*, Carne's *Syria*, several volumes of the *Landscape Annual*, *Heath's Picturesque Annual* and three plates for *Stanfield's Coast Scenery*. Stanfield held him in high regard, and thought John the best possible engraver for his plate of 'Venice' in the 1849 *Art Journal*. The important Virtue works included four plates for *Switzerland* (1836), eight for *Scotland illustrated* (1838) and four for *The Danube* (1844), all by William Beattie, with, in addition, seven plates for Willis's *American Scenery* (1840) and five for Julia Pardoe's *Beauties of the Bosphorus* (1840). 'The column of Theodosius' (see plate 31) is from the latter work, and well indicates the variations in tone he was able to achieve. Many of his plates after Bartlett appeared in the artist's own works, e.g. *Forty Days in the Desert* (c. 1847), and *Footsteps of Our Lord* (first published 1851). His two main plates for Fisher appeared in Robert Walsh's *Constantinople* (1838–40), and were 'Constantinople' after T. Allom, and 'Joannina, the Capital of Albania' after W. L. Leitch. From 1849 he engraved thirty-two plates for the *Art Journal*, one of which, 'Peace' (1854) after Landseer, had the animals engraved by John and the figures by Lumb Stocks. His last engraving in this series, 'Evening in the Meadows'

PLATE **31** 'The Column of Theodosius', steel engraving by John Cousen after W. H. Bartlett, from Julia Pardoe's *Beauties of the Bosphorous*, 1840.

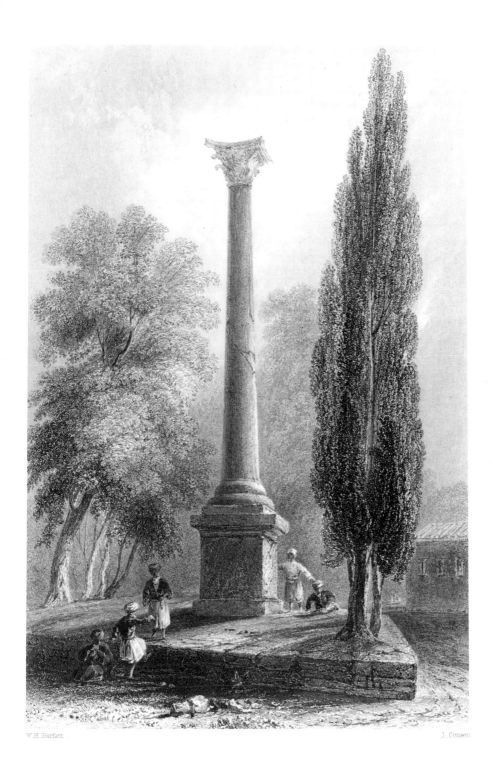

W.H. Bartlett

J. Cousen

THE COLUMN OF THEODOSIUS.

COLONNE DE THEODOSE DIE SÄULE DES KAISERS THEODOSIUS 97

(1866) after F. R. Lee and T. S. Cooper, signalled the end of his career as an engraver, overwork bringing on ill-health. He is known to have engraved only three large plates, namely 'Mercury and Herse' after Turner, and 'Towing the *Victory* into Gibraltar' with 'Morning after the Wreck' after Stanfield.

Cousen exhibited twice at the Royal Academy, in 1863 and 1864. His work showed how close observation enabled him to render accurately details not readily apparent in the original. As a person he was rather shy and retiring, but to his friends, among whom he numbered J. C. Bentley (see below, pages 100–101) and W. O. Geller the mezzotinter, both also from Bradford originally, he was very genial and kind. He had a gentle sense of humour, and a simplicity of manner which endeared him to them. He died at South Norwood on 26 December 1880, and was buried in Croydon Cemetery.[56]

CHARLES COUSEN, also born in Bradford, was John's younger brother, and it was John who taught him the art of steel engraving. His work spanned the thirty years from 1836, the date of his earliest known book work. The best of it was done after Bartlett, very often as attractive vignettes. An outstanding plate is 'Albany' (1839) for the first volume of Willis's *American Scenery*. When book work declined, Charles joined the *Art Journal* staff as one of their small number of resident engravers; between 1850 and 1888 he executed fifty-nine plates for them. Those produced in the mid-1870s show a move towards Continental practice, being more heavily etched, but in 1879, he returned to his former style. Considering he was seventy-six when he engraved his last plate, 'Catching a mermaid' after J. C. Hook, his skill was remarkable.[57]

The final group comprises four engravers who worked virtually alone, and yet made, each in his own way, a great impact on contemporary engraving.

JAMES CHARLES ARMYTAGE can lay claim to several distinctions, inasmuch as he probably practised steel engraving for longer than any other engraver, was only five years off his century when he died and made a name for himself in connection with the work he did for John Ruskin. Primarily a landscape engraver, his main work in the 1830s was done for the *Landscape Annual* and *Turner's Annual Tour*. He was very busy in the next decade working for Virtue on Bartlett's designs, and his series of sixteen plates for volume 2 of Beattie's *The Ports, Harbours, Watering-places and Coast Scenery of Great Britain*, (1842), and thirteen for the same author's *The Danube* (1844), contain some excellent work, notably 'Conway Castle' (1841) and 'Blackpool sands' (1840) from the former. At the end of the 1840s, he engraved nine designs after Sir David Wilkie for *The Wilkie Gallery*, issued by Virtue about 1849, but it was late in the next decade that his most painstaking work appeared. John Ruskin himself prepared most of the drawings to illustrate *Modern Painters*, published in five volumes by Smith, Elder and Co., but only the last three contained any illustrations; of these, the third and fourth volumes were published in 1856 and

the fifth volume in 1860. Since a number of the drawings were designed to demonstrate treatments of foliage, clouds and light, etc. the engraver's skill was taxed to the utmost, and the delicacy obtained in such plates as 'Foreground Leafage' in volume 3, and 'The Dryad's Toil' in volume 5 is truly remarkable, offset by perfect machine ruling on the background. The finest plate, however, is 'Aspen Unidealized' in volume 4. These engravings represent a rare kind of illustration, and it was reported that 'Mr. Ruskin declared himself greatly pleased with their fine quality'. There were twenty-seven altogether of varying artistic quality, so the overall effect is uneven. A further distinction achieved by Armytage about this time was the engraving of one of the largest steel plates done for a book. It appears in *The Practical and Devotional Family Bible*, published in Glasgow by William Collins in 1860 and is a large double-page spread landscape, 'Modern Jerusalem' after W. H. Bartlett. The picture area measures $15\frac{3}{8}$ by $9\frac{1}{8}$ inches; although the foreground, accounting for about one-third of the picture area, is heavily etched, the remaining one-third is delicately engraved, with the machine-ruled sky accounting for the final third. One of the best sets of his book illustrations was issued in the 1872 Imperial edition of Shakespeare, edited by Charles Knight, and published by Virtue in two volumes. The four plates 'Prince Henry' after W. Q. Orchardson, 'Troilus and Cressida' after V. W. Bromley, and 'The death of Caesar' and 'Cleopatra and Caesar' after J. L. Gerome were published in the *Art Journal* between 1872 and 1877. He had engraved forty-two plates in all for the *Art Journal* from 1847, the last one, 'Non Angli Sed Angeli' after Keeley Halswelle, being issued in 1890.

His advice was sought about this time by Marcus B. Huish, then editor of the *Art Journal*. In his introduction to a reprint of Turner's *Richmondshire* (1891), he wrote 'I have had the pleasure of going over the plates with the veteran engraver, Mr. J. C. Armytage', and there follows what must be the old man's remarks on the various engravers.[58] Four years later, Huish consulted Armytage again, and his views on the engravers of Turner's Seine and Loire pictures are, perhaps, worth repeating.

[Robert] Brandard's plates easily carried away the palm: Turner's drawings were remarkable principally for their sharpness and decision of touch; no one could render this so well and so easily as Brandard; he was able to carry a plate through with a certainty that this translation was correct, and was thus enabled to undertake a far larger amount of work than the other engravers. In the order named came [William] Miller, [John] Cousen, and R. Wallis. Higham was exceptionally good in architectural subjects, and his 'Rouen Cathedral' must be considered as one of the plates of the century. [James Tibbetts] Willmore and [William] Radcliffe [sic] he places at a much lower level, their plates being too soft, spongy and black; on more than one occasion Turner found their work so dark that he introduced a moon, and thus changed a daylight into a night effect.[59]

Armytage died on 28 April 1897, aged ninety-five,[60] the last of the old school, with the exception of E. P. Brandard, who died the following year. His close connection with Virtue the publisher over a great number of years makes it more than probable that he worked for them, preparing and re-engraving plates for their extensive publication programme.

JOSEPH CLAYTON BENTLEY was one of the most remarkable engravers. He died at the early age of forty-two, having spent only nineteen years as an engraver. Even so his output had been as great as any of his contemporaries, due principally to the speed at which he worked. This, combined with a high standard of achievement and an ability to meet deadlines, recommended him very much to the publishers for whom he worked, notably Fisher and Virtue.

He was born the fifth child and third son of a well-known Bradford lawyer, Greenwood Bentley, in 1809, and came from an old-established Yorkshire family. His pedigree shows that his second forename, Clayton, had come from his grandmother Kitty, and Joseph was a name which had come down the Greenwood side, joined in marriage to the Claytons. The Bentleys 'might be said to belong to the quiet-going, law-avoiding order of family advisers, rather than to the avaricious school of legal practitioners.'[61] He was trained in his youth as a landscape painter but as such was only mediocre. He continued this interest parallel with his engraving work, showing a natural inclination towards Yorkshire scenes (for example, 'View of the Seven Arches, Bingley'), many of which were exhibited from 1833 in London and the provinces. He painted his father's portrait, which was regarded as a good likeness by contemporaries, despite its lack of artistic ability. 'Pont Gwryd' is the only engraving known to have been made by him after his own painting. It was said that before he left Bradford he painted some frescoes on the walls of Hall Ings, the old Bentley property, but they have not survived.

When he was twenty-three, he moved to London to study engraving under Robert Brandard; he made such rapid progress that his work soon appeared in contemporary books. His first published plate was 'Feniscowles' after G. Pickering, dated 1832, and was issued in Edward Baines's *History of the County Palatine and Duchy of Lancaster* (1836) by Fisher. Two other plates, dated 1834 and 1835 respectively, appear in volume 3. For some time he exercised his painting skills in making copies of a number of the pictures for S. C. Hall's *Gems of European Art* (1846), for which he also engraved five plates. 'The Fountain' after F. Zuccarelli, and 'A Sunny Day' after A. Cuyp are good examples of his work.[62] This latter plate was reissued in the *Art Journal* for 1868. At least eight major publications included his engravings in the 1830s and thirteen appeared in the following decade. The best sustained work was in engravings after Thomas Allom in Walsh's *Constantinople* (from which comes one of his finest plates, 'Smyrna from the harbour', volume 2, page 79, also used again in Kitto's *Gallery of Scripture Engravings*, 1846–9), Rose's

Cumberland, and after Bartlett in Coyne's *The Scenery and Antiquities of Ireland*, which contains his longest series of plates, eleven in all.[63] Nearly 200 plates are known by Bentley, including ten engraved for the *Art Journal* series, taken mainly from pictures in the Vernon gallery. Some of his plates were still being issued as late as 1872, and at least three books containing his engravings were published after his death. He was too late to contribute much to the annuals; Fisher's *Drawing Room Scrap Book* and *Juvenile Scrap Book* (1839) are probably the sole examples. Weakened by hard work and the high standards he set himself, early signs of tuberculosis showed themselves in 1843–4, but he struggled on, moving to Sydenham in the hope that a change of air would effect a cure. By the end of June 1851, the disease had taken firm hold, and his condition deteriorated rapidly until his death on 9 October at his residence, Perry Vale. He left a widow and two children, but his membership of the Artists' Annuity Fund since 1839 alleviated their lot to some extent.[64]

EDWARD GOODALL was another Yorkshireman from the same area who achieved remarkable success by his own determined efforts. He was born in Leeds on 17 September 1795 and from the age of sixteen concentrated his efforts on engraving and painting. With his native skill and thorough study of the best contemporary artists, he became a self-taught artist of real ability. Until 1822, he was more inclined to paint; at the age of twenty-seven, by which time he was married with two sons, he had exhibited a landscape in oils at the Royal Academy. This attracted Turner's especial attention, leading him to make one of his more extravagant offers, namely to engrave as many plates from his paintings as Goodall would undertake. The immediate result was the production of three copper plates for *Picturesque Views on the Southern Coast of England* (1826), i.e. 'Rye' (March 1824), 'Boscastle' (March 1825) and 'Mount Edgcumb, Plymouth' (April 1826). This was the beginning of a close association with the painter. Goodall has been regarded subsequently as one of the best exponents of Turner's work; nearly all his book illustrations were after Turner. About 1824, Robert Brandard came as a pupil for a year and later Thomas Leeming Grundy was his assistant for some considerable time.

Goodall first used steel for 'Richmond Hill', drawn expressly by Turner for the *Literary Souvenir* of 1826, and further plates appeared in *The Amulet* for 1826, *The Keepsake* for 1828 and *The Anniversary* for 1829. His work for the annuals stopped when he embarked upon the sixteen designs after Turner and Stothard for Rogers's *Italy* (1830) and the twenty-seven vignettes for the same author's *Poems* (1834), with one exception, all after Turner. The partnership was renewed in 1837 when Goodall engraved sixteen out of twenty-one vignettes for Thomas Campbell's *Poetical Works* published by Edward Moxon; however unsatisfactory the volumes were as books, the engraving was of the highest order. From this date, Goodall's

book work was very spasmodic; in the 1840s he devoted more time to larger plates for the Art Unions and, later still, for the printsellers. In this latter area, he was much less successful with the public, several of his large engravings after Turner being commercial failures. 'Caligula's Bridge', considered by the engraver to be his best work, never found a publisher in his lifetime and 'Tivoli', published at the expense of Mr Allnut, an enthusiastic amateur, lost 400 guineas for its sponsor.[65] In 1845, he was elected to the Council of the Institute of Fine Arts.

His family was increasing and growing up, all taking a great interest in painting. Edward A. Goodall, his eldest son, was a member of the Society of Painters in Water-colours, as was Walter. Furthermore, two of his daughters were accomplished artists. The main honours, however, must go to his second son, Frederick, who was elected an Academician in 1863. It was natural for Edward to train his own children, so Frederick was taken from school at thirteen to be taught engraving. This idea, however, was soon abandoned so that his considerable talents in drawing and painting could be developed. By 1854, Edward was engraving his son's pictures for the *Art Journal*; out of sixteen plates Edward did for that periodical, half of them were after Frederick's pictures. Edward's last plate was after his son's 'The School of Sooltan Hassan', published in 1869. In these later plates, the figures were very finely engraved to a standard never before achieved except in his landscape work, a tribute to his skill at three score years and ten. Edward's authority on Turner's works was such that, together with John Pye, he was called upon to testify to the authenticity of a painting produced in a lawsuit in 1864, which both declared not to be by Turner. He had lived for many years in Hampstead Road, overlooking Regent's Park, and it was here, after a short illness, that he died on 11 April 1870.[66]

LUMB STOCKS (see plate 32) was yet another Yorkshireman, the last of the important engravers and one who was widely known for his engravings over a period of nearly sixty years. He was born at Lightcliffe, near Halifax, on 30 November 1812, the son of an eminent coal-mine owner. At Horton, near Bradford, where he was educated, his drawing instructor was C. Cope, the father of Charles West Cope, a famous contemporary painter. He was determined to become an engraver, and in 1827, at the age of fifteen, was apprenticed in London to Charles Rolls for six years and then, in 1833, set up on his own. The annuals provided him with his earliest work, the *Literary Souvenir* and *The Keepsake* being the chief vehicles of his engravings. Not more than two or three plates appeared in any one work and so his engravings are scattered throughout a number of volumes. He contributed two

PLATE **32** Wood-engraved portraits of Lumb Stocks, R.A. (1812–92), both from the *Illustrated London News*. Above: (1872), vol. 60, p. 29. Below: (1892), vol. 100, p. 562. (By courtesy East Sussex County Library, Brighton Reference Library.)

THE LATE MR. LUMB STOCKS, R.A.

plates after Edward Corbould to Moore's *Lalla Rookh* in 1838. In November 1839 he engraved 'Procession to the Christening' after Penry Williams followed by 'Preparing Moses for the Fair' after Daniel Maclise in July 1841 and 'Nell Gwynne' after Charles Landseer, all three of which appear in Finden's *Royal Gallery of British Art*. Four plates were contributed to *Gems of European Art* (1846), one of which, 'The Infant St John' after Murillo, was used again thirty years later in a Bible of 1877. He also did four engravings after George Cattermole, one for the Revd Richard Cattermole's work on the Civil War, first published in 1841, and three for Baroness de la Calabrella's *Evenings at Haddon Hall*, first issued 1845. Two of his best engravings were of the oval designs after Thomas Stothard for the very popular edition of Bunyan's *Pilgrim's Progress*. When published in 1839 by Seeley, it drew enthusiastic praise from a reviewer, who wrote: 'The drawings, moreover, have been engraved as they ought to have been; it is absolutely refreshing in these days of stipple-poverty to find such men as Mitchell . . . Goodall, R. Graves, Sangster, Watt and Stocks, engraving book plates'.[67] Some of his last book plates were issued in Charles Knight's Imperial edition of Shakespeare, namely, 'Florizel and Perdita' and 'Autolycus' after C. R. Leslie, both of which had been published in the *Art Journal* for 1867. This periodical had carried twenty-three of his plates from 1849 to 1884, his last engraving being 'Princes in the Tower' after Sir J. E. Millais.

In the 1840s he was drawn away from book plates to more lucrative fields. This began with the Art Union of London's commission in 1842 to engrave A. W. Callcott's 'Raffaelle and the Fornarina', a work which produced unfavourable notices such as the following: 'We scarcely think the picture has received full justice from Mr. Stocks; there appears to be indications of slovenly haste about some portions . . . the draperies especially; this looks too like indifference in sustaining a reputation making, but not made.'[68] Perhaps the Art Union agreed, because Stocks did not engrave for them again until 1865. But the Association for the Promotion of the Fine Arts in Scotland employed him in three consecutive years (1843–6) to engrave their presentation plates after Robert Scott Lauder and James Eckford Lauder. This commission was especially significant in view of the excellent Scottish engravers who might have expected to be given it. In 1849, a curious note appeared in connection with Stocks's engraving of 'The Brigand's Hat' after Thomas Uwins: 'Mr. Uwins writes to us as follows respecting this plate: "Mr. Stocks's beautiful engraving has been under my hands for the last time. I shall be most happy to bear any testimony to its excellence, and to give any evidence of my satisfaction."'[69] Why such a public declaration should have been thought necessary is a mystery, but it would appear that all this consolidated his reputation.

When the death of John Landseer, in 1852, left a vacancy to be filled in the Royal Academy, Lumb Stocks was sufficiently well thought of to secure nomination and election with a fairly good majority. He was opposed by T. L. Atkinson, Samuel Bellin, Frederick Bromley, James Carter, Thomas Landseer and G. R.

Ward; in the second vote, he polled thirteen votes to Landseer's ten.[70] From this time, the best of his engravings were shown at the Academy exhibitions, strengthening his position still further. In 1854, he was helping John Cousen by engraving the figures for 'Peace' by Landseer. Soon afterwards, he was asked to finish 'Vintage in the South of France' after Thomas Uwins for the *Art Journal*. This had been started in 1851 by John Outrim and was due to be delivered in July 1852. Over two years later it still was not finished, and the proprietors printed a scathing condemnation of their original engraver for having, the first time ever, caused them to break faith with their public.[71] The Art Union of London received him back in 1865, when he engraved 'Claude Duval' after W. P. Frith, and it was for them that he began his most important work in 1867. This was an engraving of Daniel Maclise's huge 'Meeting of Wellington and Blucher at the Battle of Waterloo', painted on the wall of the Royal Gallery in the House of Commons. Arthur Stocks, his painter son, copied it for him and the father worked with the aid of photography; it took five years to complete the engraving. The total cost was £7,872 for 19,000 impressions.[72]

The death of the engraver John Henry Robinson in 1871 led to Stocks's election to fill the vacancy as an Academician in December of that year[73] and, two years later, he was elected to the Royal Academy Council. In 1875, he became its Auditor, in the 1880s he was twice on the Hanging Committee for engravings and, in 1892, he was one of the twelve member Fine Arts Committee for the Chicago Exhibition. In the same year, Frederic Stacpoole resigned, leaving Stocks the last remaining 'master of the burin in the Academic body'. Not, alas, for long, since he died on 28 April 1892. His last plates included 'Sister's Kiss' (1884) after Sir Frederick Leighton, done for the printsellers, and 'Spanish Letter Writer' after Burgess, exhibited in 1888, when he was seventy-six. His will, when proved, showed a personal estate of £37,000; in contrast to many who died in penury he was one of the few who made a small fortune from engraving. He had attended an Academy meeting only a fortnight before, and was in good health until a few days before his death, leaving a widow and several sons.[74]

Steel engraving was almost exclusively a male occupation, but reference should be made to two sisters who appear to have been the only ladies to work in the metal. (Charles Heath's sister, Mrs Hamilton, who did much in copper, is not known to have used steel, possibly because of the physical strength needed to wield the burin.) In at least one book, the Byrne sisters managed eight pictures between them. The elder, Letitia, was the third daughter of William Byrne, landscape engraver, known principally for her etchings, and her younger sister Elizabeth was celebrated for engraving fruit and flowers. Their steel plates appeared in Thomas Hosner Shepherd's *Modern Athens . . . or Edinburgh in the Nineteenth Century* (1829), published by Jones and Co., after drawings by J. P. Neale and comprise two small engravings on each plate.[75]

CHAPTER SEVEN · The artists

The artists whose pictures or designs provided the inspiration for the steel engravings which embellish nineteenth-century books may be studied in four separate categories. The first comprises those whose main work, or the more significant part of it, was the illustration of books; its core was composed of the older artists, already trained and working in the field. Their best work had been done in the first two decades of the nineteenth century and yet they were still popular enough well into it. Such were Thomas Stothard, the brothers Richard and William Westall, and Henry Corbould. The chief illustrator for steel engraving was William Henry Bartlett, who devoted twenty-five of his forty-five years of life almost exclusively to the art, supported by Thomas Allom, whose main concern was with his work as an architect.

The second category is the largest, and consists of those who were primarily artists but whose work was also suitable for book illustration. They accepted commissions for illustrations as a minor part of their work. Here belong the Birmingham group: David Cox, Henry Room and Thomas Creswick; to them can be added the great landscape group: Joseph Mallord William Turner, Samuel Prout, William Brockedon, David Roberts, James Duffield Harding and William Clarkson Stanfield. It is perhaps significant that at least three of the group – Cox, Roberts and Stanfield – had a good grounding for their landscape work as theatre scene painters in their early days. To this category belongs also a group of younger painters, centred around Augustus Leopold Egg, Edward Matthew Ward and William Powell Frith, whose work was very popular with the mid-Victorians.

The third category was of amateurs, many of whom were serving officers of the armed services, whose travels often took them to remote places. They provided raw material in the form of sketches for other artists to work up or, in some cases, to be used as the illustrations themselves. The most celebrated of these was Lt.-Col. Robert Batty, but the band included Capt. R. Elliott R.N., the Hon. Capt. E. Fitzmaurice, Capt. Grindlay, Lt.-Col. P. Hawker, and Capt. (later Major) Irton.

Finally, an important category consists of the Old Masters and distinguished contemporary painters; their works were pressed into the service of book illustration or engraved for volumes which had the express intention of popularizing art. The most frequently copied of the Old Masters were Murillo, Raphael,

Reynolds, Rubens, Van Dyke and Wouvermans, while among contemporary painters to have their works so treated were Sir Thomas Lawrence, Sir Edwin Landseer and Gilbert Stuart Newton, followed by Richard Parkes Bonington, Sir Augustus Wall Callcott, Sir Charles Lake Eastlake, William Mulready and Henry William Pickersgill. The artists had more freedom than the engravers in the disposal of their work. They realized that their drawings could have independent lives of their own as works of art, but if they cared little for this, they could sell them outright, usually to the profit of the publishers who resold them (see below, page 128). On the other hand, artists with better business sense would hire their drawings out for engraving, retaining ownership for themselves. This was in line with the so-called copyright fees extracted by painters, but it upset line engravers like Raimbach, as well as the printsellers, who took refuge in a cheaper process, such as mezzotint on steel, in an effort to cut costs.[1]

THE BOOK ILLUSTRATORS

THOMAS STOTHARD, R.A., had a very high reputation as a book illustrator dating back to about 1781, when his designs for Smollett's *Peregrine Pickle* first attracted attention. His work is readily identified by its elegance and grace, as exemplified in his drawings for Bunyan's *Pilgrim's Progress*, first attempted in 1788. The seventeen oval designs produced in the 1839 edition were done on steel by ten engravers, led by Edward Goodall, whose four plates are among the best produced. A few of Stothard's plates appeared in the annuals, notably *The Keepsake* and *Literary Souvenir*, but his last major works in book design were his seventeen drawings for Rogers's *Italy* (1830), and the thirty-five for the same author's *Poems* (1834). All of the latter were engraved by William Finden. Over half of Stothard's estimated 4,000 designs have been engraved and a high percentage of these were for books. Most of them were for imaginative literature, and had an ethereal appearance about them; female figures in flowing robes were idealized, and the countryside, too, tended to look unreal.

RICHARD WESTALL, R.A., was also famous as a book illustrator, and is thought to have done much to promote the art of watercolour painting. Well established as an illustrator by the 1820s, he contributed plates to the early numbers of the annuals, starting with Ackermann's *Forget me not* (1825), with three designs engraved by Charles Heath and one by W. T. Fry, then *The Keepsake, The Anniversary* and the *Literary Souvenir*. Four of his designs had been engraved by Charles Heath for Campbell's *The Pleasures of Hope* in 1820, one of the earliest books to contain steel engravings (see page 15).

WILLIAM WESTALL, A.R.A., brother of Richard, drew two designs for *Finden's Illustrations of the Life and Works of Lord Byron*, one worked up from a sketch by

E. Fellows; Edward Finden engraved his 'Old Woodstock Manor' for an edition of Scott's works. He worked up a sketch by Col. Cockburn of 'View of the Chigi Palace, Lariccia' engraved by John Sands for Dudley Costello's *Piedmont and Italy from the Alps to the Tiber*, but his earliest work engraved in steel was of seven designs for Alexander Blair's *Graphic Illustrations of Warwickshire*. In his early days, William had travelled extensively; before 1820, he had produced many of his important book illustrations based on his adventures in Australia, China, India and the West Indies.

HENRY CORBOULD came from an artistic family. His father, Richard, was a portrait and landscape painter, his elder brother, George James, was an engraver and the eldest of his four sons, Edward, was an historical painter like his father. Henry was connected with book illustration from about 1811, when his designs for 'The Lady of the Lake' were exhibited at the Royal Academy. For thirty years he was engaged upon drawings for the engravers (whom he also selected to do the work) from the Elgin and other marbles in the British Museum, work for which he was considered to be particularly talented. In the same vein, pictures from the collections of the Duke of Bedford and Lord Egremont were drawn by him, and he was an early and regular contributor to the annuals, including *The Keepsake* and *Literary Souvenir*, where most of the plates bear Charles Heath's name as engraver. In the *Forget me not* (1825), his brother George engraved three of his designs: 'The Royal Nuptials', 'Ademdai' and 'Sacontala'. He also designed some of the title-page vignettes to Dionysius Lardner's *Cabinet Cyclopaedia*, published in the 1830s.

His son, Edward, also designed for Charles Heath, notably in the later volumes of *The Keepsake* and *Heath's Book of Beauty*, but his seven designs out of thirteen for Longman's 1838 edition of *Lalla Rookh* by Thomas Moore represent the high-water mark of his work in this field.

THOMAS ALLOM was the elder of the two most prolific producers of designs. He was articled to the architect Francis Goodwin for nearly eight years, and also studied at the Royal Academy Schools, after which, about 1825, he travelled abroad, chiefly in Europe, to extend his artistic experience. These journeys were to produce the drawings for innumerable book illustrations, most of which appeared in Fisher's publications between 1828 and 1850. Soon after his return from Europe, Allom began his work for Fisher in *Devonshire Illustrated* (1828), with descriptions by John Britton and Edward Waylake Brayley, and this team produced a companion volume on Cornwall in 1832. About the same time, he worked with Thomas Rose on the lake and mountain scenery of *Westmorland, Cumberland, Durham and Northumberland*, later issued in three separate volumes. In this series, Allom drew 189 of the 215 designs, the remainder being done by G. Pickering and Henry Gastineau, two minor contributors to many volumes of this kind. The chief engraver in these volumes was William A. Le Petit (forty-five plates), with James

Sands (twenty-eight) and Samuel Lacey (twenty). The next important book was *Constantinople and the Scenery of the Seven Churches of Asia Minor* (1838–40), with text by the Revd Robert Walsh, chaplain to the British Embassy at the Ottoman Porte; Allom was responsible for most of the ninety-six plates in the two series. Thirty-three engravers were employed on his designs. This was followed by *China* (1843) with text by the Revd George Newnham Wright, in which Allom executed most of the 128 designs, with help from sketches by three amateurs, Lieut. White of the Royal Marines, R. Vareham and Capt. Stoddart, R.N. Arthur Willmore engraved ten plates, and the remainder were divided between twenty-nine other engravers. *France Illustrated* (1844), in three volumes, was produced by the same author and artist, with a total of ninety-six illustrations. Two years later, Allom presented a copy of *China* and *France* to the French King during a private audience, who expressed himself 'highly gratified with both, and especially complimenting Mr. Allom on the correctness of the views in France'.[2] In 1838, George Virtue published William Beattie's *Scotland*, to which Allom contributed ninety-one drawings, dated between 1835 and 1837. This unusual occurrence was the result of Bartlett's absence in America on another assignment, and Allom was asked to commence drawings for the work. During one of his rare periods at home, Bartlett produced the eighteen drawings required to finish it. A second commission executed by Allom for Virtue was a series of oil paintings of the Seven Churches of Asia, later engraved for the *Art Journal.*

Allom's drawings are full of little touches which redeem his landscapes from formality, such as those in 'Darlington, from the Road to Yarm', in Rose's *Durham*. In the foreground appear a man and woman on horseback, to whom four children are waving. Another man and woman are trying to catch a pig by hooking a walking stick around its hind leg, and yet another family of six is depicted, the eldest child of which appears to be trying to push a possibly drunken father home, while the mother leads and the smallest child weeps uncontrollably. There is another woman putting laundry out to dry over bushes on the slope above the path and, almost invisible in the background, are two carts. These touches give his illustrations a perennial interest, and it is for them, rather than his architectural work, that he is remembered, even though he was one of the founder members of the [Royal] Institute of British Architects. He died at Barnes on 21 October 1872.

It is perhaps significant that the other eminent illustrator of the period was also trained in architectural drawing.

WILLIAM HENRY BARTLETT was born in Kentish Town on 26 March 1809, the second child in the family, and showed great promise in his drawing from an early age. Never very robust, he was sent to a boarding school at the age of seven, where the rigours of life made him very introspective. A highlight in his life there was reading Jane Porter's *Scottish Chiefs*, a copy of which circulated among the boys,

and this for Bartlett formed 'an oasis in the dreary desert of school life'. He returned home when he was twelve and, after much discussion on his future, he was allowed to follow his artistic inclinations, being accordingly apprenticed for the customary seven years in 1822 to John Britton. He was a celebrated draughtsman and antiquary and his school of architectural drawing was highly regarded. Bartlett was one of four boys there, and soon became Britton's most favoured and apt pupil. His master was very impressed with Bartlett's speed of sketching, and admitted to never having seen anybody quicker at it. This was to stand the pupil in good stead later on and contributed a great deal to the amount of work he was able to complete. During his apprenticeship, he worked all over England, chiefly in the north and west, concentrating on cathedrals and other antiquities. Britton was generous in attributing one of his best works to Bartlett's industry, namely, *The Picturesque Antiquities of English Cities*. The portrait reproduced (see plate 33) shows him aged about thirty, and forms the frontispiece to Willis's *American Scenery* (1840). In 1829, his indentures came to an end and he was 'a candidate for employment'. This he found with George Virtue, for whom most of his work was done.

His earliest work was a set of ten illustrations which appeared in the four volumes of *England's Topographer; or, a New and Complete history of the County of Kent* (1828–40) by S. W. H. Ireland and published by Virtue. Eight of the engravings were dated 1829, one 1830 and the tenth 1832. His first major commission was for 101 drawings, reproduced in the two volumes of William Wright's *History and Topography of the County of Essex* (1831–5). This occupied him until his marriage, on 6 July 1831, to Susanna Moon, niece of the printseller Francis Graham Moon. After the wedding, the couple visited a relative in Holland for a month, during which they enjoyed a ten-day excursion up the Rhine. In the spring of the following year, 1832, Henry Jorden introduced Bartlett to Dr William Beattie, a medical practitioner born in Dumfries-shire and trained in Edinburgh. It was the beginning of a close life-long friendship. His portrait (see plate 34) appeared as the frontispiece to *The Castles and Abbeys of England* (1845). Beattie's medical career was interrupted in its early stages by his poorly paid appointment as physician to the Duke of Clarence (later King William IV), during which time he turned to authorship. He was the friend of the poets Rogers and Campbell, acting as literary executor for the latter. At the time of his meeting with Bartlett, Beattie was preparing for publication his *Journal of Three Summers in the Minor Courts, &c.*, including his rough sketches of Upper Saxony. These needed some more skilled attention, however, and Bartlett was invited to produce two or three engraver's outlines. Beattie was so pleased with them that he promptly broached a more ambitious project to the artist, namely a work on

PLATE **33** William Henry Bartlett (1809–54), frontispiece to N. P. Willis's *American Scenery*, 1840, steel-engraved by B. Holl after Henry Room. Original size 5 by 4 inches. (By courtesy East Sussex County Library, Brighton Reference Library.)

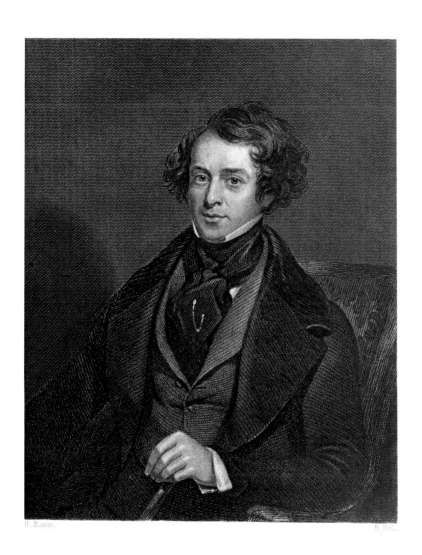

W. H. BARTLETT.

Yours truly

W H Bartlett

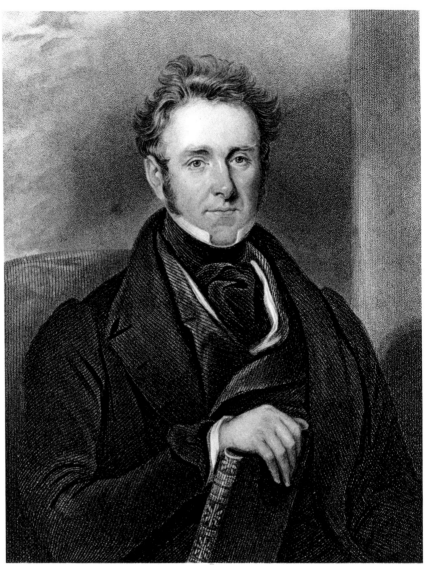

Henry Room John Rogers

William Beattie M.D.

Switzerland. Since nothing more remunerative was on hand at the time, Bartlett accepted the challenge. On 12 November 1832, accompanied by his wife, he set off for the Continent, reaching Geneva in December. He had not been sketching long when the first of many similar unlucky occurrences befell him. He caught a severe cold in the mountain snow, developed a fever and was considerably weakened by it. His wife had a difficult time nursing him in such conditions, but by the spring he had recovered sufficiently to resume work. As sketches were completed, they were sent home to be engraved, so the process of sketching, engraving and printing was proceeding simultaneously. The first part, published on 1 March 1833, made a reputation for both author and artist, so that when enough drawings had been completed for the 108 plates, the Bartletts returned home towards the autumn of that year. Publication of the parts took three years. A two-volume edition was published in June 1836, in the preface to which, the author praises the work of the artist and comments on the book's kind reception by public and critics at home and abroad.[3]

After a brief spell at home, Bartlett was commissioned, this time by Fisher, to visit the Holy Land. He set off on 2 January 1834 and was accompanied by his wife as far as Naples. This project took exactly a year and resulted in 107 plates, which were published by Fisher in the three-volume *Syria, the Holy Land, Asia Minor &c. illustrated in a series of views drawn from nature by W. H. Bartlett, William Purser &c. With descriptions of the plates by John Carne, Esq.* (1836–8). Ironically, William Purser contributed no designs at all; of the remainder, Thomas Allom produced nine, J. Salmon three, and C. Bentley one. Fifty-six engravers were employed on the plates. The volume was advertised by Fisher as the first series of 'The Turkish Empire Illustrated', and for the second series, Allom was sent out in 1836 to produce the views eventually published in Walsh's *Constantinople* (see above, page 109). This exchange of Allom and Bartlett by Fisher and Virtue may have been a *quid pro quo*, although it seems possible that Fisher was endeavouring to outbid Virtue for Bartlett's services. During the journeys, Bartlett was ill once more, this time with ague and a touch of brain fever after sleeping out in a cave. It was fortunate that with him he had a manservant competent to nurse and look after him at such times. Further details of this journey were recounted in Bartlett's own book, *Footsteps of Our Lord* (1851).

On his return to England in January 1835, he prepared the sketches for the engravers, but he was off again in April. This time he went to Piedmont in northern Italy, to illustrate a history of the Waldenses, a religious sect which flourished both in this area and in southern France. William Brockedon contributed some of the

PLATE 34 Dr William Beattie (1798–1875), frontispiece to his *The Castles and Abbeys of England*, 1845, steel engraving by John Rogers after Henry Room. (By courtesy East Sussex County Library, Brighton Reference Library.)

seventy-two illustrations to this book, and Beattie collected his material in the autumn of 1835 when he visited Geneva for the 300th anniversary celebrations of the Reformation. Having seen the Protestant valleys for himself, the author was impressed with the fidelity of Bartlett's illustrations, which were published in 1837.[4] Apart from his visits to Jerusalem, this was Bartlett's favourite journey.

Returning to England in the autumn, he was sent to the Netherlands in November, to produce the illustrations to *Holland and Belgium*, the text for which was written by Professor Van Kempen of Amsterdam. He appeared to have been back home in February 1836, but in April was off to Paris, visiting publishers, and very soon afterwards he embarked on his first trip to America. Beattie had introduced him to the American poet Nathaniel Parker Willis, who had just published one of his more important works. Willis was a popular traveller, who spent much of his time in Europe, being attached for a time to the American Embassy in Paris. Bartlett was a year in the New World, until July 1837, during which time he visited Niagara, stayed at Willis's home in the Susquehanna, and together they toured Wyoming.[5]

Bartlett was allowed only a few days in England before he embarked once more for the Middle East; it is not surprising in view of this, and the memory of his previous ill-health, that he was reluctant to go. The purpose was to follow up the success in 1836 of Julia M. Pardoe's *City of the Sultan*, with views of Constantinople and its neighbourhood. The drawings were ready at the end of 1839 and were published in *The Beauties of the Bosphorus*. Two views from it 'Kaimac Shop in the Tchartchi' (see plate 35) and 'Tomb in the Cemetery of Scutari' (see plate 36) show, on the one hand, his skill in architectural drawing and, on the other, an ability to handle more open landscape work. This assignment lasted until March 1838 and, on the way home, he sketched in Sicily in anticipation of a work on that country, but which did not materialize.

April to December 1838 was spent mainly in Canada. Most of the sketches from this visit were worked up over the next three years, and *Canadian Scenery* with descriptions by N. P. Willis was issued in 1842 in two volumes. Early in 1839 he completed the series of views begun by Thomas Allom for *Scotland Illustrated*, and then worked on the drawings for volume 2 of Beattie's revision of Finden's *The Ports, Harbours . . . of Great Britain*. Bartlett and Willis visited Ireland in June 1839 and, with the help of Joseph Stirling Coyne, publication started in 1840 of a series of 120 illustrations which took two years to complete; the two volumes of *The Scenery and Antiquities of Ireland* were issued by Virtue in 1842.

From the winter of 1839 to March 1841, Bartlett stayed at home with his family, moving in May 1840 to Ramsgate, where he spent his time in company with his wife and children as some compensation for his prolonged absences. He was now at the height of his popularity and powers, but his peace was not to last. March to December 1841 saw him on his third visit to the United States and, early in the

following year, he set off on a European journey that ended late in July 1842. This took him up the Danube,[6] through the Black Forest to the Black Sea, ending at Jerusalem, the prime objective of this tour. A detailed survey of the city had been one of his most cherished ambitions, previously prevented by a civil war, and this visit, marking a turning point in his career, is recorded in the first book to be both written and illustrated by him, *Walks about the City and Environs of Jerusalem.* The first edition, published by Virtue in June 1844 at 10s. 6d., contained only nine steel engravings; by the third edition, published in 1849, the number had risen to twenty-six. He was becoming somewhat critical of the rate of pay given by his publisher, which had not increased commensurately with the greater reputation he had achieved, so the addition of an author's fees to his own as illustrator was an attractive proposition. He describes the situation thus:

My publisher continued to employ me for some years on the same class of publications, all of which were more or less successful, and at a higher rate of remuneration; but one which, owing to the expense of travelling, never enabled me to obtain more than a mere livelihood upon a very economical footing. I did, indeed, contrive to lay by a few hundred pounds in the course of some ten years; but, just as I had done so, the trade, by which the publisher had, after working it successfully for years, already obtained a fortune, became slack; and he was unwilling to enter upon any fresh speculation. It now fell out, as is too often the case with precarious occupations like mine, that the branch I had taken up never gave me enough to lay by even the smallest independence; and I was unable successfully to enter upon any other branch of the profession. I had already been for my publisher on a journey to Palestine, with the view to the publication of a similar serial to the others; but owing to the badness of the times as he said, the work was laid by for the present.[7]

However, the market soon recovered sufficiently for Virtue to publish the book referred to and, at the end of 1846, *The Christian in Palestine* appeared.[8]

For the next two years, he exercised his pen more than his pencil in miscellaneous literary work, but early in 1845 he was off to Ireland again, selecting illustrations for a work by Samuel Carter Hall and Anna Maria Hall, probably for the new edition of *A Week at Killarney* which contained twenty steel engravings after Thomas Creswick and Bartlett.[9] This did not take him long and, since Virtue was obviously reluctant to undertake more projects, Bartlett himself suggested that he visit the Near East again to collect material for further books on the lines of his *Jerusalem.* He landed in Cairo on 8 August 1845 and the result of the journey is recounted in *Forty Days in the Desert, on the Track of the Israelites; or, a Journey from*

PLATE 35 (overleaf) 'Kaimac Shop in the Tchartchi', steel engraving by James Carter, after W. H. Bartlett, from Julia Pardoe's *Beauties of the Bosphorous*, 1840.
PLATE 36 (overleaf) 'Tomb in the Cemetery of Scutari', steel engraving by F. W. Topham after W. H. Bartlett, from Julia Pardoe's *Beauties of the Bosphorous*, 1840.

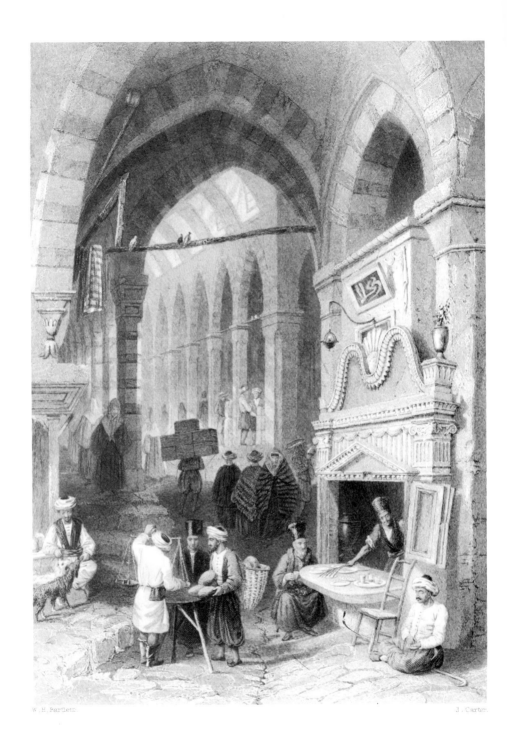

KAIMAC SHOP IN THE TCHARTCHI.

W. H. Bartlett

J. Carter.

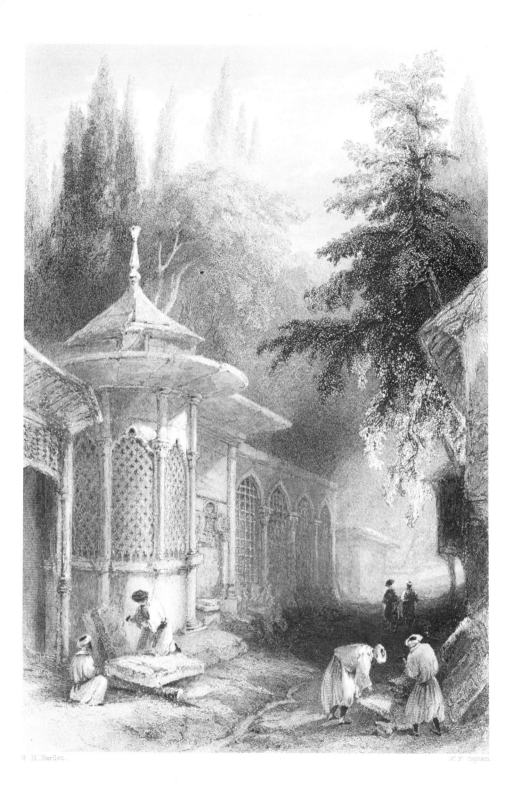

TOMB IN THE CEMETERY OF SCUTARI.

Cairo by Wady Feiran to Mount Sinai and Petra, a book which firmly established his literary reputation. It was quickly followed by *The Nile Boat; or, Glimpses of the Land of Egypt*.[10]

He was home again in November; although his letters from abroad had given no hint, it was obvious that his health had been severely impaired and that he had suffered a great deal. The family accordingly moved to the more salubrious atmosphere of Highgate, the peace of which also gave him more opportunity to follow a literary career. Here, however, he became depressed and disillusioned with 'professional' disappointments. It was only in 1846 that he recovered his spirits sufficiently to visit Wales, in order to draw illustrations for the second volume of Beattie's *The Castles and Abbeys of England*, before going on to Yorkshire in 1847.[11] In 1848, he was occupied supervising the last stages of Virtue's *The Wilkie Gallery: a selection of the best pictures of the late Sir David Wilkie, R.A., including his Spanish and Oriental Sketches, with Notes Biographical and Critical*, to which he may also have contributed some of the letterpress.[12]

He had been contributing to *Sharpe's London Magazine* for some time and in March 1849 he became editor, a post he retained until June 1852. A visit to the Mediterranean in 1850 with one of his sons – taking in Gibraltar, Granada and Malta – resulted in *Gleanings Pictorial and Antiquarian, on the Overland Route*; another such journey the following year led to *Pictures from Sicily*, published in 1852. One of his most popular works, *Footsteps of Our Lord and his Apostles in Syria, Greece and Italy: a Succession of Visits to the Scenes of New Testament Narrative*, containing twenty-three steel engravings, was issued by Virtue in 1851. By 1872, it had run into seven editions, a tribute to Bartlett's ability to tell a good story which was both a diary and a travelogue. Other books in this series had reached four editions before his death, something at least to lift his depression and restore faith in himself. Another volume drawing upon similar material appeared in 1852, when *The Life and Epistles of St. Paul* by the Revd W. J. Conybeare and the Revd J. S. Howson was published by Longman with nineteen of the twenty-six plates after Bartlett (see plate 37). Drawing upon materials gathered from the New World, England and Holland, Bartlett turned his attention to an historical subject, which required a fourth visit to America, undertaken in 1852. The outcome was *The Pilgrim Fathers; or, the Founders of New England in the Reign of James the First*. Another visit to Jerusalem was made in 1853, accompanied by his eldest son and his brother, the Revd F. A. Bartlett, Rector of Newchurch. On their safe return, there was no time for Bartlett to see his material through the press before he was off again. *Jerusalem Revisited* was not issued in his lifetime, the posthumous publication being superintended by his brother towards the end of 1854.

PLATE **37** Steel-engraved title-page to vol. 2 of *The Life and Epistles of St. Paul*, 1852, by the Revd W. J. Conybeare and the Revd J. S. Howson. Original size $11\frac{1}{4}$ by $8\frac{3}{4}$ inches.

THE LIFE

EPISTLES OF ST. PAUL;

The Rev. W. J. Conybeare, M. A. & The Rev. J. S. Howson, M. A.

VOL. II.

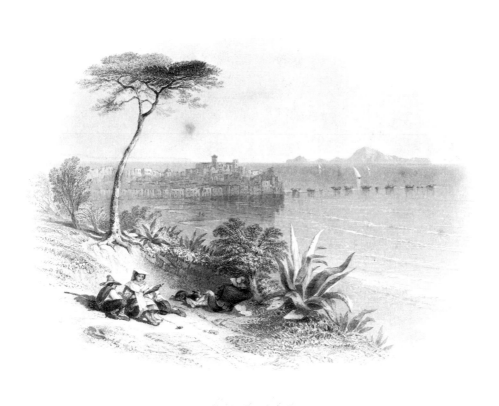

In the spring of 1854, he contracted, with great reluctance, to explore the Seven Churches of Asia Minor. He took leave of his family and friends with a heavy heart. His brother accompanied him once more as far as Strasbourg, and he reached Smyrna on 5 August. But a cholera epidemic cut short his tour; with only fifty drawings in his portfolio, he set off for home on the French mail steamer *Egyptus*. He made the most of a few hours ashore at Malta but once again on board ship he rapidly became ill. He died suddenly on 13 September and was buried at sea the following day. Although his health appeared to be good, despite some pain, it was no doubt largely due to overwork and anxiety that he passed away at the early age of forty-five. By a strange coincidence, Bartlett's companion on a number of his eastern journeys, Mr F. Catherwood, was believed drowned when the *Arctic* steamer sank about the same time.[13]

Bartlett's family was left with little support, but William Beattie's efforts saved them from absolute penury. The preparation and publication by subscription of his *Brief Memoir . . .* of Bartlett attracted orders for at least 281 copies, realizing £400, and his influence with the Prime Minister obtained a pension of £75 a year for the widow.[14] Bartlett's collection of several hundred original drawings was sold by auction early in January 1855 by Southgate and Barrett of Fleet Street, and was regarded at the time as one of the more important and attractive sales.[15]

Bartlett's importance lies in the fact that, although his speed of execution may not have produced the best pictures artistically, he did travel and observe for himself, so that his drawings were faithful representations of scenes as he saw them. He would not rely, as did Turner and others, upon sketches by amateur artists, later worked up for publication. This detailed account of his working life provides one of the best insights we have into the pressures exerted on a book illustrator, engaged by a rather exacting publisher at a time when steel-engraved illustration was at its zenith.[16] About eighty different engravers are known to have interpreted his work, among them all the eminent names, as well as men like H. Adlard, E. Challis, J. J. Hinchcliff and F. W. Topham.

The second group of artists is made up of those whose book illustrations comprised a comparatively minor part of their output. Birmingham produced a small number who were trained side by side with the engravers.

DAVID COX, who was a close friend and contemporary of William Radclyffe, was the most important of these. Born on 29 April 1783, son of a Birmingham blacksmith, Cox early showed an aptitude for art, and for eighteen months was apprenticed to a locket painter. When his master died, he was compelled to earn a living by scene painting for the Birmingham Theatre. But after four years, in 1803, the unsettled life drove him to London, where his acquaintance with John Varley focused his ideas on watercolour painting. At this time, too, he started teaching, in which vocation he was successful throughout his career. In 1808, his only child,

David Cox junior, was born. From 1815 to 1829 he lived at Hereford, and then in London for eleven years. In 1840, he finally moved back to Harborne, when he turned away from watercolour to oil painting. Most of his work was exhibited at the Society of Painters in Water-colours, of which he was a member from 1813. His death, on 7 June 1859, removed one of the foremost artists in this medium from the scene.[17] His most significant contribution to book illustration appeared in the forty-nine designs he drew for Roscoe's two volumes on north and south Wales, 1836 (see page 72), but he had also contributed six designs to Blair's *Graphic Illustrations of Warwickshire* (1829), all of which he owed to the exertions of William and Edward Radclyffe, who engraved the majority of his work. Between 1838 and 1840 three designs appeared, in each of *The Fashionable Guide and Directory* (c. 1840), Wordsworth's *Greece* (1839), and *Heath's Book of Beauty* (1841). His son also contributed designs to some of these volumes. Among Cox's last work were three drawings engraved by Thomas Higham, William Taylor and Henry Wallis for R. M. Martin's *The Indian Empire* issued after 1857, the last one being worked up from a sketch by Capt. R. Elliott, R.N.

HENRY ROOM practised most of his life in Birmingham as a portrait painter. He exhibited regularly at the Royal Academy from 1826, and when he went to live in London in 1830, his portraits of literary and artistic figures began to appear in books, chiefly as frontispieces. A series of portraits appeared in the *Evangelical Magazine*, but one of his earliest frontispieces (see plate 38) engraved by James Thomson, was of Julia Pardoe[18] and was published in 1840 in her *Beauties of the Bosphorus* (see above, page 114). James Thomson also cut Allan Cunningham's portrait for the *Complete Works of Robert Burns* (c. 1842); H. B. Holl engraved Bartlett's portrait (see plate 33, page 111), and John Rogers executed William Beattie's likeness (see plate 34, page 112). Room's most attractive work was 'The Hamlet's Pride'; it is dated November 1845 and was engraved by W. Edwards for *The Beauties of Moore*. All four engravers specialized in portrait work and, with the exception of John Rogers, most of their output was done for the printsellers, not books. At one time, Room was secretary of the reformed Birmingham Society of Artists, of which he was an original member.[19]

THOMAS CRESWICK, the last of the Birmingham group, was born in Sheffield on 5 February 1811. His father moved to Birmingham following his trade of cutler, and Thomas was sent to the art schools run by Barber and Lines to become a painter. In 1828, when he was only seventeen, he moved to St Pancras in London, and was soon exhibiting his landscapes, mainly of northern England and Wales, at the Royal Academy and British Institution. A series of oil studies resulted from an extended tour in Scotland, undertaken in 1839. By 1842, his name was sufficiently well known to secure him election as Associate of the Royal Academy. He reached the zenith of his career in 1847, was elected an Academician in 1850, but by 1856,

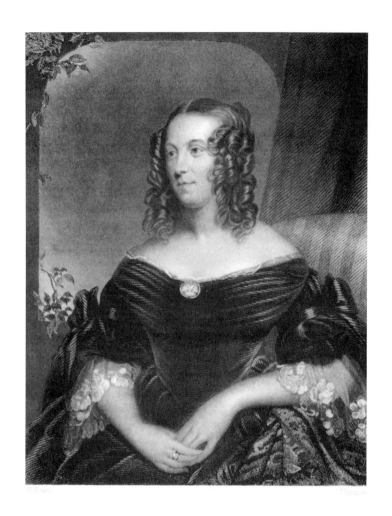

H. Room J. Thomson

LONDON GEORGE VIRTUE.

the quality of his productions had fallen off. When his house at Linden Grove, Bayswater, which he had occupied since 1836, was threatened by the construction of a railway nearby, Creswick built himself a six-roomed cottage with very little garden at The Grove, Notting Hill. His wife was also a painter, concentrating on flower studies. He was taken ill early in 1868, and died on 28 December 1869. His collection of pictures and about one hundred of his sketches were sold at Christie's on 6 May 1870. The Royal Academy instituted a Creswick Prize after him; in 1891, it was worth thirty pounds. His steel-engraved book illustrations, the more important being those of Ireland, are scattered throughout a number of books; eighteen first appeared in *Heath's Picturesque Annual for 1837*, and were reissued, with others, in *Ireland: its Scenery, Character, &c. by Mr. and Mrs. S. C. Hall* (1841–3). Twelve of his drawings were engraved for Leitch Ritchie's *The Wye* (1839), published by Longman. *American Scenery* (1840) contained a few of his illustrations, but among his earliest work were the seven plates engraved by William Radclyffe for Roscoe's *Wanderings and Excursions in North Wales* (1836). Of these, the best were 'Bettws y Coed', 'South-Stack lighthouse near Holyhead' and 'On the River Mawddach near the Cataract'. He drew some illustrations to the works of Scott, Moore, Burns and Byron, notably the five workings of designs by amateurs and three of his own for Byron's *Childe Harold's Pilgrimage*, published by Murray in 1841. Of these, 'Ouchy – Lausanne' is outstanding, and his drawing of 'Ehrenbreitstein' after a sketch by Lieut. Allen invites comparison with Turner's picture of the same subject done for John Pye. The engravings in this volume were executed by the Finden studio.[20]

Cox and Creswick represent a class of painter whose talents were most sought after by the book publishers. There is no doubt that landscapes were by far the most popular subjects for book illustration, and it is not surprising that this group of landscape painters is the largest, containing also the most important names.

JOSEPH MALLORD WILLIAM TURNER, the eldest, was by far the greatest of the contemporary painters to take an interest in steel engraving as a means of reproducing his work. This has been so thoroughly investigated by W. G. Rawlinson,[21] that any detailed comment is superfluous, indeed, impertinent, in this present study. It was made apparent in Chapter 6 how far his illustrations permeated the whole period, and an indication of his relations with engravers is given in his encounter with Willmore (see above, page 76). William Radclyffe of Birmingham was paid the signal compliment of a visit from Turner whenever the painter was in that vicinity.

He had been illustrating books from the beginning of the century – one of his

PLATE **38** Julia Pardoe (1806–62), frontispiece, steel-engraved by James Thomson after Henry Room, to her *Beauties of the Bosphorous*, 1840.

earliest uses of steel was for some of the mezzotints in his *Liber Studiorum* – but by 1836, with the last of his drawings for the *Picturesque Views in England and Wales* series, his work for the engravers was virtually at an end. Probably his last work was a title-page vignette for an edition of Bunyan's *Pilgrim's Progress* published in 1847. His engraved work during this period occupied most of his time, produced most of his income and consisted of about 500 plates. Such an output kept active a whole army of engravers who, in some cases, were driven to despair by Turner's continual supervision, involving alterations to successive proofs and even modification of the original picture so that the engraving should profit. This habit shows itself in the faulty technique of many of his later drawings; Turner has been criticized for undertaking, despite his age and position, the illustration of such volumes as Campbell's *Poems* and Moore's *Poems*, as well as working from the sketches of other men for *Finden's Landscape Illustrations of the Bible* (1837).[22] Some of Turner's illustrations produced for the annuals did less than justice to his work. The first of his steel line engravings was published in the *Literary Souvenir* for 1826, and 'Richmond Hill', which appeared opposite page 39, was 'drawn expressly for this work'[23] and engraved by Edward Goodall. 'Bolton Abbey, Wharfedale', which appeared opposite page 313 of the same volume, was engraved by Edward Finden. After Turner had contributed regularly to *The Keepsake*, *The Amulet* and similar annuals, *Turner's Annual Tour* was published by Longman, with text by Leitch Ritchie, containing, on average, twenty illustrations by Turner. Although some first-class engravers were employed, the resulting small prints were, for whatever reason, of very poor quality. The volume for 1835, *Wanderings by the Seine from Rouen to the Source*, contains engravings which are remarkable for the sky effects, incorporating shafts of light through dark clouds, rainbows, etc. The series of drawings for frontispieces and title-page vignettes to accompany Cadell's twelve-volume edition of the *Poetical Works of Sir Walter Scott* (1833–4) are also well known. When the Novar collection, put together by Hugh A. J. Munro of Novar, was sold on 2 June 1877, among the fifty-five Turner drawings, most of which were made for engravings, was one for 'Johnny Armstrong's Tower'. This was the title-page vignette for volume 2, engraved by Edward Goodall, which fetched £399; and 'Nervack Castle' for volume 6 brought in £406.[24] One of his engravers, J. C. Armytage, recalled the concern Turner showed for the safety of his drawings. Armytage had called at Turner's house to apologize for the late return of proofs of plates for a volume of *Turner's Annual Tour*, which he was submitting for approval, only to find the painter much more concerned to get his originals back. According to a bargain struck between him and Charles Heath, Turner was to retain the drawings.[25]

Turner's personal relationships never seem to have been very happy ones, and the following incident concerning one of his prints illustrates other people's reactions to him, despite his acknowledged eminence. One of the better printsellers kept a shop in Rathbone Place, London; he was an admirer of Turner's work and

never omitted an opportunity to acquire copies of the artist's *Liber Studiorum* plates. One such came into his possession much damaged, stained and in generally poor condition. He had little hesitation, therefore, in exposing it in his shop window, thinking it could come to little more harm than it had already suffered.

... passing one day, Turner saw the damaged print, bounced into the shop, and fell foul of the printseller. 'It's a confounded shame to treat an engraving like that!', pointing to the window. 'What can you be thinking about to go and destroy a good thing – for it *is* a good thing, mind you!'

'*I* destroy it!' said the shopman in a rage. 'What do you mean by saying I destroyed it? and who the devil are you, I should like to know? I didn't ask you to buy it, did I? You don't look as if you could understand a good print when you see one. *I* destroy it! Bless my soul, I bought it just as it is, and I would rather keep it till Doomsday than sell it to you; and why you should put yourself out about it, I can't think.'

'Why, I did it,' said Turner.

'Did what! – did you spoil it? If you did you deserve –'

'No, no, man, my name's Turner, and I did the drawing, and engraved the plate from it.'

'Bless my soul!' exclaimed the printseller. 'Is it possible that you are the great Turner? Well, sir, I have long desired to see you; and now that I have seen you, I hope I shall never see you again, for a more disagreeable person I have seldom met.'[26]

SAMUEL PROUT, after a bad start with John Britton early in the nineteenth century, eventually became one of his assistants and went on to be an important exponent of architecture and landscape, particularly on the Continent. He was 'Painter in water colours in ordinary to His Majesty' in 1830, and royal patronage was further extended to him by Queen Victoria and the Prince Consort. This is all the more remarkable since he suffered a great deal from migraine and short-sightedness. He first visited France in 1818, went to Venice in 1824, and in subsequent annual tours, visited most of France, Germany, Switzerland and Italy. This, in Ruskin's view, made him the chronicler of European cities before they were destroyed by rebuilding programmes.

The core of his steel-engraved work consists of sixty-five plates distributed throughout three books published between 1829 and 1831. The first of these was Thomas Roscoe's *The Tourist in Switzerland and Italy*, which contained twenty-six engravings, most of them dated 28 October 1829, and although first-class engravers such as Miller, Willmore, Brandard, Wallis and Heath were employed, many of the plates lack fine feeling, were heavily etched and give the impression of haste. Charles Heath, who already had a great deal of work on hand, superintended the plates, so it is probable that the supervision was not as good as it ought to have been. The plates, moreover, were printed by Fenner, Sears and Co., who were not able to give them the best of attention. The following year came Roscoe's

The Tourist in Italy, containing a further twenty-six engravings, most of which are dated 28 October 1830. In 1832, thirteen engravings appeared in the *Continental Annual*, which this time were engraved under the superintendence of E. J. Roberts and printed by Brain.[27] Prout also contributed pictures to some of the other annuals, for example *The Keepsake* from 1830 and the *Forget me not*. Then followed designs for *Finden's Illustrations of the Life and Works of Lord Byron* (1833–4), Rogers's *Italy* (1830), Brockedon's *Italy* (1842), several Indian scenes from Martin's *Indian Empire*, and a drawing of Melrose Abbey to illustrate Scott's *Works*, together with a picture of Coldingham, worked up from a sketch by J. Skene. Prout's virtual abandonment of steel engraving at the end of the 1830s was a result of his interest in lithography, a process which he, with Roberts and others, used increasingly.

WILLIAM BROCKEDON, like Prout, was a Devonian, and while still in his teens, kept the family watchmaking business in Totnes going for five years after his father's death. He left to study in the Royal Academy Schools in 1809 and, after an experimental period, settled down to paint historical pictures. In the summers of 1821 and 1822 he went to Italy, spending a winter in Rome, and it was from this visit that most of his steel-engraved work derives. The *Literary Souvenir* for 1825 contains two topographical drawings, 'France – Lyons' (page 187) and 'Spain – Fortress of Saguntum' (page 259), engraved by Edward Finden, as well as a 'Mother and child' (page 64), engraved by William Humphrys. Brockedon's first major work, of which he was author, artist and publisher was *Illustrations of the Passes of the Alps by which Italy communicates with France, Switzerland and Germany* (1828–9). It contained ninety-five of his designs, one of the best being 'Lake of Orta', published 1 November 1829. Then followed *Journal of Excursions in the Alps*, and in 1833–4 he supplied the 'original and selected information on the subjects of the engravings' for *Finden's Illustrations of the Life and Works of Lord Byron* (see above, page 88). He contributed only one plate to it, that of 'Countess Guiccioli' in volume 2, page 117, engraved by Henry Thomas Ryall, which was one of the few book illustrations by this eminent engraver. His *Road-book of the Route from London to Naples* commenced publication in parts in 1831, to which Prout and Stanfield also contributed some of the twenty-four views, all engraved by the Findens. His last important work on Italy was *Italy, Historical, Classical and Picturesque*, which began publication on 1 February 1842. Twenty-four monthly parts were planned, and it was completed at the end of 1843. The publishers were Duncan and Malcolm with Blackie and Son, and when, in 1864, the latter firm alone produced another edition, the publisher's preface was critical of the original title, calling it 'less appropriate' than the new one, *Italy, Illustrated and Described*.[28] His last work appeared in Dudley Costello's *Piedmont and Italy from the Alps to the Tiber*, published by James Virtue sometime after 1855. Although it reprinted many plates from the annuals and Beattie's *Switzerland*, this publication contained some fresh work by

Brockedon. He devoted his later years to science rather than art, and amassed a small fortune from his inventions, which included a rest, or form of easel, for painters doing fine work.

DAVID ROBERTS was born the son of a shoemaker and the eldest of five children (three of whom died in infancy) in Church Lane, Stockbridge, near Edinburgh. After a very unhappy schooling, he was apprenticed for seven years to Gavin Beugo, a house painter or interior decorator. He and his fellow apprentices were keen enough to set up their own 'life academy', and thus he became reasonably proficient in the finer points of painting though without the advantages of formal tuition. In 1816, he executed his first scenery paintings for a circus, and then graduated via several theatre companies to Drury Lane and Covent Garden, where he was employed from the autumn of 1826. He married in 1820, and in the next year met Stanfield, the two men becoming firm friends although they were rivals in their work. Stanfield encouraged him to paint seriously, and David's first works were exhibited in 1822. In 1823, they both joined the newly formed Society of British Artists, other members of which included the engravers Heath, Burnet and Meyer. In 1826, Roberts sent his first pictures to the Royal Academy.

His visit up the Rhine in the summer of 1830 was cut short by the three-day revolution, but some of his drawings were used to illustrate Bulwer-Lytton's *The Pilgrims of the Rhine* (1832). Early in 1832, a series was drawn for the *Continental Annual*, for which he was paid £280. During the summer of the same year, he planned the visit which inspired the greater part of his steel-engraved work. He had intended to visit Italy (which he eventually saw in 1851), but changed his mind at the last moment on the advice of his friend and compatriot David Wilkie, turning his attention to Spain. His reason is given in a letter to another friend, David Hay, dated 28 June 1832: 'I think on altering my route from Italy to Spain, as nothing has been done that gives any idea of the magnificent remains of the Moorish architecture which are there.' He left London on 17 October, reached Madrid on 16 December and in March and April of 1833, went to Tangier, the first artist (so he believed) to have visited the North African coast. An outbreak of cholera hastened his departure; he landed at Falmouth on 22 October. His return caused some interest in artistic circles – on 1 November he was writing to Hay: 'I am already waylaid by publishers, and my terms will be of my own making.' Within twenty-four days he had accepted an offer from the publisher Robert Jennings. Another letter dated 25 November says:

My dear Hay – I have just concluded an engagement to do the illustrations for the *Landscape Annual* for next year, consisting of twenty drawings and a vignette, for which I am to receive four hundred and twenty pounds, and to have the choice of my own engravers. This I incline to think is the highest price any artist, with the exception of Turner, has received for drawings of a similar nature. My journey has been expensive, and my risks not few; but the

subjects I have selected and drawn stagger all who see them, and are deeply interesting in a historical as well as a pictorial point of view.

These drawings were done in the summer of 1834, and nine further vignettes were added for the same remuneration. When it appeared, Roscoe's *Tourist in Spain: Granada* (1835) contained twenty-one steel engravings and ten on wood. A review in the *Athenaeum* remarked: 'The scenes are treated with consummate skill by the painter, and translated no less excellently by the engraver.' Four drawings were made for *Finden's Landscape Illustrations of the Bible*, and 'Ruins', engraved by Robert Wallis, for the *Literary Souvenir* (1835).

The summer of 1835 was spent in preparing twenty-one views, chiefly of Andalusia, for the 1836 volume of the *Landscape Annual*. Jennings paid £420 for these but for the additional wood-engraved vignettes Roberts received an extra £50. The first edition of 5,000 copies was sold out soon after publication in October, as was a second printing of 2,000, but the publisher further added to his profit by selling the original drawings for £40 each, double what he had paid for them. Thomas Roscoe, the author of the text, acknowledged 'that for much of the information comprised in the notes . . . the author is indebted to the personal observations of the [artist]'. For the 1837 volume, he was paid £25 a drawing, most of which had been completed by the end of March, and for the fourth and final volume in the series, he provided twenty drawings, published as *The Tourist in Spain and Morocco* (1838). He had completed these by June 1837, was paid £500 'and to render the work as complete as possible, he made many of the drawings from sketches by his friends, Lieutenants Smith and Eldridge, Colonel Harding and Richard Ford.'

In the summer of 1836, he had contracted with Hodgson and Graves to make twenty-six large drawings of Spanish subjects 'to be engraved on stone' for £350. These were eventually published as *Picturesque Views in Spain*, and it was this experience which began his long association with lithography and accounts for his rather abrupt abandonment of steel engraving. But the final break came when he returned from his trip to Palestine in July 1839, as described in his journal:

Previously to my leaving for the East, I had promised to give Messrs Finden the refusal of the work, and on my return, after having arranged the form in which it was to be brought out, these gentlemen promised to let me know what terms they would give me for the copyright and use of the drawings. After having waited four months without having received any offer from them, I applied to Mr. Murray, who at first agreed to my proposal; but after calculating the outlay (£10,000) told me the risk was too great. I had been applied to by Mr. Moon, whom I made acquainted with all the circumstances, and he at once agreed to bring out the work in the manner I had proposed – viz. two volumes on Syria containing 120 subjects, price £21; two volumes on Egypt, containing 120 subjects, price £21; and one volume on modern Cairo, containing sixty subjects, price £10. 10s. – in all,

£52. 10s. I was to be paid £3,000 for the use of the drawings. This was a great risk on the publisher's part; but by exhibiting the drawings in London and other principal towns, his subscription list in May 1841 was nearly double Murray's estimate of cost.

The larger size and use of colour doubtless attracted the extra subscribers, who could see a future for this fresh means of picture reproduction. They were finally lithographed by Louis Haghe, the Belgian artist, with whom Roberts became very friendly, to the extent of going abroad with him, accompanied by Louis's brother Charles.

His work was recognized in 1839 by his election to Associateship of the Royal Academy, and to full member on 10 February 1841. Edinburgh honoured him with a public banquet in 1842, and the freedom of the city in 1858.

J. Hogarth asked him to do forty drawings for £1,000 in the summer of 1846, which appeared as *Scotland Illustrated.* It was not very successful, and Robert Cadell the publisher wrote in a letter: '*Scotland delineated* [sic] is most creditable, but . . . it is rather late; [and] too dear . . . our own dear land . . . has been hackneyed from Fisher and Company upwards. The mind of the . . . public . . . is diseased, and has been so for over fifteen years at least, and he is a clever fellow who can tickle the brute's ear!'

Roberts left the fortune made from his illustrated works to his only daughter Christine (Mrs Henry Bicknell). The last of his steel-engraved works to appear was 'Baalbec (Ruins of the Temple of the Sun)', engraved by John Pye and dated 4 April 1849 in Finden's *Royal Gallery of British Art.* Two versions of this picture were exhibited at the Royal Academy in 1846.[29]

WILLIAM CLARKSON STANFIELD was born in Sunderland of Irish parents, his father being an actor. When quite young, he went to sea and served for some time in the Navy. In his spare time he sketched ships and seascapes, his artistic ability was noticed and on one occasion he was asked to paint the scenery for a play enacted by the ship's crew. He was discharged after a fall, and from 1818 to 1829 he was engaged at various theatres as a scene painter, ending up at Drury Lane. He first exhibited his marine paintings in 1823 and did so well in the next six years that he was able to devote his whole energies to it. By 1832 he was an Associate of the Royal Academy and was made a full member in 1835.

His first steel-engraved book work appeared in *The Anniversary* (1829), to which he supplied a title-page vignette, engraved by William Raymond Smith and dated 1 November 1828, with the 'Castle of Chillon' (page 164) engraved by Robert Wallis, dated 1 October 1828.

His first Continental visit was in 1830, the immediate result of which was twenty-six drawings for the 1832 volume of *Heath's Picturesque Annual*, devoted to the scenery of the north of Italy, Tyrol and the Rhine. The 1833 volume contained twenty-six further sketches of the Rhine, Belgium and Holland. The engraving

'Rotterdam' is from this volume (see plate 60, page 195). In 1834, the sea coasts of France provided subjects for twenty-one drawings, and together, these seventy-three plates represent the core of his steel-engraved work.[30] Twenty-two engravers were employed, led by Robert Wallis (sixteen plates), J. T. Willmore (nine plates), Robert Brandard (eight plates) and William Miller (five plates). For *Finden's Illustrations of the Life and Works of Lord Byron* (1833–4) he provided nineteen pictures, five of which were his own, nine after sketches by W. Page, two after Capt. Elliott and one each after Capt. Roberts, Dr Holland and Gen. Sir Samuel Hawker. *The Keepsake* for 1833 contained his 'Verrex in the Val d'Aosta', engraved by Charles Heath, and fifty-two of his drawings appeared in the edition of Scott's *Works* published in the same year. Fourteen engravers were employed on them. The pinnacle of his book illustration work was reached in 1836, when forty large plates were published by Smith, Elder and Co. as *Stanfield's Coast scenery. A Series of Views in the British Channel.* 'Dartmouth', engraved by J. B. Allen, is particularly outstanding. Two of his compositions were engraved for Finden's *Royal Gallery of British Art.* The 'Battle of Trafalgar', engraved by William Miller (1 November 1839) was commissioned by the United Services Club and exhibited at the Royal Academy in 1836, and the 'Day after the Wreck' was engraved by John Cousen in 1847.

The greater part of 1839 was spent in Italy, providing himself with material to last several years. In the summer of 1841, he was in Scotland, drawing scenes for Cadell's Abbotsford edition of Scott's Waverley novels. Part 1 was published on Saturday, 30 April 1842; ultimately the edition contained nearly 100 steel engravings. Apart from some drawings in Brockedon's *Italy* (1842) and Martin's *Indian Empire* (c. 1857), his major excursion into book illustration was over. A few of his later continental views were lithographed, but he did not use the medium extensively.

He died on 18 May 1867. When his oil and watercolour sketches were sold by Christie's, in May 1868, they realized a very considerable sum.[31]

JAMES DUFFIELD HARDING, the last of the important landscape painters, was born at Deptford. He took after his father, a pupil of Paul Sandby, an artist and a teacher. In his early teens he was articled to an attorney and then for a year to Charles Pye, the engraver. He regarded engraving as a 'painful drudgery', so that when Pye moved to Upton near Windsor, Harding refused to go with him and promptly turned to painting. In 1818, he was awarded a silver medal by the Society of Arts for an original landscape and in the same year he was elected to the Society of Painters in Water-colours. Soon after his election to full membership of the Society, in 1822, he took up the teaching of drawing, for which purpose he wrote several books, including *Lessons on Art.* Among his earliest book illustrations were three for Blair's *Graphic Illustrations of Warwickshire*, all engraved by William

Radclyffe. These were 'Charlecote', dated 27 March 1827, 'Sutton Coldfield from the Park', dated 3 December 1827, and 'Tamworth', dated 1 December 1828. For the same engraver, Harding also produced a title-page vignette of St Govan's Head, Pembrokeshire, which appeared in Roscoe's *Wanderings and Excursions in South Wales* (1836). At the end of 1830, he had three months in Italy on a commission for Robert Jennings, the results of which are to be found in the fourth volume of the *Landscape Annual* for 1833, published in October 1832, containing twenty-six engravings. The next volume had another twenty-six illustrations of France by him, one of the best plates being 'Avignon', engraved by J. T. Willmore. Seventeen illustrations were contributed to *Finden's Illustrations of the Life and Works of Lord Byron* (1833–4) and when, in 1840, *Heath's Picturesque Annual* was devoted to Windsor Castle, with text by Leitch Ritchie, ten of the fifteen designs were by Harding. Finally, in 1842, thirteen drawings appeared in the first volume of Beattie's *The Ports, Harbours . . . of Great Britain*, and two were issued in Brockedon's *Italy*. In common with David Roberts, the greater attractions of lithography ended his steel-engraved work and it has been said that his publications did much to stimulate and improve the process, despite his shortcomings as an artist. One of his earliest lithographs was Turner's 'View of Leeds', which appeared in Hullmandel's catalogue for 1824. He received two gold medals from the Académie des Beaux Arts for lithographs exhibited in Paris and a magnificent diamond ring from Louis Philippe, to whom he dedicated his lithographically illustrated *Sketches at Home and Abroad* in 1836.[32]

The remaining artists in this group were slightly younger, and although Egg and Ward contributed their share, it was the early work of the youngest which was outstanding.

WILLIAM POWELL FRITH was born at Studley, Ripon, Yorkshire, and studied art from the age of sixteen (1835) at Mr Sass's Academy, Bloomsbury Street, London, which he left in 1838. By 1841 he was exhibiting at the Royal Academy, and taking much of his inspiration from literature, especially Shakespeare, Goldsmith and Dickens, it was not surprising that his picture 'The Village Pastor' from Goldsmith's *Deserted Village*, engraved by Francis Holl, earned him election as Associate of the Royal Academy in 1845 at the age of twenty-four, on Thomas Creswick's nomination. Most of his book illustration was done at this time, commencing with ten 'beauties' for *The Beauties of Moore*, probably his best work in this vein.[33] The young ladies portrayed were 'Black and Blue Eyes', 'The Exile', 'The Pensive Thought' (all engraved by W. Edwards), 'Anna', 'Lesbia', 'Love's Summer Cloud' (all engraved by William Holl), 'Nora Creina', 'The Morning of Life', 'Laughing Eyes' (all engraved by Edward Finden) and 'Sleeping Beauty', an exquisite plate engraved by W. H. Mote. They were published between March and November 1845. In *My Autobiography*, the artist recalls this venture of the Findens to rival *Heath's Book of Beauty*, and goes on:

A number of young artists living in intimate intercourse – myself, Egg, Elmore, Ward, and others – agreed to contribute. The sums we received for each picture varied from £10 to £15. 'Lesbia', 'Nora Creina', 'Wicked Eyes', and 'Holy Eyes', and many more fell to me – so many, indeed, that I used up all the pretty models, and any of my well-favoured friends that I could persuade to sit. 'Holy Eyes' became a great difficulty. None of our models had features or expressions that could help one to realize Moore's beautiful lines:

> Some looks there are so holy,
>> They seem but given
> As shining beacons solely
>> To light to Heaven.

Nor could I discover among my acquaintances a form that would assist me. On telling a friend of my difficulty, he said 'I think can introduce you to a young lady who would be exactly what you want.'

The friend's doctor, Dr Rose, had recently married a beautiful nineteen-year-old girl, whom the artist met at dinner. She was perfect for his purpose and, in due course, sittings began. Late one night, Dr Rose appeared in a distressed state on Frith's doorstep, saying that his wife was a drunkard, a fact he was unable to detect easily since he had lost his sense of smell. Rose swore that she must go, but between them, Frith and a lawyer persuaded him to send her to an institution in Bridgwater to 'dry out'. At the end of eighteen months, the process duly completed, she returned home and signed an undertaking never to touch strong drink again, except with her husband's permission. After only six weeks, Rose found her drunk once more and promptly brought Frith and the lawyer to witness her degradation for themselves. Returning to the doctor's house, his wife was nowhere to be seen, so Rose went in search of her.

In a few moments we heard a cry that literally froze my blood. We rushed from the room. The cry was repeated, and a voice added, 'Come here – come here!' We descended the stairs, and met a frightened footman, who pointed to the surgery. We entered and found Rose on his knees by the dead body of his wife. The smell of prussic acid that seemed to fill the surgery told the fate of the miserable girl'.[34]

This affecting story had a peculiar sequel. When the book was published 'Holy Eyes' had been painted by J. G. Middleton and engraved by Francis Holl. Whether Frith could not bear to finish the portrait or whether the engraved plate is a portrait of Mrs Rose will remain a mystery. Frith, incidentally, recompensed his sitters with proof engravings of his pictures and, in one sad instance, a young lady waited three years, receiving it just before her death from consumption.[35] 'The Duel', an illustration to Shakespeare's *Twelfth Night*, engraved by John Brain, first appeared in S. C. Hall's *Gems of European Art* (1846) and was used in 1872 for Charles Knight's Imperial edition of Shakespeare. In 1847 he contributed 'Aurora

Raby', engraved by W. H. Mote to *Heath's Book of Beauty*. In the same year, his 'Adelaide' was the frontispiece to *The Keepsake* and the *Heroines of Shakespeare* (1848) included his 'Olivia' (see plate 1, page 5) and 'Audrey', both engraved by Mote. When his election as R.A. was announced in 1852, this added to his already very fashionable reputation and he was able to devote himself to the production of large works such as 'Derby Day' and 'The Railway Station'. These were much sought after for engraving by the printsellers; the latter, engraved on a large steel plate, was published by Henry Graves.[36] He preferred reproductions of his work to be engraved, but even so, he admitted that lithographs, which had been done by Maguire, an old student friend of his, had produced the most faithful transcripts.[37] Frith died at the advanced age of ninety on 2 November 1909.

The landscape artists also relied heavily on the work of amateurs who prepared sketches on the spot to be worked up for publication. Many of these amateurs were serving officers of the Armed Forces whose duties took them to inaccessible places; as they adopted watercolour painting for relaxation, a wide range of material was available to the illustrators. The Hon. Capt. W. E. Fitzmaurice produced pictures of Palestine, Capt. Grindlay of India, and Major Irton of Greece, while Lt.-Col. Peter Hawker confined himself to his hobby of shooting. Capt. Robert Elliott, R.N., however, well-known as a painter of marine subjects at the end of the eighteenth century, supplied landscape artists with sketches of his travels, some of which were later engraved and published together. Henry Fisher brought out his major work, *Views in the East*, in parts between 1830 and 1833, plates of which were reissued in Emma Roberts's *Hindostan* (1850).

The most celebrated amateur was Lt.-Col. Robert Batty, who came from an artistic background. His father, a physician, was a keen amateur artist, and his sister shared an interest in Italy, first aroused in Robert when he was fifteen. He took a degree in medicine at Cambridge but entered the Army, first going into print with his accounts of the 1813–15 campaigns. He visited Spain alone, made some accurate views of Madrid, none of which appeared in his lifetime, and in 1819 executed drawings in France which were published by Rodwell and Martin in *French Scenery* (1822). *German Scenery*, drawn in 1820, came out in 1823, as did *Welsh Scenery*, issued by Murray and containing thirty-five views, all engraved by Edward Finden. This was republished in 1825 by Robert Jennings, such was its popularity. *Scenery of the Rhine, Belgium and Holland*, with sixty-two views, followed in 1826; *Hanoverian, Saxon and Danish Scenery*, also with sixty-two views, in 1829, and *Six Views of Brussels* in 1830, all issued by Robert Jennings. He illustrated *A Family Tour through South Holland*, with text by his father-in-law, Sir John Barrow, and published by Murray in 1831. His last works in this vein were *Scenery in India* and *Select Views of the Principal Cities of Europe*, published by Moon, Boys and Graves in 1832. He also contributed to Samuel Rogers's *Italy* (1830) and *Finden's Illustrations of the Life and Works of Lord Byron* (1833–4). When Josi retired as Keeper of Prints at the

British Museum in 1845, Batty stood as a rival to Carpenter, who was appointed to succeed. He died of paralysis on 20 November 1848.[38]

The fashionable artists were paid scant attention by the book publishers and the artists themselves preferred to treat with the printsellers. As a result, apart from Lawrence and Landseer, many contemporary artists are badly represented. The work of Sir Thomas Lawrence, chiefly his portraits, was reproduced in the annuals – notably *The Amulet*, *The Keepsake*, and *Literary Souvenir* – until his death in 1830. Engraved by Heath and the Findens, his work afterwards appeared in books such as Browne's *History of the Highlands* (*c.* 1845), and Baines's *History of . . . Lancaster* (1836). Sir Edwin Landseer's pictures, also popular with the annuals, were mainly from his early period; scenes such as 'The Highland Breakfast Party' were favourites. The animal pictures, which became so characteristic of his later work (and which called forth the exclamation of 'Mon Dieu, encore des chiens!' from two French visitors surveying the wares of the Pall Mall printsellers),[39] were represented only occasionally, for example, by Benjamin Phelps Gibbon's engraving of 'The Travelled Monkey' in *The Anniversary* (1829).

CHAPTER EIGHT · The books

The part played in the production of the steel-engraved book by the engraver, artist and, to some extent, the author, has been outlined in the preceding chapters. As some discovered to their cost, the publishing of these books was no easy matter, involving the outlay of large sums of money with no guarantee of an immediate return, let alone a profit. It was important, as the publishers well knew, to produce the right kind of book in order to secure good financial returns, and, where professional judgement was accurate, rewards could be considerable.

The most popular kind of illustrated book by far was that containing views, mainly topographical works. The illustrations of Constantinople and the Near East, Palestine, India, China, Spain, Switzerland, Italy, France, the Low Countries, North America and Germany were all reworked time after time, but the attention devoted to the British Isles in its regional, mountain and coastal scenery was even greater. This latter was a continuation of the early nineteenth-century interest in such topics. Antiquities, described by men such as John Britton, formed an offshoot to this category, concentrating as they did on buildings rather than scenery. Such works frequently contained up to 120 plates each and the text was merely a description of the scenes, with no independent existence of its own. The work would normally be sold at about a guinea for each of several volumes with forty or so plates in each.

The next largest category was literature, chiefly English, with poetry as the most popular. The romantic poets such as Campbell, Burns, Byron and Moore were among the main texts illustrated; in prose, Scott and Bunyan led the field. Editions of Shakespeare, too, produced many imaginative illustrations. In addition to texts with specially designed engravings, publishers issued series of illustrations for binding into any contemporary edition. A few copies of the plates from the *Landscape Annual*, published from 1830 to 1839, were printed each year on large paper illustrating, for example, Byron's *Works*, Rogers's *Italy* (although it had its own vignettes), *Eustace*, etc., ranging from two guineas for the ordinary prints to five guineas for proofs on India paper with the etchings. Smith, Elder and Co., about 1844, was offering for 21s. the *Byron Gallery*, 'a series of 36 historical embellishments to illustrate the poetical works of Lord Byron ... adapted by their size and excellence to bind up with and embellish every edition published in England of

Lord Byron's Works, and also the various sizes and editions published in France, Germany and America; ample directions being given for placing them in the respective editions.' It was 'in a new and elegant binding, forming a splendid ornament for the Drawing-Room table.'[1] In 1832, Charles Tilt published *Landscape and Portrait Illustrations of the Waverley Novels* in three volumes at a guinea each, containing in all, 120 steel engravings 'of a suitable size to bind with the new edition of the Waverley novels, but for those who prefer them in a separate form, are accompanied by descriptions of each subject.' The new edition referred to was the forty-eight volume set published by Robert Cadell between 1829 and 1834, and which contained only a frontispiece and engraved title-page in each volume. Nine years later, Fisher did much the same thing 'designed to serve as embellishments to the various editions, or as a separate work.'[2] How and Parsons produced the *Landscape, Historical-landscape and Architectural Illustrations to the Works of Shakespeare* in 1841–2, where a total of eighty steel engravings after designs by G. F. Sargent were to 'be printed in such a size as to bind up with any of the editions of Shakespeare now publishing of a larger size than foolscap 8vo.'[3]

The third category comprised art books, nearly all of which were constructed around paintings by old and modern masters and contained a minimum of text. When issued by book publishers, such books were reasonably priced. For instance, S. C. Hall's *Gems of European Art*, published in two volumes between 1844 and 1846 by Virtue, contained ninety plates, averaging $8\frac{1}{2}$ by 6 inches, and sold for five pounds. When published by the printsellers, the price was much higher. For example, Rudolf Ackermann's *Engravings after the Best Pictures of the Great Masters* (1840–5) had only twenty plates, each measuring $13\frac{1}{2}$ by $9\frac{1}{2}$ inches, and sold for five guineas. Only about a quarter of the plates were done on steel, the remainder being on copper, all by Edinburgh engravers, the most important being William Forrest and including William Miller.

The temptation to reissue plates from the *Art Journal* in book form was irresistible, and some books were made up wholly or in part of such engravings. The first steel engraving to appear in the *Art Union* (the predecessor of the *Art Journal*) was of 'Leicester Abbey' from the Shakespeare illustrations published by How and Parsons, and about fifteen more were used in book advertisements before 'original' plates were begun in August 1847. An average of thirty-six plates on steel a year were issued until 1865, when some etchings by the 'new' school were included, and a drastic cut was made in 1885 when the price was reduced to 1s. 6d. a month, resulting in only twelve plates a year. The last steel engraving was published in 1890. Chapman and Hall were the publishers when the 'original' plates commenced, but in January 1849 a change of title to *Art Journal* and of publisher to George Virtue represented a break with the old style of periodical. Virtue continued a Chapman and Hall idea by publishing in 1849 *The Drawing-room Table Book*, put together by the wife of the *Art Journal*'s editor, Mrs Anna Maria Hall. The

twenty engravings were 'choice and early impressions of the prints which have appeared in the *Art Journal*, and of which a limited number only were taken for this express purpose', and the volume was published at one guinea. This rather vague impression of exclusiveness must be set against the background of the monthly circulation figures, which showed 7,000 copies in 1846, 14,000 in 1847, almost 18,000 in 1850 and nearly 25,000 in 1851, requiring that many impressions from each steel plate for the *Art Journal* alone. Eleven years later, Samuel Carter Hall, the *Art Journal*'s editor, supervised the *Royal Gallery of Art, Ancient and Modern*, published jointly by two printsellers – P. and D. Colnaghi, London, Agnew and Sons, Manchester – and Virtue. A review in 1861 reveals that

prior to the appearance in the *Art-Journal* of the series of engravings headed 'The Royal pictures', proof impressions of the plates on India paper, with descriptive letterpress, have been issued to subscribers . . . in three sizes; the *largest* half grand eagle size, artists proofs of which only 100 were printed; the *second* half columbier size, unlettered proofs, of which only 100 were printed – these two sizes were delivered in portfolios; and the *third*, quarto grand eagle size, 400 printed . . . The entire work consisted of . . . 144 engravings . . . When the authorised number of impressions was taken from each plate, the steel was cut down to the size of the *Art-Journal* page, to prevent the possibility of any engraving being hereafter issued as a *proof* without detection . . .

The plates appeared in the *Art Journal* between 1855 and 1860. When announcing it, the proprietors had this to say: 'Without by any means undervaluing the prints which appear monthly in this Journal, it will be obvious to all that they cannot be *proofs*; that in printing from 16,000 to 18,000 impressions, the plate necessarily wears; we do our utmost to keep it in "a good state".'[4] A final example of the use of *Art Journal* plates occurs in a series of monographs of popular painters, issued towards the end of the century, of which *The Works of Sir Edwin Landseer, R.A., Illustrated by Forty-four Steel Engravings* is one. Published by Virtue and Co. about 1877, it contained only five engravings not previously issued in the *Art Journal*, three of which were engraved by J. C. Armytage and two by S. Allen. None of the large volumes of reproductions appear to have sold very well. Finden's *Royal Gallery of British Art* dragged on to an unsuccessful conclusion under Hogarth, Hall's *Royal Gallery of Art* had not come up to the publisher's pecuniary expectations and, when a band of engravers got together to produce their own series, the results were even more catastrophic. In the late 1820s, John Pye had put forward the idea of publishing prints from works in the National Gallery and, to that end, the 'Associated Engravers' came into being. The signatories of the dedication were John Burnet, George Cooke, George Doo, William Finden, Edward Goodall, John Le Keux, Henry Le Keux, John Pye and John Henry Robinson, all of whom, except Cooke, supplied plates, and who were joined by William Miller, William Bromley, J. H. Watt, William Greatbach, Richard Golding, James Stewart and William

Humphrys. Most of them also worked in steel (the engravings were done in copper), and since it was financed by the engravers themselves, they must have been able to summon up considerable resources between them. The expense is indicated by the sum spent on the 'Consecration of St Nicholas' after Paul Veronese, where John Linnel was paid £50 for his watercolour copy of the picture and Richard Golding eventually received 300 guineas for engraving it. The fixing of this latter sum also shows the rather unbusinesslike approach of the Engravers' committee, which had originally set aside 200 guineas for it, but when the work was nearing completion it resolved 'that this estimate appearing to the meeting inadequate to the just claim of Mr. Golding's known talent, and their consequent expectation hereby resolve unanimously that Mr. Golding be paid three hundred guineas for engraving the same.'[5] In 1829, George Barret was to get thirty guineas for a copy of a picture, but as it took him longer than his estimate, the Engravers gave him £10 extra. William Miller had been asked to engrave it, but the enterprise ended in 1840 before he could commence work, and all he received was 200 guineas for his engraving of Gainsborough's 'The Watering Place'. Said to have been fully subscribed at the outset, the parts appeared so irregularly that in the end it consisted of twenty-nine engravings in seven portfolios for fourteen guineas a copy. It was a sad day in November 1845 when M. A. Nattali the publisher offered remaindered copies of *Engravings from the Pictures in the National Gallery* at the very reduced price of five guineas. The bound volume, originally sixteen guineas, was offered for £6. 16s. 6d. In 1875, the engravings were resurrected once more and published by Chatto and Windus.[6] Contemporary opinion felt that it had been produced some years before public taste was ready for it, but this view was not supported by subsequent attempts of a similar nature. Such enterprises were peculiar to England, since on the Continent these 'galleries' were undertaken either by the Government or with Government aid.

Close on 300 sculpture plates were also issued in the *Art Journal* from 1847 to 1884, some being collected by Mrs Hall to form *The Gallery of Sculpture*. This art form was, at this time, in a disastrous condition; so little was it understood that the editor, S. C. Hall, was warned that to publish such plates would ruin the journal. On several occasions he received in his post a torn plate of a semi-nude figure in protest against attempts to introduce indecencies into families! In the end, they were among the most popular of the periodical's illustrations.[7] The plates were engraved by several specialists, including H. C. Balding (twenty-three plates between 1869 and 1884), Edwin Roffe (nineteen plates, 1852–77) and, the most prolific, William Roffe (seventy-seven plates, 1848–84).

Volumes on history and biography rank together as the next important categories numerically, but the engraving content contained very little of value, consisting chiefly of frontispieces and engraved title-pages.

Predictably, the Bible was a favourite book to illustrate, and although Bartlett's

pictures of Palestine appeared in many copies, Biblical scenes from the Old Masters were also employed, interspersed with plates by John Martin and other contemporary artists.

Books on architecture, heraldry, cookery, natural history, zoology, botany, sport and technical subjects, together with some periodicals, encyclopaedias and dictionaries were among other categories illustrated by steel engravings.

One final group has been omitted from this list, since it was very much a product of the time and depended upon steel engraving for its success. This is the annual, which, because of its novelty, has attracted more attention than the other categories of publication. It was merely an adaptation of something which had been known in slightly differing forms all over Europe since the early eighteenth century. In England, they had been called 'pocket-books', a typical example of which was *The Ladies' Polite Remembrancer*. Such publications were roughly equivalent to a modern diary, with its wealth of factual information at the front. But the older version contained much less diary space and was more of a miniature reference book, listing things which every man and woman of fashion ought to know. One of the best known was the continental *Almanac de Gotha*, but the great English source of information was the *Annual Register*; both of these publications were drawn upon by the first annuals. The pocket-books were published in the autumn of each year, to be given as Christmas and New Year presents. Once the year had started, as with modern diaries, their sale virtually ceased. The annuals adopted the same publication schedule, but as they retained their interest past the New Year, their use as birthday, Easter and other special occasion gifts increased their circulation immeasurably. This was achieved by removing most, if not all, of the 'useful' information which dated, replacing it by a literary and artistic miscellany which did not date. The idea had been suggested in 1821 of a publication which would contain short tales, sketches, poems, etc., illustrated with line engravings, but for a variety of reasons, it was not taken up by a publisher until the middle of 1824. But in November 1822, Rudolf Ackermann, printseller in the Strand, had set the ball rolling by the publication of his *Forget me not, a Christmas and New Year's Present for 1823*. A German himself, he was familiar with the literary almanacs and pocketbooks produced in his homeland, so his first English publication contained the flower of the old and the seeds of the new type of book. Stipple engravings of a 'Madonna' after Guignand, and twelve emblematical designs of the months by Burney were all engraved on copper by J. Agar. The verses to the months were written by William Combe. Other contents included tables of population returns from the last census, chronicles of the preceding year's events, genealogies of the reigning sovereigns and a list of their diplomatic agents. The significant addition, however, was that of a tale and a sketch, apparently of German origin, which distinguished it from its predecessors and laid the foundations of a new class of book. It was a great success and, although two rivals came out at the end of 1823, a

large number of copies were sold, reaching at the height of its fame 20,000 in a year. The 1825 volume had 'Steel' engraved at the bottom right-hand corner of each of its thirteen plates, the first example of the metal's use in an annual. W. T. Fry, George Corbould, Charles Heath and Robert Wallis were responsible for the engravings after Richard Westall, Thomas Uwins, Henry Corbould and J. Hardy. Frederick Shoberl was the *Forget me not*'s only editor from its inception to the last volume in 1846.

One of the two rival publications mentioned above was *Friendship's Offering*, begun at the end of 1823 by Lupton Relfe, a Cornhill bookseller, but by 1827, it was in the hands of Smith, Elder and Co., edited first by Charles Knight and redesigned in 1844 under the editorship of Leitch Ritchie.

It was not until the end of 1824, however, that Alaric Watts produced the first true annual in his *Literary Souvenir; or Cabinet of Poetry and Romance*, composed entirely of poetry, prose and engravings, put together from the best authors and painters who could be persuaded to work for him. The title was taken from an old and popular pocket-book, which had been used as a sub-title to the single published volume of *The Graces, or Literary Souvenir*, edited by the Revd George Croly. When Croly gave up in July 1824, Watts, whose ideas had been fermenting for five years, was able to step into the breach, since they both shared the ill-fated publisher, Hurst, Robinson and Co. He had only a short time to prepare for publication in November, but the publisher was responsible for selecting the illustrations and employing the engravers. As a result, the ten small steel engravings were done in somewhat of a hurry, three by Charles Heath, three by Edward Finden and the others by J. Mitchell and William Humphrys; William Brockedon was the artist for three of the plates. The finished result was poor; in a letter to Joseph Ogle Robinson on 5 July 1825, Watts complained that the 'choice made of some of the embellishments does not altogether accord with my taste.'[8] In September, Watts was suggesting a printing of 2,000 copies, and Robinson's estimate two days later of 3,000 to 4,000 was based on a subscription order for 1,000, 'if we would give [the bookseller] a little advantage.' On 16 November, a day or two before publication, a second printing of 2,000 was ordered to augment the original 5,000; by 30 November, a 10,000 sale for the next year's issue was being confidently predicted. A further letter of 26 April 1825 noted 'we sold about 60 copies at our last trade sale, whilst all our rivals are as dead as though they had never existed.'[9] In the end, 6,000 copies of the first volume were sold, according to the preface (page iii) of the 1826 volume. Preparations for the 1826 volume were in hand by December 1825 – 'Leslie's "Rivals" you shall have . . . And we must have some beautiful landscape from that giant Turner.'[10] Charles Robert Leslie's 'The Rivals', engraved by William Finden, was said to have created quite a sensation in London; on 20 November, only a day or two after publication, Watts was writing that, as a result, about seventy retail orders had been taken for large paper copies and that the

collector John Sheepshanks had taken eight proofs before letters. Turner's picture 'Richmond Hill', engraved by Edward Goodall, and Gilbert Stewart Newton's 'The Forsaken', engraved by Charles Heath, were both executed expressly for the work. Peter de Wint's 'Windsor Castle', also engraved by Heath, was included, although Watts had rejected it for the 1825 volume on the grounds that the castle was about to undergo extensive alterations, thus making the view out of date. Ironically, this turned out to be one of the better engravings in the volume, which also included an early steel engraving by James Thomson of a statue by Francis Chantrey of Lady Louise Jane Russell, drawn for reproduction by Henry Corbould. The success of the small plates gave rise to larger copies being made by the printsellers. Watts guarded his property jealously, and wrote to Mr (probably Robert) Jennings, protesting about the piracy of his (Watts's) engraving of Newton's 'Lover's Quarrel', which was done by Charles Rolls for the frontispiece of this volume, though with what success it is not recorded.

The publication of the 1826 issue coincided with the failure of over seventy banks in November and December 1825, and the start of the 'Great Panic' of 1826, in which Hurst, Robinson and Co. crashed on 14 January, bringing down Constable in Edinburgh and with them the fortunes of Sir Walter Scott. Sir Thomas Lawrence was another victim, since the firm had paid him £3,000 a year from May 1822 for the exclusive privilege (which did not belong to him, incidentally) of engraving from his pictures. Watts went through a difficult time sorting out his affairs with the firm, but by April he had John Murray and Andrews of Bond Street interested in taking over his annual. By June 1826, however, he had decided to keep it going himself, and he confidently expected to make between £600 and £700 a year from it. The *Literary Souvenir* continued thus with ten engravings a year until the volume for 1835, when, on 5 December, Watts sued *Fraser's Magazine* and the printer Moyes for an 'illiberal critique' upon it, obtaining a judgement, with £159 damages.[11] A new series commenced in 1835, adding the sub-title '*and Cabinet of Modern Art*', published by Whittaker and Co. of Ave Maria Lane. In this form it contained twenty-five engravings of pictures from the French and English schools with descriptions and an occasional poem based on the illustration; it had effectively been transformed into an annual primarily devoted to art, omitting almost entirely the literary element. It was the end of this annual as such, since its title in 1836 became simply *The Cabinet of Modern Art*, the last volume being issued in 1837. Between 1828 and 1831 Watts had visited France in the hope of producing an edition of his *Souvenir* there, but all that came of it was the reproduction for the first time in England of French pictures by contemporary artists in the volumes of 1832–3.[12]

Returning to the year 1825, Samuel Carter Hall expanded his already considerable literary interests by the publication 'for serious persons' of *The Amulet; or Christian and Literary Remembrancer*, published by William Baynes and Son. The

1826 volume contained eleven engravings on steel, four by Edward Finden, three by Charles Heath, one each by James Mitchell and H. Melville and two mezzotints drawn and engraved by John Martin (see above, page 15). The number dropped to ten engravings in the next year, but rose to a more normal twelve in the 1828 volume. Eleven volumes were issued in all, ending with that for 1836. By this time, Hall's attention had turned to his three volume *The Book of Gems*; *The Poets and Artists of Great Britain*, an illustrated anthology of poetry from Chaucer, published in 1836, 1837 and 1838. The 1831 volume of *The Amulet* brought Hall into sudden and sharp conflict with an artist and engraver, neither of whom were closely connected with book illustration at this time. A letter explains:[13]

The print published in the 'Amulet for 1831' to which the names of George Barrett [sic], painter and John Pye engraver are attached was originally engraved for the 'Anniversary' and 3,400 impressions printed from the plate; but that work having been discontinued, the prints were subsequently appropriated to Sharpe's London Magazine [John Sharpe had published *The Anniversary*, 1829]. After having been thus printed and published, the plate was purchased by the proprietors of the 'Amulet', edited by Mr. Hall, and the composition being mutilated by cutting it down to suit the size of that Annual, it is again before the world in the character of a new and original work of art. We make this statement as an act of justice to ourselves, and to the public who may patronize the 'Amulet' lest they should think they are purchasing a new and entire work of ours, instead of a print thus disfigured; *and impressions sold as proofs*; although printed after 3,400 had been taken from the plate in its original state.

London. George Barret

18th December 1830. John Pye

Hall pleaded, probably with some truth, that he was ignorant of these facts at the time of purchase, and it must be said that the annual's impressions are no worse than others in the volume, a tribute to the staying power of steel. The picture was 'Sunset', opposite page 225, and is thought to be one of Pye's best line illustrations.

The year 1827 brought into being the longest-running and best-known of the annuals, *The Keepsake*, which published its last volume in 1856, after which the steel-engraved annual ceased to exist. It also marks the beginning of a long and numerous series of books, the engravings of which were done 'under the superintendence of Mr. Charles Heath'. This venture was the gesture of a flamboyant showman, willing to try anything and, in general, making it succeed. Up to this time, the annuals had been published at twelve shillings a volume, but Heath's flair for production resulted in a much more attractive volume, exchanging the printed paper boards and small format for red watered silk, gilt edges and a larger size, which characterized the whole series. The first volume was edited by W. Harrison Ainsworth and all the articles were written anonymously. It contained eighteen engravings, ten of which carried Heath's name as engraver, and a dedication page,

bearing an engraving after Thomas Stothard of a flower wreath, printed in blue, green, red and mauve. There was also an eighteen-page article on pocket-books and keepsakes. The sale of 15,000 copies (compared with 8,000 for the 1827 *Literary Souvenir*) at one guinea a copy was a very remarkable achievement in the face of prognostications of failure and success was largely due to the quality of the engravings. Heath was not satisfied with the editor, however, and Frederic Mansel Reynolds was brought in for the next volume. Heath and Reynolds then set off together for Scotland and the Lake District early in 1828, visiting the great writers of the day and persuading them with great eloquence and determination of the advantages of mutual co-operation, overcoming their last scruples with high monetary offers which the authors found it difficult to refuse. Sir Walter Scott received £500 for contributions to a single volume, comprising a juvenile drama, 'House of Aspen', 'My aunt Margaret's Mirror', and two tales omitted from 'Chronicles of Croft Angry'. Southey had fifty guineas for a piece the author described as 'a pig in a poke', and even Wordsworth was persuaded to join in. Altogether the literary pieces for the 1829 volume cost £1,600 out of a total of 11,000 guineas for the whole work, with another £600 expended on 4,000 yards of red watered silk at three shillings a yard for bindings, ordered in February 1828. This mad spending spree so alarmed his publishers, Hurst, Chance and Co., and Robert Jennings that they took control of the venture, since the expenditure would not, in their view, result in a commensurate return on copies sold. The strain thus put upon the partnership of proprietor and publisher brought the final break in 1831.

For the next fifteen or sixteen years, *The Keepsake* was published by Longman, whose dealings with Heath went back to 1818 at least. Just before Heath's death in November 1848, the publication was finally transferred to David Bogue, who published nine volumes up to the year before his death in 1857. The editor also changed several times before the end, with Lady Emmeline Stuart Wortley taking over from Reynolds in 1840, to be succeeded the following year by Margaret Power, Countess of Blessington (see plate 39) whose second husband was the Earl of Blessington. She lived with Count Alfred D'Orsay for some considerable time, spending the last few years of her life in Paris, a fugitive from creditors, where she died on 4 June 1849. This affected the preparations for the 1850 *Keepsake*, so her niece, Miss M. A. Power, stepped into the breach, finishing that volume and remaining its editor until the end. Gradually the number of engravings in each volume dropped to twelve; after Charles Heath's death, the superintendence of the engravings was taken over by his son Frederick Augustus Heath. In its thirty volumes, about 400 engravings were issued, representing something like £42,000 in payments to engravers alone. At least twenty-four of the original steel plates are known to survive, illustrating two of the later volumes and engraved by, among others, B. Eyles, Alfred T. Heath and W. H. Mote.[14] It is known that this was one of

Drawn by A.E. Chalon, R.A. Engraved by E.T. Pyal

the annuals highly favoured by Queen Victoria and her family. There exists, for example, a copy of the 1847 edition, inscribed on the engraved title-page to 'Eliz[th] Sloan from Prince Albert'.[15]

The same year, 1827, brought the eminent publisher William Pickering into the annual lists with *The Bijou; or Annual of Literature and the Arts*, which only ran for three volumes. It was edited by W.F. (Watts gives Harris Nicolas)[16] and beautifully produced; Robert Balmanno, Secretary of the Artists' Fund, assisted the publisher in the selection of the illustrations. Of the fifteen engravings to the first volume for 1828, seven were after designs by Thomas Stothard and three after Sir Thomas Lawrence. Augustus Fox was the engraver of five plates, four of which were small headpieces about $2\frac{1}{4}$ by 1 inch; other engravers included Robert Brandard, W. Ensom, Edward Finden, William Humphrys, Robert Wallis and W. H. Worthington.

The great explosion came, however, in 1828; for 1829, no less than seventeen different volumes were issued. The most important of these was *The Anniversary; or Poetry and Prose for MDCCCXXIX*, edited by Allan Cunningham. This volume, published by John Sharpe and printed by Charles Whittingham of the Chiswick Press, is of outstanding charm and beauty and by far the best produced of all the annuals. Dedicated to the President and members of the Royal Academy, most of the artists contributing the eighteen illustrations were either full or Associate members thereof. W. Allan, Beechey, Danby, Hamilton, Hoppner, Howard, Landseer, Lawrence, Shee, Turner and Westall were joined by Barret, Bonington, Gainsborough, Linton, Stanfield and Stephanoff and their work engraved by men such as Edward and William Finden, Edward Goodall, H. Robinson, Charles Rolls and Robert Wallis. One plate met with an accident just before completion, so 'Evening – Twilight', engraved by Goodall after Barret, was substituted. The innovation of the year was the children's annual, based sometimes on the adult version, such as the *Juvenile Forget me not*, edited by Mrs Anna Maria Hall, and the *Juvenile Keepsake*, edited by Thomas Roscoe, or independent productions such as the *Christmas Box*, edited by Crofton Croker, and *New Year's Gift*. The latter was edited by Mrs Priscilla Maden Watts and survived only until 1836. By the 1840s, they had become too much like ordinary annuals and quite unsuitable for children; as one reviewer put it: 'As a child's annual, the matter and diction [of the *Juvenile Scrap Book*] is too advanced, and young persons, from the ages of 12 to 18, hardly need an annual.'[17] A contemporary estimate of the financing of the 1829 output gives some idea of the money involved and its distribution. The income is

PLATE **39** Margaret Power, Countess of Blessington (1789–1849), for a time editor of *The Keepsake*. Stipple and line steel engraving by H. T. Ryall after A. E. Chalon, from vol. 1, p. 65, of Wright's *Gallery of Engravings*, 1844–6. Original size $9\frac{1}{8}$ by $7\frac{1}{8}$ inches. (By courtesy East Sussex County Library, Brighton Reference Library.)

based upon an assumed sale of 150,000 copies, bringing in an estimated £90,000. A third of this was spent on bookseller's profits, with a further £10,000 as a profit to the publisher, leaving £50,000 to meet production bills. The largest single item in this latter sum by far was £12,000 to the engravers; £4,000 went to the plate printers, and £3,000 to the artists. The authors and editors were paid £6,000 and advertising and incidentals accounting for another £3,000. The bill for materials represents most of the remainder: paper, £5,500, silk and leather, £4,000 and, finally, £9,000 for binding.[18]

Under Charles Heath's influence, efforts were made to introduce some novelty into the annuals by selecting two predominant aspects from the general volumes and concentrating on those. The first was a series containing landscapes, views, etc., initially produced in 1829 by Robert Jennings of 62 Cheapside, entitled the *Landscape Annual*, which ran for ten volumes, until 1838. From 1835 it was called *Jennings' Landscape Annual*, but the descriptions were provided throughout by Thomas Roscoe, a miscellaneous literary writer of some note. The series attracted a great deal of attention because of the eminent artists associated with it, men such as Samuel Prout, J. D. Harding and David Roberts. But the first volume, on Switzerland and Italy, suffered from hasty preparation of the plates. Many were heavily etched and lack the finer attention to detail which became the hallmark of later volumes even though eminent engravers had been employed; these included J. B. Allen, Thomas Jeavons, William Wallis, J. T. Willmore and Heath himself. Heath's disagreement with his publishers over *The Keepsake* also resulted in him selling his share of the *Landscape Annual* to Jennings early in 1831. He had obviously planned for this eventuality well in advance because, in the autumn of 1831, he published his rival *Picturesque Annual for 1832*. The drawings were by Clarkson Stanfield, and the leading engravers were some of those employed on the rival, including Robert Brandard, Edward Goodall, Thomas Jeavons, William Miller, Robert Wallis, J. T. Willmore and, of course, Charles Heath. Although the volume was published by Longman and the first plates in the book bear their imprint, from page 150 the plates were published by Hurst, Chance and Co., a clear indication that Heath had probably done a deal with his share of the *Landscape Annual*, involving some plates originally destined for the latter. The writer of the descriptions was Leitch Ritchie, another miscellaneous writer, mainly for periodicals, who edited the series until the 1840 volume. In 'A word prefatory' to the first volume, he distinguishes the descriptions given in the volume from those in other books being published at the time.

...perhaps...when the drawings come to be published, the most *useful* literary accompaniment would be a common guide-book. Such works, however, already exist in sufficient abundance; and instead of having recourse to the common expedient – of reproducing, in a new form, the experience of former travellers, the author conceived the idea of presenting to

the reader a set of *bona fide* sketches of his own, the result of impressions made upon his mind on the spot. The appearance in the midst of these, of relations which the profane will term *romances*, must be accounted for by the necessities of the ANNUAL – a plant which, having been reared in an atmosphere of poetry and fiction, would, perhaps, run the risk of drooping if suddenly transplanted . . .[19]

Stanfield continued to draw for the 1833 and 1834 volumes but, in an effort to maintain the standard, two artists (D. Maclise and T. Creswick) had combined by 1837, and, by 1840, four artists provided only fifteen plates in the volume on Windsor Castle. The failure of *Jennings' Landscape Annual* released Thomas Roscoe and his services were promptly taken up by Heath, replacing Ritchie for the 1841 volume. The series ended with the volume for 1845, a total of fourteen issues in all. Heath had also arranged that Ritchie should collaborate with Turner on three volumes of *Turner's Annual Tour* in 1833–5, which began bravely enough with forty-five plates in the first. The last contained only twenty, most of which were badly done, so it can be imagined that the strains generated by two characters such as Heath and Turner led Longman to abandon the project. Ritchie, in a letter to Alaric Watts dated from Edinburgh, 6 December 1852, gives a glimpse of the situation as he saw it.

My intercourse with Turner, I regret to say, was extremely slight, notwithstanding the duration of our business connection for three years. You are aware that before then, the Annuals were chiefly miscellanies of tales and poetry; and when our plan of original tours was commenced, it was considered that it would be dangerous to their popularity as drawing-room books, to have much to do either with useful details or thoughtful speculation. For this reason my continental tours were a mere selfish enjoyment. I wandered a great deal on foot in the most erratic manner. Sometimes I escaped from my own custody for a week at a time, and at last caught myself, perhaps, at a village wedding. Such being the case, you will feel that I could not think of Turner for a companion, one of the most prosaic souls in everything but his art. Heath wanted me to arrange that we should travel together; but I never mentioned the subject, nor did he. I was curious in observing, however, what he made of the objects he selected for sketching, and was frequently surprised to find what a forcible idea he conveyed of the place without a single correct detail. His exaggerations, when it suited his purpose, were wonderful; bolstering up, for instance, with two or three stones the spire or rather stunted cone of a village church; and, when I returned to London, I never failed to roast him on the subject . . .[20]

These were the best examples of the species, but they had many imitators. The *Continental Annual and Romantic Cabinet* published its first (and, it is believed, only) volume in 1832, edited by William Kennedy with thirteen illustrations by Samuel Prout. The engravings were 'under the superintendence of Mr. E. J. Roberts', who worked for Charles Heath over many years; although published by Smith, Elder

and Co., Heath's influence can still be seen, even to the employment of eminent engravers. Another volume published about 1838 by Parry and Co. was the *Continental Tourist and Pictorial Companion*. Neither the artists or the engravers of the sixty-two plates were well known; John Shury and Son engraved just over half of them.

Another development centred around portraits, chiefly by Sir Thomas Lawrence, scattered throughout the early annuals, which were concentrated into volumes carrying pictures of beautiful women, named and unnamed. The first in the field was *Heath's Book of Beauty*; Longman published most of the seventeen volumes issued between 1833 and 1849. The first volume was edited by L.E.L. (Laetitia Elizabeth Landon), a well-known contributor to the annuals, and whose portrait (see plate 40) typifies the kind of plate which appeared in these books. The Countess of Blessington, however, was appointed to her first annual with the 1834 volume. The combination of a Countess as editor and portraits of beautiful women was thought to be irresistible; at one time, the inclusion of her portrait in such a series was as desirable to a lady of fashion as her presentation at Court or marriage at St George's. Society occasionally questioned the right of certain ladies to be included. The preparation of text to go with the engravings was frequently left to the ladies' admirers, resulting in literary efforts of less than high quality. Nonetheless, when the series came to an end with the 1849 volume, David Bogue carried on the tradition for a further eight volumes in his *Court Album; a Series of Portraits of the Female Aristocracy*, which by 1857 had added ninety-two more engravings, average size 9½ by 7 inches. This was considerably larger than the average annual engraving, and even larger than those from *Heath's Book of Beauty*. These volumes also employed a different set of engravers and artists. Among the artists were A. E. Chalon, Edward Corbould, F. Grant, John Hayter and J. W. Wright. The engravers included the most prolific of the portrait engravers, William Henry Mote, William Henry Egleton, B. Eyles, William and Francis Holl and Henry Robinson. A last, despairing effort came from the Findens, who produced their *Tableaux* from 1837 to 1844, and in the first of national character, beauty and costume expressed their hope that the larger size of plates would add to their interest as works of art. In the 1840 volume, they added a new, and they hoped, interesting feature by engraving round the central picture, as a framework, a series of smaller scenes illustrating points in the story. Mrs Anna Maria Hall edited the first volume; she was succeeded first by Mary Russell Mitford and then by Mrs Priscilla Maden Watts. The larger size brought an increased price, this set being

PLATE **40** Laetitia Elizabeth Landon (1802–38), editor of the first volume of *Heath's Book of Beauty*, 1833. Steel engraving by J. Thomson, after D. Maclise, from vol. 1, p. 19, of Wright's *Gallery of Engravings*, 1844–6. (By courtesy East Sussex County Library, Brighton Reference Library.)

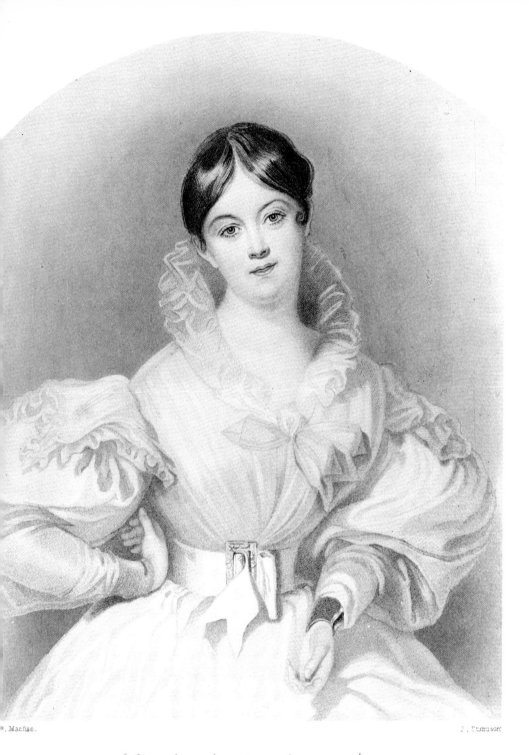

"Alas! hope is not prophecy — we dream,
But rarely does the glad fulfilment come.
We leave our land — and we return no more!"

L. E. L.

published at a sum roughly three times that of its rivals, i.e. two guineas. Female portraits blossomed everywhere. Heath's *Gems of Beauty* (1837–40) and *Portraits of the Children of the Nobility* (1838–41) were followed by a number of publications: among others the single volume *Beauties of the Opera, English Pearls*, portraits of the female characters in Shakespeare, *Finden's Gallery of the Graces* and *Finden's Illustrations of the Daughters of Erin*. In all these, however, 'the sentiment and taste of the annuals was being scorched up by fashion'.[21]

There was an indulgent attitude towards the annuals in the 1830s, as is evinced in the following extract of a comic verse, attributed to Thomas Hood, entitled 'The Battle of the Annuals'.[22]

The 'Battle of the Annuals'
 May yield at least some sport;
The public voice their trumpet is;
 And verse and prose their *forte*.

For precedence they boldly strike;
 Naught can their warmth repress, –
They all are volunteers, although
 The offspring of the *Press*.

In leather trappings some appear,
 While others silk reveal;
And most, like knights of other days,
 Are armed *with plates of steel*.

The lordly 'Keepsake' lauds himself
 And is all 'vain enough';
But 'neath his silken robe there peeps
 A garb of *common stuff*.

In vain it boasts its gaudy hues
 By men of rank drawn out;
That all *his* contributions are
 Rank nonsense, none can doubt.

But lo! he marches to the field,
 Prepared for the assault;
Goose quills are bristling in the air,
 The lines as usual, – *halt*.

Now from the 'Heath' a band arise,
 An amazonian train,
The 'Book of beauty' leads them forth
 For conquest on the *plain*.

The 'Landscape' boldly 'takes the field'
 Like hound upon the scent;
They're all *in tent*; the 'Amulet'
 On preaching is *intent*.

The 'Literary Souvenir', too,
 Appears with lines in lots;
'*What's* in a name?' who cry, will find
 Taste in the name of Watts.

And lo! the brave 'Forget-me-not'
 Comes boldly in the van;
Armed at all points, the skilful Muse
 Bids fair to *hack her man*.

As early as 1831, thought was given to the time when the bubble would burst. Engravers were being kept in work by the annuals,[23] which also fostered the fast-growing art of watercolour painting.[24] Ten years later, it was 'no use concealing the fact, that the public have grown weary of these annual "samenesses"; and that consequently the publishers do not feel justified in producing them by expending large sums of money.'[25]

FRIENDSHIP'S OFFERING.

"I give you all—I can no more,
Though poor the 'Offering' be."—
Yet 'tis worth millions, if you judge
By what it has *cost me !*

My wife—ah yes—I part with her
As friendship's sweet reward,
I've got her *in a line* to go
Upon her own ac-*cord !*—

And that half-crown you're *pulling* out
Still leaves *me*, Bill, no *pull*—
I'm letting a *whole tigress* go
For only *half-a-bull !*

Farewell, and of your bargain, boy,
Long live you to be proud,
You've only given *half-a-bull*
To have your *spirit cowed !*

THE BOOK OF BEAUTY.

" My pretty blue belle"—I am going to tell
Of the beautiful book which you edit so well,
With your own sweet face as the frontispiece dear,
And your *pen* in your mouth, love, instead of your ear !

Who would not be a goose now—to have such a quill
For your red lips to hold so remarkably still ;
With ink like your spirit—uncommonly blue,
And a feather to fly with—though not, love, from you !

Your eyes shed such light on your beautiful phiz,
That at last your wise owl has a twinkle in his :
You're a Queen—fair advised by the sagest of sages,
With a book in whose prison you shut up your *pages !*

Most sublime are your looks—lady editor—when
You are having resort like a sheep—to your *pen*
And your book may be grand—but in you I behold
The true Book of Beauty that I long to *fold !*

FRIENDSHIP'S OFFERING.

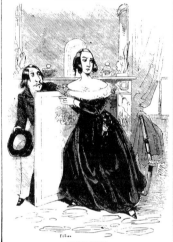

FORGET-ME-NOT.

FORGET-ME-NOT.

Forget me not ! Don't leave me here,
Imprisoned for Love's gentle thievings,
I thought I was too TAKING far
Ever to be among your *leavings.*

Forget me not—this is indeed
An awkward hole for lover's dodging,
I've oft admired the chimney *board*
But can't endure the chimney *lodging !*

Forget me not—ambition's voice
Aided by love's may spur my fate,
But still I've no desire to claim
Such close alliance *with the great !*

Forget me not—I'm like one pledged
To you—alas and *by* you too ;
But, dearest, though you've *popped* me *here,*
Pray do not keep me *up the flue !*

THE KEEPSAKE.

Yes, I've found it—it's true like a *ship* in a *squall,*
And far less addicted to *bat* than to *bawl,*
But you know what to darling humanity's due
So I've brought the sweet babby uncradled to you !

'Tis a Keepsake—you know sir—and year upon year
You will find it, I promise, becoming more *dear.*
Never let it *catch cold*—though mamma may have smiled
When she ask'd you one day for a *draft upon Childe.*

No no—keep this keepsake as sweetest of sweets,
He's a dear little annual—though not stitched *in sheets,*
And you can if he wants a profession you know
Bring him up to the *long robe*—he came to you so !

Educate him so neatly—that he must be one
Of a million who takes the *shine* out of your *son !*
Then when you've done all that a father can do,
Let *him* spend your fortune and he'll *do for you !*

PLATE **41** Verse and wood engravings making fun of the annuals, from the *Illustrated London News*, 1842, vol. 1, p. 521. Original size 9 by 9¼ inches. (By courtesy East Sussex County Library, Brighton Reference Library.)

The publication of verses in the *Illustrated London News* for 1842 (see plate 41) gave a rather derisory view of the annuals, which probably reflected public attitudes of the time.

Another critical summary appeared in 1844. 'At last arose the rage for Annuals, and for a time Art lay prostrate at the feet of Nonsense. We cannot think of criticising the Annuals – happily they are nearly extinct. ONE MILLION STERLING has, at the last estimate, been wasted on their production. Oh, that our readers could see – as we have seen – all the Annuals which, from the rise to the decline and fall of the imbecile mania, have appeared – in one small space of, perhaps, 8 feet by 6 feet – and moralize as we have done upon the public taste! That taste has of late been venting itself in part in Art-unions, not the most objectionable of safety-valves; but this, it seems, is now closed by the fiscal hand of government.'[26]

At the death, in 1857, of David Bogue, the last of the old annual publishers, a new form of gift book had arrived, illustrated with wood engravings and reflecting the taste of the day. The obituary of the steel-engraved annual appeared in the *Art Journal* for 1857.[27]

CHAPTER NINE · Publishing and the publishers

Publishing books illustrated by steel engravings was a very costly business. The usual sum involved was in the order of £10,000 and more,[1] so that only the largest firms could sustain a flow of such books and survive. Of the general publishers, three – Longman, Murray and Smith, Elder and Co. – published regularly in this field. Apart from Charles Tilt (with his partner and successor, David Bogue), only Fisher and Virtue specialized, sharing the remainder of the market between them. The smaller firms could only issue such works if they combined their resources; in a shared publication, each partner would have his own name printed first on the title-page of copies he was to sell. Bibliographical confusion can result where the same book appears to be published by several different people.

With the exception of the annuals, most of the illustrated books were published in parts, a form begun in the eighteenth century and peculiarly suited to topographical works. The 'number trade', as it was called, was firmly established, enabling the cost and preparation of a work to be spread over two or three years. Both publisher and purchaser shared the advantages. For the former, delays in the production of plates and text were avoided, since the chronological appearance of the engravings bore little relation to their eventual order in the book. Production could commence as soon as the first drawings were received from the artist, who might well be occupied for up to a year preparing them (see above, pages 110 and 113). If a change of plan was called for, then it could be implemented without the subscribers being aware of it. Not only could production costs be spread, thus limiting the amount of capital required at any one time, but income from the sale of parts was immediate. Over a period of time, the popularity of the work might so increase sales that more copies overall would be sold than by other methods. The purchaser could more easily be persuaded to lay out 2s. 6d. a month for parts than a guinea or so for complete volumes, and there was the possibility that his interest in the work could be sustained for the whole series. There were disadvantages, of course. Any publication delays would diminish a subscriber's interest; it is common enough to find incomplete volumes where parts were not bought or supplied, or were merely mislaid; it is also common to find a volume of plates, sometimes from several series, bound up together but without text. Almost any variation can be found, raising problems for the bibliographer, not least among which is that of

dating. Publishers such as Murray dated their parts, but even the title-pages issued by publishers such as Fisher, Virtue and Mackenzie are normally innocent of any attempt to date them. Bound-in advertisements and internal evidence must be extensively relied upon, with only approximate results. The trade bibliographies of the time are notoriously unreliable, listing the appearance of a volume some years after the part issues and sometimes missing editions altogether.

The average cost of a monthly part was 2s.6d., but both Fisher and Virtue, because of their rivalry and large turnover, were able to produce at the equivalent of two shillings per month. Fisher in particular, sold fortnightly issues at one shilling each, but this practice found no favour elsewhere with this type of book. The number of plates in each part varies from one to five, the average being four, usually accompanied by the same number of text pages, but practice varied so much that nearly every part examined showed exceptions. The cost of each plate varied considerably, ranging from a *maximum* of threepence to one shilling each but averaging sixpence, which was so cheap when compared with prices charged for comparable engravings by the printsellers that they became very alarmed at the potential loss of trade. This was a very real threat, since many book engravings were published in much the same way as ordinary prints, being available in the three usual forms, i.e. prints, proofs and India paper proofs. The prices quoted above were for ordinary prints but the monthly parts of Finden's *Views of Ports and Harbours* (1837) at 2s.6d. were supplemented by a few plain proofs in royal quarto at four shillings and proofs on India paper at five shillings. Beattie's *The Castles and Abbeys of England* commenced publication in December 1841 with the imperial octavo parts at 2s.6d., but 'a more elegant edition on superfine royal quarto paper will be printed at the same time at 5s. with first impressions; but as this edition will be limited to the number of subscribers, it is particularly requested that those who wish to secure it, would at once forward their names.'[2] The proof impressions with their rarity value were aimed at the print collector anxious to fill his portfolio, and even the annuals tried to take advantage of this. The 1828 volume of *The Amulet* carried on page 14 the following advertisement: 'A limited number of proofs of the engravings have been taken and may be had of the publishers of the volume or of J. Bulcock, 163, Strand, price 24s.', which was twice the price of the full volume. The *Forget me not*, too, issued its illustrations as quarto India paper proofs for one guinea a set from 1828 to 1840. Text was printed to match these sizes, resulting in large paper copies, but, as an alternative, a portfolio was often provided, as for the artist's proofs of illustrations to Thomas Campbell's *Poetical Works*, published by Moxon in 1837. The cost of the portfolio was thirty shillings. In this case, vignettes 3 by $2\frac{3}{4}$ inches looked lost on huge colombier sheets of paper 29 by 23 inches and

PLATE **42** Paper cover, printed black on cream, to Part XI of *Finden's Illustrations of the Life and Works of Lord Byron*, 1833. Original size $9\frac{3}{8}$ by $6\frac{3}{4}$ inches.

FINDEN'S

LANDSCAPE ILLUSTRATIONS

TO

MR. MURRAY'S

FIRST COMPLETE AND UNIFORM EDITION

OF

THE LIFE AND WORKS

OF

LORD BYRON.

LONDON:

JOHN MURRAY, ALBEMARLE STREET.

SOLD ALSO BY

CHARLES TILT, FLEET STREET.

1833.

PRINTED BY A. AND R. SPOTTISWOODE, NEW-STREET-SQUARE.

GENERAL ADVERTISER.

BEAUTIES OF THE COAST AND INLAND

SCENERY

OF

GREAT BRITAIN;

WITH

Topographical and Historical Descriptions

OF THE

PORTS, HARBOURS, SEATS,

AND

PRINCIPAL WATERING PLACES OF FASHIONABLE RESORT,

BY W. BEATTIE, ESQ.,M.D., OF THE HISTORICAL INSTITUTE OF FRANCE, &c.

ILLUSTRATED WITH STEEL ENGRAVINGS OF A SUPERIOR DESCRIPTION,

BY FINDEN AND OTHERS.

ARTISTS, W. H. BARTLETT, ESQ., ETC. ETC.

N. B. Professional Gentlemen, Tradesmen, &c., are respectfully informed that by becoming Advertisers in this work, they are entitled to an Advertisement in each Part, Gratuitously; by taking the Book as published Monthly, in Parts at 2s. each. Many Thousands have entered their names for the work.

☞ All Advertisements sent to the Office for Insertion, are considered orders for the Book.

London:

PUBLISHED FOR THE PROPRIETORS,

BY T. FRYS, No. 48, NORTHAMPTON STREET, CLERKENWELL.

SUPPLIED BY AGENTS. PUBLISHED MONTHLY.

totally divorced from their original conception. Books containing larger engravings akin to those produced by the printsellers were usually double the price. Finden's *The Beauties of Moore* began part publication towards the end of April 1845, and imperial quarto parts containing four plates and letterpress were sold at five shillings each. India paper proofs on atlas quarto paper were eight shillings and the same on colombier folio paper were priced at twelve shillings. Finden's *Royal Gallery of British Art*, probably the highest priced of all these ventures, was originally issued early in 1839 with three plates in each part at £1. 5s. 0d. for prints, two guineas for India paper proofs, and three guineas for proofs before letters. When Hogarth assumed responsibility for the project, he issued the earlier parts again, commencing 1 October 1844, but although the prints were still sold at £1. 5s. 0d. the proofs were two and a half guineas, and five guineas before letters. All of these editions were 'delivered in a handsome portfolio'.[3] Hogarth was a printseller and could therefore be expected to bring the project into line with his own trade practice. In such cases, the dividing line between the publishers of illustrated books and the printsellers was very fine indeed.

Parts were usually issued in paper wrappers; that of *Finden's Illustrations of the Life and Works of Lord Byron* (see plate 42) contains five plates with tissues, and one page advertising an appendix (see plate 27, page 88). Part 25 of a new edition of Beattie's *Ports, harbours . . . of Great Britain* (see plate 43) was issued after February 1859 and contained twenty-five pages of advertisements (see plate 44), four plates placed face to face in pairs with interleaving tissues, and eight pages of text. The advertisements were entered free, but the application to advertise was regarded as an order for a copy of the book; in this particular part there were 166 advertisements. The practice of reissuing books in parts was taken to its logical conclusion by Fisher, who started again immediately one set was finished, resulting in the repeated and obvious alteration of the dates at the foot of each plate.

Another method was to publish volumes in divisions, corresponding usually to three parts, or the equivalent of a quarterly production. These were issued in a cloth casing, blocked blind and gold, and frequently survive in this format, more permanent than the paper covered parts. Typical divisions were those used in a reprint of *The Scenery and Antiquities of Ireland*, by J. Stirling Coyne and others, with 120 drawings by W. H. Bartlett, published sometime after 1855 by James S. Virtue (see plate 45). There were five divisions, containing twenty-four plates and forty-eight pages of text each, intended for publication in two volumes; the title-pages, contents lists and directions to the binder for placing the plates appear at the end of the fifth division. The price was 7s. 6d. a division, with the set costing 37s. 6d., a considerable reduction on the original published price in 1840 of thirty parts at two

PLATE 43 Paper cover, printed black on green, to Part 25 of William Beattie's *The Ports, Harbours . . . of Great Britain*, c. 1859. Original size 11¼ by 8¾ inches.

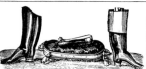

shillings each, or bound cloth and gilt for three guineas. Some plates still have the publication line 'Geo. Virtue 26, Ivy Lane', even though the title-page gives James S. Virtue, City Road. Some kind of permanence must have been envisaged for these parts by the publisher, since all edges were gilt.

The ability of steel plates to produce thousands of prints manifested itself in three main ways. The continuous production of reprints by the same publisher is the most obvious, requiring minimum effort with maximum profits. The second is the publisher's manipulation of his plate stock, producing them in a different form. An example of this is *The Gallery of Engravings*, edited by the Revd George Newnham Wright and published by Fisher in one shilling parts from 1844 to 1846. Each part contained four engravings at half the normal price, and the three volumes, each containing sixty-four plates (sixty-five in volume 1), were sold at a guinea each. The preface is quite frank about the situation:

During many years the proprietors of the Caxton Press devoted their energies to the production of Illustrated works of high character, as regarded literature and art; and their vast store of *authentic* engravings, representing the most picturesque objects in many lands . . . at length accumulated to an unprecedented extent. Selecting from this rich treasury, without any reservation on account of extreme rarity or conspicuous merit, and actuated as much by public principles as by private profit, they have embodied in one continuous work the best performances of British artists, constituting a gallery more justly entitled to the name of *National* than any other that has ever preceded it . . .

This last claim is certainly an overstatement, but the volumes do represent a good cross section of work then published. Plates are of all shapes and sizes so, despite the influence of the accompanying text, there is no unity in the volumes; they look what they are, scrapbooks. The use of the plates again for profit was achieved, but the following extract from the *Patriot*, referring to these volumes, puts another point of view. 'We rejoice to see such beautiful engravings thus placed within the reach of the labourer and the mechanic. The humanizing influence of such works is not, or, at least, ought not to be, beneath the consideration of the statesman, the philosopher or the Christian.'

The third indication of the endurance of steel plates is provided by the reprints done when copyrights fell into another publisher's hands. From the famous reprint publisher Henry G. Bohn the work was likely to be a straight reprint with reset text, and in a handsome format. This happened with Samuel Carter Hall's *The Book of Gems*. First published in 1838, Bohn issued a reprint in 1844 with a more ostentatious binding, followed in 1866 by another reprint in which the plates had been retouched, issued by Bohn's successors, Bell and Daldy.[4] In another example, John

PLATE 44 Page of advertisements from Part 25 of William Beattie's *The Ports, Harbours . . . of Great Britain, c.* 1859. Original size 11 by 8½ inches.

Carne's *Syria* was altered so much that the text was virtually unrecognizable and the number of illustrations reduced. Publication, by Fisher, commenced in 1836, with 120 plates in three volumes; there was a second part publication by the same publisher in January 1841. Twenty years later, a similar edition was put out by the London Printing and Publishing Company Limited in two volumes with 109 plates. Some titles were changed and Fisher's publication line was replaced. Some of the plates were also used in *Gallery of Scripture Engravings* (1846–9) by John Kitto, and for this titles in French were added, which remained on the prints taken for Carne's 1861 edition.

During the whole period, editions of steel-engraved books were sold on the Continent. France and Germany were the best markets, and both Fisher and Virtue had offices of their own in Paris. Longman used agents, who were Rittner and Goupil in Paris, Charles Jugel in Frankfort, T. O. Wiegel in Leipzig and the Fleet Street firm of A. Asher and Co. in Berlin. This latter company was responsible for publishing *Le keepsake français 1840*, with a text printed in France and drawn from the writings of the best French authors. The twenty-four plates were English steel engravings, four of which had appeared in *Heath's Versailles*, published about four years earlier by Longman. The French, who could produce nothing approaching the English quality of steel engraving, imported the impressions they required.[5] Most of the Virtue and Fisher volumes were available in both countries; for this reason they carried French and German titles on either side of the English one on the plates (see plate 2, page 8). Beattie realized his debt to the translator in the preface of his *Scotland* (p. viii): 'In acknowledging the merits and services of his foreign coadjutors, the author is bound to offer his testimony in favour of the German and French translations by John Von Horn, D.D., and Monsieur De Bauclas, who have transferred this, and his other Works, into their respective languages with taste, spirit and fidelity.'

An even closer link was forged with Germany in the persons of William Tombleson and Henry Winkles. Tombleson was an engraver in the 1820s, who contributed thirteen plates after Thomas H. Shepherd to *Metropolitan Improvements* (1829). Although he did not desert his profession entirely, he turned, in the 1830s, to publishing from 11 Paternoster Row, his outstanding book being *Tombleson's Thames* by William Gray Fearnside, published about 1834. Fearnside was a translator into German, and the book carried the imprint of Creuzbaner and Co., Carlsruhe. Twenty-two of the eighty plates were engraved by Henry Winkles, who, it is believed, worked as an engraver in Carlsruhe from 1819 to 1832.[6] The illustration of 'Sunbury Locks' (see plate 46) with its very appropriate frame of

PLATE 45 Division 5 of *The Scenery and Antiquities of Ireland* (after 1855) by J. S. Coyne and others. Cased in green grained cloth, blind blocked, with the spine and central vignette blocked in gold. Original size 11 by 9¼ inches.

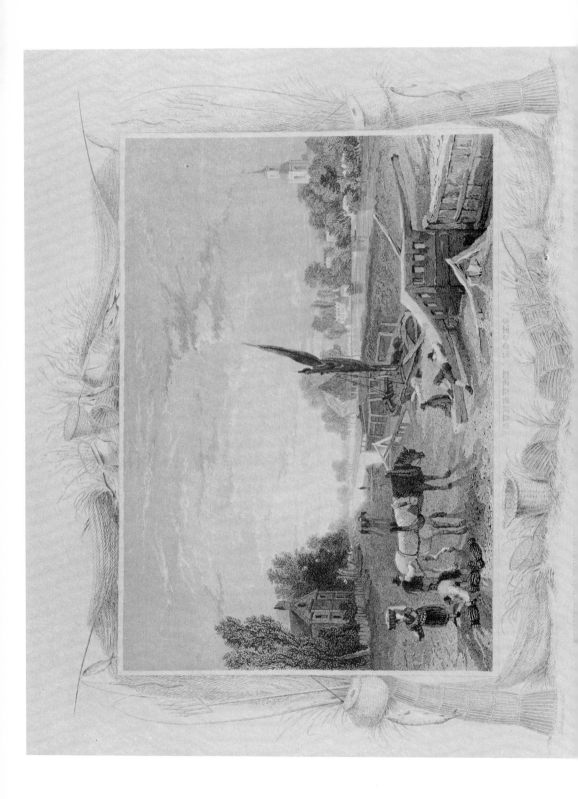

fishing tackle is one of the best plates in the book. According to a modern writer, Spemann, 'the German engraver Frommel fetched Winkles over and with him opened a studio in Karlsruhe, which soon proved to be a great success.' Most of his English book work appeared in the 1830s, such as the three volumes on English cathedrals (1836–42), in which he was joined by B. Winkles. The latter also produced *French Cathedrals* (1837), with twelve of the fifty plates after Hablot K. Browne. At the same time, Georg Wigand in Leipzig was employing a number of English engravers, who were said to have lacked commissions in England, for such works as his *Picturesque and Romantic Germany*.[7] The engraver Albert Henry Payne, a partner in the publishing firm of Brain and Payne of 12 Paternoster Row, also published prints in Leipzig and Dresden. In some cases, the text is bilingual, as in *Engravings after the Best Pictures* (1841–3), published by Ackermann and others.

Longman, whose imprint changed with great rapidity during the nineteenth century because of a succession of partners, was one of the first publishers to use steel engraving. Among their earliest volumes was Campbell's *The Pleasures of Hope*, 1821 (see above, page 15), and from this time developed the close association with Heath. In 'superintending' most of their engravings, he became, to all intents and purposes, their art editor, discharging this task with distinction and a great deal of public support.[8]

Charles Heath was the younger, and reportedly illegitimate, son of James Heath, the Academician and Engraver to the King. His father brought him up in the profession, and among other things, he experimented with several ways of producing pictures, including engraving on stone. As early as 1804 he exhibited a Venus and cupids at Somerset House done on stone.[9] He was then soon engaged upon the small book plates at which both he and his father excelled. The etched portrait by Mrs Dawson Turner (see plate 47) shows him aged thirty-eight. He married in his early twenties and he and his wife reared a large family. One son, Frederick Augustus, followed his father an an engraver and another, William, became an engineer. At Frederick's birth, Charles's address was 15 Russell Place, Fitzroy Square, London, but by 1818 he had moved to 6 Seymour Place, Euston Square. About 1811 he received his first important commission to engrave Benjamin West's 'Christ Healing the Sick', for which he was paid 1,800 guineas,[10] and from 1813 to 1818 was engaged on fourteen plates for Ottley's *Engravings of the Marquis of Stafford's Collection of Pictures* (1818) published by Longman. By then, the volume of work passing through his hands led to the employment of a number of assistants and pupils, many of whom achieved eminence in engraving. The first of his assistants was Thomas Wallis, the figure engraver, who worked until his death

PLATE **46** 'Sunbury Locks', steel engraving by W. Lacy after William Tombleson, from *Tombleson's Thames*, c. 1834, by William Gray Fearnside. Original size 7$\frac{3}{8}$ by 6$\frac{3}{8}$ inches. (By courtesy East Sussex County Library, Brighton Reference Library.)

PLATE **47** Charles Heath (1784–1848) at the age of thirty-eight. Etching (1822), after Henry Corbould, by Mrs Dawson Turner from *One Hundred Etchings by Mrs. Dawson Turner* (unpublished). (By courtesy the Trustees of the British Museum.)

for Charles and was the father of Robert Wallis, also an engraver. Richard Rhodes was Heath's principal assistant for the latter part of his career, and Edward John Roberts, who joined the studio about 1813, stayed for at least twenty years, living in the house and being mainly responsible for etching plates to be finished by other engravers. Heath's first pupil, James Henry Watt, arrived in 1815 at the age of sixteen. He did very little book illustration on steel, but devoted most of his time to copper engravings for the printsellers. Richard James Lane, another sixteen-year-old, followed in 1816, but he deserted line engraving for lithography. At about the same time, George Thomas Doo arrived (see plate 48), later to become one of the outstanding nineteenth-century engravers and an Academician. James Tibbetts Willmore also worked with Heath, from 1822 to 1825, as did James Baylis Allen, who assisted Charles after a period with the Findens and before he had a spell with Robert Wallis.

Charles Heath was among the earliest engravers to use steel for book illustration,

THE LATE MR. G. T. DOO, R.A.,
ENGRAVER

PLATE **48** George Thomas Doo (1800–86), wood engraving from the *Illustrated London News*, 1886, vol. 89, p. 579. (By courtesy East Sussex County Library, Brighton Reference Library.)

most of his early work being done on Jacob Perkins's patent hardened steel plates used with siderographic printing (see above, pages 14 and 15). The association with Perkins from 1819 survived Heath's bankruptcy in 1821, but both men were involved (1823–4) in litigation with a calico printer over a breach of patent, a case which they won. The failures of banks and businesses in the Great Panic of January 1826 reduced their bank-note printing business, compelling Heath to sell his stock engravings in May to raise some money. By May 1829, Heath has retired from the firm, and his place had been taken by Perkins's son-in-law, Joshua Butters Bacon.[11] The Heath family returned to the firm at the beginning of the twentieth century; in 1904, Charles's grandson, James Dunbar Heath, was responsible for the company's move from its Fleet Street premises to Bermondsey.[12] Heath's name appeared on a multitude of engraved steel plates for nearly thirty years up to his death. Many were described as 'manufactured' plates,[13] and were the products of his studio, in the making of which he may have had little or no hand.

It is difficult to assess his capabilities as a steel engraver since his many other activities left him little time to spend on it. A high proportion of the designs he put his name to were after Henry Corbould and his son Edward Henry, who married one of Heath's daughters. Edward's drawings were the mainstay of Heath's *Gems of Beauty* (1840), with verses by the Countess of Blessington. The Corbould family designs also represented much of the work engraved by Frederick Augustus Heath and Alfred T. Heath. Associated with the annuals from the beginning, Charles's work with *The Keepsake* and *Heath's Book of Beauty* has already been referred to in Chapter 8. In addition, he 'superintended' the engravings of a number of other works, notably Moore's *Lalla Rookh*, containing thirteen engravings, seven of which were after designs by Edward Corbould; *A Book of the Passions* by G. P. R. James with sixteen plates; Bulwer-Lytton's *Leila*, with fifteen engravings; and the Countess of Blessington's *The Belle of a Season: a Poem*, with illustrations by A. E. Chalon. All were published by Longman. He also put together a few volumes under titles such as *Beauties of the Opera*, *Drawing Room Portfolio* and *English Pearls*, which were very popular in the 1840s in the hands of David Bogue. But one of Heath's last projects was a folio edition of the Gospels, published by Chapman and Hall in 1848. His relations with John Murray were not so happy, however. Letters in the period 1818–20 reveal some tension. Heath was inclined to be imperious and rather pernickety in his almost obsessive desire to make every arrangement crystal clear and unambiguous (see above, pages 66 to 67). The last straw was an action which ended on 2 March 1830, brought by Murray against Heath in the King's Bench Division over the assumed right of an engraver to keep twelve copies of an engraving executed for a client. The first jury found in Heath's favour, but Murray, after consulting a number of engravers as to the trade custom then prevailing, obtained a retrial, this time achieving a reversal of the earlier decision and destroying the right of engravers to keep such copies.[14]

Although very successful in most of his business dealings, Heath's finances were never very robust, due to his free spending habits. Another crisis occurred early in 1839 when, on Wednesday, 5 June, Christie and Manson sold 'The exquisite collection of DRAWINGS by modern artists selected to illustrate the beautiful works of CHARLES HEATH, Esq. comprising the choice works of the following distinguished modern artists:– Chalon, R.A., Stephanoff, Parris ... Also several of the beautiful original drawings for the works of Versailles by Mackenzie &c.'[15] Later in the year, he returned to lithography for financial help and, with Edward Corbould, published 'A series of scenes, exhibited at the Castle of the Earl of Eglinton during the recent tournament.'[16] This period was not unrelieved gloom, however. On a visit to Paris in late 1838 or early 1839, Heath had sent the French monarch, Louis-Philippe, a copy of the recently completed two-volume edition of *Picturesque Views in England and Wales* (1832–8) from drawings by J. M. W. Turner and with text by H. E. Lloyd, and received from His Majesty a diamond snuff-box

as some indication of his approval.[17] In April 1840, Heath sold his stock engravings accumulated since 1826 and, about the same time, finished a labour of seven years with the publication of 'Europa' after William Hilton. Originally issued by the engraver, it was one of his better large works; it was distributed at the end of 1841 by F. G. Moon.[18] Heath died on 18 November 1848 in his sixty-fourth year. In its obituary, the *Art Union* wrote that 'he has probably created as much work for his professional brethren as any living man.'[19]

John Murray's close connections with the Findens, discussed in Chapter 6, brought him into early contact with steel engraving, but his adoption of it was rather slower than Longman's. One of his earliest books so illustrated was Reginald Heber's *Narrative of a Journey through the Upper Provinces of India* (1828). But, according to a letter written by Edward Scriven (see plate 49) on 8 April 1829, Murray was not disposed to pay engravers the higher rates claimed by them.

When I called in Albemarle Street the other day I had not the pleasure of seeing you, but Mr. Dundas conversed with me regarding the plates you spoke of putting in hand soon (some of them) when I last saw you. Mr. D. at the same time said he had to tell me that you have thought the charge high upon those four steel plates, the Buonaparte portraits. I explained to him what I wished to say to you on the matter, and he was so good to undertake telling you. The difference of time-taking is so considerable between copper and steel, that what may appear as a heavy charge upon the latter, but too frequently pays the Engraver far less for his labour than what would seem moderate for copper; but in all cases where a long number is at all expected being in request, the added expence [sic] of steel, when put down as ranging somewhere about half as much again as copper, becomes ultimately a very far less cost to the proprietor of a Work, because the steel plate being as only one and a half or thereabouts of copper, will produce impressions equal to six, seven or eight copper ones; and even more than that in case of need: while rating the copper at as much as two thousand, it generally will require some attention in retouching to reach that number tolerably . . . Yours, Edwd. Scriven.[20]

Murray's illustrated works were chiefly literature, notably Byron, but in a number of books he was connected with Charles Tilt, fine art and miscellaneous publisher of 86 Fleet Street. Tilt issued, among others, *Finden's Tableaux* and *Gallery of Beauty*, Roscoe's *North Wales* and *South Wales* and Fisher's *Angler's Souvenir* in the 1830s and from all his transactions made a large fortune, which he retired to enjoy in 1842. His partner from 1841, David Bogue, bought the business and extended the reprint list which Tilt had inaugurated. However, he published very few new books with steel engravings until he secured the copyright of *The Keepsake* in 1848 on Charles Heath's death, retaining it until his own death in 1857. Before that he had concentrated on books containing female portraits, such as the *Court Album* and *Heroines of Shakespeare*. W. Kent and Co. succeeded Bogue in the Fleet Street premises, but in a short time the business had passed into the hands of the latter's

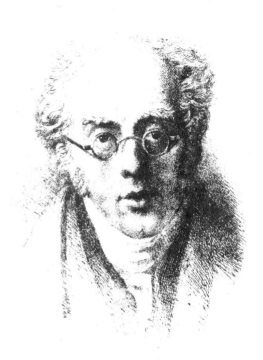

PLATE **49** Edward Scriven (1775–1841), portraits engraved by his pupil Benjamin Phelps Gibbon from John Pye's *Patronage of British Art*, 1845. Above: after a drawing by William Mulready (p. 314). Below: after the painting by Andrew Morton (p. 309). (By courtesy East Sussex County Library, Brighton Reference Library.)

rival, Henry George Bohn. Bohn had begun his publishing career in 1831, but his reprinting activities did not commence effectively until the mid-1840s. Bogue fell foul of Bohn by reprinting some illustrations in his edition of Roscoe's *Life of Lorenzo de Medici*, of which the latter had acquired the copyright with some remainders. Bohn promptly sued and won, enabling him to oust Bogue eventually from the reprint field. Bohn bought copyrights from many sources, one of the most surprising being the series of Bartlett's books from Virtue, which continued to sell well into the 1870s. *Footsteps of Our Lord* was first published in 1851, reaching its fourth edition in 1859 with Virtue at 10s. 6d. a volume. Bohn issued an edition at 7s. 6d. in 1862 and, after Bohn's retirement, the book was issued by Bell and Daldy in its seventh edition in 1872. Other examples were the publication of the second edition of Ritchie's *Windsor Castle* in 1848, after a first publication in 1840 by Longman, and Hall's *The Book of Gems*, first issued in 1836–8, reissued by Bohn in 1844 and in 1866 by Bell and Daldy. Among the most celebrated remainders secured by Bohn

was the stock of Brockedon's *Illustrations of the Passes of the Alps* in 1839, when he offered the two volumes, published at ten pounds, for £3. 13s. 6d.; the proofs were similarly sold at about one-third the original published price.[21] It had been published originally by the author (see above, page 126) but distribution problems had considerably reduced his financial return. A reprint was issued in 1877 under the Bohn imprint. His influence undoubtedly kept the steel-engraved book alive much longer than otherwise would have been the case and encouraged a slight revival between the 1860s and 1880s, a period during which a few original works also appeared. Bohn retired in 1864, his stock being taken over by George Bell and Daldy for about £40,000.[22]

The elder of the two major houses in London was that established by George Virtue, who was born about 1793 at Coldstream, a small town in Berwickshire. He was twenty-six when he went to London, founding his publishing firm in 1819, and by 1829 had established it at 26 Ivy Lane, in the neighbourhood of Paternoster Row and Newgate Street, close to the office of Henry Fisher, his rival for the next decade or two. William Henry Ireland's *England's Topographer; or, a New and Complete History of the County of Kent* (1828–9), published in four volumes and containing 125 engravings, was one of his earliest illustrated works. Through it began his connection with W. H. Bartlett, which has been explored in Chapter 7. This partnership made Virtue a small fortune from sales at home, on the Continent and in America. He issued over a hundred illustrated books, and his biographer estimated that he was responsible for the production of about 20,000 copper and steel engravings in his career, employing most of the important contemporary artists and engravers. By the 1840s, he had branches in Paris and New York. However, demand for the illustrated book had fallen, calling forth a change in the style of presentation, as announced in Beattie's *The Danube* (1844). 'In addition to the 80 steel engravings, the text is further illustrated by nearly the same number of woodcuts, which give a new and striking feature to the work, and render it ... more rich and attractive than any of the popular series yet issued by the same enterprising Publishers'.[23]

Virtue then turned his attention to the *Art Journal*, which he acquired in 1848. By the issue of three plates with each 2s. 6d. monthly part, he kept steel engraving alive during a time of depression. He even gave discounts for direct purchase; the three-volume four-guinea edition of *Scott's Commentary on the Holy Bible* was advertised in 1849 with a note appended: 'A very liberal allowance will be made to Clergymen and others whose orders are addressed direct to George Virtue, 26 Ivy Lane, London.'[24] In 1849, he was publishing from 25 Paternoster Row,[25] which was also the address of Arthur Hall and Co. In the same year, the Virtue list of books was advertised as 'Works published by Arthur Hall & Co., 25, Paternoster Row, London.'[26] By 1850, the imprint had changed to Arthur Hall, Virtue and Co., 25 Paternoster Row, in which form it lasted until 1862. George retired from

the business in January 1855, and died on Tuesday, 8 December 1868, at the home of his daughter, Mrs Morrison, in Porchester Square.

He was succeeded by his sons George Henry, William A. and James Sprent Virtue. It was upon the latter, aged twenty-six, that his father's mantle descended. He had been apprenticed to his father in 1843 and, at the age of nineteen, went to the branch at 26 John Street, New York. He was based there for the next six years, making only one short visit home in 1850. During this visit he joined the Stationers' Company as a liveryman; his father was already a member of the Court. From New York, James travelled throughout North America, promoting the company's business; on taking over from his father in 1855, James's experience of the home firm was rather scanty. When the association with Arthur Hall ended in 1862, James set up with his elder brother, George Henry, a second business (Virtue Bros and Co.). From 1864 to 1866 it was located at 1 Amen Corner, but when George Henry died, on 21 July 1866, it was sold. Soon after this, the firm took on a new lease of life, spending thousands of pounds on refurbished editions of the Bible, Shakespeare, etc., and monographs on Victorian artists, edited by James Dafforne, assistant editor of the *Art Journal*. The Shakespeare copyright was bought in 1868, and the Imperial edition began publication in parts early in 1872. At least one illustration 'The Death of the Earl of Warwick' after J. A. Houston, 1872, was added, engraved by T. Brown, who also executed four of the last original steel-engraved plates to be issued by the *Art Journal* between 1876 and 1879. The artists' monographs were published under the imprint of Virtue, Spalding and Daldy. Samuel Spalding joined the firm in 1871, and Frederick Richard Daldy, George Bell's partner, arrived in 1874. In 1875, the firm became a limited company, of which Daldy remained a partner for some years. Among the more important volumes published were Wornum's *Turner Gallery* (*c.* 1861) and Turner's *Richmondshire* (1891), both expensive reprints of earlier works, the latter being one of the last works to be issued in James's lifetime. He died on 29 March 1892. The firm still exists, although many of its links with the past have been severed. After a bankruptcy about 1900, Herbert Virtue retained the *Art Journal* business until it closed in 1912. He retained only a few steel plates from the original firm, and these were lost in an air raid in 1940, when the London offices at Thavies Inn, E.C.1, were destroyed. The company now operates from 25 Breakfield, Coulsdon, Surrey.[27]

Established many years earlier, the firm of Henry Fisher (see plate 50) arrived in London three years after George Virtue. Born in Preston, Lancashire, son of

PLATE 50 Henry Fisher (1781–1837), printer and publisher. Steel-engraved frontispiece by Cochran, Cook, Holl, Robinson and Thomson, after Henry Moses, to
C. H. Timperley's *Dictionary of Printers and Printing*, 1839. (By courtesy East Sussex County Library, Brighton Reference Library.)

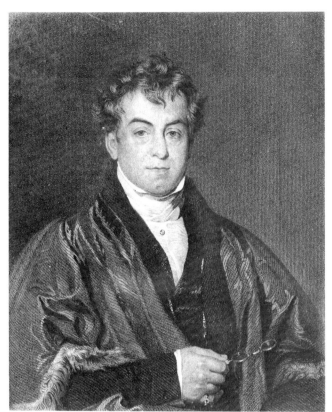

Painted by F. Holmes.—Engraved & Printed by Mess.rs G. Virtue. 26th H.H. Robinson, & Thomass.

A Fisher

Thomas Fisher, a timber merchant, Henry lost his father at an early age, but was able to attend school until he was thirteen. He was articled to Mrs Sergeant, a local printer and bookbinder, in 1794. She operated an incentive scheme whereby apprentices were allowed to keep all they could earn above a certain amount. Henry, by working long hours and with short meal breaks, earned large sums, which his employer came to resent paying. After four years, he left and finished his apprenticeship with Hemingway and Nuttall, printers in Blackburn. He married at the age of seventeen in 1798 and, soon afterwards, the principals of his firm parted company, Nuttall moving to Liverpool, taking Henry with him. Largely concerned with printing for the 'number' trade, Fisher developed some ideas for increased circulation. When he suggested a series of distribution depots across the country, he was given charge of that in Bristol, where he spent three years. His value to the firm was recognized so well that by the time he was twenty-four (1805) he had been offered a partnership and a salary of £900 a year. The Caxton Press, as it was now called, was appointed Printer in Ordinary to the King in 1815, and had as one of its editors Dr Adam Clarke, who was later tutor to Henry's two sons. The press published editions of standard and divinity works under Clarke's supervision. When, in 1818, Jonas Nuttall and his partner Dixon retired with ample fortunes, Henry was left as sole proprietor of a flourishing concern, employing about a thousand people in its various departments and probably the largest business of its kind in the United Kingdom. Disaster struck in Fisher's fortieth year in the form of a fire which, on 30 January 1821, entirely destroyed the plant and stock on Copperas Hill, Liverpool. Its value was in the order of £40,000, somewhat in excess of the £36,000 for which it was insured.[28] It was typical of Fisher's energy and determination that he moved immediately to London, accompanied by his fore-men and most of the work force, to set up printing works at Owen's Row, Clerkenwell, with a publishing house at Newgate Street. Four years later, in 1825, he took his son Robert, who had been at Cambridge and destined for the Church, and his London agent, Peter Jackson, into partnership. The firm they established was Fisher, Son and Co.

In 1828, the production of *Devonshire Illustrated* began the firm's long association with their principal artist, Thomas Allom (see above, pages 108–9). The Revd George Newnham Wright began his connection as an editor and text writer with Fisher in 1832, with a volume on Lancashire, an *Historical Guide to the City of Dublin*, followed by *Landscape and Historical Illustrations of Scotland and the Waverley Novels* (1836). Two of the last publications to be planned by Henry before his death were the four-volume *History of the County Palatine and Duchy of Lancaster* (1836) by Edward Baines and John Carne's *Syria*, which began publication in 1836. Henry died on 28 June 1837 at his house in Highbury Park. He had served, like Virtue, on the ward council of Farringdon Within and, just before his death, had been nominated as Sheriff of London and Middlesex.

The business thrived and expanded under Robert Fisher and Peter Jackson under the old name, but during the 1840s the publishing address was Angel Street, St Martin's le Grand. There was a Paris branch, situated first at the Quai de l'Ecole and afterwards in the rue St Honoré. In 1849, Robert sold his share of the business, and the imprint changed to Peter Jackson (late Fisher, Son and Co.). Many of the copyrights were sold off in the 1850s, following the general decline of the steel-engraved book.

The rivalry between Fisher and Virtue appeared to be quite a friendly affair, as their names appeared together on the title-page of at least one publication, Robert Huish's two-volume *Memoirs of George the Fourth* (1830) where it was 'Printed for T. Kelly Paternoster Row, Fisher, Son and P. Jackson, Newgate Street, Jones and Co. Temple of the Muses, Finsbury Square; and G. Virtue, Ivy Lane.'

Steel engraving was further supported by the Art Unions, which published engravings for issue to each subscriber in return for their annual fee and used engravings as prizes. Competitions were held to produce designs based upon well-known books of the artist's choice, which were then sometimes engraved and published. The Art Unions attempted to interest the public at large in art and gave some an opportunity to own contemporary drawings, paintings, marbles, bronzes, etc., drawn in a lottery, for the expenditure of a small annual sum, usually of one guinea per person. People did sometimes take up more than one subscription in the increased hope of a prize. The annual draw was a great assembly of patrons, and the first person to draw a prize could choose a work of art to a stated value from those currently on exhibition. This value decreased as the list proceeded, until the lesser prizes were reached, among which prints often figured. To avoid total disappointment, all subscribers received the specially commissioned print for the year and, since numbers were usually large, a steel plate was essential. Most of these prints were larger than book plates and were framed to adorn Victorian sitting-rooms. The artists and engravers were often drawn from the ranks of the book illustrators.

Art Unions first appeared in France about 1800, when M. Hennin sponsored an informal group which, in 1816, merged into the Société des Amis des Arts. Over a period of twenty years, £9,000 was spent in engraving twenty-eight pictures exclusively for members. The movement spread quickly through France, particularly active societies being formed in Rouen and Nancy. The Art Union appeared in Germany under the patronage of Baron Von Stengel, a keen collector who organized soirées for his friends at Bamberg. When he died in 1822, the meetings were continued by his friends; on 1 December 1823, they formally organized themselves into a Kunstverein.[29] This plan soon spread to other German cities, where Art Unions flourished for many years.

The first British Art Union was founded in Scotland in 1833. In December 1834, the Association for the Promotion of the Fine Arts in Scotland held its first meeting

of subscribers to encourage the purchase of pictures from the Scottish Academy, and 694 people joined. The number was nearly doubled in their second year, when the first engraving was produced – a mezzotint by Robert M. Hodgetts of David Scott's 'The Taking Down from the Cross', at a cost of £250. In its fourth year, 2,800 one-guinea subscriptions were taken, of which 500 guineas was spent on the line engraving by Robert Graves of 'The Examination of Shakespeare' after George Harvey. The change to line engraving was undoubtedly brought about by the increased membership, requiring more prints than even a steel mezzotint plate could provide. Subsequent engravers employed were William Miller, John Burnet, Charles Rolls and Lumb Stocks. Between 1839 and 1868, William Miller did four large and six small plates, all on steel, the first of which, 'Loch an Eilan' after H. M'Culloch, brought him £340 out of the £800 set aside by the Society for its production. A suggestion to revert to mezzotint plates in 1848 was considered to be a 'retrograde step'.[30]

The Society for the Encouragement of British Art, founded in 1835, gained so little support that its influence was negligible. The establishment in 1836 of the Art Union of London met, therefore, little opposition in the metropolis. During its second year, 1837–8, 150 guineas was set aside to engrave the picture selected from the Royal Academy by a prizewinner, namely 'A Camaldolese Monk Showing the Relics in the Sacristy of his Convent at Rome' after William Simson, R.S.A., engraved by William O. Geller, a mezzotinter.[31]

Dissatisfaction with the management of the Association for the Promotion of Fine Arts in Scotland led to the foundation of the New Association for the Promotion of the Fine Arts in Scotland in 1837, which, in 1843, became the Art-Union of Scotland.

About 1838 or 1839 the Association for the Purchase of British Engravings was set up, with officers in Edinburgh; the architect James Newlands was secretary and Robert Sclater, die-cutter, treasurer. This proposed to purchase as many of the best engravings after British artists as would be allowed by an annual payment of five shillings (less the deduction of management expenses). The usual distribution by ballot would be undertaken, but support did not seem to be strong and no further trace of it is found after 1842.[32]

The Royal Irish Art-Union, founded in 1840, was also anxious to encourage native art. At the end of 1841, an exhibition was announced, contributions to which had to have been executed by persons resident in Ireland for the previous year at least. A total of 100 guineas was offered in prize money for success in eight classes, the first and most important prize being twenty-five pounds for a line engraving on copper or steel not less than 6 by 4 inches.[33] The organizers were very conscious of criticisms expressed about the quality of the prints issued by Art Unions[34] and of the doubts cast upon the exclusiveness of prints to Art Union subscribers. Consequently, they passed a motion in respect of their first print,

engraved by H. T. Ryall, of which over 1,300 copies had been taken, in the following terms:

Resolved – With a view to the keeping strict faith with the original subscribers of the Royal Irish Art-Union for the years 1839 and 1840, who have each received an impression from the steel plate of 'The Blind Girl at the Holy Well', that the said plate to be now destroyed, to prevent the possibility of the print getting into general circulation at any future time: and also to satisfy the subscribers at large that, with the exception of a few complimentary impressions, such as those voted for presentation to Her Majesty the Queen, Prince Albert &c., no one but an original subscriber has or can become possessed of that print, as by a rule of the said Society established.[35]

They also had problems both in finding engravers and in meeting delivery dates. Samuel Sangster was eventually appointed to engrave their second plate, after G. T. Doo (who had accepted a commission for the Art Union of London) and Robinson had declined, owing to pressure of work. Later engravers failed to deliver on time, so by 1848 the Royal Irish decided that no plate would be announced until they were certain it could be produced on time.[36]

In September 1841 appeared the first advertisement requesting a plate for presentation purposes on behalf of the Manchester Association for the Promotion of the Fine Arts. Engravers were asked to submit specimens of work, which had to be ready by the following February, of a print not less than 15 by 12 inches, quoting terms for the supply of 100 prints. This was in the tradition which existed for separate prints, by which the engraver would be responsible for supplying the paper and the plate to the printer, whose work the engraver often supervised.[37] In December an engraver was advertising: 'TO ART-UNIONS – An engraver has a PLATE, now nearly completed, to dispose of. It is a LINE ENGRAVING, on steel, size 15 in. by 12; and the subject is well calculated for the purpose of an ART-UNION. Apply, by letter, to A.B. 3, Grove-terrace, St. John's Wood.'[38] These advertisements appeared regularly for some years, varied only by the Art Union of London offering £500 for an original picture, with the painter superintending its engraving in due course.[39]

Provincial and local Unions mushroomed in the early 1840s. They existed, for instance, in Newcastle, Islington, Glasgow, Norwich, Plymouth, Exeter and Sheffield. Furthermore, in June 1842, Henry Hering announced a British agency for the Councils of the German Art Unions, particularly those of Berlin, Düsseldorf and Dresden, and copies of their engravings were made available for inspection at his offices. This increased employment for artists and engravers came when the first flush of book illustration was over; the large sums paid for individual plates must have attracted most of the important engravers. By the end of 1842, however, another cloud had appeared on the horizon. Richard Lloyd and J. L. Grundy were secretaries of the National Art-Union, launched to meet criticisms levelled at

existing societies. Their most important selling point concerned the prints which they proposed to offer, promising delivery of a print chosen from three or four, at the time the subscription was paid, each being a line engraving. To meet these requirements, high quality prints were needed but produced cheaply and in quantity. Some were purchased from F. G. Moon direct, but Turner's 'Ancient Italy', engraved by J. T. Willmore, and 'Modern Italy', engraved by William Miller, were the first two plates to be multiplied by the new electrotype process. The claims and counter-claims for and against the quality of such plates, raising doubts about its effectiveness, went on for the rest of the decade (see below, pages 191–2). The Art Union of London tried the process with varying success, but early in 1848 announced its return to steel as a safer means of securing good and consistent print quality. By the date of its draw, 18 December 1843, the National Art-Union was in financial difficulties, with less than 3,000 of the 20,000 tickets sold, and Mr Lloyd had lost many hundreds of pounds; its liberal principles had been far too costly.

The competition had, however, clearly shown a need to introduce something new into the Art Union programme. In October 1842, the Art Union of London advertised for a series of ten designs 12 by 8 inches in outline, illustrating some epoch in British history or the work of an English author. A premium of sixty pounds was offered, with further remuneration for superintending the engraving. By the closing day, 25 March 1843, thirty sets of designs had been submitted, six from Milton's *Paradise Lost*, four from *Comus*, three from Bunyan's *Pilgrim's Progress*, two from Shelley's *Prometheus Unbound*, two from Spenser's *Faerie Queene*, and the remainder from miscellaneous topics, including Shakespeare. On 4 April the judges chose the designs of H. C. Selous for *Pilgrim's Progress*, which were then engraved by Henry Moses and issued to all subscribers for the following year. W. Rimer won the prize in 1844 for his designs to *The Castle of Indolence*, engraved by four hands, including F. Joubèrt.

At the end of 1843, the print publishers petitioned the Prime Minister, Sir Robert Peel, against the activities of the Art Unions as injurious to their trade, and doubts were cast upon their legality. A Select Committee of the House of Commons was appointed in May 1844. It sat in June and July, and the engravers John Burnet, C. E. Wagstaff, H. T. Ryall, John Pye, Charles Turner, William and Edward Finden and H. C. Shenton were called to give evidence. Burnet and William Finden thought that the Art Unions had not assisted art, and the worst aspects were the use of electrotypes on the grounds that 'the great principle is not to make common – to restrict would be a great benefit indeed.' Shenton, on the other hand, thought that engravers ought to be very grateful to them.[40] After the publication of the report early in 1846, a Bill was introduced in May, and the Act legalizing Art Unions became law in August of that year.[41] The seal was finally set on 1 December 1846 with the grant of a Charter of Incorporation to the Art Union of London. During the time of the report's compilation, the size of prints was being

criticized. Most were of a large size and when framed took up a great deal of wall space. Smaller ones could be bound or put into portfolios; the size and quality of Robert Graves's engraving of Harvey's 'The Examination of Shakespeare' was regarded as ideal.

R. A. Spriggs, of the Library of Arts, 106 Great Russell Street, issued the first volume of the *London Art Union Prize Annual* in 1845, which contained engravings of 250 works of art selected as prizes in past years. The Art Union sanctioned but did not authorize the publication, in which the plates were superintended and etched by Henry Melville, and were finished in a mixed style. A second volume came out in 1846.

A variation on the single presentation plate was made in 1861, when a series of six engravings by R. C. Bell, Lumb Stocks and C. W. Sharpe were made after designs by Sir J. N. Paton entitled 'Dowie dens o' Yarrow'. These three engravers combined the following year to produce a volume of 'illustrated songs of Robert Burns'. Both books were published by the Royal Association for the Promotion of Fine Arts in Scotland. Some years later, the Association developed a series of original illustrations to Scott's novels by members of the Scottish Academy, executed by native engravers. In 1877, five line engravings illustrating *The Legend of Montrose* were issued and *The Fair Maid of Perth* was similarly treated in the following year.

The Art Union of London issued, in 1870, illustrations to Charles Kingsley's *Hereward the Wake* by H. C. Selous, engraved by Charles G. Lewis; in 1872, a group of eight steel engravings, *Coast Scenery*, after David Cox, Copley Fielding and Samuel Prout, engraved by E. P. Brandard, Charles Cousen, T. A. Prior and Arthur Willmore; and, in 1879, Byron's poem *Lara*, illustrated by the sculptor C. B. Birch.

This period coincided with the rise of the spurious or so-called 'shilling' Art Unions, which were societies issuing only prints at a low cost, sometimes as little as a shilling each. Unscrupulous operators bought up old and exhausted steel plates and printed from them as many poor copies as they could sell. The results 'would disgrace a hovel, or a workshop, or a Thames barge'.[42] This naturally brought the whole concept into disrepute, and a decline ensued.

One of the last line engravings to be prepared for the Art Union of London was executed by Arthur Willmore of E. Duncan's 'Return of the Lifeboat' (1877). After this date, the Art Unions turned increasingly to original etchings for their plates, a practice which extended well into the twentieth century. Support for the Unions was falling off, however, and in 1894, the Scottish Association wound up its affairs, leaving the London Art Union to continue almost alone.

CHAPTER TEN · Plate printing and the printers

The final step in the production of a steel engraving is as crucial to its ultimate appearance as any of the preceding stages; since bad printing is a comparatively rare phenomenon, it is sometimes difficult to appreciate the care needed to produce good results. A great deal depends upon the printer's skill to secure uniformly good impressions and his ability to prolong the life of the plate. This latter is a vital factor in printing copper plates, where only a maximum of 800 reasonable impressions can be achieved, but less significant with a steel plate, where hundreds of thousands can be obtained with a minimum of retouching. Many engravers appreciated the need for good printing, and even went so far as to stipulate which printer should reproduce their engravings. It is claimed that George Doo and John Pye, for instance, always had their plates printed by McQueen. For this reason, quite apart from the fundamental differences between relief and intaglio work, plate printing was normally undertaken by specialist firms: it is rare to find text and plates done by the same printer.

The main item of a printer's equipment was the copper-plate printing press (see plates 51 and 52) many examples of which are still in use. It was simply constructed, comprising two rollers between which paper and plate were pressed closely together in order to pull out the ink from the incised lines in the metal. At the beginning of the nineteenth century, a secure, upright wooden frame supported two rollers made of oak, fixed a certain distance apart, one above the other. To one end of the upper roller was attached a star handle formed by four or five long bars, each of which reached nearly to the ground, designed to give the operator the maximum purchase in turning the press. Between these rollers was introduced a sandwich, made up of a flat bed, sliding on runners, a sheet of zinc to impart some resilience to the engraved plate, which came next, a sheet of paper and, finally, a packing of felts or blankets to take up any remaining space. The rollers were fixed to take this sandwich fairly exactly, so that any variation in the thickness of plate had to be compensated for by adjusting the packing. Later versions of this press in-

PLATE 51 The earliest type of copper-plate printing press, with either four or five handles, part of plate 1 from Berthiau and Boitard, *Nouveau manuel complet de l'imprimeur en taille-douce*, Paris, 1892. (By courtesy St Bride's Printing Library.)

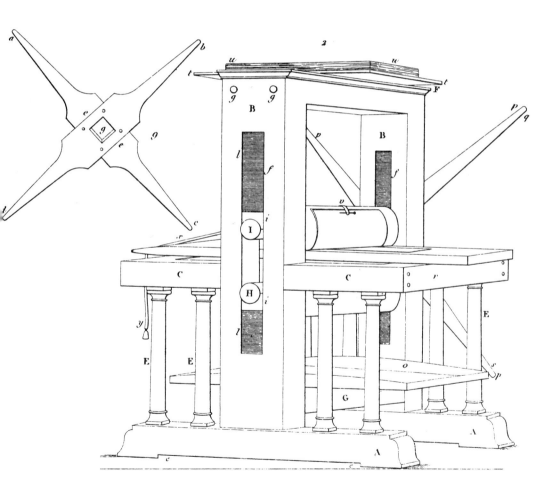

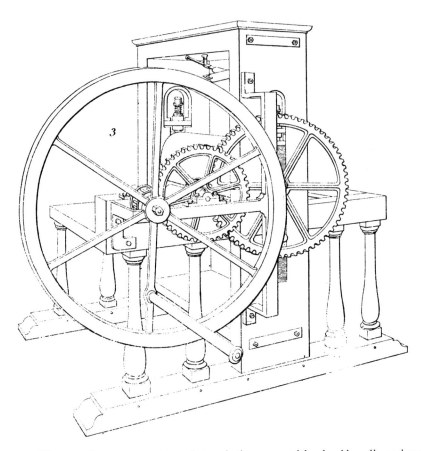

PLATE 52 Nineteenth-century copper-plate printing press with wheel handle and gear wheels, part of plate 3 from Berthiau and Boitard, *Nouveau manuel complet de l'imprimeur en taille-douce*, Paris, 1892. (By courtesy St Bride's Printing Library.)

corporated improvements such as frames, beds and rollers made of iron, gears, flywheels and lever or screw pressure adjustments, but the basic performance was the same. The gears were introduced between the star handle and a toothed wheel attached to the upper roller, giving more effect to the initial impetus, and the theoretical ability to operate faster and for longer periods. The flywheel maintained the momentum on larger machines, assisting in a smoother passage of the plate through the press, thus eliminating strong impressions where the press had slowed or even halted momentarily through loss of power. The cylinders themselves were made of steel, rendering them more durable and smoother in action. Much of this improvement was effected because of the interest in bank-note printing from steel plates. For instance, the communication of R. H. Solly to the Society of Arts Committee on Forgery outlines suggested improvements[1] and was accompanied by an engraving showing an 'Improved copper plate printing press for Bank notes.' To meet the problem of printing from blocks, as opposed to plates of

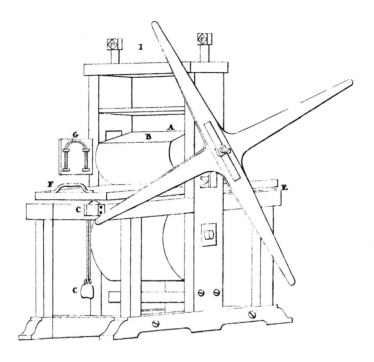

PLATE 53 Press with D roller, patented 28 February 1803 (Patent no. 2683) by Robert
Kirkwood (1774–1818) of Edinburgh, part of plate 4 from Berthiau and Boitard, *Nouveau
manuel complet de l'imprimeur en taille-douce*, Paris, 1892. (By courtesy St Bride's Printing
Library.)

steel, Perkins incorporated into the bed of the press a heater in the form of a block of
cast iron. This was heated and reheated as necessary, so that the printing block,
fixed into the press, could be inked without removing it. Later presses incorporated
a gas heater. He also adopted a device used by the calico printers to enable the bed
to return to the operator without producing a second pressure on the print, namely
that of a D-roller, where one side of the cylinder was cut away to allow the return.
Robert Kirkwood had patented this device in February 1803, suggesting that
either the upper or lower cylinder could be cut away. Alternatively, either roller
might be raised and lowered by means of levers (see plate 53).[2] On the normal
press, some printers permitted a second pressure on the return, which occasionally
gave a double or blurred impression. Perkins also advocated the use of a rotary
press, where plates were attached to the upper cylinder, while, in 1830, Augustus
Applegath took out a patent involving the bending of plates to fit two-segment
beds.[3] A very much later device, still used in many presses, was that which gave

'reciprocating motion to bed of press by use of one or more cog wheels, the teeth of which take into a rack or racks underneath the bed'.[4]

Iron presses were installed in the new Tottenham Court Road premises of McQueen in 1832, using a large iron wheel with a small handle fixed into a slot on one of the spokes, instead of the star-handle device.[5] The original watercolour drawings (see plates 54–56), done in the 1840s, of a lightweight iron press made by J. R. and A. Ransome of Ipswich, a firm still famous for their lawn mowers and agricultural machinery, underline the great simplicity of the presses.

The printing process itself, however, was complicated, requiring a great deal of experience on the part of the operator. The following account is of nineteenth-century practice but where printing is still done on hand-operated machines the techniques are essentially the same. A very stiff ink was used and had to be warmed to make it workable. It was rolled firmly across the whole plate and forced into the incised lines, the surplus being then wiped from the surface. During this operation, the plate was warmed on a heater and removed to the 'jigger' for wiping. Most book-plate printers took the view that only the lines actually incised on the plate should be printed. The finesse achieved by dragging a little ink across the edges of the lines (retroussage), or leaving a thin film of ink on the surface to give a toned effect, was left to the printseller's wares. The wiping itself was effected in three main stages: a piece of coarse canvas was used to remove most of the ink, then a piece of muslin or fine canvas took up most of what remained before the plate was polished with the palm of the hand, which was coated finely with whitening or chalk. The wipers had to be firm enough not to remove ink from the incised lines and, as such, were inclined to be abrasive, wearing the plate away by imperceptible degrees at each printing. The fine texture and smoothness of steel, combined with its hardness, enabled ink to be removed more easily and the wear much reduced. As the plate had to be removed from the press to be heated before re-inking, it could be turned so that the delicate parts were protected from too much wiping. Although it came too late to be of much practical use, Theodore Bergner communicated via Samuel W. Lowe of Philadelphia his intriguing method of avoiding wiping a plate.

PLATE 54 Copper-plate printing press designed in the 1840s by J. R. and A. Ransome of Ipswich, from a scrap-book entitled *Old Ploughs, Implements and Sundries*. Original size 9 by 11 inches. (By courtesy University of Reading, Museum of English Rural Life, Ransomes Collection, and Mr James Mosley.)

PLATE 55 (overleaf) Copper-plate printing press designed in the 1840s by J. R. and A. Ransome. Parts of the press. Original size 9⅛ by 11⅝ inches. (By courtesy University of Reading, Museum of English Rural Life, Ransomes Collection, and Mr James Mosley.)

PLATE 56 (overleaf) Copper-plate printing press designed in the 1840s by J. R. and A. Ransome. Buck wood cross. Original size 11⅝ by 9⅛ inches. (By courtesy University of Reading, Museum of English Rural Life, Ransomes Collection, and Mr James Mosley.)

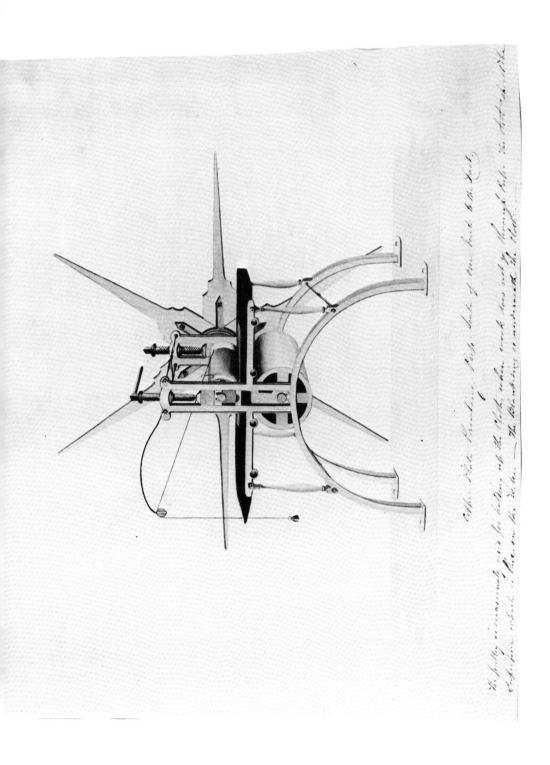

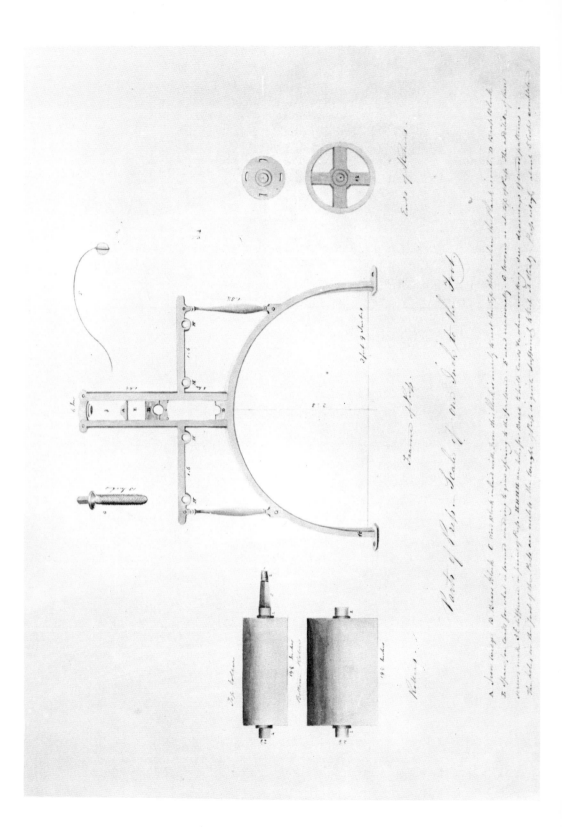

7 feet 2 inches

19 inches

2½ inch Spanish or Honduras Mahogany
worked down to 2¼ inch, for Plank

7 inches

3 feet 6 inch thick 2 inch

Beech wood Cross 7 feet in length both sides alike
fixed on to the spindle of Top roller with a Nut

185

This involved filling in the incised lines with substances such as gum, resin and wax, and coating the unengraved surface with an amalgam of copper and mercury. By its composition, this coating would reject the ink, only filling the now empty lines (the wax, etc. having been removed). Printing could then take place on a letter press alone, or combined in a forme with type. The only doubt about this process concerned the ability of a relief press to exert sufficient pressure to pull out the ink from the engraved lines; in all other respects it represented an answer to a difficult problem.[6]

After wiping, a sheet of special paper was placed on the plate to take the impression. The lightly sized paper was fairly thick, slightly absorbent, soft and smooth. Most paper, for whichever process, was damped before use, but this preliminary was vital to the success of plate printing. Ideally, the paper was prepared the day before and allowed to 'draw'. This made possible very close contact with the roller surface, enabling the paper to be pressed into the incised lines so that it pulled out the ink forming the design. In the majority of cases, the size of the sheet was larger than the plate itself, so that the steel edge, slightly bevelled, made its own impression, known as a plate mark. This was usually the only positive indication that an engraving had been printed from a metal plate, but its absence in books may be due to having been trimmed off during binding. Even this is not infallible, however, since plate marks can be added artificially, as happens in modern books. Most of the moisture would have been squeezed out of the paper in its passage through the press, but as the sheets came off the press they were piled into packs of about six, interleaved with tissue and allowed to dry, although if the ink depth was very great, the prints were hung over rope or cord lines. (Where a plate has been deeply bitten and the ink depth considerable, it may still be rubbed off after as long as a century, leaving a black mark on the fingers.) Some time later, the prints were pressed, usually under heavy weights,[7] although a screw press is used today. A piece of tissue was usually inserted before each plate in a book to prevent set-off, with the intention that it should be discarded when this object was achieved. Most frequently it has been retained, with the result that its acid content has produced spots on the print. These are difficult to treat. The obvious remedy is to remove the offending paper altogether, but the conservationists now advocate its replacement by an acid-free tissue, in order to preserve, it is suspected, any monetary value the book may have.

The first prints taken from a plate are always valued for their fresh and clear appearance, having a higher price put upon them in consequence. The use of steel plates reduced this value, since many more prints could be produced before the plate showed signs of wear; it was claimed that thousands of prints could be printed with little observable difference between the first and last (see above, pages 24–7). This gradually affected printing-house staffing, since the early proofs were always taken by specially skilled workmen, known as provers, working slowly and care-

fully to produce the finest specimens. Between two and six provers were employed, according to the size of the shop. A copper plate, yielding a maximum of 750 to 800 good impressions, would need careful handling to preserve its clarity. With steel plates, a prover's attention was not so necessary for the plain proofs; their principal function was then the production of India proofs. Thin India paper, fine, opaque and of good quality was used to take the actual ink, showing off the impression to the best possible advantage. But, because of its thinness, it needed to be backed by thicker plate paper. The India paper, cut to almost the same size as the original plate, was given a coating of fine paste, laid on the inked plate first and the thicker paper placed on top of that. Both passed through the press together, and the India paper adhered firmly to the damp backing sheet. Books with such illustrations must be stored in ideal atmospheric conditions, or else the thinner will peel from the thicker paper and be very difficult to replace. Modern papers are supplied ready pasted. Because of the time taken to paste and print these proofs, output was restricted to about thirty or forty in one day.

The number of good copies obtained from steel plates also weakened the print market. The production of book illustrations as prints affected the livelihood of the printsellers, so the possibility of limiting the numbers produced was seriously examined. This control was effected in two ways. The first was certification by an independent body that only so many copies had been printed from a plate; the second was by destruction of the plates. The Association of Print-Publishers and Dealers was set up in 1847, with Dominic Colnaghi as Chairman. William Walters, formerly employed by Boydell and Moon, was appointed Secretary, and one of his duties was to stamp and number each proof copy of a print, also ensuring, either by defacing or destroying the plate, that no more copies could be taken. This system only applied to prints priced one and a half guineas or above, so very little restriction was placed upon steel engravings by this action, although they were the principal cause of it. The destruction, by cutting into small pieces, of some large steel plates by Thomas Boys in 1855 caused a public outcry, but he defended his action on the grounds of protecting the investment of collectors possessing proof impressions; William Greatbach, C. G. Lewis, H. T. Ryall and J. T. Willmore were some of the engravers affected.[8] The publisher Hogarth relinquished the book side of his business in 1854 and put the remaining engravings of Finden's *Royal Gallery of British Art* up for auction by Southgate and Barrett. In order to preserve the worth of the original impressions, it was announced that the steels would be destroyed in the auction room during the sale. A precedent had been established by the same auctioneers in destroying the originals of Roberts's *Holy Land* and other publications. Something went wrong, however, because the forty-eight steel plates were sold by public auction for £2,000 in 1860. This raised further speculation of a reissue, but no trace has been found of it in book form, so perhaps the buyer recouped his outlay in the publication of separate prints.[9] Considerable stocks of

plates were built up at publishers and printers, most of which have since been lost or sold, but the discovery in 1975 of plates relating to Scott's works at the premises of Adam and Charles Black revives hope that others may come to light in due course. Longman sold the plates of Goldsmith's *Geography* for scrap metal in February 1866; 'By old metal plates 5 cwt 3q. @ 25/– Spott. £7.3.9d.'.[10]

There remains the effects of omitting to ink certain engraved lines, or stopping them out. The vignette (see plate 57) which forms the centrepiece of the engraved title-page to W. G. Fearnside and Thomas Harrel's *The History of London; Illustrated by Views in London and Westminster* (1838), published by Orr, has had no ink applied to the title above it or the publication lines below, both of which still appear on the engraved plate, now in the possession of Thomas Ross and Son. Another example provoked a public explanation after irate purchasers had complained about the state of their prints in Samuel Rogers's *Italy* (1830).

That any painful feeling could connect itself with this work we did not think possible; we have treasured it as the jewel of our libraries ... But as public journalists, what do seem to be public wrongs will obtrude themselves upon us ... There are, as is well known, two editions ... one published at £1.8s.od., the other appearing to have proof plates before the letters at £3.3s.od. It was, however, proved to us, that some 3 gn. copies, with what appear to be proofs before letters had plates taken after the letters, and that the letters, a well known trick in the profession, *had been stopped out*. This we confess startled and staggered us, and we determined to ask for an explanation.

The truth, then, after inquiry, appears to be that with the best intention of preventing wrong being done, the parties have placed themselves in a position that may certainly excuse the suspicion of wrong doing, and the following explanation is justly due to the public. The *first* and *folio proofs sold without the text have the artists' name to them*; and when the books were to be printed – be it remembered that the plates are on the same page as the text – stopping out the name seemed to be the better, *if not the only way*, to enable the public to distinguish the early from the late impressions; those persons therefore who have the 3 gn. copies may be assured that they have *the earliest proofs* printed with the text; indeed a moment's reflection will satisfy them that a fraud of this nature would have required a conspiracy for no possible self-benefit of publishers, bookbinders, printers and copper-plate printers.[11]

A more blatant use of worn steel and copper plates occurred in 1855, when letters were removed from them to produce what purported to be artist's proofs, or proofs before letters, afterwards re-engraving the lettering. The industrial and manufac-

PLATE 57 'Monument and St Magnus Church', steel-engraved title-page vignette by John Woods after J. H. Shepherd, from Fearnside and Harrel's *The History of London; Illustrated by Views in London and Westminster*, 1838. Original size 5½ by 4 inches. (By courtesy East Sussex County Library, Brighton Reference Library.)

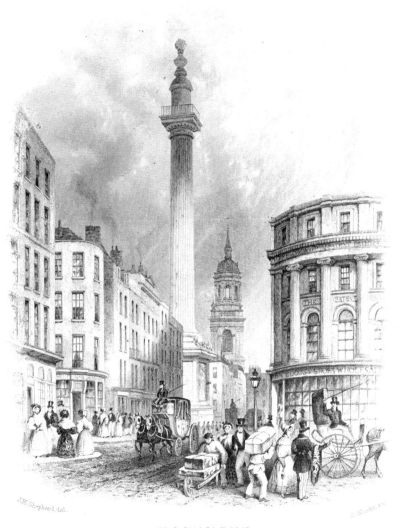

MONUMENT·
AND
ST MAGNUS CHURCH.

turing areas of Britain were the market where many copies were sold, but some suspicious buyers alerted the public to the fraud, although not until some profits had been made in this way.[12]

The great problem besetting plate printers, to which no satisfactory solution was found during the period under review, was the speed with which plates could be printed. It was estimated that a careful, steady workman could print no more than 180 to 200 good ordinary impressions of a 7 by 10 inch plate in a fourteen-hour working day,[13] but much depended on the size and complexity of the plate. The portrait which appeared in volume 2 of Moore's *Life of Byron* was a 'highly finished engraving'; because no more than fifty impressions a day could be taken from it, publication was delayed.[14] Even in the 1880s, it was estimated that the most expert of Virtue's printers would regard the production of one hundred copies of a quarto plate as a fair day's work.[15] In view of this, one wonders how the figure of 400 copies a day was arrived at by Joseph Clinton Robertson when discussing his proposal for relief metal plates before the 1836 Select Committee.[16] Speeding up the press by using a steam engine did not find a great deal of favour for the reason that slow and deliberate pressure was considered necessary to draw the ink satisfactorily out of the incised lines and to produce a good impression.[17] Although John Oldham was reported to be printing Bank of Ireland notes from steel plates on a press driven by an eight-horsepower engine in 1816,[18] and Jacob Perkins's press of 1819 was also steam driven,[19] both were used almost exclusively for printing bank-notes. There is no record of book illustrations being printed from such presses, not even by Perkins himself, even though the same source states that the press was used 'principally' for bank-note printing. In the 1880s, the position in art illustration was summed up thus:

Hitherto copper plate printing has been entirely confined to manual labour, a very tedious and slow process . . . but, at the Exhibition of Printing Appliances held in London in 1880, a copper-plate printing machine was shown in operation with steam as the motive-power. This seems to answer the purpose intended so far as ordinary commercial work is concerned, but whether it be competent for fine art work yet remains to be proved. The . . . machine . . . was exhibited by . . . Messrs. Bradbury and Wilkinson.[20]

Even this did not seem to be entirely satisfactory because, in 1885, the printers were saying that 'a satisfactory copper-plate machine was yet unknown'.[21] In 1901, a machine which could print over one thousand copies an hour from deeply engraved plates was produced.[22] Wiping the plate also slowed down the process. Most printers regarded this, rightly, as an art and the key to a good impression, so that Robert Neale's invention to remove the ink and polish the plates by a succession of rollers was not destined to find much favour.[23] The use of duplicate plates was another possible solution and was employed as a matter of course for etchings on steel.[24] But the laborious nature of steel engraving, as well as the length of run

obtainable from one plate, ruled this out for any but the most exceptional cases. Such an exceptional case was the demand for Scott's *Waverley Novels*, published by Cadell in 1830. At the end of a volume in the author's possession appears the following advertisement:

This new edition of the Waverley novels having at this early stage of its progress attained a degree of success unprecedented in the Annals of Literature, the Proprietors have the pleasure of stating, that they are in consequence enabled to bring forward DUPLICATE Engravings on STEEL, of the whole designs of the respective Artists. This course has been adopted, that every purchaser may depend on receiving undoubted good impressions, notwithstanding the very large number printed.

Each volume only contained a frontispiece and engraved title-page, the pictures measuring 3 by 2½ inches, so the expense and labour would not be exorbitant. It is doubtful whether many titles would have sold enough copies to warrant such measures.

The invention of electrotyping by Thomas Spencer, a Liverpool picture-frame maker, in 1838 appeared to provide the ideal answer to the multiplication of plates, and certainly it found a great deal of favour among the calico printers. His own method was to pass a sheet of lead and the original copper or steel plate through a very powerful press, producing a relief mould upon which copper could be 'grown' to form a new plate. His omission of any reference to the deposition of iron would indicate that his experiments had produced nothing useful in this field.[25] Commercial use was rapidly made of this; Edward Palmer, of 103 Newgate Street, London, was among the first to offer duplicate copper plates from copper or steel originals.[26] In 1841, he published some of his work, including prints from some steel plate originals engraved by Finden, Heath, Robinson, Miller and others.[27] The Art Unions were enthusiastic about the possible ability of producing thousands of prints quickly, offsetting delays occasioned by engravers, but their first trials were not successful; one plate was rejected after 200 impressions, although McQueen managed to print 800 impressions from another.[28] The failure of the early plates was ascribed to lack of cohesion between the atoms deposited, thus hastening wear during printing. By 1844, a more effective plate, thirteen to fourteen pounds in weight, was formed in fourteen days by the London printer Vaughan Palmer, of 42 Gloucester Street, Bloomsbury, compared with the ten weeks taken previously.[29] Vaughan Palmer made six electrotypes of William Greatbach's engraving of 'The Children in the Wood' after William Westall. Of these, five yielded 10,000 copies, an average of 2,000 each, certified by the printers, among whom were J. Ross of Dixon and Ross, H. Wilkinson and McQueen.[30] By 1848, the Art Union of London had reverted to steel, providing four plates from four different pictures (instead of four plates from the same picture), in order to meet the criticism of worn plate impressions then prevalent.[31] Abraham Raimbach took a very different view,

expressing it as his opinion that, to take full advantage of the electrotype's possibilities, it was necessary to expand greatly the number of print-buyers, an event he could not see happening in the very near future.[32] It has been impossible so far to prove that electrotype duplicates were used for book illustrations, but the possibility exists. It offers no avantage above the fact that more presses could be employed in producing copies from the one plate and/or its electrotypes, but the speed of production per press would still be limited.

A more likely solution to the problem of speed lies in the use of lithography. The connection of some artists, notably J. D. Harding, with lithography as a suitable medium for reproducing their work has already been noticed. The use of the copper-plate printing press for printing lithographs in the early days of the art made it easy for both types of work to be done in the same establishment, especially if metal plates were used instead of stone. Another London printer, William Day, of 17 Gate Street, Lincoln's Inn Fields, was perhaps the most successful in combining both methods in one shop. This juxtaposition encouraged the use of transfer lithography, where an impression from an engraved plate was used to make a lithographic plate on either stone or zinc. The process was well developed by 1838 when Day observed that 'this mode is very useful with hurried jobs and long numbers',[33] achieved in part by the use of a proper lithographic press, which ran more easily than a copper-plate press. Transfer lithography was introduced by the inventor of lithography, Alois Senefelder himself; it involved a drawing the right way round on prepared paper being transferred the wrong way round on to the stone or zinc, ready for printing; indeed, he considered this the most important part of his invention. As early as 1822, the Society of Arts offered a silver medal or twenty guineas 'for the best method of transferring drawings from paper to stone for the purpose of lithography, superior to any in use';[34] in 1839, R. Redman was given the Silver Isis Medal and five pounds for his method and 'chemical ink' of making transfers from copper plates. The lithographer Webb gave it as his opinion that transfer to zinc gave the sharper impressions, and E. F. Madeley, of the Lithographic Office, a London company with offices at 3 Wellington Street, Strand, added supporting testimony.[35] In the Great Exhibition catalogue, 1851, George James Cox of the Royal Polytechnic Institution is claimed as the inventor of an improved method of transferring metal engravings to stone, some examples of which were exhibited.[36] It may be noted that James Virtue had five lithographic presses working in the 1880s.

There is no doubt that lithography produced some good work in this field. However, when steel engravings are reproduced, much of the fine work suffers, especially at the edges of the vignettes. The print has a rather flat appearance, due in some measure to the uniform thickness of ink applied, as opposed to the different depths, however slight, achieved by the engraved plate. It is perhaps ironic that lithography provides the best twentieth-century method of reproducing steel

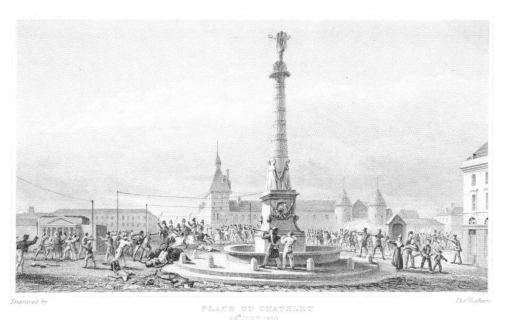

PLACE DU CHATELET
28TH JULY 1830

PLATE 58 'Place du Châtelet'. Steel engraving by Thomas Higham from *Paris and its Historical Scenes*, 1831, vol. 2, p. 135 (from the series *Library of Entertaining Knowledge*).

engravings, using photography instead of transfer, better even than collotype, which could also be considered. The reproduction (see plate 58) of Thomas Higham's engraving of the 'Place du Châtelet'[37] by lithography would preserve well the lines of the original and an even better result would be obtained with the title-page of *The Youth's Instructor and Guardian for 1824* (see plate 59); it is true, though, that neither of these has very fine lines to copy.

The modern printer's solution to the reproduction of fine lines has been to emphasize the tone of the picture, using a screen to break up the image and to reduce it to a mass of dots. At first sight, this may be seen as a practical arrangement, since the resulting print may be pleasing enough in itself. This is so in the copy of Stanfield's 'Rotterdam' (see plate 60),[38] but when the reproduction is compared with the original, the loss of definition is clearly seen. Tone represented by engraved lines can never be reproduced satisfactorily by dots. The reproduction, using a screen, of the engraved title-page to Shepherd's *Modern Athens* (see plate 61) shows the inadequacy of this method. The edges of the central vignette have lost their beautiful gradations, and the lettering, translating the sharp incised lines of the original into rough-edged dotted images, loses much of its effectiveness.

THE

Youths Instructor,

and

GUARDIAN,

FOR 1824.

VOL. 8.

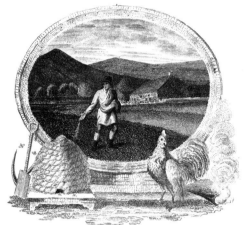

Emblems of the culture of the human mind.

LONDON:

Published & Sold by J. Kershaw, 14, City Road, & 66 Paternoster Row,
Sold also at the Methodist Chapel Houses in Town & Country.

Engraved Smith by T. Brown.

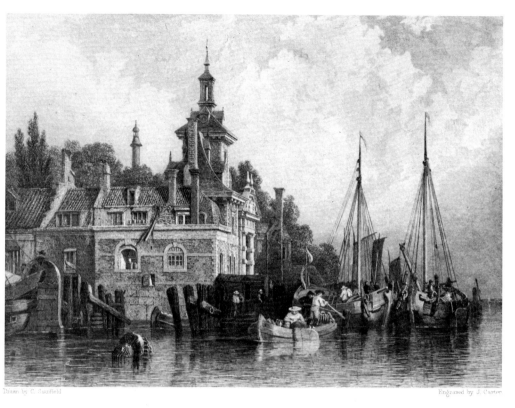

Drawn by C. Stanfield. Engraved by J. Carter.

ROTTERDAM.

PLATE **60** 'Rotterdam', steel engraving by J. Carter after Clarkson Stanfield, from p. 235 of Leitch Ritchie's *Travelling Sketches on the Rhine*, 1832, which is the 1833 volume of *Heath's Picturesque Annual*.

One of the disadvantages of transfer lithography was the destruction of the original on the paper. If the master plate was damaged, there was no hope of exactly reproducing the design again. Senefelder, therefore, used a method, though he never described it, whereby the drawing was retained intact by only removing part of the grease and none of the pigment from the original. Joseph Pennell claimed to have described the process for the first time,[39] but when a similar method was announced by which line engravings could be exactly and quickly reproduced, there was immediate consternation among engravers and others. In 1844, an unknown engraver in ill-health invented a means of producing plates, mostly in steel, from merely a print of the original. Any amount of plates, each yielding up to 20,000 impressions could be manufactured from a single print, taking only a few

PLATE **59** Title-page, steel-engraved by T. Brown, from *The Youth's Instructor and Guardian for 1824*.

MODERN ATHENS,

DISPLAYED IN A SERIES OF VIEWS,

OR

EDINBURGH.

IN THE

NINETEENTH CENTURY;

EXHIBITING THE WHOLE OF THE

NEW BUILDINGS, MODERN IMPROVEMENTS,

Antiquities & Picturesque Scenery,

OF THE

SCOTTISH METROPOLIS & ITS ENVIRONS,

FROM ORIGINAL DRAWINGS,

BY

Mr THOS. H. SHEPHERD.

WITH HISTORICAL TOPOGRAPHICAL & CRITICAL ILLUSTRATIONS.

Drawn by Tho. H. Shepherd.

Engraved by W. Wallis.

EDINBURGH CASTLE.

LONDON.

Published by Jones & Co. Temple of the Muses, Finsbury Square, Jany 1, 1829.

days to produce. A trial plate of the 'Head of Christ' after Delaroche, engraved in a year by Auguste Blanchard, took seven days to reproduce. Later on, it was claimed that copies could be taken in a quarter of an hour. The reproduction of bank-notes created the greatest cause for alarm; it was reported that a similar invention in Vienna had resulted in the purchase of the inventor's silence by the King to prevent its widespread use. It would appear that although the engraver's family helped him, he alone knew the secret. Since no explanation was immediately forthcoming, it probably died with him;[40] it was about twenty years before anybody hazarded an explanation in print of the process. In 1864, the engraver Jean Ferdinand Joubert put forward the following theory:

The plate and engraving to be reproduced were prepared with a certain solution, which caused the engraving to adhere to the steel plate, the engraved portion being face to face with the plate. This being done, the paper was removed from the back of the engraving, leaving the ink adhering to the steel plate. A certain varnish was then spread over the plate, which adhered to it only in those parts not covered with the ink. The plate was then washed in a certain bath, and the varnish adhered, while the ink was removed. The plates were then treated with acids, but the result, he believed, was very imperfect, owing to the lateral biting. To produce anything like the original, the plate, after the above treatment, required to go into the hands of the engraver, and be almost engraved over again.[41]

The cautiousness over the composition of the solution, varnish and bath maintain the secrecy, even if Joubert himself knew, but in one respect his explanation does not agree with earlier accounts. In these, the observers allowed that the results often wanted the brilliancy of the original prints, but more than one reference is made to the return of the print unscathed. Joubert's explanation appears to indicate the destruction of the print, so the truth may lay in between, as in Senefelder's method, with only a small amount of ink being taken from the original to form the duplicate image. Whatever the truth, this potentially dangerous invention went underground and more conventional means were encouraged.

The most enduring discovery in the production of prints was made in 1858. Thomas Spencer and his successors had concentrated almost exclusively upon the duplication of copper plates without a great deal of success, but it was twenty years before the deposition of a hard metal upon a softer became a practical reality. If it had been known forty years earlier, steel engraving would never have been developed; the ease of engraving in copper combined with the hardness of a steel surface provided the ideal solution for all concerned. Developed by Henri Garnier in Paris, the process was patented in England in March 1858, and was exploited by Jean Ferdinand Joubert, who had collaborated with Garnier. The deposition of an

PLATE **61** Title-page vignette steel-engraved by W. Wallis after T. H. Shepherd, from his *Modern Athens*, 1829.

197

iron surface was a simple process; the French term given to the process was *acierage*, while in English it was called 'steel-facing'. Coating by other metals was known; the specific claim of this patent was for iron on copper and other metallic printing surfaces. Various possibilities emerged from this. Since a coating of iron could be renewed at will by removing the old with nitric acid, the original copper could have a succession of such coatings and produce many more copies than a steel plate by itself. It was claimed that, since the plate was never worn, all impressions would be equally good and that this advantage could be extended indefinitely by the facing of electrotypes. The one distinct advantage of steel engraving – that of permitting very fine work which could survive the printing process – was also removed by steel-facing, because the coated copper could generally resist the breakdown between lines and surface wear, of course, was reduced. One argument used against it was that it would imperceptibly change the appearance of the engraving. Some thought they could detect such differences, but it is still advocated by practitioners of the art – the sole survivor of the nineteenth-century processes.[42] One person who took an early interest in steel-facing was Henry Bohn, the reprint publisher. He was delighted with the results from the first plates done for him, and 'was now testing it upon plates which, but for this process, would be worthless.'[43] The engravers Le Keux, William Humphrys and George Doo were known to be interested in the development, and a protracted correspondence in the *Journal of the Society of Arts* involving Henry Bradbury went on for nearly a year, during which he claimed a prior invention of zinc plating on copper and challenged Joubert's right to the steel-facing process. The firm he founded, Bradbury, Wilkinson and Co. specialized in the facing of electrotypes during the latter part of the century.[44]

SOME PLATE PRINTERS

About thirty printers concerned with the production of steel engravings have been encountered during the course of this study. All books seen contained the name of the text printer, as required by law. As for the plates, only the large paper copies could be relied upon to provide some information, however meagre, as to their printer. This was usually given as a name or abbreviation, e.g. 'McQueen' or 'McQ.', below the publication line, in the left-hand or, more commonly, the right-hand bottom corner of the plate; when ordinary copies were taken, the printer's name was often removed when the volume was trimmed in binding. The reason for the printer's name appearing at all is obscure, unless it was the equivalent of eighteenth-century press marks, intended to indicate the payment due to the operator. It may be significant that the practice seems only to have begun with steel, where several printers were employed on the plates for one book.[45] Finden's *The Beauties of Moore* employed five printers, i.e. Wilkinson (22 plates), McQueen

(16), Tomlinson (4), Brain (2), and Horwood and Watkins (2). Ross's *Narrative of a Second Voyage in Search of a North-west Passage* used four, i.e. Gaywood and Co. (6), McQueen (3), Wilkinson (2) and J. Yates (2).

Some copper-plate printers were also engravers, for example, Alfred Adlard of 7 Wardrobe Place, Doctor's Commons, who printed the illustrations to Hall's *Ireland* (1841–3). In 1841, he was advertising 'that all commissions confided to him will be executed by competent artists and workmen; and from his being situated in the immediate neighbourhood of Paternoster-row, possesses facilities for executing orders for the Country at very short notice. – Armorial bearings found.'[46] There are a number of Adlards known as London printers in this period, notably James William and Charles.[47] H. Adlard engraved many illustrations in contemporary books, and may have been related.

There were three main combinations of engraver and printer. Firstly, there were engravers and printers working independently, based on the ancient relationship where it was the engraver's responsibility to provide the paper and supervise closely the actual work.[48] Secondly, there were the engravers who were also printers. Thirdly, there were the firms who engraved their own work without always naming the individuals responsible for the plates. This latter category included such firms as Fenner, Sears and Co., who engraved four and printed two plates from Thomas Allen's *History of the Counties of Surrey and Sussex* (1829). They were also employed for the early volumes of Robert Jennings's *Landscape Annual*, but since the results were not entirely satisfactory, Lloyd and Henning took over for the 1833–5 volumes. This firm changed its name to Lloyd and Co. (1836) and to R. Lloyd in 1837, by whom three plates to Finden's *Royal Gallery of British Art* were printed between 1840 and 1842. A number of smaller firms were engaged on engraving and printing steel-engraved vignettes for local guides, the plates then being used to print small albums containing about six views, and even reproduced on linen to form the centrepieces of tablemats, sold as seaside souvenirs.[49] There were many firms up and down the country who held stocks of engravings which were put to many different uses; even the smallest printing houses had their selections of 'stock blocks' used for different jobs from letter heads to advertisements. The small numbers appearing on some plates, bearing no relation to the pagination of a book in which they appear are probably stock numbers (see plate 2, page 8, where the number 98 appears in the centre between artist and engraver). One of the few published stock books clearly indicating this practice is *Art for Commerce : Illustrations and Designs in Stock at E. S. and A. Robinson, Printers, Bristol in the 1880's* (introduced by Michael Turner and David Vaisey and published by Scolar Press, 1973). The firm of Robinson was, among other things, a copper-plate printer, and a few of its plates were done by well-known engravers, such as George Cooke and Thomas Landseer.

Perkins and his successive partners printed some book illustrations throughout

the period, many in connection with Charles Heath. 'Perkins & Bacon', 'Perkins, Bacon & Petch' (from 1834 to 1852, when Henry Petch, an engraver with the firm was also a partner) and other variations appeared on plates printed for *The Keepsake* and other work for Longman until the 1850s. The firm had nearly forty rolling presses working for them in 1839, but not all engaged on book illustration.[50]

The two major names as printers of steel-engraved book illustrations were McQueen and Virtue, both of London.

Started by William Benjamin McQueen in 1816 at 72 Newman Street, Oxford Street, the firm moved to new premises at 184 Tottenham Court Road in 1832[51] where it remained until it went to Chiswick in 1930. In 1956, the firm finally merged with Thomas Ross and Son. Among the steel engravers who had plates printed by them were: J. B. Allen, R. Brandard, J. Burnet, G. T. Doo, B. P. Gibbon, E. Goodall, W. Greatbach, the Finden brothers, C. Heath, J. Heath, F. and W. Holl, W. Miller, J. Pye, H. T. Ryall, J. H. Robinson, L. Stocks, C. W. Sharpe, W. H. Simmons, J. Thomson, A. and J. T. Willmore and J. H. Watt.[52] As an example of the firm's involvement in most of the important books of the period, their printing of fifty-eight plates for Brockedon's *Illustrations of the Passes of the Alps* can be quoted. Chatfield printed fourteen and S. H. Hawkins nineteen of the remainder. Steel plates, presumably for books, were still being printed by McQueen for the publishers Bell & Co. as late as the 1930s.[53] James Lidstone's poem about McQueen (see plate 62) is one of a series he wrote on City firms. Extravagant though the language may be, it is one of the few contemporary comments on the engraver's and printer's art couched in appreciative terms.

Dixon and Ross, established 1833, does not appear to have been so active in book work, concentrating mainly on printing for the printsellers and the Art Unions. One of the partners, John Dixon, printed the plates for Allan Cunningham's *The Anniversary* (1829), this information being given a prominent place on the engraved title-page.

George Virtue entered the printing field in 1851, by which time the boom in steel-engraved works was over. Before this date he had employed a number of printers for his books; when he took over publication of the *Art Journal* in 1849, he inherited arrangements already made by Chapman and Hall, the previous publishers. Up to August 1847, the *Art Journal* had been content to reprint already published plates, but a new policy of issuing original engravings on steel resulted in the use of ten printers in the first two years. These were McQueen (1847–51, 16 plates), Brooker and Harrison (1847–8, 7 plates), Dixon and Ross (1847, 4 plates),[54] H. Wilkinson (1847–54, 33 plates), James Yates (1847, 1 plate), E. Brain (1848–51, 23 plates), William Day (1848–51, 14 plates), R. M. Marks (1848–9, 7

PLATE 62 Verse on the printer McQueen by James T. S. Lidstone, from a pamphlet, *The Londoniad*, 1857, published by its author. (By courtesy Mr Philip McQueen.)

First-Class Medal, at Paris, in 1855.

M'QUEEN,

Copper and Steel Plate Printers,

No. 184, TOTTENHAM COURT ROAD

(*Opposite Howland Street*).

" Whate'er Lorrain's light hand with softening hue,
Or savage Rosa dash'd, or learned Poussin drew."
James Thomson's " Castle of Indolence."

THIS is the glorious Art that merits praise
Through every age from Finiguerra's days,
When SPEED in legend'ry lore well versed,
From Antwerp brought it on to James the First;
And since that time, through rolling ages down,
'Mong sons of Art, the loftiest in renown,
Those whom Genius and their country bless,
Have practised on the COPPER-PLATE PRINTING PRESS.
And those who could o'er their compatriots rise,
By force of talent ever bore THE PRIZE:
The Engraver, at his best, would strive in vain
The summit of his glorious Art to gain,
If circumspection, too, were not display'd,
And to their talent brought the *Printer's* aid.
What wondrous specimens! let all confess,
In living splendours from the teeming press.
In countless numbers, and in magnitude,
Arise with richness, ease, and freedom all embued,
They so entrance even now the Artistic Bard,
That he unto the Artists doth award
Palms beyond the Epic, and Olympic odes
Of fictious Heroes and their shadowy Gods.
What cause doth such rejoicing Muse assign,
He ranks the first in all his glorious line;
No names I mention, but the ardent Bard
Draws inspiration from his Hero's Card.

plates), Collins and Scarrott (1849, 1 plate) and Horwood and Watkins (1849–51, 8 plates). Only McQueen, Wilkinson, Brain, Day and Horwood and Watkins were employed by Virtue, who added Thomas Brooker, (1851, 2 plates),[55] Gad and Keningale (1850–4, 8 plates) and R. Holdgate, (1852–4, 4 plates).[56]

In 1851, George Virtue bought premises at 294 City Road, which were adapted and extended to become one of the best organized printing works of its kind in London. By the time he retired, in 1855, the firm was quite self sufficient, printing all the works published from Ivy Lane. By the 1880s, the printing department for steel engravings and etchings was thought to be the largest in the trade, housing forty presses, one of which was on view at the 1877 Caxton Exhibition at South Kensington,[57] and a very considerable stock of steel plates. By this time, Virtue considered it an undesirable practice to print direct from original plates, thus keeping them fresh to produce only electrotypes, which process was used extensively to provide duplicate plates, available also to the trade, which were then steel-faced to extend their life.[58] Virtue had been interested in *acierage* from the beginning, having undertaken experimental printing from a plate which had only one half of its surface coated in order to prove once and for all that the process made no difference to the appearance of the final print.[59] Virtue used electrotypes in 1872, when a series of monographs on nineteenth-century painters (Edwin Landseer, C. R. Leslie, Daniel Maclise, William Mulready and Clarkson Stanfield), edited by the *Art Journal*'s assistant editor, James Dafforne, were illustrated with line engravings 'not printed from worn plates'.[60] Before this, and even co-existent with electrotyping, a staff of about eight expert engravers were constantly employed in touching up the plates as soon as wear was detected, so that none but satisfactory impressions were printed. This practice could be a damaging one, however, as Joubert noticed when introducing steel-facing. He remarked that some plates had been so extensively touched up that scarcely any of the original engraving was left.[61] At one stage, the Virtue printing works employed about 400 people. Shortly before Christmas 1866, when extensions to the City Road premises had been completed, the management gave an 'entertainment' to their work force. 'The evening was happily spent', and the rest of the account goes on to detail the speeches from the management, including the 'hearty and affectionate address' given by one of the foremen. James Virtue was out of town, so William Virtue took the chair, delivering a homily on the mutual interest of employers and employed, referring to the fact that some employees were the sons of older workmen. 'Mr. Deputy Virtue' (i.e. George) was also present, with other members of his family, and spoke on the theme that temperance, industry and morality were the bases of prosperity. His description as 'Deputy' referred to the civic posts he held at the time.[62] The firm also printed and published art plates. Twenty-five of their mezzotints were bought by Thomas Ross and Son, probably at the bankruptcy sale at the end of the nineteenth century, and are still in use today.[63]

Henry Fisher of the Caxton Press (see above, pages 170–73) had ten copper-plate presses working in his Liverpool premises. When the fire of 1821 overwhelmed it, 400 original drawings were also lost and over a thousand employees were put out of work. It is a fair assumption that copper-plate presses formed part of his new establishment at Owen's Row, Clerkenwell in London, since he would be well aware of the advantages of printing his own plates as well as his own texts.[64]

Of the provincial printers only three have any significance. T. Radclyffe of Birmingham was concerned with printing at least half of the engravings for *Graphic Illustrations of Warwickshire* (1829), for which his kinsman (possibly brother) William engraved the plates. W. and D. Duncan of Glasgow printed most of the plates for Wilson and Chambers's *The Land of Burns* (1840), published by Blackie. Joseph Swan, the third of this group (see plate 63) first arrived in Glasgow about 1818, and from 1822 until 1869, when he retired, is recorded as running a business described as 'engraver, publisher, copper-plate and lithographic printer'. He also printed bank-notes for a short time. In all this, he was probably no different from many such establishments of the day, but his publishing ventures included eight important topographical works with steel-engraved plates. Among them were two books by J. M. Leighton, namely, *Select Views of Glasgow* (1828) and *Select Views on the River Clyde* (1830); other titles included *Lakes of Scotland* (1834), *Historical Description of Paisley* (1835) and *Historical Description of Dundee* (1836), both by Charles Mackie, and *Perthshire Illustrated* (1843), by Sir W. Hooker. Swan was said to have perfected an engraving machine, of what kind is not known, and was one of the first to operate a steam-powered lithographic press, of which he eventually had a dozen or more and upon which *Swan's Universal Copy Books* were printed. He employed five or six copper-plate printers in the mid-century, three of whom were Willie Kirkland, John Hutcheson (who later went to Blackie's) and R. M. Steven. Picture engravers on his staff were Henry Bell and William Marshall; of the others, one or two specialized in letter and seal engraving.[65] The reason for this lack of provincial printers may be found in a letter from William Miller, dated 15 July 1833, concerning four of the illustrations to Cadell's edition of The *Poetical Works of Sir Walter Scott* (1833). The letter accompanied the touched plate and proof of 'Melrose', the frontispiece to volume 6, and it is of this plate that he writes: 'I hope with the great superiority of London printing the effect of the plate will be good.'[66] The book producers in Scotland had a reasonably good name and most of the Irish engravings were produced either there or in England. It was an occasion worthy of comment, therefore, when a press opened in Ireland in 1848 with suitable machinery for printing high-class engravings, but apart from a plate for the Royal Irish Art-Union, no other production of this press has so far emerged.[67]

PLATE **63** (overleaf) Joseph Swan (d. 1872), from Thomas Murdoch's *The Early History of Lithography in Glasgow, 1816–1902*, 1902. (By courtesy The Mitchell Library, Glasgow.)

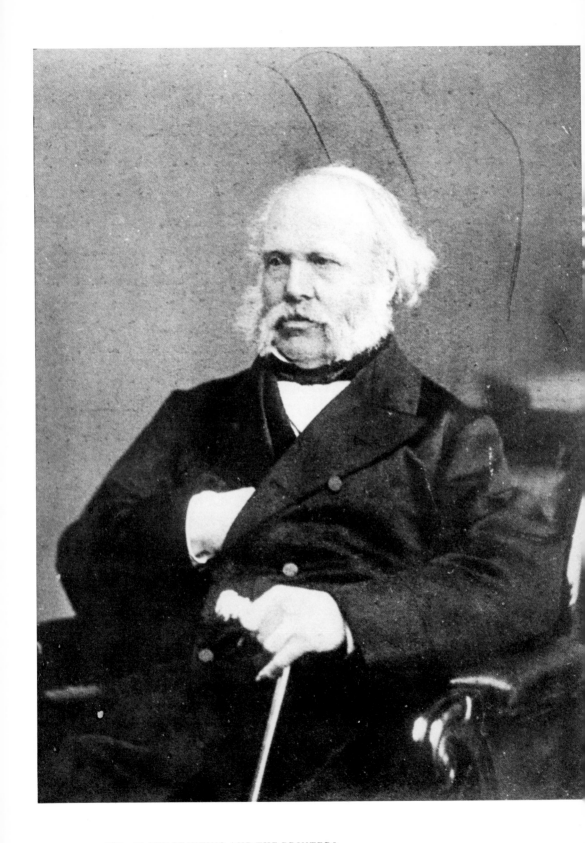

CHAPTER ELEVEN · Decline of the art

Steel engraving had been in common use for about eight years when the first warnings were given of a bubble which might soon burst. Although other figures are not readily available, the average number of new works published annually in England between 1800 and 1827 was, according to one estimate, 588.[1] What is certain is that, with the modern aids to production then coming into use and a wider reading public, both the number of works and of copies would rapidly increase. The annuals were but one manifestation of this; in order for them to be produced on time, the use of several engravers and printers was essential. The very rapid expansion of the engraving profession was causing alarm by 1831, when it was predicted that the engravers would need to seek other employment when the annuals no longer existed.[2] The annuals continued, however, and, by the time they had ceased to provide adequate work, other events had supervened. There was a drift away from line engraving, one small indication being the number of engravers who left for America between the years 1832 and 1836 before the trade revival had increased prosperity once more. Although only five steel engravers can be named as having emigrated to America,[3] many others are known to have gone. In the mid-1830s some other unemployed engravers left for Leipzig to work for, among other people, Georg Wigand.[4] By 1839, work for the printsellers in line was at such a low ebb that more line engravers were being forced to turn to mezzotint, which was a quicker and cheaper method for the print publishers.[5] Seventeen years after its introduction, steel line engraving was almost confined to the illustrated book and the Art Unions.

It was also in 1839 that the beginnings of two rival processes made themselves felt. Lithography, which had first been used in English book illustration for one singularly unsuccessful plate in J. T. Smith's *Antiquities of Westminster* (1807), had never been taken seriously and was even regarded with hostility by some editors. Alaric Watts, in a letter of 31 July 1824 to the publisher Joseph Ogle Robinson, refers to a book which had been submitted for approval on Greece and the Ionian Isles. 'The author says he has some drawings "which might be lithographed". Lithography is damnation to any respectable book. If found worth engraving, they should be slightly etched.'[6] Until 1840, comparatively few English book illustrations were printed by this method.[7] Thackeray, in an oft-misquoted passage,

attributes this to the amount of money tied up in already established methods such as steel engraving, which had captured most of the market, and commercial speculation, which insisted that the utmost profit be made from such outlays. He goes on to elaborate on the middle-class experience with art, confining it to an 'Album', two 'Annuals' and portraits or miniatures of the family, with a yearly visit to a local exhibition and a ten-yearly visit to the National Gallery. In contrast, the French were surrounded with better art in their cafes, restaurants and shops, whilst in their homes, some bad engravings but many good lithographs gave them an appreciation of contemporary painting. The Englishman's snobbish attitude to art – where he was now able to obtain prints cheaply, the like of which had formerly been only within the reach of the wealthy – was contrasted with the French attitude, where the cheapness of the means had little to do with the quality of the finished print.[8] The lack of wealth and enterprise on the part of the French and German publishers doubtless allowed lithography to gain ground quickly but it also permitted the export of steel-engraved books and prints to the Continent, thus delaying the development of French and German steel engraving. French versions of the annuals and topographical books published in England have already been referred to in Chapter 8, but as late as 1850, books produced in France were still using English steel engravings for their illustrations. An example of this was *La Siesta* by H.-L. Sazerac, published in Paris by H. Mandeville, with a preface dated 21 July 1850. Reproductions of English paintings by artists such as Landseer, Reynolds and Stanfield were engraved by H. Beckwith, J. C. Bentley, J. Cousen, Gibbs, F. Joubert, C. W. Sharpe, R. Staines and L. Stocks. One plate has 'Printed by McQueen' engraved upon it; it seems likely that a whole stock of engravings was bought up to embellish the text, which was printed in France. That France had, in the 1840s, some line engravers of eminence can be adduced from the fact that the print publisher Puckle sent two portraits of Queen Victoria and Prince Albert there for engraving, thus raising the comment that 'while we have many admirable line engravers, little employed, was it either necessary, wise or just to consign them to the care of French artists?'[9]

A further step was taken in 1844 to protect English engravers, when an Act of Parliament[10] laid an import duty on engravings first published in a foreign country of a half pence each single or one and a half pence per bound dozen, either plain or coloured. The extent of the trade is indicated by figures for 1846, when the import of prints and drawings for home use stood at 388,630 singles (including 28,239 published in Saxony or Prussia) and 243,828 bound or sewn (including 426 published in Saxony or Prussia). German artists became interested in steel engraving towards the end of the 1830s, when many of them regularly etched on the metal.[11] Some engravings by Edward Schaeffer were reviewed in 1843 with the following comment: 'The engravings before us are executed in the ordinary German line manner; that is, they are characterised by the thinness of a very careful etching,

rather than by anything like the fulness and richness of French and English line engraving.'[12] The English art public also had some opportunity of becoming familiar with current French and German books and prints through the activities of firms such as Hering and Remington of 153 Regent Street. They were agents for the German Art Unions, which were conducting at this time an extensive advertising campaign over here, so that German art was familiar through engravings of it, even though these enhance 'the best points of German productions, and veil some of their principal defects.'[13]

Returning to lithography for a moment, although two great works, Gould's *Birds of the World* and Owen Jones's *Alhambra*, were begun in 1832 and 1836 respectively, they were not finished until the next decade. They were followed, in the 1840s, by a spate of chromolithographed works; the great period of British lithography began about 1845.[14] The volumes were usually large folios, and it was only in landscape designs that there was any real danger to the steel-engraved market, with its commitment to a small format. The accent on colour added a dimension which did not affect steel either, but tended to replace the popular hand-coloured aquatinted book.

A far more serious rival was wood engraving. After the death of Thomas Bewick in 1828 and Robert Branston the elder in 1827, wood engraving lost the impetus obtained in the previous forty or fifty years and went into a decline. It was a process associated through woodcuts with productions of a poor kind and it had nothing to offer in comparison with the new and brilliant steel engravings. This much was admitted in 1839: 'The wood cannot produce – at least, it has not as yet produced – such admirable blending of tints as the steel does',[15] but the real problem was lack of designers for wood. Those who, like Stothard, had the ability, found they could earn more by designing for steel. Any wood engraver who wished to learn the craft on his own, as Branston the elder did, was compelled to copy the current steel-engraved plates and was unable to develop a style of his own. This problem was not solved until the 1860s, when designers and cutters like the Dalziel brothers came together to breathe new life into the medium. Wood engraving gained new importance in the 1840s; the coming of the *Illustrated London News*, in 1842, demanded the speed, cheapness and ability to print with type that the process could offer. In 1845, the first coloured wood engraving appeared in a book. Very soon a new, cheaper annual or Christmas gift book was on the market, illustrated with competent wood engravings, many of them in colour, displacing the steel-engraved variety, which also had to compete with the expensive chromolithographed work, on the lines of those printed by Vizetelly for John Murray.[16] Squeezed in both directions, the steel-engraved annual retired gracefully, kept alive only by the determination of David Bogue.

In face of such competition, the steel-engraved travel book introduced wood engravings to embellish the text. The reviewer of *The Keepsake* for 1842 writes that it

'is very mediocre; and the publisher has completely defaced it by the introduction of several miserable substitutes for wood-cuts, according to the invention of some unhappy patentee.'[17] In 1844, Beattie's *The Danube* introduced wood engravings to 'give a new and striking feature to the work' (see above, page 169). Bohn's second edition of Ritchie's *Windsor Castle* (1848) added thirty-six wood engravings 'by the first artists' (according to the title-page) to the fifteen steel engravings of the original volume. As more wood engravers became proficient and electrotypes more common, wood engraving became a substitute for steel engraving in all but the finer aspects of tone, until wood in its turn was replaced by the mechanical photographic processes at the end of the century. Many of the less independent engravers, such as those working in ateliers – men who are, generally speaking, unknown by name – probably continued their employment in the same establishments, drawing on lithographic stones,[18] turning to wood engraving or continuing repair work on existing copper and steel plates.

The arrival of the penny post in 1840 provided yet another source of employment for some book engravers. Rowland Hill, prime mover in the enterprise, had approached Perkins, Bacon and Co. late in 1839 with an offer for them to produce the necessary dies and plates for producing stamps. Their reputation as the most experienced of the security printers was probably the reason for this invitation. The first postage stamp to be produced was the celebrated Penny Black, for which a reducing was prepared by Henry Corbould. Charles Heath was asked to do the engraving, but in the event the dies were prepared by his son, Frederick Augustus Heath. Another member of the family, Charles Heath's son-in-law, Edward Corbould, later prepared designs for subsequent colonial issues.

The first of about half a dozen book engravers who turned to this new occupation was William Humphrys. He was born in Dublin and had emigrated with his family at an early age. Trained as a bank-note engraver by George Murray of Philadelphia, he returned to England in 1823. He joined the book engravers of the time: his first and most important book work was in the *Literary Souvenir* and *The Bijou*. At the end of the 1830s he was among the engravers forced to turn to mezzotint, and was willing enough, therefore, to work on stamp engraving in its early days. He returned to America for two years, between 1843 and 1845, where he engraved at least one plate in an American annual, *The Gift*, for 1844, and settled again in London, where he was known as the 'American engraver'. He engraved 'The Coquette' after Sir Joshua Reynolds in 1849 for Finden's *Royal Gallery of British Art*, and the Queen's portrait for the first New Zealand stamps, issued in July 1855. He had gone to Genoa in search of health, but died there on 21 January 1865, aged seventy-one.[19] Humphrys was typical as well as one of the most successful of a small band of men who could turn their hand to any kind of steel engraving.

John Henry Robinson, R.A., did most of his early book work in such publications

as *The Anniversary* (1829) and Rogers's *Italy* (1830). His principal work was done for the printsellers, but he was also responsible for the engraving of the 1850 Belgian stamp depicting King Leopold and first engraved what has been described as the most frequently reproduced design ever known, namely the vignette of Britannia used for a hundred years on Bank of England notes.

Charles Henry Jeens was one of the younger engravers, trained by Brain and William Greatbach. His work with stamps included engraving stock dies of the Queen's head, and the vignettes of the early pictorial Newfoundland stamps, issued in the 1860s. He was employed as an *Art Journal* engraver, working on seventeen plates of his own between 1856 and his death. In the 1860s and 1870s, his book work on steel was largely comprised of frontispieces; he made contributions to *The Royal Shakespeare* (1883–4), published by Cassell, and Wornum's *Turner Gallery* (*c*. 1861). Hamerton commented on a series of his portraits on page 362 of *The Graphic Arts* (1882).

Finally, there was the work of Jean Ferdinand Joubert de la Ferté (see above, pages 197–8 for his introduction of *acierage* into England). He was born in Paris, on 15 September 1810, of a family ruined by the Revolution. In 1840 he came to England, married an Englishwoman and became naturalized. An early example of his English work was seen here in 1845, when Gambart published his 'Penseroso' after Winterhalter, and a series of ten plates were engraved for the *Art Journal* between 1848 and his death. The last two plates were published posthumously in 1884 and 1886. He was associated as chief engraver with the printers De La Rue until 1865, engraving, before 1854, the heads for fiscal stamps and, in 1855, the head for the first Indian issue. To circumvent Perkins's patent on the siderographic process, Joubert introduced the French method *en épargne*, which meant that a relief block was produced in steel and used for letterpress printing, yet giving a very similar appearance to an engraved print. He also introduced steel-facing to the firm. He took four years over his line engraving of 'Atalanta's Race' after E. J. Poynter, one of the last successful works of its kind, published in 1881. His engravings after the same painter for Moxon's edition of Keats's *Endymion* appeared in 1872, and two steel engravings by him came out in *Picturesque Europe* (1876–9) published in parts by Cassell, Petter and Galpin.[20]

The decline in line engraving in the early 1840s led to a further three defections to America between 1840 and 1845, a time of economic crisis. The suggestion, in 1847, by the Board of Trade to the Art Union of London that it should sponsor engravings of the Old Masters (presumably to continue previous unsuccessful attempts based on the National Gallery), securing the services of eminent engravers by high fees, raised hopes of Government help for the art. It was rumoured that J. H. Robinson had been offered £5,000 to engrave 'The Raising of Lazarus' (published 1865, engraved by G. T. Doo), but the Art Union's rejection of the idea ruined any hopes in the immediate future of Government aid for art of any kind.[21]

A gloomy assessment appeared in 1848, indicating that even the printsellers were having a lean time, with only a few mezzotints in hand, and the *Art Journal* claimed that its project of engraving the Vernon Gallery was about the only work then obtainable for line engravers. They stated that this fact even persuaded Robert Vernon to agree to the scheme in order to give steel engravers some employment. Out of twenty-eight engravers working on it, twenty were said to be without other commissions; even the copper-plate printers were said to have idle presses 'which we shall call into full activity'.[22] Thirty-five years later, the situation looked like this to one observer:

In the middle of the century, inartistic mixture of styles, mechanical means replacing true work, exigiencies of copyright, and above all, the complete severance of the engraver not only from the painter, but also from his only rightful patron the public, had worked its sure result. Some good men survived . . . but no young school had been forming to replace those dying out, and everything presaged the gradual extinction of engraving as one of the great arts . . .[23]

This sentiment was still being echoed in 1871 when a correspondent wrote, quoting a local newspaper: 'The art of steel engraving is dying out amongst us, the youngest line engraver now in England being said to be over 40, and without a pupil.'[24] This downhill trend was enough to send four engravers to America in 1850, with a total of nine between 1850 and 1854. One of these was John Rogers, who went in 1851 after having done a considerable number of book plates here, and who was accompanied by Charles Westwood, a competent engraver, who committed suicide four years later.

From this time, steel engraving had to fight for survival. The 1850s merely produced original works which were already in preparation and reprints of one or two of Bartlett's works, but nothing new of any significance was undertaken, even allowing for the appearance of Ruskin's *Modern Painters* (1856–60). Of the sixteen or so important steel engravers working in the early 1860s most had died by the end of the 1880s or, if they were still living, had already done their last work. The expense of line engraving was beginning to tell against it, as was the time taken to produce a plate. The arrival of separate chromolithograph prints from France meant that the end was in sight, and it was to be hastened by the coming of photography. Charles Landseer is reported as saying that this event would be 'foe-to-graphic', a common pun in its day, but in many ways his prediction was correct. The year 1865 was the turning point. The Misses C. C. and M. E. Bartolacci published ninety-seven photographs of Turner's *England and Wales* and *Richmondshire*. A reviewer, after remarking that the original steel-engraved works were rare, added: 'Even if the originals were accessible, we believe these photographic copies would be preferred; the "new" art gives them greater delicacy, combined with greater vigour, and they seem to be more truthful transcripts of the

painter's mind.'[25] This view was not shared by many people, but the idea developed. In 1868, Virtue and Co. issued *Pictures by the Old Masters in the National Gallery*, photographed by Signor L. Caldesi, with letterpress by Ralph Nicholson Wornum, thus preventing the revival of the earlier engraved series. Things were no better for the printsellers. Henry Graves took two photographers to court in 1866 for illegally reproducing two engravings, the copyright of which he was the owner, and obtained judgement against them with heavy fines. It was argued, however, that an engraving could not be harmed commercially by a photograph, since the former appealed to a collector who could afford to buy it at a high price and the latter to a poor man who merely wanted a reproduction of the picture. A clerk from Bradford wrote that the large size of published prints did not fit his small rooms, but that the photographs did, and the latter, moreover, suited the contents of his purse.[26] Photography had come to stay and the printseller was forced to come to terms with it or go out of business. The 1865 volume of the *Art Journal* also broke with tradition; for the first time, five etchings replaced some of the steel engravings usually supplied. In December of that year announcement was made of 'a photographic copper plate . . . with impressions from it, so clear and beautiful as to be really a substitute for engraving' from which 200 prints could be taken in an hour. As a last forlorn hope, the appointment of R. J. Lane, A.R.A., to start an etching class at South Kensington was seen as a point from which students could be encouraged into line engraving.[27]

The decline of English work in the 1860s let a trickle of Continental line-engraved work into the country. It was characterized by more open engravings, with less detail and a rather coarse appearance, due in part to more extensive etching before the burin was applied. Most of the French work was published by Goupil of Paris, who were almost the only firm in Europe to encourage line engraving at this time. The engravings of Auguste Thomas Marie Blanchard, one of the most eminent French engravers, A. Emile Rousseaux, a young talented pupil of Henriquel Dupont, Jean Charles Thevenin, son of the Director of the French Academy at Rome, and Joseph Gabriel Tourny were familiar to the art lovers of the 1860–80 period. This import of talented work, however, only exacerbated the situation by sending important commissions to France, such as the engraving of Frith's 'Derby Day' by Blanchard. The engraving rights had been bought by Gambart for £1,500, a sum equivalent to its initial purchase price, given by Jacob Bell. The French engravers took practical steps to preserve their unity by founding the Société Française de Gravure in 1868, followed some time later by the Société des Graveurs au Burin, a distinct contrast to the Chalcographic Society in this country, which closed down in the 1880s (see above, page 59). A report on the 1880 Paris Universal Exhibition revealed that France had 1,100 exhibiting engravers in steel, aquafortis and wood. The order of material is perhaps significant. The Belgians A. Danse, John de Mare and J. Franck were joined by the Germans Louis

Jacoby, the celebrated Professor F. Knolle of the school at Brunswick, Th. Langer and Johann Leophard Raab, and the Italian, Luigi Calametta, sometime professor of engraving in the Academy of Milan.

In an effort to compete, C. W. Sharpe changed to the new mode, but older artists like Charles Cousen kept to the traditional style. By the mid-1870s, the artistic trend in book illustration was towards etchings or photographs. In practice, wood engraving served the run of the mill volumes, despite the small revival of steel engraving promoted by Virtue (see above, page 170) in some of his books.

Etching changed its course in 1880 when F. Seymour Haden founded the Society of Painter-Etchers. For most of the century, etching on steel for books had been familiar in the Cruikshank illustrations to Dickens and the Thackeray plates for his own novels. The efforts of the Etching Club, formed about 1840, to produce fine, limited editions of Goldsmith, Gray, Milton and Shakespeare were directed by Webster, Thomas Creswick, C. W. Cope, R. Redgrave and others. Through these means, etching gradually became a respectable art medium, needing no intermediate engraver and tending to turn its back upon book illustration, which slowly lost its popularity. The main advantage which kept etching alive was the speed with which plates could be produced, thus enabling borrowed pictures to be returned more quickly to their owners.

The *coup de grâce* came in 1880 with the first commercially viable photogravure process. Its treatment of tone made it appear to be the ultimate solution to that problem and its remarkable spread over the next twenty or thirty years effectively reduced the popularity of rival processes. Book publishers and printsellers alike were soon using it. When, for instance, Cassell published Longfellow's *Evangeline* in 1882, fifteen of its twenty-three designs by Frank Dicksee were produced in photogravure. W. P. Frith's series of five pictures entitled 'The Race for Wealth' were unsatisfactorily reproduced by photogravure, leading to his 'absolute abhorrence' of it, although he did admit that some good work had been done in it. His main objection was to photogravure's destruction of line; in this respect it was, of course, the very opposite of steel engraving.[28] These new processes were most successfully exploited by the French and Germans; a French house in London claimed in 1888 that they had a turnover of £20,000 a year on photogravure plates alone.[29] Such line engravings as were being done used only copper once more, which was then steel-faced.[30] They were mainly large plates – in 1893, J. B. Pratt attracted notice with his translation of Landseer's pictures, and Charles W. Sherborn gained an award for line engraving at the Chicago Exhibition.[31] The great vogue for cheap editions in the last days of the century led to the introduction of relief line blocks,

PLATE **64** 'Windsor Castle', steel engraving by E. P. Brandard after J. Ramage, from James Taylor's *The Age We Live In*, published in eight divisions in the last two decades of the nineteenth century. Original size 5 by 7⅜ inches.

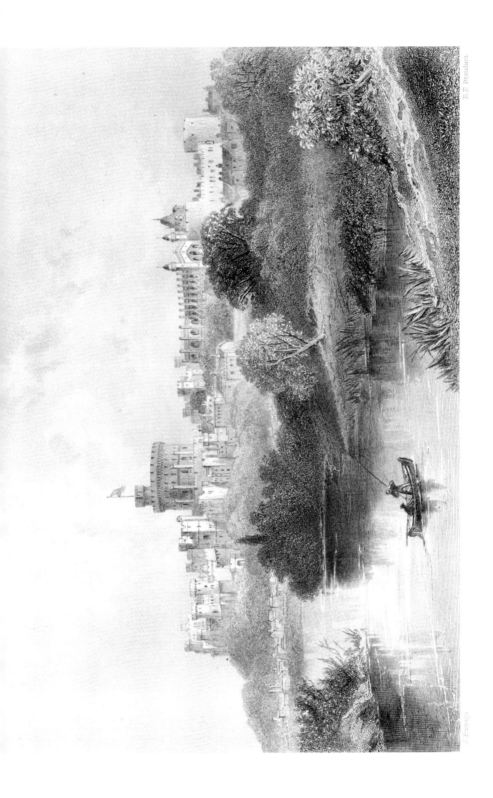

J. M. W. Turner

WINDSOR CASTLE.

WILLIAM DALRYMPLE, LONDON: CHAPMAN & HALL.

E. P. Brandard

which could be printed with the text, made from photographic copies of etchings and engravings. The novels of Dickens suffered most from this because the steel etchings were comparatively uncomplicated as compared with the steel engraving, the lines of which were so minute and close together as to be difficult of reproduction by this means.

Interest in the steel engravers was revived, in the 1870s and 1880s, by a series of exhibitions. In 1877, the Royal Birmingham Society of Artists staged an exhibition of engravings by Birmingham men as part of their spring exhibition for that year. Three rooms were devoted to a total of 496 prints, 306 of which had been selected and framed by Algernon Graves from the stock of Henry Graves, the London printsellers. They were exhibited in the small octagon room and the Front Room east of the Society's New Street premises. The remaining 190 prints had been collected by the eminent local artist Charles William Radclyffe, and were shown in the Front Room west. The Graves prints were all for sale, the price printed against each in the catalogue, ranging from 12s. 6d. for Robert Brandard's 'Loch Leven Castle' (1835) after George Cattermole, to £28. 17s. 6d. for J. T. Willmore's 'Crossing the Bridge' (1847) after Edwin Landseer. Although some etchings and wood engravings were included, by far the greatest number were line engravings on steel and represented the nucleus of a Birmingham school of engravers (see above, pages 69–78).[32] A collection of J. T. Willmore's line engravings were shown in the Fine Art Treasures exhibition at Folkestone in 1886. It was remarked that fine specimens were seldom seen on public display, firstly, because of their rarity, since no effort had been made to collect them, and secondly, resulting from their rarity, because their merits had been unappreciated.

J. C. Armytage's 'Non Angli Sed Angeli' after Keeley Halswelle was the last steel engraving to appear in the *Art Journal*, in the year 1890. By 1894, the Americans had finally jettisoned copper and steel engravings in magazines for wood engraving, enabling more rapid production using electrotypes.[33] Armytage was of considerable assistance to Marcus B. Huish in the production of his Turner volumes in this decade, skilfully touching up the plates for what was, to contemporary eyes, an old-fashioned book. Steel engravings continued to appear in books: for instance, the frontispiece to *Tom Cringle's Log* (1895) by Michael Scott was a seascape vignette, engraved by Edward Goodall after Clarkson Stanfield. For the most part, they were reprinted, as in this case, from earlier plates. One of the few exceptions to this were the plates to the editions of James Taylor's *The Age We Live In : A History of the Nineteenth Century, from the Peace of 1815 to the Present Time*, published by William Mackenzie in eight divisions at various times (the author has seen copies of about 1885 and 1895). The engraving of 'Windsor Castle' by Edward

PLATE 65 'Scarborough', steel engraving by E. P. Brandard, from Thomas Baines's *Yorkshire Past and Present*, 1871–7. Original size 6 by 8⅜ inches.

Engraved by E. P. Brandard.

215

PLATE **66** Edward Paxman Brandard (1819–98),
from a photograph by Disderi
reproduced in the *Illustrated London News*, 1898,
vol. 112, p. 249.
(By courtesy East Sussex County Library,
Brighton Reference Library.)

Paxman Brandard (see plate 64), after a picture by J. Ramage, was on traditional
lines, but the work also contained a portrait of Lord John Russell 'Engraved by
Holl from a photograph by Mayall', and a photograph by F. Frith of 'Calcutta',
engraved by R. Dawson. These examples could be multiplied and show how
tenaciously some publishers held on to traditional methods. It was also true that
the use of existing plates was cheaper than preparing new illustrations by photo-
graphic or other means.

Lumb Stocks had died in 1892, J. C. Armytage in 1897, so when E. P. Brandard
(see plate 66) died in 1898 he was the last of his line. His plate of 'Scarborough' (see
plate 65) was done in the 1870s. It appeared in Thomas Baines's *Yorkshire Past and
Present: A History . . . to the Year 1870*, published by William Mackenzie, and is
remarkable for the amount of machine ruling present on the sky and sea, as well as
the buildings. Its appearance suggests that it, too, was probably taken from a
photograph, and contrasts rather oddly with the following note, written by
Brandard a few years later:

It is with peculiar pleasure . . . that I have engraved the present drawing, which forms so
striking a contrast to the usual black and white engravings of the present day, as to which,
the primary object is to get them up as quickly and showily, and inexpensively as possible,
giving the engraver little chance of expending over them the time and talent which
characterized the plates done thirty or forty years ago, which were so full of refinement, and
of delicate finish and beauty.[34]

The engraving referred to was 'Barnard Castle' after Alfred Hunt, done for
Hamerton's *The Graphic Arts* (1882).

The final word comes from a survey of nineteenth-century industry. 'No other
occupation has suffered more than engraving from the competition of new in-
ventions and the change from ancient to modern methods. Every branch of the
business has been affected in this way.'[35]

NOTES

N.B. Place of publication of printed books cited is London unless otherwise stated.

CHAPTER ONE · Introducing the steel engraving

1 Information from Margaret Timmers, Research Assistant, Department of Prints and Drawings, Victoria and Albert Museum. The plate and print are on display in the Technical processes exhibition of the Victoria and Albert Museum.

2 Herbert Furst, *Original engraving and etching: an appreciation*, Nelson, 1931, p. 58.

3 The Dürer and subsequently mentioned plates are in the Department of Prints and Drawings at the British Museum.

4 Haward C. Levis, *A descriptive bibliography of the most important books . . . relating to the art and history of engraving . . .*, Ellis, 1912, pp. 10–11.

5 Arthur M. Hind, *A history of engraving and etching . . .* 3rd ed., Constable, 1923.

6 William Gilpin, *An essay on prints*, 3rd ed., Printed by G. Scott . . ., 1781, p. 53.

7 Edward Marston, *After work: fragments from the workshop of an old publisher*, Heinemann, 1904, p. 27.

8 *Printing patents; abridgements of patent specifications relating to printing 1617–1857 . . .*, Printing Historical Society, 1969 (original edition of 1859, and supplement of 1878), p. 322. Examples of plates printed by this process appear in the quarto edition only of John Britton's *Autobiography*, 1850.

9 *The complete works of William Hogarth . . . with an introduction by James Hannay and descriptive letterpress by Rev. J. Trusler and E. F. Roberts*, William Mackenzie, n.d.

10 John Landseer's comments are very apt: 'Now to colour a legitimate engraving . . . is not less palpably absurd to an eye of tasteful discernment, than it would be to colour a Diamond, which . . . would but obscure the native brilliancy and beauty of the stone . . . If a good engraving must thus suffer by being coloured; so neither can bad ones be thus converted into good pictures; at the utmost, nothing better than a sort of mule production can thus be generated – though with much more of the ass than of the horse in its constitution.' *Lectures on the art of engraving delivered at the Royal Institution of Great Britain*, Longman, Hurst . . ., 1807, pp. 180–1.

11 John Thomas Smith, *A book for a rainy day; or recollections of the events of the years 1766–1833 . . .*, edited with an introduction and notes by Wilfred Whitten . . ., Methuen, 1905, pp. 306–7.

12 *Notes and queries*, 9th series, vol. 4, 1 July 1899, p. 13.

13 Hans W. Singer and William Strang, *Etching, engraving and the other methods of printing pictures*, Kegan Paul, Trench, Trubner & Co. Ltd, 1897, p. 58.

14 Philip Gilbert Hamerton, *The graphic arts; a treatise on the varieties of drawing, painting and engraving in comparison with each other and with nature*, Seeley, Jackson and Halliday, Fleet Street, 1882, ch. 26. *Art Journal*, vol. 43, 1881, pp. 15–16.

15 Ruari McLean, *The wood engravings of Joan Hassall*. Oxford U.P., 1960, p. 24.

16 Walter Crane puts it even more forcefully: 'Such books as Rogers's *Poems* and *Italy* with vignettes in steel from Thomas Stothard and J. M. W. Turner are characteristic of the taste of the period, and show about the high-water mark of the skill of the book engravers on steel. Stothard's designs are the only ones which have claims to be decorative, and he is always a graceful designer. Turner's landscapes, exquisite in themselves, and engraved with marvellous delicacy, do not in any sense decorate the page, and from that point of view are merely shapeless blots of printer's ink of different tones upon it, while the letterpress bears no relation whatever to the picture in method of printing or design, and has no independent beauty of its own. Book illustration of this type, – and it was a type which largely prevailed during the second quarter of the century – are simply pictures without frames.' *Of the decorative illustration of books . . .*, Bell, 1896, p. 118.

CHAPTER TWO · Siderography and after

1 Elizabeth Harris, 'Experimental graphic processes in England, 1800–1859', *Journal of the Printing Historical Society*, vol. 4, 1968, p. 73.

2 Society of Arts, Minutes of Committees, 1822–3, pp. 96–101, 106–11. The form 'Society of Arts' instead of 'Royal Society of Arts' has been preferred, since most of the material used in this study was published under this name.

3 John Pye, *Patronage of British art*, Longman, 1845, p. 372.

4 Harris, op. cit., p. 69.

5 Charles Turner, 'On the invention, progress and advantages of the art of engraving in mezzotint upon steel', letter, dated 14 October 1824, in Society of Arts, *Transactions*, vol. 42, 1824, pp. 55–7.

6 A. D. Mackenzie, *The Bank of England note: a history of its printing*, Cambridge U.P., 1953, pp. 32–4.

7 *London Journal*, 1820, p. 384.

8 Arthur Hayden, *Chats on old prints*, Fisher Unwin, 1906.

9 Society of Arts, *Transactions*, vol. 40, 1823, pp. 41–3.

10 George Maile is credited with the first use of steel plates in A. W. Tuer, *Bartolozzi and his works . . .*, Field & Tuer, 1881, 2 vols., vol. 1, p. 80. The Walton (after Housman) and Cotton (after Sir Peter Lely) portraits show a certain proficiency in mezzotint for flesh tones, but the effect is considerably spoilt by a clumsy use of stipple to outline facial features. They were used again, together with the other copper illustrations, in

Thomas Zouch's *Life of Isaak Walton*, published by Septimus Prowett in 1823, in which the plates carry a legend indicating their origin at the hands of T. Gosden, the sporting book-binder, who is said to have financed them. The advertisement to this latter volume ascribes the engraving of the portraits to Mr Mitan (although they are clearly signed 'G. Maile') and states that they are 'engraved on steel plates'.

11 'The mezzotint engravings on steel by T. Lupton and C. Turner are singularly interesting on account both of their intrinsic merit and of their being the earliest specimens of an invention of incalculable importance . . .' *European magazine*, vol. 83, January 1823, p. 57.

12 Harris, op. cit., p. 72.

13 Frederick W. Faxon, *Literary annuals and gift books . . . 1823–1903*, Private Libraries Association, 1973. Reprint of 1912 edition with two added essays, one by Iain Bain on the illustrations, pp. 19–25. Other work on the illustrations has been done by Andrew Boyle in his *Index to artists in the annuals*, and the microfiche editions of twenty-eight titles have been published by Chadwyck-Healey.

14 *Pinnock's catechisms. A catechism of British geography . . .* 5th ed., printed for G. B. Whittaker, 13 Ave Maria Lane by R. Gilbert, St John's Square, 1827.

15 Thomas Campbell, *The pleasures of hope, with other poems, by Thomas Campbell*, new ed., Longman, Hurst, Rees . . ., 1821.

16 Longman Group, Limited, Archives at the University Library, Reading: Miscellaneous Publications Expenses Ledger A1, 1807–1820; Phillips' Purchase Ledgers, 1812–1836; 1837–1877. Published 1976 on seventy reels of microfilm by Chadwyck-Healey.

17 Ibid., pp. 24, 674.

18 Rev. David Blair (pseud. for Sir Richard Phillips), *Universal preceptor, being a general grammar of arts, sciences and useful knowledge . . . by the Rev. David Blair*, 12th ed., improved, Sir Richard Phillips & Co., Bride Court, Bridge Street, 1820 (price 5s. bound). The only other illustrations are woodcuts in the text.

19 Society of Arts, *Journal*, 13 January 1865, p. 134.

20 Other sources for this chapter include: Greville and Dorothy Bathe, *Jacob Perkins : his inventions, his times, & his contemporaries*, Philadelphia, U.S.A., Historical Society of Pennsylvania, 1943; Henri Delaborde, *Engraving . . .*, trans. R. A. M. Stevenson, with an additional chapter on English engraving by William Walker, Cassell & Co., 1886; H. W. Dickinson, *James Watt ; craftsman and engineer.*, Cambridge U.P., 1936 (reprinted by David and Charles, 1967); Abraham Raimbach, *Memoirs and recollections of the late Abraham Raimbach, Esq., engraver . . . by M. T. S. Raimbach*, Frederic Shoberl, jun., privately printed, 1843; Society of Arts, *Report of the Committee . . . relative to the mode of preventing the forgery of banknotes*, Society of Arts, 1819; Alfred Whitman, *The masters of mezzotint . . .*, Bell, 1898.

1 The date of Charles Warren's birth is quoted in various sources as 1767 (*Dictionary of National Biography*) and 1762 (Pye, and the Victoria and Albert Museum). Since no substantiation can be found for the former, the latter date has been accepted, since it is that given by his friend John Pye, writing before 1845, and who is more likely to have possessed first-hand knowledge of the fact. Other efforts to trace Warren's year of birth through church records have so far revealed nothing.

2 Society of Arts, manuscript 'List of members, 1803–1812'.

3 Joseph Hill and William Midgley, *A history of the Royal Birmingham Society of Artists*, Birmingham, The Society and Cornish Bros, [1928], pp. 4–8.

4 Pye, op. cit., p. 312 et seq.

5 *Evangelical Magazine*, new series, vol. 1, 1823, p. 3. The first two portraits of Collyer and the Revd Alexander were larger versions of the small square portraits used in previous volumes, most of which were poorly done. The third, of the Revd Thomas Weaver of Shrewsbury, engraved by T. Blood, was in another contemporary style of a stipple vignette filling most of the page, and one used for many years by the *European Magazine*. Blood had engraved regularly for some time for this latter magazine, and in the 1824 volume, William Holl (probably the elder, 1771–1838) contributed a portrait on steel of the Revd G. Burder in the August number.

6 Society of Arts, *Transactions*, vols. 37–42, 1819–24.

7 Efforts so far to trace copies of these editions have failed to produce them. It may be, of course, that they were never published, and since the originals deposited with the Society of Arts seem, in the course of time, to have been lost, there is no record of them.

8 W. L. Maberley, *The print collector : an introduction to the knowledge necessary for forming a collection of ancient prints . . .*, Saunders & Otley, 1844, p. 165.

9 *Annual Register*, 1823, p. 195.

10 *Gentleman's Magazine*, vol. 93, part 2, 1823, p. 187.

11 Pye, op. cit., p. 354.

12 Peter Coxe, *The social day ; a poem in four cantos*, printed by J. Moyes, Greville Street, for James Carpenter & Son, Old Bond Street and R. Ackermann, Strand, 1823.

13 Lord Ronald Sutherland-Gower, *Sir David Wilkie*, George Bell, 1908, p. 92.

14 *Notes and queries*, 4th series, vol. 2, 24 October 1868, p. 394.

15 Ibid., p. 591. Also 8th series, vol. 4, 1893, p. 271.

16 See also account in Society of Arts, Minutes of Committees, 1822–3, manuscript minutes, pp. 78–82, 96–101, 106–11; *Transactions*, vol. 41, pp. 88–95.

17 A great deal of confusion exists over this person. For some reason, the *Dictionary of National Biography* lists Ambrose William as Charles's son (1781?–1856), and Samuel Redgrave's *Dictionary of artists of the English school . . .*, new ed., George Bell, 1878, registers no relationship between Alfred William and Charles. From other sources, notably John Pye's *Patronage of British art*, 1845, we know that all but one of Warren's children predeceased him, so that the only possible relation of whom we have any

knowledge (through the *Gentleman's Magazine* account) is his brother, who received the Gold Medal.

CHAPTER FOUR · The art of steel engraving

1 Charles Frederick Partington, *The engraver's complete guide . . .*, printed by Sherwood, Gilbert & Piper, *c.* 1825. (*Book of trades series, no. 6*).

2 Theodore Henry Fielding, *The art of engraving, with the various modes of operation, under the following different divisions: etching, soft-ground etching, line engraving, chalk and stipple, aquatint, mezzotint, lithography, wood engraving . . .*, M. A. Nattali, 23 Bedford Street, Covent Garden, 1844. This is the second edition; the first was published in 1841.

3 Maberley, op. cit.

4 Philip Gilbert Hamerton, *The graphic arts*, Seeley, Jackson & Halliday, 1882, ch. 26.

5 Philip Gilbert Hamerton, *Drawing and engraving; a brief exposition of technical principles and practice*, A. & C. Black, 1892, ch. 4. (Black was one of the proprietors of the *Encyclopaedia Britannica*.)

6 Ibid., pp. 124–8.

7 Singer & Strang, op. cit., pp. 58–9.

8 William F. Miller, *Memorials of Hope Park, comprising some particulars in the life of our dear father William Miller . . . together with a list of his engravings*, privately printed, 1886, (limited edition of fifty copies), pp. 113–16.

9 The original is now in the Tate Gallery.

10 Alaric Alfred Watts, *Alaric Watts: a narrative of his life*, Richard Bentley & Son, 1884, 2 vols., vol. 2, p. 227.

11 William Powell Frith, *My Autobiography and reminiscences*, 3rd ed., Richard Bentley & Son, 1887, 2 vols., vol. 1, pp. 105–6; vol. 2, pp. 190–1.

12 Thomas Oldham Barlow, R.A. (1824–90). The portrait was published by T. McLean in 1862 and reviewed in the *Art Journal*, 1862, pp. 243–4.

13 Royal Society of Artists, Birmingham, *Exhibition of engravings by Birmingham men; with an introduction and biographical notes by John Thackray Bunce, Professor of Literature to the Society*, Birmingham, printed by E. C. Osborne, 84 New Street, 1877, p. 15; *Turner Gallery*, ed. R. W. Wornum, *c.* 1873, p. 62; Watts, op. cit., vol. 1, p. 308.

14 *Art Journal*, vol. 17, 1855, p. 98.

15 Watts, op. cit., vol. 1, pp. 254–8.

16 Henry Thomson, R.A. (1773–1843), for some time Keeper of the Royal Academy, historical painter, produced 'Juliet' in his last, and probably his best work in 1825. Redgrave, op. cit., pp. 429–30.

17 *Art Union*, vol. 1, 1839, p. 171. Later in the century, these extra payments for engraving became quite common. A counsel's opinion, given in 1846 by Richard Godson, ruled that the copyright to engrave is vested in the owner of the picture; when a picture is sold, the engraving rights are transferred. Moreover, two or more *separate* copyrights may exist to different people at one and the same time. *Art Union*, vol. 8, 1846, p. 72.

18 Mrs Sarah Uwins, *A memoir of Thomas Uwins, R.A.*, Longman, 1858, 2 vols., vol. 1, pp. 24–5.

19 An exhibition of some seventy to eighty such watercolour copies from the royal pictures and used for the *Royal gallery of British art*, ed. S. C. Hall, Colnaghi, 1861, 4 vols., was held in the publisher's gallery prior to publication on 1 September 1854, together with proof impressions of the plates. *Art Journal*, vol. 16, 1854, p. 218.

20 In the Department of Art, Birmingham City Museums and Art Gallery there are drawings for twenty-eight of the thirty-two full-page engravings in the book, which also includes twelve vignettes.

21 Society of Arts, *Transactions*, vol. 40, 1823, pp. 41–3.

22 Ibid, vol. 42, 1825, pp. 55–7. Rhodes became bankrupt in 1827. (*The Reliquary*, vol. 3, 1862–3).

23 Great Exhibition, 1851, *Catalogue . . .*, 1851, 3 vols., vol. 2, pp. 606, 609, 657, 839. Sellers also supplied steel and copper plates to the American bank-note companies through his New York office (*Sheffield and Rotherham up-to-date*, 1897).

24 Fielding, op. cit., p. 110.

25 Andrew Ure, *Dictionary of arts, manufactures and mines* 7th ed., Longman, Green & Co., 1878, 3 vols., vol. 2, p. 285.

26 Society of Arts, *Transactions*, vol. 41, 1823, p. 93.

27 Miller, op. cit., p. 114.

28 Pye, op. cit., pp. 387–8. In John Landseer's *Lectures . . .* there occurs in Lecture 3, delivered in 1805, the following passage, p. 141: 'The next mode of Engraving that solicits our attention is that invented about fifteen years since by Mr. Wilson Lowry. It consists of two instruments, one for etching successive lines . . . and another more recently constructed for striking . . . *mechanical curves . . .*' In the author's interleaved copy of this work in the British Library (Reference Division, C.60.n.2), Landseer has crossed out the word 'about' and inserted 'from 10 to . . .', placing the date between 1790 and 1795.

29 *Annual biography and obituary*, 1825, pp. 96–100. 'About 1790 or 1791 completed, principally with his own hands and of wood, his first ruling machine' (p. 96).

30 Society of Arts, *Transactions*, vol. 51, 1837. Society of Arts, *Journal*, 13 January 1865, pp. 134–5. They are described in this article by S. T. Davenport.

31 Partington, op. cit., p. 112.

32 Society of Arts, *Transactions*, vol. 42, 1824, p. 46. Society of Arts, Minutes of Committees, 1822–3, p. 99. 'Lowry invented a menstruum, but . . . he makes a secret of it & has sold it to Perkins & Coy.'

33 Society of Arts, *Transactions*, vol. 41, 1823, p. 94.

34 Manuscript letter and holograph account, forming the basis of the article in Society of Arts *Transactions*, vol. 42, 1824, pp. 43–51. (Royal Society of Arts Library D5/26.)

35 Ibid., vol. 44, 1826, pp. 48–55.

36 Fielding, op. cit., p. 38.

37 Partington, op. cit., p. 107.

38 William Marshall Craig, *A course of lectures on drawing, painting and engraving . . .*
Longman, Hurst, Rees, Orme & Brown, 1821, pp. 397–8. W. G. Rawlinson, *The
engraved work of J. M. W. Turner, R.A.*, Macmillan & Co., 1908, 2 vols., vol. 1,
p. xiii.

39 Rawlinson, op. cit., p. xiv.

40 S. W. Hayter, *New ways of gravure* 2nd ed., Oxford U.P., 1966, p. 196.

41 Partington, op. cit., p. 102.

42 Ibid., p. 107.

43 '. . . for it is well known he would alter the treatment of even his best pictures to render
them delicate and sparkling from the hands of the engraver.' *Art Journal*, vol. 16, 1854,
p. 338.

44 Thomas Creswick altered his painting 'Way to church', engraved by J. C. Bentley,
at the touching stage by placing a spire on the tower of the church to make it more
prominent. The tower would have gone unnoticed in a bank of trees without it.
Art Journal, vol. 11, 1849, p. 272.

45 Frith, op. cit., vol. 2, pp. 340–3.

46 Smith, op. cit., p. 253, note 1.

47 Society of Arts, *Transactions*, vol. 40, 1823, p. 43.

48 Ibid, vol. 42, 1825, p. 57.

49 Bathe, op. cit., pp. 150–1. Ure, op. cit., article on freezing.

50 Tuer, op. cit., vol. 2, p. 101.

51 Visit to Thomas Ross & Son, 5 Manfred Road, Putney, London, 15 September 1975.

CHAPTER FIVE · The corporate life of the engravers

1 Miller, op. cit., Catalogue of engravings, p. xiii and xiv.

2 *Art Union*, vol. 1, no. 4, 15 May 1839, p. 57.

3 *Art Journal*, vol. 27, 1865, p. 140.

4 Hayden, op. cit., p. 210.

5 *Art Union*, vol. 10, 1848, p. 315. 'Some . . . although they have engraved with their
proper hands the best plates of modern times are unknown to the public; having for
some years worked in the studio of engravers whose names appeared on the plates in
Lieu of those by whom the plates were executed. It is needless to say that we shall
tolerate no such unjust principle; be the plate good or bad, the merit or demerit will be
given to him to whom it is due.'

6 Craig, op. cit., pp. 372–3.

7 Raimbach, op. cit., p. 23.

8 Parliament, House of Commons, *Report of the Select Committee on arts and their connexion
with manufactures . . .*, 1836, Paper No. 568, p. 81, paras. 944–5.

9 Ibid., p. ix.

10 Ibid., p. 113 (para. 1316); p. 184 (para. 2187); p. 113 (para. 1320).

11 Ibid., p. 79 (para. 923) ; p. 114 (para. 1329).

12 Pye, op. cit., pp. 193, 245–7.

13 Ibid., p. 192.

14 Ibid., p. 193.

15 *Art Union*, vol. 1, 1839, p. 8.

16 Ibid., p. 65.

17 *The Rules, Orders and Regulations of the Society of Engravers instituted at London 1802 under the immediate patronage of H.R.H. the Prince of Wales*, printed for T. Bensley, Bolt Court, 1804.

18 Levis, op. cit., p. 95.

19 W. B. Sarsfield Taylor, *The origin, progress and present condition of the fine arts in Great Britain*, Whittaker & Co., 1841, 2 vols., vol. 2, pp. 363–6.

20 John Landseer, *A letter to a member of the Society for Encouraging the art of Engraving in objection to the scheme of patronage now under consideration and written with a view to its improvement . . .*, 1810. This was followed by a second and third letter, both 1810.

21 Taylor, op. cit., vol. 2, p. 250. D. E. Williams, *The Life and correspondence of Sir Thomas Lawrence . . .*, Henry Colburn & Richard Bentley, 1831, 2 vols., vol. 1, p. 333.

22 Levis, op. cit., pp. 98–9.

23 Redgrave, op. cit., p. 388.

24 Taylor, op. cit., p. 250.

25 *Art Union*, vol. 1, 1839, p. 43.

26 Robert W. Buss, *Almanack of the fine arts*, 1852, pp. 154–5.

27 John Lewis Roget, *A history of the Old Water Colour Society . . .*, Longman, Green, 1891, 2 vols., vol. 2, pp. 313–14.

28 *Art Union*, vol. 8, 1846, p. 92 ; vol. 10, 1848, pp. 129, 202.

29 'Rule 10 – It being very essential that the meetings of the Society should be confined to its intrinsic objects, and not degenerate into a bazaar for the buying and selling of works of art, it must be regarded as a point of honour by every member and visitor, and strongly urged by this rule, that no purchase or sale, nor attempt to buy and sell, nor any inquiry respecting the price of any object shown at any meetings of the Society, shall be permitted during the time of the *conversazione*.' *Art Union*, vol. 1, 1839, p. 43.

30 *Art Union*, vol. 1, 1839, p. 24.

31 Ibid., vol. 2, 1840, p. 25.

32 A prospectus had been issued which advanced as its two main objects the 'advancing of the interests of its [engraving's] professors, and be the means of diffusing a more correct taste to the public at large.' *Art Union*, vol. 2, 1840, p. 10.

33 S. C. Hutchison, *The history of the Royal Academy, 1768–1968*, Chapman & Hall, 1968, p. 115.

34 See note in the *Art Journal*, vol. 14, 1852, p. 290, commenting on the Academy's need to advertise for a successor.

35 *Art Journal*, vol. 64, 1902, pp. 146–7.

36 Ibid., vol. 15, 1853, p. 97.

37 Ibid., vol. 17, 1855, p. 98.

38 Ibid., vol. 45, 1883, p. 275.

39 Ibid., vol. 34, 1872, p. 61; vol. 36, 1874, p. 126; vol. 42, 1880, p. 159; vol. 51, 1889, p. 157; vol. 54, 1892, p. 192.

40 Ibid., vol. 43, 1881, p. 94.

41 Ibid., vol. 58, 1896, p. 218. 'It is possible that the introduction of photogravure and its acceptance in certain high quarters may have had something to do with this . . . slighting of engraving . . . What really lies at the root of the question is the fact that too many painters know nothing, and care less, about black and white art . . .'. Ibid., p. 222.

42 Ibid., vol. 66, 1904, p. 192. See also a similar account by Celina Fox: 'The engravers' battle for professional recognition in early nineteenth century London' (*The London Journal*, vol. 2, no. 1, Longman, 1976, pp. 3–31).

CHAPTER SIX · Some steel engravers

1 Royal Society of Artists, Birmingham, op. cit., p. 6.

2 *Art Journal*, vol. 12, 1850, p. 275.

3 Miller, op. cit., p. 115.

4 *Art Union*, vol. 8, 1846, p. 65; vol. 9, 1847, p. 353.

5 Miller, op. cit., pp. 89, 116.

6 Ibid., Catalogue of engravings, p. xiv, xv, xvii, xx, xxvi.

7 The book was published in November 1831, and the portrait of John Hampden was taken from an original portrait in the possession of the Earl of St Germains; the engraving was about 4 by 3 inches. The portrait of John Pym was engraved by E. Finden from an original miniature by Cooper, and measured 3 by 2 inches. It later fell into the hands of the reprint publisher Henry Bohn, and when, in 1889, George Bell put out the fifth edition (which included a memoir of the author George Grenville, Baron Nugent [d. 1850]), the original steel plates were still producing reasonable prints. Some stipple portraits had been added, engraved by Phillibrown, making a total of twelve in all. George Grenville Nugent, *Memorials of John Hampden, his party and his times* (5th ed., illustrated with twelve portraits engraved in steel), George Bell, 1889 (Bohn's libraries).

8 The letters quoted are all from the archives of John Murray, 50 Albemarle Street, which were consulted with his kind permission, and the invaluable assistance of Mrs Virginia Murray.

9 This material has been added to the St Bride Printing Library, five of the letters being dated from 1793 to 1796 and one 1819. The former are from his father, George, living in Dunster, Somerset, and are addressed to son Samuel, living first with Thomas Bonnors, engraver of Gloucester, and in 1796 with another branch of the family, John Bonnor, living in London. The last letter is a purely personal one from his sister. The

two notebooks run from April 1820 to April 1822 and from July 1827 to April 1841, both being decorated by excellent drawings, some in colour. It appears from entries made in the early book that his son (presumably his eldest, born, 1801, and then aged eighteen) was apprenticed to his father, many entries about his activities being in his own hand, and an entry under 1836 reads thus:

'Return 22 Decr. Artists' Fund

S. Rawle 61 Wife 61 six

Children 35, 33, 28, 26, 23 & 21.'

10 *Art Union*, vol. 1, 1839, pp. 171–2.

11 *Art Journal*, 1850, p. 276.

12 John R. Harvey, *Victorian novelists and their illustrators*, Sidgwick & Jackson, 1970, appendix 1, pp. 186–9.

13 Parliament, *Report* of 1836, op. cit., p. 81 (paras. 945–54).

14 [Alexander Blair], *Graphic illustrations of Warwickshire*, Birmingham, Beilby, Knott and Beilby, W. & T. Radclyffe, Robert Wrightson; . . . Harding, Lepard & Co., Pall Mall East, London, 1829.

15 T. Radclyffe engraved a map for this volume, and was also the engraver of a portrait of Sir George Chetwynd after B. Wyon.

16 Thomas Roscoe, *Wanderings and excursions in South Wales, including the scenery of the River Wye* . . ., C. Tilt and Simpkin & Co., Wrightson and Webb, Birmingham [1836]. Thomas Roscoe, *Wanderings and excursions in North Wales* . . ., C. Tilt, and Simpkin & Co., Wrightson and Webb, Birmingham, 1836.

17 *Art Journal*, vol. 66, 1904, p. 245.

18 Ibid., vol. 9, 1847, p. 331; vol. 10, 1848, p. 144.

19 Mrs Anna Maria Hall (ed.), *The drawing room table-book* . . ., George Virtue, 1849, nos. [8] and [15]. The former was printed by McQueen and the latter by Dixon and Ross.

20 Society of Arts, *Transactions*, vol. 42, 1824 and vol. 44, 1826. The recipient's name is given as George Edward Radclyffe of George Street, Edgbaston, Birmingham in the latter entry.

21 Christopher Wordsworth, *Greece; pictorial, descriptive and historical . . . with upwards of 350 engravings on wood and 28 on steel, illustrative of the scenery, architecture, and costume of that country*, William S. Orr & Co, Paternoster Row, 1839. Originally published in monthly parts during the year. J. C. Bentley was the next largest contributor with six engravings, and ten other engravers were employed, among them Edward's father, William Radclyffe. One, 'The Temple of Apollo at Bassae', p. 319, was after his brother, Charles.

22 [Charles Heath], *Heath's Versailles*, published for the proprietor by Longman & Co. *c*. 1836.

23 *Art Journal*, vol. 24, 1862, pp. 193, 144.

24 Article from an unidentified Birmingham newspaper, undated, but after 1884, from a scrap-book in Birmingham Reference Library, p. 250, headed 'Birmingham artists. Charles W. Radclyffe.'

25 Material on the Radclyffe family has been taken from the following sources: Royal
 Society of Artists, Birmingham, op. cit., pp. 16–18; Hill and Midgley, op. cit., pp. 4–8,
 31 et seq.; William Upcott, *A bibliographical account of the principal works relating to
 English topography*, Richard and Arthur Taylor, 1818, 3 vols. (typescript index of
 engravers by Gavin Bridson, 1975, in the Library of the National Book League),
 entries 1265–6, 1483; *Art Journal*, vol. 18, 1856, p. 72; vol. 36, 1863, p. 87; vol. 37,
 1864, p. 40.

26 *Art Union*, vol. 1, 1839, p. 164.

27 William Brockedon, *Illustrations of the passes of the Alps, by which Italy communicates with
 France, Switzerland and Germany . . .*, printed for the author, 11 Caroline Street, Bedford
 Square, 1828–9, 2 vols., published in parts, 1827–9.

28 Royal Academy, General Assembly, Minutes, 3 November 1856.

29 *Art Union*, vol. 9, 1847, p. 363.

30 Royal Academy, Council Minutes, 7 March 1862 (manuscript).

31 Published by J. L. Fairless, Newcastle on Tyne. *Art Journal*, vol. 26, 1864, p. 156.

32 Material on J. T. Willmore was taken from *Art Journal*, vol. 25, 1863, pp. 87–8 and
 Tinsley's Magazine, March 1889, pp. 257–9.

33 *Art Journal*, vol. 26, 1864, p. 156; vol. 34, 1872, p. 314; vol. 36, 1874, pp. 93, 95;
 vol. 40, 1878, p. 96; vol. 46, 1884, p. 320; vol. 50, 1888, p. 384.

34 Ibid., vol. 23, 1861, p. 144.

35 Ibid., vol. 25, 1863, p. 156.

36 *Art Union*, vol. 6, 1844, pp. 78, 100; *Art Journal*, vol. 37, 1875, p. 340.

37 *Illustrated London News*, 19 April 1898, p. 249; *Art Journal*, vol. 60, 1898, p. 158.

38 James Baylis Allen material from: *Art Journal*, vol. 38, 1876, p. 106; Royal Society of
 Artists, Birmingham, op. cit., pp. 9–10.

39 Letter dated 23 May 1866 to Edward Cooke, National Library of Scotland,
 Department of Manuscripts, MS. 10994, ff. 82–3.

40 Miller, op. cit. This is a discursive account, reprinting many domestic letters of little
 importance. The catalogue of engravings is the most complete encountered of an
 engraver of this period. Copies belonging to Edinburgh City Libraries and the
 National Library of Scotland were consulted. Scottish Record Office, Calendar of
 Confirmations, Registration of 24 March 1882. Value of moveable estate was
 £1729. 15*s*. 1*d*.

41 Bell, *Art Journal*, vol. 34, 1872, p. 284; Burnet, ibid., vol. 12, 1850, pp. 275–7; Croll,
 ibid., vol. 16, 1854, p. 119; Horsburgh, ibid., vol. 31, 1869, p. 360; Redgrave, op. cit.;
 Howison, *Art Journal*, vol. 13, 1851, p. 44; Lizars, Redgrave, op. cit., Smyth, *Art
 Journal*, vol. 13, 1851, pp. 183, 201.

42 Mitan was apprenticed originally to a writing engraver but, after training at the
 Royal Academy Schools, became a book-plate engraver of some promise until his
 death at the early age of forty-six.

43 *Gentleman's Magazine*, 1852, vol. 2, pp. 542–3.

44 Coxe, op. cit. Postscript to advertisement on p. x. The plate was subsequently engraved by T. Thomson, and finished by Charles Heath because Finden's later engagements prevented his re-engraving it.

45 Rt. Rev. Reginald Heber, *Narrative of a journey through the Upper Provinces of India . . .*, Murray, 1828, 2 vols. Sir John Ross, *Narrative of a second voyage in search of a north-west passage and of a residence in the Arctic regions . . .*, A. W. Webster, 1835.

46 The letter, of 21 April 1841, reads: 'I have to acknowledge the receipt of your letter acceeding to the terms proposed thro' Mr. Dundas by us for the purchase of our interest in the illustrated edition of Childe Harold, which is satisfactory to us. We have only one point to add, which was forgotten yesterday, which we feel assured you will agree to; we shall require a dozen copies of the work, in order to discharge various obligations to private friends who have aided us greatly in the progress of the Work. I remain, my dear Sir, Yours very respectfully, Edw. F. Finden.'

47 This title was taken from one of the paper-covered parts in which the prints were first issued at 2s. 6d. each for five prints.

48 *Views of ports and harbours, watering places, fishing villages, and other picturesque objects on the English Coast, engraved by William and Edward Finden, from paintings by J. D. Harding, G. Balmer, E. W. Cooke, T. Creswick and other eminent artists*, Charles Tilt, Fleet Street, 1838. The text was written by W.A.C. according to the preface, dated 23 November 1837. This volume was reissued in 1975 by Anthony J. Simmonds, 71 Cromwell Avenue, Highgate, London, at £5 (compared with the original part publication of 30s.). William Beattie, *The ports, harbours, watering places and coast scenery of Great Britain, illustrated by views taken on the spot by W. H. Bartlett . . .*, George Virtue . . ., 1842, 2 vols. The engraved title page reads: 'Finden's views of the ports . . . continued by W. H. Bartlett'. See p. 190, 'L'Envoy'. See also William Beattie, *Brief memoir of the late William Henry Bartlett . . .*, published by subscription, printed by M. S. Rickerby, 73 Cannon Street, City, 1855, p. 30.

49 National Library of Scotland, Department of Manuscripts, MS. 9994, f. 90. Miller, op. cit., Catalogue of engravings, p. xxvi.

50 *Art Journal*, vol. 19, 1857, p. 99.

51 Thomas Moore, *The beauties of Moore ; a series of portraits of his principal female characters from paintings by eminent artists, executed expressly for the work, engraved by or under the superintendence of Mr Edward Finden, with descriptive letterpress*, published by Chapman and Hall . . ., 1846. Reissued with a memoir of the poet, by John Tallis and Company, London, Edinburgh, Dublin and New York (1853).

52 *Art Union*, vol. 10, 1848, p. 33.

53 *Art Union*, vol. 8, 1846, p. 306.

54 Main sources for the Finden brothers: *Art Journal*, vol. 14, 1852, p. 350; vol. 19, 1857, p. 121; *Illustrated London News*, 9 October 1852, p. 299; *Gentleman's Magazine*, vol. 2, 1852, pp. 542–3; vol. 1, 1857, p. 497; British Museum, *Catalogue of engraved British portraits in the Department [of Prints]*, 1908–25, 6 vols.

55 Main sources for the Wallis brothers: *Art Journal*, vol. 41, 1879, p. 28; vol. 52, 1890, p. 382; J. Maas, *Gambart . . .*, Barrie & Jenkins, 1975, p. 45 et seq.

56 Main sources for the Cousen brothers: *Art Journal*, vol. 11, 1849, p. 41; vol. 15, 1853, p. 152; vol. 43, 1881, p. 63; vol. 51, 1889, p. 364; *Bradford Antiquary*, vol. 2, pp. 198, 203–5 (from an article by Butler Wood, formerly Chief Librarian of Bradford, entitled 'Some old Bradford artists', a paper read March 1892).

57 There appear to be differing dates for his year of birth, ranging from 1806 (Slater's *Engravings and their value*) to 1819 (Benezit, Thieme and Becker, etc.) The local variant is 1813, however, and since Charles's earliest known book work is dated 1836, this agrees well with the probabilities of the situation. (John was twenty-four when his first important book plate was published.) Extensive searches in local parish and other records have failed to confirm or deny this supposition.

58 *Richmondshire, illustrated by twenty line engravings after drawings by J. M. W. Turner, R.A., with descriptions by Mrs. Alfred Hunt, and an introduction by Marcus B. Huish . . .*, J. S. Virtue, 1891. Limited edition of 500 copies. Intro., pp. xii–xv.

59 *The Seine and the Loire, illustrated after drawings by J. M. W. Turner, R.A., with introduction and descriptions by M. B. Huish, LL.B* (new ed.), J. S. Virtue . . ., 1895. Intro., p. x.

60 *Art Journal*, vol. 59, 1897, p. 222.

61 William Cudworth, 'Old Bradford lawyers', in *Bradford Antiquary*, 1895, vol. 2, p. 65.

62 Ibid., p. 71.

63 Revd Robert Walsh, *Constantinople and the scenery of the seven churches of Asia Minor, illustrated in a series of drawings from nature by Thomas Allom . . .*, Fisher, Son & Co., 1838–40, 2 vols. Thomas Rose, *Cumberland: its lake and mountain scenery, etc., etc. Illustrated from drawings on the spot by Thomas Allom . . .*, Peter Jackson (late Fisher), c. 1847. Joseph Stirling Coyne, and others, *The scenery and antiquities of Ireland, illustrated in one hundred and twenty engravings from drawings by W. H. Bartlett*, Virtue, 1842, 2 vols.

64 *Art Journal*, vol. 14, 1852, p. 15. *Bradford Antiquary*, 1895, vol. 2, pp. 199–200.

65 Edward Walford, *Men of the time . . .* new ed. Routledge, 1862, p. 327.

66 Sources for Edward Goodall: *Art Union*, vol. 7, 1845, p. 102; *Art Journal*, vol. 17, 1855, p. 109; vol. 24, 1862, p. 46; vol. 26, 1864, p. 155; vol. 32, 1870, p. 182.

67 *Art Union*, vol. 1, 1839, p. 186.

68 Ibid., vol. 6, 1844, p. 100.

69 *Art Journal*, vol. 11, 1849, p. 97.

70 Royal Academy, General Assembly minutes, 10 February 1853.

71 *Art Journal*, vol. 16, 1854, pp. 65, 356.

72 Ibid., vol. 29, 1867, p. 62; vol. 34, 1872, pp. 241, 300; vol. 37, 1875, p. 190.

73 Ibid. vol. 34, 1872, p. 61.

74 Ibid. vol. 36, 1874, p. 126; vol. 46, 1884, p. 212; vol. 54, 1892, pp. 64, 126, 192, 255. Other sources: *Illustrated London News*, 13 January 1872, p. 27; 7 May 1892, p. 562; *The Magazine of Art*, vol. 15, 1892, pp. 323–4; William Sandby, *History of the Royal Academy of Arts . . .*, Longman, 1862, 2 vols., ch. XIX, pp. 355–6; Michael Bryan,

Bryan's dictionary of painters and engravers new ed. rev. and enlarged under the superintendence of George C. Williamson, G. Bell & Sons, 1926–34, 5 vols., vol. 5, p. 130.

75 Redgrave, op. cit., pp. 67, 207.

CHAPTER SEVEN · The artists

1 Raimbach, op. cit., p. 139.

2 Prospectus for the volume, 1846.

3 William Beattie, *Switzerland* . . ., Virtue, 1836, 2 vols, 'To the Reader', dated 30 May 1836.

4 William Beattie, *The Waldenses ; or, Protestant Valleys of Piedmont and Dauphiny* . . ., Virtue, 1837.

5 The result of this trip was *American scenery ; or, land, lake and river illustrations of Transatlantic nature* . . . *the literary department by N. P. Willis*, Virtue, 1840, 2 vols. Some illustrations were provided by Henry Room, Thomas Creswick and T. Doughty, and thirty-two engravers were employed on the total of 120 illustrations.

6 This resulted in the publication of William Beattie's *The Danube : its history, scenery and topography* . . ., Virtue, [1844]. 'In addition to the 80 steel engravings, the text is further illustrated by nearly the same number of woodcuts . . . Of these illustrations, the greater portion was taken on the spot by M. Alresch – a German artist of well-known talent and reputation – and drawn by Mr. Bartlett, who has also contributed various original views, interspersed throughout the work.' Preface, p. iv.

7 Beattie, *Brief memoir of Bartlett*, pp. 32–3. Most of the information on Bartlett is taken from this source, and his published works.

8 Henry Stebbing, *The Christian in Palestine ; or, scenes of sacred history* . . ., Virtue, 1846.

9 Samuel Carter Hall and Anna Maria Hall, *A week at Killarney, being a guide to tourists to the Lakes of Killarney*, Virtue, c. 1846. The work had first been published by Jeremiah How in 1843 with only eight engravings. S. C. Hall was for many years the editor of the *Art Journal*, also published by Virtue.

10 William Henry Bartlett, *Forty days in the desert* . . ., Arthur Hall & Co., 1848 (10s. 6d., twenty-seven steel engravings). William Henry Bartlett, *The Nile boat* . . ., Arthur Hall, Virtue & Co., 1849 (16s., thirty-five steel engravings).

11 This work has all the hallmarks of a 'Beattie rescue' on the lines of Finden's *Ports, harbours* . . ., since the original volume containing eleven plates, six of which were by G. F. Sargent, commenced part publication in December 1841 (*Art Union*, vol. 3, 1841, p. 194). It was published by Mortimer and Haselden, 21 Wigmore Street, Cavendish Square, and Tilt and Bogue, but by 1845, George Virtue was advertising the bound volume with 250 woodcut illustrations at 25s. (Prospectus, dated January 1845). Bartlett's commission for the 27 vignettes in volume 2 was obviously an attempt to inject life and an established name into the work, which appeared in 1851 as *The castles and abbeys of England, from the national records, early chronicles and other standard authors*, by

William Beattie, M.D. . . ., J. S. Virtue, 2 vols. (25*s.* each). The same publisher reissued it early in 1876. (*Art Journal*, vol. 38, 1876, p. 63).

12 This series of sixty-seven large plates was published in parts before its final issue in book form in 1849. It is listed in Beattie's *Brief memoir* . . ., p. 52, as one of the books with which Bartlett was connected, although in what capacity is not clear. Twenty-six of the plates were engraved by William Greatbach.

13 William Henry Bartlett, *Jerusalem revisited*, Virtue, 1854, preface, p. vii, footnote.

14 *Dictionary of National Biography*, under Beattie.

15 *Art Journal*, vol. 17, 1855, p. 33.

16 In addition to the works listed in this section, Bartlett's illustrations have appeared in: *The pictorial history of Scotland*, with illustrations on steel from drawings by W. H. Bartlett and other artists; *Views illustrating the topography of Jerusalem, ancient and modern*, by W. H. Bartlett, 1845; *Scripture sites and scenes from actual survey in Egypt, Arabia and Palestine*, by W. H. Bartlett; *The history of America*, by W. H. Bartlett, continued by B. B. Woodward; *The practical and devotional family Bible* . . ., Glasgow, Collins, 1860, twenty-two illustrations by Bartlett; *[Thomas] Barber's picturesque illustrations of the Isle of Wight* . . ., Simpkin Marshall [n.d.] thirteen illustrations by Bartlett; *The complete works of Robert Burns*, J. S. Virtue, *c.* 1860, one illustration by Bartlett; *The gallery of Scripture engravings, historical and landscape* . . ., with descriptions by John Kitto, Fisher, 1846–9, over a dozen illustrations by Bartlett; *The Holy Bible* . . ., Oxford U.P., 1877, another edition, 1880; *Piedmont and Italy from the Alps to the Tiber, with a descriptive and historical narrative by Dudley Costello* [James Virtue, after 1855] (most of the illustrations seem to have been used before, e.g. 'Lausanne (Canton Vaud)' after Bartlett, engraved by J. W. Appleton, had previously appeared in Beattie's *Switzerland*, dated 1 July 1834); *The fashionable guide & directory to the public places of resort illustrated with views*, published for the proprietors by T. Fry, *c.* 1838. A panorama of Jerusalem and the Holy Land was painted from Bartlett's drawings in 1851, and was exhibited all over the country, including Ireland. (Beattie's *Brief memoir* . . ., p. 52.)

17 Sources for Cox: Redgrave, op. cit.; *Art Journal*, vol. 48, 1886, p. 29.

18 Julia M. Pardoe was born in Yorkshire in 1806 and died on 23 November 1862, having for some years supported herself, and latterly her mother, by her literary activities.

19 Redgrave, op. cit. Hill and Midgley, op. cit., p. 8.

20 Sources for Creswick: *Art Union*, vol. 1, 1839, p. 170; *Art Journal*, vol. 18, 1856, pp. 141–4; vol. 26, 1864, p. 40; vol. 32, 1870, pp. 53, 159; vol. 53, 1891, p. 63; Redgrave, op. cit.; William Tinsley, *Random recollections of an old publisher*, Simpkin Marshall, 1900, 2 vols., vol. 1, p. 45; article from an unidentified Birmingham newspaper, undated, but after 1884, from a scrap-book in Birmingham Reference Library, headed 'Birmingham Artists. Charles W. Radclyffe' p. 250.

21 Rawlinson, op. cit., vol. 2. Part B deals with his line engravings on steel, giving lists of plates and books. W. G. Rawlinson, *Turner's Liber Studiorum* . . ., 2nd ed., Macmillan, 1906. A. J. Finberg, *Life of J. M. W. Turner*, 2nd ed., Oxford U.P., 1961. Walter

Thornbury, *Life of J. M. W. Turner, R.A.* new ed., Chatto and Windus, 1877. Contains letters from Turner to his engravers.

22 Edward Dillon, 'Turner's last Swiss drawings', in *Art Journal*, vol. 64, 1902, p. 329.

23 *Literary Souvenir* . . ., 1826, Preface, p. vii.

24 *Art Journal*, vol. 39, 1877, p. 222.

25 Marcus B. Huish, *The Seine and the Loire* . . ., J. S. Virtue, 1895, p. viii.

26 This story, probably exaggerated, is told in Frith, op. cit., vol. 1, pp. 133–4.

27 Thomas Roscoe, *The tourist in Switzerland and Italy* . . ., Robert Jennings, 62 Cheapside, 1830. (*The landscape annual*, 1830, vol. 1.) Thomas Roscoe, *The tourist in Italy* . . ., published for the proprietors by Robert Jennings and William Chaplin, 62 Cheapside, 1831. (*The landscape annual*, 1831, vol. 2.) *Continental annual and romantic cabinet for 1832*, with illustrations by Samuel Prout, Esq., F.S.A., edited by William Kennedy, Esq., published by Smith, Elder & Co., 65 Cornhill. (Engraved title-page has centre picture by Prout, border by F. W. Topham.) Redgrave, op. cit.

28 *Italy, illustrated and described in a series of views, from drawings by Stanfield, Roberts, Harding, Prout, Leitch, Brockedon, Barnard, &c. &c., with descriptions of the scenes, and an introductory essay, on the political, religious, and moral state of Italy by Camillo Mapei* . . . *and a sketch of the history and progress of Italy during the last fifteen years (1847–62) in continuation of Dr. Mapei's history by the Rev. Gavin Carlyle* . . ., Blackie, 1864, publisher's preface, p.v.

29 Redgrave, op. cit. *Art Journal*, vol. 17, 1855, p. 54; vol. 27, 1865, p. 16; vol. 20, 1858, pp. 201–3. James Ballantine, *The life of David Roberts, R.A., compiled from his journals and other sources* . . ., Edinburgh, Adam and Charles Black, North Bridge, 1866. Quotations from pp. 1–164.

30 There is some confusion as to the date of Stanfield's birth, given variously as 1793, 1794 and 1798. Most accounts tend to follow *The Times* obituary notice, which states that he was in his seventy-fourth year when he died on 18 May 1867. The volumes of Heath's *Picturesque annual*, were published by Longman, with texts by Leitch Ritchie.

31 Redgrave, op. cit. *Art Journal*, vol. 19, 1857, p. 137; vol. 29, 1867, p. 171; vol. 30, 1868, p. 120; vol. 46, 1884, p. 143.

32 *Art Journal*, vol. 18, 1856, p. 269. Redgrave, op. cit. *Library of the fine arts* . . ., published by M. Arnold, vol. 1, no. 1, February 1831, p. 86. Elizabeth Robins Pennell and Joseph Pennell, *Lithography and lithographers; some chapters in the history of the art* . . . *together with descriptions* . . . *of modern artistic methods*, T. Fisher Unwin, 1915, p. 102.

33 Moore, op. cit.

34 Frith, op. cit., vol. 2, pp. 199–207.

35 Ibid., vol. 1, p. 279.

36 *Art Journal*, vol. 59, 1897, p. 132.

37 Frith, op. cit., vol. 1, p. 212.

38 *Art Union*, vol. 7, 1845, p. 108. *Art Journal*, vol. 11, 1849, p. 20.

39 *Art Journal*, vol. 37, 1875, p. 31.

1 Prospectus in *Friendship's offering*, 1844.

2 *Art Union*, vol. 3, 1841, p. 19.

3 Ibid., p. 110.

4 *Art Journal*, vol. 23, 1861, p. 256; vol. 16, 1854, p. 152.

5 Ibid., vol. 29, 1867, p. 7.

6 *Art Union*, vol. 7, 1845, pp. 332, 350; vol. 9, 1847, p. 64. *Art Journal*, vol. 37, 1875, p. 32. Roget, op. cit., vol. 1, pp. 413–14, 443.

7 *Art Journal*, vol. 42, 1880, pp. 353–5.

8 Watts, op. cit., vol. 1, pp. 172–3.

9 Ibid., p. 176.

10 Ibid.

11 C. H. Timperley, *A dictionary of printers and printing with the progress of literature . . .*, H. Johnson, 1839, pp. 931–2.

12 Watts, op. cit., contains a great deal of information on the annuals in general as well as his own *Literary Souvenir*.

13 *Athenaeum*, Saturday, 25 December 1830, p. 811.

14 These are in the store of Thomas Ross and Son of Putney in three packets. One contains twelve plates, the other two, six each, all of which are addressed to Tilt.

15 A copy in the Bloomfield collection of Brighton Public Library.

16 Watts, op. cit., vol. 1, p. 305.

17 *Art Union*, vol. 4, 1842, p. 288.

18 Ibid., vol. 1, 1839, p. 172.

19 Leitch Ritchie, *Travelling sketches in the north of Italy, the Tyrol and on the Rhine . . .*, Longman [1831] (Heath's *Picturesque annual* for 1832), pp. iii–iv.

20 Watts, op. cit., vol. 2, pp. 312–13.

21 Ibid., vol. 2, p. 160.

22 Ibid., vol. 2, pp. 154–6. Roget, op. cit., vol. 2, pp. 4–5.

23 *Library of the fine arts*, vol. 1, no. 3, April 1831, pp. 262–4.

24 Martin Hardie, *Water colour painting in Britain*, Batsford, 1968, 3 vols., vol. 3, *The Victorian period*, ch. 2, 'The annuals and their influence', pp. 22–42.

25 *Art Union*, vol. 3, 1841, p. 206.

26 *Quarterly Review*, 73 (147), 1844, p. 192. The reference to the Art Unions is expanded in ch. 9, p. 322 et seq.

27 *Art Journal*, vol. 19, 1857, pp. 372–4.

CHAPTER NINE · Publishing and the publishers

1 Whitaker's *History of Richmondshire* cost Longman £10,000 in 1823, most of which was never recovered, Watts paid out £2,620 for the 1827 volume of his *Literary Souvenir*, an untypically low figure, (Watts, op. cit., pp. 248–51) but balanced by Heath's

expenditure of 11,000 guineas on the 1829 *Keepsake* (Preface, p. iii). Heath's *Paris and its environs*, published by Jennings and Chaplin had, by 1834, cost them £10,000 (Advertisement in *Landscape annual*, 1834), and in 1837, William Beattie's *Scotland* had cost nearly £40,000, and provided regular employment to upwards of one thousand families and individuals (Preface, p. viii).

2 *Art Union*, vol. 3, 1841, p. 194.

3 Ibid., vol. 2, 1840, p. 150.

4 Reviewed in *Art Journal*, vol. 28, 1866, p. 355.

5 W. J. Stannard, (ed.), *The art exemplar. A guide to distinguish one species of print from another with pictorial examples and written descriptions of every known style of illustration* (after 1853), p. 18. Victoria and Albert Museum Library copy was consulted.

6 E. Benezit, *Dictionnaire critique et documentaire des peintres, sculptures, dessinateurs et graveurs . . .*, revised ed. Paris, Librairie Grund, 1966, 8 vols., gives him as an engraver at Carlsruhe, working from 1819 to 1832. During this time he also exhibited in London.

7 The quotation is from Adolf Spemann, *Masters of landscape steel engraving . . .*, Stuttgart, A. Spemann, 1952 (16pp, thirty-two plates), p. 10. This is the only volume on English steel-engraved book illustration so far published.

8 'To Mr. Charles Heath the public owe a large debt; he has now catered for their amusement and information for a long period; and has no doubt achieved that success to which he is undoubtedly entitled. In the whole range of London publishers there is no man of greater enterprise, nor one who has so strenuously laboured to maintain the reputation he has acquired for good taste and mature judgment' (*Art Union*, vol. 2, 1840, p. 179).

9 Pennell, op. cit., p. 93.

10 Taylor, op. cit., vol. 2, p. 224.

11 Bathe, op. cit., pp. 83, 109, 119, 138.

12 Ibid., p. 165.

13 Turner's *Richmondshire . . .*, 1891, intro., p. xiv.

14 Timperley, op. cit., p. 910.

15 *Art Union*, vol. 1, 1839, p. 79.

16 Ibid., p. 170.

17 Ibid., p. 24.

18 *Art Union*, vol. 2, 1840, p. 43; vol. 4, 1842, p. 1. *Dictionary of National Biography*, under Charles Heath.

19 *Art Union*, vol. 10, 1848, p. 368. Obituary, *Art Journal*, vol. 11, 1849, p. 20.

20 Letter to John Murray in the publisher's possession. Scriven was Historical Engraver to George IV.

21 *Art Union*, vol. 2, 1840, p. 64.

22 F. A. Mumby and I. Norrie, *Publishing and bookselling*, 5th ed., Cape, 1974, pp. 224–6.

23 William Beattie, *The Danube . . .*, Preface p. iv.

24 Prospectus in the author's possession.

25 Compare the imprint, George Virtue, 25 Paternoster Row, in Mrs A. M. Hall's *The drawing room table book* 1849.

26 Printed and dated list in the author's possession.

27 Further sources for Virtue: *Art Journal*, vol. 31, 1869, p. 25; *London, provincial and colonial press news*, February 1886, pp. 15–16; *Dictionary of National Biography* under James Sprent Virtue; Philip A. H. Brown, *London publishers and printers; a tentative list, c. 1800–1870*, British Museum, privately printed, 1961, typescript, pp. 44, 98; Letters dated 4 July 1974 from Michael Virtue, director, and 12 August 1974 from Guy Virtue, senior director, of Virtue and Company Ltd.

28 The information in Timperley, op. cit., is not consistent. The figures quoted come from p. 948, but on p. 879, the date is given as 7 February.

29 *Art Union*, vol. 6, 1844, pp. 145–6.

30 Ibid., vol. 10, 1848, p. 250. By this time, the Association had acquired the prefix 'Royal'.

31 Ibid., vol. 1, 1839, pp. 2–3, 20. This report was freely used the following year as a basis for Edward Edwards's *The fine arts in England; their state and prospects considered relatively to national education . . .*, Saunders & Otley, 1840, pp. 238–53.

32 *Art Union*, vol. 3, 1841, pp. 14, 25; vol. 4, 1842, p. 37.

33 Ibid., vol. 3, 1841, p. 181.

34 Expressed in *Art Union*, vol. 2, 1840, pp. 144–5, and vol. 4, 1842. Letter dated 15 March, signed 'A Subscriber'.

35 *Art Union*, vol. 4, 1842, p. 158. The artist of 'The Blind Girl . . .' was Frederick W. Burton.

36 Ibid., vol. 4, 1842, p. 216; vol. 10, 1848, p. 161.

37 Miller, op. cit., p. 114.

38 *Art Union*, vol. 3, 1841, p. 193.

39 Ibid., vol. 6, 1844, p. 303.

40 Ibid., vol. 8, 1846, p. 108.

41 Public General Acts 9 & 10 Vict.c.48.

42 *Art Journal*, vol. 39, 1877, p. 253. The annual report of the Art Union of London, 1877, also denounces these practices in no uncertain terms.

CHAPTER TEN · Plate printing and the printers

1 Society of Arts, *Report of the Committee . . .*, op. cit., pp. 55–6.

2 *Printing patents*, op. cit., p. 108.

3 Ibid., Joseph C. Dyer's patent, 3385, 1 October 1810, p. 123: Jacob Perkins's patent, 4400, 11 October 1819, p. 145: Augustus Applegath's patent, 5988, 31 August 1830, p. 181. F. J. Melville, *Postage stamps in the making . . .*, rewritten and completed by John Easton, Faber, 1949, pp. 112–13.

4 *Printing patents*, op. cit., George Frederick Rose's patent, 1968, 31 August 1855, p. 499.

5 *Journal of the Printing Historical Society*, vol. 2, 1966, plate 2.

6 *Printing patents*, op. cit., Theodore Bergner's patent, 331, 7 February 1856, pp. 515–16.

7 *Journal of the Printing Historical Society*, no. 2, 1966, plate 4a 'Pressing printed work between boards and under 56lb. weights'.

8 *Art Journal*, vol. 17, 1855, p. 314.

9 Ibid., vol. 16, 1854, p. 154.

10 Longman Archive, Phillipps' Purchase ledgers, 1837–1877.

11 *Athenaeum*, no. 170, 29 January 1831, p. 75.

12 *Art Journal*, vol. 17, 1855, p. 167.

13 Ure, op. cit., vol. 2, p. 289.

14 *Athenaeum*, 25 December 1830, p. 813.

15 *London, Provincial and Colonial Press News*, February 1886, p. 16.

16 Parliament, House of Commons, *Report from the Select Committee on arts . . .*, 1836, Part 1, p. 133, (para. 1664).

17 Society of Arts, *Report of the Committee . . .*, op. cit., p. 55.

18 Mackenzie, op. cit., pp. 32–4.

19 Bathe, op. cit., plate XX.

20 J. S. Hodson, *An historical and practical guide to art illustration . . .*, Sampson Low, 1884, pp. 71–6.

21 *London, Provincial and Colonial Press News*, February 1886, p. 17.

22 *The Times*, 'Printing in the XXth century', *The Times*, 1930, p. 119.

23 *Printing patents*, op. cit., no. 128, 18 January 1853, p. 343.

24 Harvey, op. cit., pp. 188, 191.

25 Thomas Spencer, *Instructions for the multiplication of works of art in metal by voltaic electricity . . .*, Glasgow, Richard Griffin & Co., 1840, pp. iv, vii, 37.

26 *Art Union*, vol. 2, 1840, p. 182.

27 Edward Palmer, *Illustrations of electrotype*, 1841 (*Art Union*, vol. 3, 1841, p. 97).

28 *Art Union*, vol. 5, 1843, pp. 44, 247.

29 Ibid., vol. 6, 1844, pp. 9, 347.

30 Ibid., vol. 9, 1847, p. 62.

31 Ibid., vol. 10, 1848, p. 65.

32 Raimbach, op. cit., p. 143.

33 Society of Arts, *Transactions*, vol. 52, 1839, p. 192.

34 Pennell, op. cit., pp. 14, 101, 270–3.

35 Society of Arts, *Transactions*, vol. 52, 1839, pp. 190–2.

36 Great Exhibition, 1851, *Catalogues*, vol. 2, p. 836.

37 *Paris and its historical scenes*, Charles Knight, 1831, vol. 2, p. 135 (*Library of entertaining knowledge*).

38 Leitch Ritchie, *Travelling sketches on the Rhine . . .*, Longman, 1833 (*Heath's Picturesque annual for 1833*), opposite p. 235, plate 23.

39 Pennell, op. cit., pp. 289–91.

40 *Art Union*, vol. 6, 1844, pp. 69, 362; vol. 7, 1845, p. 8 (with illustration); vol. 8, 1846, p. 18; vol. 9, 1847, p. 181.

41 Society of Arts, *Journal*, 5 February 1864, p. 183.

42 Anthony Gross, *Etching, engraving and intaglio printing*, Oxford U.P., 1970, pp. 159–60.

43 Society of Arts, *Journal*, 26 November 1858, pp. 15–20. See also *Art Journal*, vol. 20, 1858, p. 356.

44 Society of Arts, *Journal*, 1859, pp. 172–3, 189, 221, 236–7, 601–2, 612–13, 625; 1860, pp. 444–5; Hodson, op. cit., p. 74–5.

45 This point was put in a letter dated 13 June 1976 to Philip McQueen, together with the suggestion that it was possibly an advertisement for the printer or a means of returning plates to the printer for storage. In his reply, he indicated that he could shed no further light on the topic, adding that the point had not been considered before and that he believed the practice originated with McQueens in the 1820s.

46 *Art Union*, vol. 3, 1841, p. 2.

47 William B. Todd (compiler), *A dictionary of printers and others in allied trades, London and vicinity, 1800–1840*, Printing Historical Society, 1972.

48 Miller, op. cit., p. 114.

49 Such a set exists at the Museum, Rottingdean, Sussex. A local stationer, H. Tuppen, was the proprietor of 'Six views of Rottingdean and its neighbourhood. Price sixpence. Pubd. by H. Tuppen, Rottingdean'. The $3\frac{1}{2}$ by $2\frac{1}{2}$ inch vignettes were also printed on linen table mats, decorated with a fringe, and in both cases, they bore the legend 'Engraved by Newman & Co., 48, Watling Street, London'. Although undated, local historians have placed them after 1860, because by that date, the south aisle of the church shown in the picture had been built.

50 Bathe, op. cit., pp. 152, 164.

51 The premises and presses are illustrated in the coloured folding frontispiece to Iain Bain's article on Thomas Ross and Son, *Journal of the Printing Historical Society*, no. 2, 1966.

52 Tuer, op. cit., vol. 2, p. 100.

53 Interview with Philip McQueen, 25 September 1975.

54 See Tuer, op. cit., p. 102 for further information.

55 See Tuer, op. cit., p. 101 for further information.

56 See Tuer, op. cit., p. 102 for further information.

57 *Art Journal*, vol. 39, 1877, p. 277.

58 *London Provincial and Colonial Press News*, February 1886, pp. 16–17.

59 Society of Arts, *Journal*, 26 November 1858, p. 20.

60 *Art Journal*, vol. 34, 1872, p. 31. The quotation goes on: '(for science enables us so to multiply engravings that a million impressions might be taken, the latest as good as the first) but each as sharp and as brilliant as a proof.'

61 Society of Arts, *Journal*, 26 November 1858, p. 18.

62 *Art Journal*, vol. 29, 1867, p. 30.

63 Interview with Philip McQueen, 25 September 1975.

64 Timperley, op. cit., pp. 879, 948.

65 Thomas Murdoch, *The early history of lithography in Glasgow 1816–1902*, Glasgow, T. Murdoch & Co., 1902, pp. 9–17. Obituary in unnamed newspaper cutting dated 22 September 1872, from scrapbook in Mitchell Library, Glasgow, p. 23.

66 Letter in the Department of Manuscripts, National Library of Scotland, MS. 10994, f. 81.

67 Tinsley, op. cit., vol. 2, pp. 223–4. *Art Union*, vol. 10, 1848, p. 161. Other sources include: Geoffrey A. Glaister, *The glossary of the book*, Allen & Unwin, 1960, pp. 85–6; David Strang, *The printing of etchings and engravings*, Ernest Benn, 1930; Society of Arts, Minutes of Committees, 1822: 1823, manuscript volume, p. 80; *Journal of the Printing Historical Society*, no. 2, 1966, pp. 3–22.

CHAPTER ELEVEN · Decline of the art

1 Timperley, op. cit., p. 901, taken from the London Catalogue.

2 *Library of the fine arts . . .*, vol. 3, p. 262, 1831.

3 These figures were obtained by comparing the list in D. McNeely Stauffer, *American engravers upon copper and steel* (New York, Grolier Club, 1907, 2 vols.) and Mantle S. Fielding's Supplement (Philadelphia, 1917) with the author's list. The figures by themselves are too small to be significant, but Stauffer has not been able to name all his engravers; he notes on p. 111 that 'a group of engravers was brought to Philadelphia', presumably from Europe or England, only one of whom is tentatively identified. A total of eighteen emigrant steel engravers can be named, but only eleven of them appeared to make a permanent home in America.

4 Spemann, op. cit., p. 10.

5 *Art Union*, vol. 1, 1839, pp. 148, 173.

6 Watts, op. cit., vol. 1, p. 230.

7 Pennell, op. cit., p. 106.

8 *London and Westminster Review*, 1839, vol. 23, pp. 283–5. The article is signed 'T'. Pennell, op. cit., ascribes it to Thackeray, pp. 109–10.

9 *Art Union*, vol. 6, 1844, p. 99.

10 Public General Acts, 7 & 8 Vict.c.73.

11 *Art Union*, vol. 1, 1839, p. 63.

12 Ibid., vol. 5, 1843, p. 22.

13 Ibid., vol. 4, 1842, p. 142.

14 Pennell, op. cit., pp. 106–9.

15 *Art Union*, vol. 1, 1839, p. 25.

16 Nicolette Gray, *XIXth century ornamental types and title pages*, Faber, 1938 (reprinted 1951), pp. 78–80.

17 *Art Union*, vol. 3, 1841, p. 206.

18 Murdoch, op. cit., p. 10. 'In a very short time the comparative rapidity of Lithographic printing so left copper-plate printing behind, that the latter all but ceased to exist, and hence the engraving establishments had all to become

Lithographic, but they retained their engravers, who, in the early days took the place of the Lithographic writers.'

19 Sources for William Humphrys: Redgrave, op. cit., pp. 229–30; Stauffer, op. cit.; *Art Union*, vol. 1, 1839, p. 173; vol. 3, 1841, p. 190; vol. 5, 1843, p. 314.

20 Sources for Joubert: *Art Union*, vol. 7, 1845, pp. 146, 241; *Art Journal*, vol. 43, 1881, p. 256; vol. 46, 1884, p. 64. The information on postage stamps comes largely from Melville, op. cit., ch. 1, 'Printing in 1840'; chs. 6 and 7, on the Perkins process, contain other valuable material relevant to this study.

21 *Art Union*, vol. 9, 1847, pp. 230, 414; vol. 10, 1848, pp. 30, 125.

22 Ibid., vol. 10, 1848, pp. 315, 287.

23 Delaborde, op. cit., p. 324.

24 *Notes and queries*, 4th series, vol. 7, 1871, p. 510.

25 *Art Journal*, vol. 27, 1865, p. 31.

26 Ibid., vol. 28, 1866, pp. 312, 351.

27 Ibid., vol. 27, 1865, pp. 381, 126.

28 *Art Journal*, vol. 44, 1882, pp. 219–20. Frith, op. cit., vol. 1, p. 273; vol. 2, p. 152.

29 *Art Journal*, vol. 50, 1888, p. 28.

30 [H. Teilman Wood], *Modern methods of illustrating books*, Elliot Stock, 1887 (*The book lover's library*, ed. by Henry B. Wheatley) pp. 4–5.

31 *Art Journal*, vol. 55, 1893, pp. 31, 224, 306.

32 Ibid., vol. 39, 1877, p. 148. Royal Society of Arts, Birmingham, op. cit., pp. 9, 23–42.

33 Henry Blackburn, *The art of illustration*, W. H. Allen, 1894, p. 183.

34 Hamerton, *The graphic arts*, op. cit., footnote to p. 364.

35 C. Booth, *Life and labour of the people in London*, Macmillan, 1892–7, 10 vols., vol. 8, p. 108.

APPENDIX · Engraved on steel

from *All the Year Round* 27 October 1866

a never-ending variety of statistical tables, from which even the most hungry statician can appease his appetite to his heart's content!

Only think! Twenty-one editions — one thousand each—of "Our empty Coal-cellars, and What's to fill them?" devoured in the short space of twenty-one days, by twenty-one thousand admiring political economists and stunned staticians, each and every one of whom talked himself clean out of breath to twenty-one more almost driven-mad political economists and stunned staticians who had not been fortunate enough to make a purchase of "Our empty Coal-cellars, and What's to fill them?"

Nevertheless, twenty-one editions, of one thousand copies each, demolished in twenty-one days, is not half enough to satisfy the craving of the public upon this home-touching topic. All heads (especially the thickest and hardest) are filled with Bunglebutt. The fame of Bunglebutt resounds everywhere — morning, noon, and night. Every twenty-four hours the name of Bunglebutt turns up in every column of every morning and evening newspaper, no matter what may be its price or its political colour. Then who can wonder that the twenty-second and much-augmented edition of "Our empty Coal-cellars, and What's to fill them?" has gone to press?

But at the last moment, when the panting public are almost at the point of frenzy for this twenty-second and much-augmented edition, the splendid idea strikes somebody that it should be adorned with a portrait of the great Bunglebutt, "beautifully engraved upon steel, in the highest style of art."

Jolterhead, the eminent photographic artist of Lower Pighurst, who has accomplished no end of cartes de visite of the mighty Bunglebutt in every possible pose—sometimes with his left foot thrown over his right foot, with his hat in his right hand, and sometimes with his left hand upon his left hip, and his hat upon the table, against which he rests gracefully—has just accomplished a great triumph, in the shape of a large portrait of Bunglebutt. Hence the splendid idea of somebody—perhaps the immortal Bunglebutt himself—that "Our empty Coal-cellars, and What's to fill them?" should hereafter be delivered to the panting public embellished with this photographic portrait of the great Bunglebutt, "beautifully engraved upon steel, in the highest style of art."

The dreadful consequence of this "at the last moment" determination is, that Pickpeck, the engraver, is sent for, and is commandingly requested to engrave upon steel the portrait of Bunglebutt in the "highest style of art," from a muzzy and black-as-your-hat photograph, as quick as "a flash of lightning." There is no help for it; the public are panting for the twenty-second and much-augmented edition of "Our empty Coal-cellars, and What's to fill them?" The book is ready to go to the binder. It is, therefore, Pickpeck, the stipple engraver, the dawdling Pickpeck, who alone keeps, as it were, the cellar-door of publication shut up, and simply because he cannot engrave, "in the

ENGRAVED ON STEEL.

Bunglebutt, the great Bunglebutt, member of parliament for the flourishing town of Lower Pighurst, has come out decidedly strong this time! Bunglebutt, at any time, is an awfully knowing blade; a regular Adam Smith over the nation's wealth collectively, and over his own wealth individually.

Bunglebutt—who has been returned by a majority of nine hundred and ninety-nine of the most enlightened of Lower Pighurst, to serve in the imperial parliament—is admitted, on all hands, to be up to a thing or two; his grasp over the mysteries of political economy is so tremendous, and his appetite for statistics is so alarming, that ever since he came out with his exhaustive pamphlet, "What will Britannia do when her last shovel of coals has been put on the fire?" not only the Lower Pighurstians to a man, woman, and child, but the political economists and the most cunning staticians in all parts of the kingdom have combined to consider the great Bunglebutt as a match for any two chancellors of the exchequer, one down and the other come on. Yet, all this is nothing to what the great Bunglebutt has since done on the momentous coal question. Bunglebutt is, himself, a great manufacturer, and consumes no end of tons of coals every week. Our daily increasing consumption of coals so rankles in his heart that he sees the day when it will be all up with England and her coals, together. To avert this stupendous calamity, the mighty mind of the far-seeing Bunglebutt has been hard at work, both in and out of parliament, until the interesting result has been the production of his truly stunning work, "Our empty Coal-cellars, and What's to fill them?"

Only think! A book on the great coal question consisting of one thousand and one closely printed pages, filled from beginning to end with

highest style of art," the portrait of Bunglebutt as quick as "a flash of lightning."

However, whether the great Bunglebutt is "beautifully engraved in the highest style of art" or not, the art and mystery of engraving a portrait upon steel is not to be accelerated beyond "putting on the screw," in the shape of working night and day; this poor Pickpeck does, but engraving even a book-portrait upon steel is a work of time for all that; besides which, Bunglebutt is the proud possessor of a peculiar obliquity of vision in one eye, and that simple, if not beautifying, circumstance will bring much wailing and woe upon Pickpeck, the engraver, before Bunglebutt is done with.

It happens to be half-past one P.M. on Monday, when Pickpeck has undertaken the "flash of lightning" impossibility. The muzzy and black-as-your-hat photograph has been delivered to him; the size of the steel plate has been settled upon; and so, to save time, although it is two miles out of his way yet on his way home, Pickpeck posts along to the steel-plate maker, to order his plate; but somebody has ordered half a dozen "flash of lightning" plates five minutes before the arrival of Pickpeck, so Pickpeck is content to accept the promise that he shall have his "flash of lightning" plate last thing on Wednesday night, or first thing on Thursday morning. Here's delay—what is to become of "Our empty Coal-cellars, and What's to fill them?" What is to become of the panting public? Down with Pickpeck!

Pickpeck returns to his home to prepare for action. The first serious thing to be accomplished is, to carefully trace the outline of the portrait. Pickpeck selects a fine clear piece of gelatine, or glass paper, fastening it down over the portrait, which, being a photograph, does not show as perfectly through the glass paper as Pickpeck could desire; nevertheless, with the aid of a magnifying-glass and his properly sharpened etching-needle, Pickpeck manages to trace, that is to say, slightly to scratch or cut, on the upper surface of the glass paper, the outline of Bunglebutt's majestic countenance, as it shows itself through the transparent sheet of glass paper.

At length the steel plate arrives; whereupon Pickpeck well washes with turpentine the polished side thereof, besides further polishing that same side by friction with whiting; then he prepares to lay an etching-ground. Having firmly fastened a hand vice to one end of the steel plate, by which it may be held out at arm's length, then, with sundry pieces of paper crumpled up, and placed all alight in a fire-shovel, Pickpeck proceeds to warm the steel plate through, from the underneath side, against which he is slowly moving the flame arising from the ignited print paper; the heat being adjusted to that degree which, in his long experience, Pickpeck conceives to be sufficient to cause the etching-ground to melt and flow freely.

The mysterious compound called etching-ground—carefully tied up in a piece of silk—is a small globe, not unlike, in size and colour, a rather corpulent brandy-ball: a sweetstuff known to most of us in our childhood.

The steel plate being sufficiently heated, Pickpeck passes his silk-covered ball of etching ground up and down the polished side of the steel plate : the warmth contained in it causing the etching-ground to flow out freely through the pores of the silk covering; thus leaving across the front of the steel plate what look like so many streaks of treacle. Pickpeck then takes up his dabber, also made of silk, stuffed with wadding, and to which a holder is attached; the entire dabber resembling most completely a two and a half-inch inverted mushroom. With this inverted mushroom-looking dabber, Pickpeck dabs up and down, and backwards and forwards, over the treacle-like streaks of etching-ground, until the latter have become beautifully manipulated into one harmonious and level tint, very much, in appearance as to colour, like the top of a hot-cross-bun. One more operation, and the etching-ground will be complete. Lighting a wax taper—which, to yield a good body of flame, has been doubled up into lengths so as to make a cable of eight wicks, the whole gently twisted together, and presenting the appearance of a peppermint-stick, only not quite so white to look at—Pickpeck makes of the steel plate, by holding it at arm's length aloft, a temporary ceiling above his head, but with the etching-ground-covered side of the steel plate turned downwards. Beneath this extemporised ceiling, Pickpeck flickers the lighted wax taper of eight wicks to and fro, so that the smoke arising from the wax-taper flame ascending to the steel-plate ceiling, that smoke sinks into and amalgamates itself with the etching-ground, which is still meltingly hot; the consequence of this last performance is, when the steel plate becomes cold, that the mixture of wax-taper smoke and melted etching-ground has produced a polished lacquer-like coating on the steel plate, causing it to resemble a well-japanned piece of black tea-tray.

The steel plate being quite cold, and the etching-ground perfect enough to satisfy Pickpeck—who is very fastidious in all these operations—he prepares to "turn off the tracing." Putting the glass paper, upon which the countenance of the wise Bunglebutt has been cut, or scratched, or traced, over a piece of white paper, but with the tracing uppermost, Pickpeck proceeds to sprinkle a little lead-pencil dust on it, and then, with a small piece of cotton rag, sweeps, or brushes, as much of the lead-pencil dust into the traced lines as they will hold. He soon ascertains when each line is well filled, by their suddenly appearing black, owing to the white paper underneath the transparent sheet of gelatine, or glass paper.

And now to effect the transfer of the tracing on to the etching-ground. The glass paper, on which is the "counterfeit presentment" of the tremendous Bunglebutt, is laid with the traced side downwards upon the etching-ground itself, and, when it is fastened in position, Pickpeck, with one of his choicest burnishers, proceeds to burnish over the upper or non-traced-upon side of the glass paper. The pleasing result of this operation is, that, as the burnisher passes

along, it presses the lead-pencil dust out of the lines of the tracing on to the etching-ground, and all so perfectly, that, upon the removal of the glass paper, the eye of Pickpeck beholds every line of the tracing shining like threads of silver upon the black japanned-looking etching-ground.

Now the valorous Pickpeck can commence his etching; that is to say, he, with his etching-graver, begins to perforate the etching-ground with divers and innumerable dots, dug down into the steel, along the transferred lines of silvery pencil-dust, representing in outline the figure-head of the profound Bunglebutt. Pickpeck arranges his dots accordingly along the lines aforesaid, just as his judgment conceives they will best carry out, in an artistic manner, this much-desired representation. The etching completed, the bright dots dug into the steel—bright because surrounded and relieved by the black etching-ground—now blaze away until the etching seems to represent a kind of starry firmament turned upside down, and composed of countless illumination-lamps on a small scale.

The etching completed, Pickpeck has nothing to do but to prepare himself, and the steel plate, for the "biting-in;" a process whereby a certain acid, called nitric, antagonistic to steel in all its notions, will do, in a few minutes, what even an engraver could not accomplish so well, were he to labour no end of days. But, before biting-in, the steel plate must be "walled," and then "stopped out."

For the purpose of walling the plate Pickpeck gets a small pan of lukewarm water, into which he puts the wall-wax, or bordering-wax, as it is variously called; the same being a compound of common pitch and beeswax, in equal proportions. When this wall-wax is sufficiently softened by the warmth of the water, Pickpeck, upon his table, rolls it out, until it looks like an extra-long piece of stick-liquorice, but not quite so big in its circumference; then with the thumb and the first finger of both hands he presses the round stick of wall-wax to a flat, about the eighth of an inch in thickness by one inch in breadth. The next thing to be done is to place this flat strip of wall-wax on its side edge, round the entire etching; where it somewhat resembles a little great wall of China, made of hardbake, but without the almonds. The edge of the wall-wax resting on the steel plate, being securely pressed down, so as to cause it to adhere firmly to the plate, and not allow the acid to escape beneath the wall, the remainder of the plate — between the wall and the etching — although it is already covered with the etching-ground, is nevertheless now covered over with a coating of Brunswick black, fresh from the bottle, and laid on with a camel-hair brush; the Brunswick black being carried round the base of this little great wall of China, with every possible care, the more effectually by such attentive stopping-out, to keep the acid within bounds, and thereby prevent "foul biting"—a kind of accident most repugnant to the soul of Pickpeck. On the left side of the steel plate, while erecting the wall, and while the wax is still warm and pliable, Pickpeck, by a dexterous action of his fingers, presses out a spout to allow of the acid being poured off the plate with increased facility.

At length the stopping-out being perfectly dry, with a small-spouted jug half full of malignant-smelling acid grasped in his left hand, Pickpeck looks one moment down upon the bright shining dots of his etching; the next moment the deed is done; the acid is poured on to the etching — confined within the limits of the little great wall of China. The etching-ground and the Brunswick black being both impervious to all acidical attacks, the acid has nothing to do but to tumble headforemost into the dots, dug through the etching-ground into the steel below. The acid no sooner tumbles into the dots, than they almost immediately lose their brightness: just as though the acid, being so pugnaciously inclined towards steel, had suddenly given every individual bright dot a black eye. Anyhow, the acid is fighting for its life in these dug-out dot holes; the acid is tearing off minute particles of steel, and throwing them up out of the dot holes in such multitudes as to cause a brownish cloud to be seen floating about the little lake, the pungent odour from which has already begun to tickle the nose of Pickpeck. But the time has now come for Pickpeck to interfere. Swiftly he pours off the acid from within the little great wall of China, rapidly supplying the place of the acid with pure water; which operation he repeats again and again, so as to wash thoroughly the dots that have been so much belaboured by the violent conduct of the acid. Upon pouring off the water and drying up the few bubbles that have remained fondly hanging about the etching, Pickpeck comes to the conclusion, on a close examination, that the biting is sufficient. Removing, therefore, the wall, and washing off the etching-ground and the Brunswick black with turpentine, the steel plate once again appears silvery white: while the dots, owing to the vigorous performance of the acid, appear jet black; whereby the mighty Bunglebutt looks up at Pickpeck in brilliant outline.

All things, such as acid, Brunswick black, wall-wax, and other "biting traps" being carefully put away, Pickpeck sits down to begin engraving in earnest. First, then, he proceeds —by digging the point of his stipple-graver down into the steel plate, and thence chipping out a minute particle of that metal—to lay a tint of tiny dots all over the expressive face of Bunglebutt; sometimes placing the dots close together, thereby to render the finer markings of the features; sometimes placing the dots wider apart, as various muscles swell out and give the varied rotundities of Bunglebutt's countenance. When one tint of dots has been laid down all over the great man's face, Pickpeck, by means of a powerful magnifying-glass, is enabled to place a second dot close to the side of the first dot—Siamese-twins fashion; thus he proceeds upon his way, putting a dot here, and a dot there, and a dot wherever his artistic judgment tells him a dot should be

placed. Such is the art and mystery of stipple-engraving upon steel; and so Pickpeck goes on dotting from day to day, until he has wrought out, by means of these multitudinous dots, a fair representation of the "form and pressure" of a Bunglebutt "in his habit as he lives."

But, say what you will, engraving upon steel *is* a very slow process; therefore Pickpeck has no help for it but to go on dot, dot, dotting, with his greatest vigour; first oppressed by the heat of the sun during the day; then, baked almost beyond endurance by the heat from his oil lamp at night. And thus, although the head of Bunglebutt, as it is being engraved, is no bigger than a bronze penny-piece, Pickpeck has to dot, dot, dot, his countless dots day after day, besides suffering from all the ills which an engraver's flesh is heir to. These are ills that come in the shape of indifferent gravers; one graver is too hard, and away flies its point as soon as it touches the steel plate, making, instead of a dot beautiful in shape and clearness, an ill-formed dent, probably twice as big as was required for the purpose. Sometimes the result of this sudden snapping of the point of the graver is a slip, which brings with it loss of time—first to erase the slip, and then to make good the surface of the steel plate. The next graver, and the next after that, will be, in all probability, too soft, and here is more trouble for Pickpeck; nearly half his time is lost in re-sharpening his gravers, for, the moment some of them touch the steel plate, their points get doubled up. Thus, Pickpeck frets and fumes, and fumes and frets, and carries on his work "through difficulties of which it is useless to complain," as Johnson observed concerning the labour of his Dictionary. Yes; all this Pickpeck has to do, to an extent which makes him feel with bitter force the further words of the great lexicographer; for the engraver dots away, day after day, "without one act of assistance, one word of encouragement, or one smile of favour" from anybody.

But after all this work and labour, after all this dot, dot, dotting, to get out the true light and shade of Bunglebutt's sage countenance—upon taking a proof at this middle stage of the engraving, the proof looks rather white and ghostly; consequently, increase of power must be had quickly, and can be had quickly by what is called re-biting; therefore, Pickpeck prepares for the more than usually delicate operation of "a re-bite."

For laying his re-biting ground, Pickpeck does not use the ground he employed for etching upon, although that would serve the purpose very well; but Pickpeck is a particular fellow in these matters, and has, therefore, his special corpulent-looking brandy-ball-coloured ground for re-biting; yet the materials composing these grounds are the same in both cases—that is to say, virgin wax, Burgundy pitch, and asphaltum; but it is by the most subtle cunning that the proportions have been varied, so as to make each ground the more efficacious for its particular department.

In this operation of re-biting, the first thing that Pickpeck has to do, is, beautifully to clean the engraved surface of the steel plate with turpentine; then, placing a lady's silver thimble full of whiting upon the well-cleaned surface, with a little fresh turpentine added, wherewith to make the whiting into a kind of paste, the same is then laid completely over the plate, and, when quite dry, the superfluous whiting being brushed off with a clean piece of cotton rag, the surface of the steel plate will suddenly appear as bright as polished silver, while every individual engraved dot and line looks somewhat pretty, being perfectly filled with dry and hard whiting. But this must be removed before the ground can be laid; so, with a piece of carefully selected stale bread, quite free from the least speck of grease, Pickpeck gently rubs the stale bread over the engraved parts: when forthwith the whiting leaves the dots and lines, which are then observed to sparkle like diamonds of the purest water.

The steel plate being thus prepared for a re-biting ground, and at the back or under side of the plate the proper amount of warmth having been applied, the first important thing for Pickpeck to do is to pass down the margin of the plate the silk-covered ball of re-biting ground, which, as if by magic, leaves in the wake of its passage what looks like a stroke of treacle. This is then gently manipulated about the margin of the plate by means of a series of delicate pats or dabs with the re-biting dabber, until the ground is diffused about and thinned down into a homogeneous tint, like a layer of leaf-gold. Now comes the trial of skill; from this leaf-gold looking tint of re-biting ground, lying on the margin of the plate, Pickpeck begins to pass with his dabber over the engraved surface with the gentlest of all gentle pats, and, as his manipulation is this time perfect, the satisfactory result is, that over Bunglebutt's expressive head and shoulders there presently appears a golden film of re-biting ground, the same resting upon the blank bits of steel situated between and around each line and dot that has been engraved upon the steel plate; moreover, every dot is shining away through the golden film of re-biting ground, like so many homoeopathic spangles; for if the smallest particle of the re-biting ground had flowed over the sides of any line or dot, and so down into these graver-made cavities, the acid would very politely decline to act therein.

The next thing to be done is for Pickpeck to carefully cover over with his Brunswick black all such parts of the engraving as he does not desire to re-bite. Then, once again, Pickpeck surrounds the steel plate with a second little great wall of China, composed of the same kind of wax that the first was made with. The Brunswick black being carried home to the base of this little great wall of China, the process of stopping-out the plate for re-biting is complete, while the Brunswick black will in a comparatively short time be dry enough and hard enough to decline letting the acid make way through its coat, so as to do damage to the surface of the steel beneath.

Pickpeck prepares to pour his re-biting acid on the plate and within the mystic circle of wall-

wax. As before observed, the engraved portion of the plate, not stopped out with Brunswick black, is only covered with a delicate gold-leaf-looking film of re-biting ground, which, thin and delicate as it is, being nevertheless perfectly laid, scorns the most desperate attack of the acid; consequently the acid aforesaid is no sooner poured upon the plate than it pops down into the dots, taking their shine off in no time. As in the case of the etching, so with the engraving, minute particles of metal are torn away, whence every dot is being enlarged by this violent mode of proceeding on the part of the acid. And very sharp and attentive work is this re-biting, for all that Pickpeck wishes to accomplish, though of such great importance, is nevertheless—on steel—almost of a momentary nature in its working. An instant too long —nay, the winking of Pickpeck's eyelids—and the work of days may be undone in half a second. But fate is this time kind to Pickpeck; his re-biting is a success. Nay, more, though Pickpeck, in his anxiety to see a proof, starts off himself to the steel and copper-plate printer at full speed in the broiling sun, as though he were walking for a heavy wager, his proofs are beautiful, for all the nice operations of the skilful "prover" are successful. Pickpeck would, notwithstanding his toils, begin to feel a little happy, were it not for that obliquity of vision on the part of Bunglebutt; which circumstance fills the heart of the engraver with misgivings. But still he works on manfully, toning here, burnishing a little there, and attending to all the refinements of drawing in every part of Bunglebutt's face, until he is enabled to submit what is, as he flatters himself, a very satisfactory finished proof. This, however, does not end the woes of Pickpeck. The sons and daughters of Bunglebutt—to say nothing of the wife of Bunglebutt's bosom—all make their remarks upon the engraving. These remarks are highly complimentary to Bunglebutt, and, as a natural consequence, very uncomplimentary to the engraver. The prodigious Bunglebutt himself writes a letter of remarks. This letter fills four pages of the largest cream-laid note-paper. The writing is very small and very close, and the remarks are directed at the inartistic manner in which Pickpeck has rendered the expression of "the left-hand eye."

To speak in plain and honest English, Pickpeck believes that the obliquity of Bunglebutt's left eye is a positive squint—an uncompromising squint; and that he has rendered its expression perfectly, even to its most subtle refinements of drawing. However, the Bunglebutt family perceive in "the left-hand eye" of their great papa—the real live eye—only "a stern expression of deep meditation, combined with a profundity of philosophical thought." Upon that, Bunglebutt criticises, in three pages of closely written note-paper of the largest size, the refinement of expression to be observed in what he calls "the left-hand eye;" all of which intellectual expression, in the united opinion of the Bunglebutt family, he, Pickpeck, has entirely missed. After this, nothing is left for Pickpeck but to throw, as well as he can, his whole soul into the soul of Bunglebutt, and to do his best to coax and coquet with that same left-hand eye, engraving divers dots, first a little on this side, then a little on that side, then a trifle above, then a trifle below: with a few very refined dots placed in the very apple of "the left-hand eye" itself. After doing all this, there are more journeys to the steel and copper-plate printer, and more finished proofs to be submitted, to be followed by more criticism; for the Bunglebutt family think a great deal of the "profundity of philosophical thought" which they perceive in that parental "left-hand eye," a most evil eye to Pickpeck. But all this monstrous long time the panting public are clamouring with frenzy for the twenty-second and much-augmented edition of "Our empty Coal-cellars, and What's to fill them?" embellished with the portrait of the author, which was to have been engraved "like a flash of lightning," but is not done yet.

Consequently a finished proof has to be submitted for a third time, and has to be a third time criticised; this necessitates a fourth finished proof, which, although the Bunglebutt family still think the engraver has not quite entered into all the depths of expression to be observed in "the left-hand eye," is happily accepted by them: while, taken altogether, they admit the engraving to be a very nice engraving, which will doubtless be received by the panting public as a decided adornment to "Our empty Coal-cellars, and What's to fill them?"

INDEX

Numbers in italics indicate main references

Academie des Beaux Arts 131
acierage 33, 198, 202
Ackerman, Rudolf 3, 41, 54, 136, 139, 163
Addison, J.
 Poems 18
Adlard, Alfred 199
Adlard, H. 50, 120, 199
Admiralty charts 73
Aedes Althorpianae 84
Agar, John S. 19, 58, 139
Age We Live In 214
Agnew and Sons 137
Ainsworth, W. Harrison 142
Albert, Prince 61, 125, 145, 175, 206
Alhambra 207
All the Year Round 33
Allan, Sir William 79, 145
Allen, Lieut. 123
Allen, James B. (1803–76) 69, *78*, 85, 95, 130, 146,
 164, 200
Allen, S. 137
Allen, Thomas
 History of . . . Surrey and Sussex 199
Allnutt, *amateur* 102
Allom, Thomas (1804–72) 35, 73, 76, 100, 106,
 108–9, 113, 114, 172
 'Constantinople' 96
 'Darlington, from the Road to Yarm' 109
 'Smyrna from the harbour' 100
Almanac de Gotha 139
American Antiquarian Society 12
American Scenery 77, 96, 98, 110, 123
Amulet, The 15, 68, 101, 124, 134, 141, 142, 154
Andrews, *publisher* 141
Angler's Souvenir 167
Anniversary, The 95, 101, 107, 129, 134, 142, 145,
 200, 209
Annual Register 139
annuals 139–52, 205
Ansdell, Richard 55
Antiquities of Athens 46

Antiquities of Westminster 205
Applegath, Augustus 181
apprenticeship 64
Arabian Nights' Entertainments illustrations after
 Smirke 19
Archer, John W. (1808–64) 85
Archibald, William 64, 79
Armstrong, Cosmo 19, 58
Armytage, James C. (1802–97) 55, *98–9*, 124, 137,
 214, 216
Art for Commerce 199
Art Journal 38, 54, 55, 72, 73, 77, 78, 82, 95, 96, 98,
 99, 100, 101, 102, 104, 105, 109, 136, 137, 138,
 152, 169, 170, 200, 202, 209, 210, 211, 214
Art Journal circulation figures 137
Art Union (later *Art Journal*) 57, 74, 136, 167
Art Union of London 73, 77, 94, 104, 105, 174, 175,
 176, 177, 191, 209
Art Union of Scotland 174
Art Unions 102, 152, 173–7, 191, 200, 205
Artists' and Amateurs' conversazione 59
Artists' Annuity Fund 19, 28, 58, 76, 94, 101
Artists' Benevolent Fund 58, 59
Asher, A. 161
Ashford, Mary 70
Associated Engravers 137
Association for the Promotion of Fine Arts in
 Scotland 104, 173, 174
Association for the Purchase of British
 Engravings 174
Association of Print-Publishers and Dealers 187
ateliers 54, 208
Athenaeum 128
Atkinson, T. L. 104

Bacon, Frederick (1803–87) 59, 76, 85
Bacon, Joshua B. 165
Bacon, T.
 Tales, Legends and Historical Romances 87
Baines, Edward
 History of . . . Lancaster 100, 134, 172
Baines, Thomas 87
 Tales, Legends . . . Yorkshire Past and Present 216